Basquiat

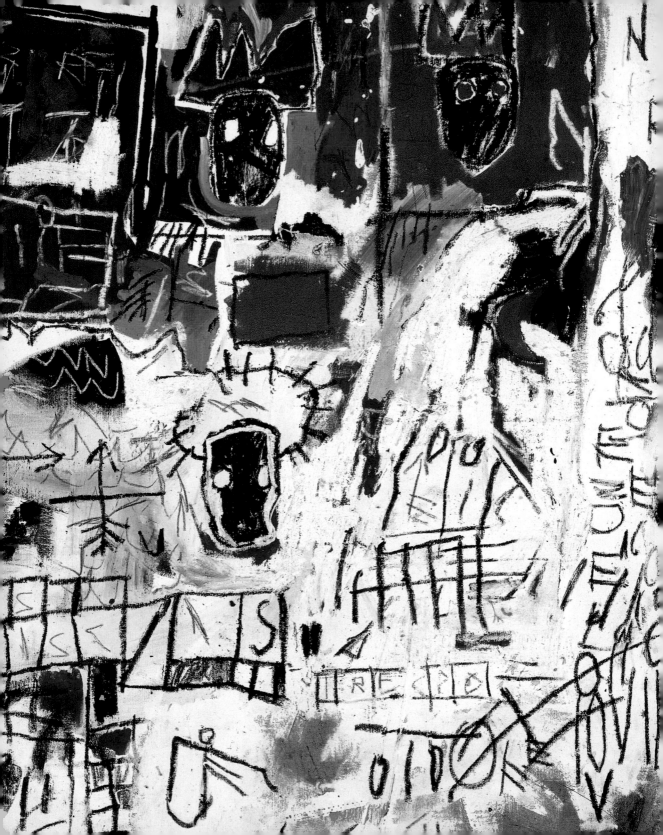

Basquiat

Edited by
Marc Mayer

Co-curated and with essays by
Fred Hoffman
Kellie Jones
Marc Mayer
Franklin Sirmans

Brooklyn Museum

MERRELL
LONDON · NEW YORK

Published on the occasion of the exhibition *Basquiat*, organized by the Brooklyn Museum.

The co-curators of the exhibition were Marc Mayer, *Basquiat* Project Director and at that time Deputy Director for Art at the Brooklyn Museum, now Director and CEO of the National Gallery of Canada; Fred Hoffman, Ahmanson Curatorial Fellow at the Museum of Contemporary Art, Los Angeles; Kellie Jones, Associate Professor of Art History and Archaeology at Columbia University; and Franklin Sirmans, Curator of Modern and Contemporary Art at the Menil Collection, Houston.

JPMorgan Chase generously sponsored the national tour of *Basquiat*. The Federal Council on the Arts and the Humanities granted an indemnity for this project.

Published by

Merrell Publishers Limited
70 Cowcross Street
London EC1M 6EJ

merrellpublishers.com

in association with

Brooklyn Museum
200 Eastern Parkway
Brooklyn, NY 11238-6052
www.brooklynmuseum.org

First published 2005
Compact paperback edition first published 2010

This publication was organized at the Brooklyn Museum
James Leggio, Head of Publications & Editorial Services

British Library Cataloguing-in-Publication data:
Basquiat, Jean-Michel, 1960–1988.
Basquiat.
1. Basquiat, Jean-Michel, 1960–1988 – Criticism and interpretation.
2. Basquiat, Jean-Michel, 1960–1988 – Exhibitions.
I. Title II. Mayer, Marc (Marc Daniel), 1956– III. Hoffman, Fred, 1944–
IV. Brooklyn Museum.
759.1'3-dc22

A catalogue record for this book is available from the Library of Congress.

ISBN 978-1-8589-4519-4

Photograph Credits
The majority of the photographs of works of art reproduced in this book were provided by the owners or custodians of the works, indicated in the captions. The following list applies to photographs for which an additional acknowledgment is due.

© 2005 Artists Rights Society (ARS), New York/VG Bild-Kunst, Bonn; digital image © The Museum of Modern Art/Licensed by SCALA/Art Resource, New York: p. 56. Edo Bertoglio, © New York Beat Films LLC 2000, courtesy Maripol: p. 101. Christie's, New York, courtesy Udo Brandhorst: p. 107. © Marina D., courtesy Maripol: p. 100 (left). Ivan Della Tana: pp. 144, 164. The Royal Collection © 2005 Her Majesty Queen Elizabeth II: p. 48. Gagosian Gallery, New York: pp. 118, 152, 153. Nan Goldin: p. 93. © Bobby Grossman: p. 99 (right). © Lizzie Himmel: p. 104. © George Hirose: p. 97 (right). © Paul Laster: p. 99 (left). Malca Fine Art, New York: pp. 39 (left), 128, 131. Robert McKeever: p. 20. Digital image © The Museum of Modern Art/Licensed by SCALA/Art Resource, New York: p. 49. © 2005 Board of Trustees, National Gallery of Art, Washington, D.C.: p. 45. Douglas M. Parker Studio: pp. 35, 88, 117. © Patisse, courtesy Maripol: p. 100 (right). © 2005 Estate of Pablo Picasso/Artists Rights Society (ARS), New York; digital image © The Museum of Modern Art/Licensed by SCALA/Art Resource, New York: pp. 57 (left), 137. Richard Leslie Schulman: p. 57 (right). Tony Shafrazi Gallery, New York: p. 156. Jerry L. Thompson: p. 120 (left). © Brian D. Williams, courtesy Maripol: p. 170. Zindman/Fremont: pp. 38 (left), 146.

Basquiat was supported at the Museum of Contemporary Art, Los Angeles, by the Ahmanson Foundation through the Ahamson Curatorial Fellowship with major support provided by the Broad Art Foundation. Additional support provided by Quiksilver.

Produced by Merrell Publishers Limited
Designed by Empire Design Studio, New York
Printed and bound in China

Front cover: Detail of *Untitled (Head)*, 1981 (p. 35)
Back cover: Basquiat writing graffiti in the film *Downtown 81 (New York Beat)*, 1980–81
Page 2: Detail of *Peso Neto*, 1981 (p. 34)
Pages 10–11: Detail of *Untitled (Crown)*, 1983 (p. 119)

CONTENTS

SPONSOR'S STATEMENT

JPMorgan Chase is proud to sponsor the national tour of *Basquiat*. We are pleased to be associated with the Brooklyn Museum, one of the country's most distinguished cultural institutions, which shares our commitment to supporting the works of both emerging and established artists.

JPMorgan Chase's longstanding support for arts and culture is recognized widely. It is a key factor in our commitment to the well-being and vitality of the communities we serve, and we seek to support the best in arts and culture offered in our markets around the world. Here in New York City, that means partnering with the Brooklyn Museum. Worldwide, JPMorgan Chase's support of arts and culture is reflected in any one of its multiple endeavors as collector, educator, corporate sponsor, or exhibition host.

JPMorgan Chase has built its own international art collection over the course of forty years. The collection began in 1959 with an emphasis on supporting emerging artists and contemporary works. Today, it includes more than twenty thousand works in JPMorgan Chase offices worldwide, encompassing paintings, works on paper, photography, sculpture, glass, ceramics, video, and indigenous arts, with representation from every region in the United States and every country in which we do business. It is continually shared with our communities. We are proud to have drawings by Jean-Michel Basquiat in our collection.

From the Brooklyn Museum, JPMorgan Chase's support of *Basquiat* will continue at the Museum of Contemporary Art, Los Angeles, and the Museum of Fine Arts, Houston. We welcome our role in bringing the works of Jean-Michel Basquiat to more people, promoting cross-cultural dialogue and giving us all a broader understanding of the world in which we live.

Chairman and Chief Executive Officer
JPMorgan Chase & Co.

6

FOREWORD

Museums such as the Brooklyn Museum can help a community raise its children to become well-rounded and productive adults. Experiencing the diversity of world art can teach tolerance and respect, for example, because beyond the often startling differences that separate one culture's aesthetics from another's, a functional similarity waits to be discovered. That is to say, art is how we remember and celebrate, how we impart our knowledge and beliefs, and how we generate beauty, no matter the time or place in which we may have lived. Moreover, regular visits to an art museum can inspire us to be productive in our own lives, because we see in its displays the admirable results of someone else's efforts, perhaps someone who lived long ago and far away, which can help us foresee the positive results of our own labor. Bursting with information—full of history, science, literature, religion, and philosophy, as embodied in objects from around the world—art museums are also full of exquisite pleasures: the combination of insight and delight that nourishes minds.

Nothing, however, is quite as gratifying to those of us who work in museums as when such institutions help to produce a great artist.

Jean-Michel Basquiat was no stranger to the museums of New York, but he is known to have had a special fondness for the place he called "the Brooklyn." He was a Junior Member of the Brooklyn Museum when he was six years old, encouraged by his parents in his artistic inclinations from their earliest signs. Born and raised in Brooklyn, Basquiat would have first experienced world art in "the Brooklyn's" vast collections. We like to think that this unique prodigy, who knew fame throughout the art world while still in his early twenties, may have come by some of his highly eclectic interests from spending time in this great institution. His tragic death at the age of twenty-seven, after a short yet breathtaking career in art, was a loss not only to his family, but to all of us who value intelligence and innovation in the fine arts. Fittingly, Jean-Michel Basquiat is buried in Brooklyn's Green-Wood Cemetery, among Civil War heroes, Abolitionists, and a number of other great American artists.

Of the many people who have made this exhibition possible, we are most grateful to Gérard Basquiat, who felt strongly that his son's work be shown in this museum, to be seen here by young people from Brooklyn. Gérard's good-natured generosity at every step in the long and complicated organization of this exhibition has been exemplary, and we thank him most warmly. The advice and help of Jeffrey Deitch have also been invaluable from the very inception of the project. His wisdom related to an artist whose work he knows so well has been a great benefit to this exhibition. We would like to thank all the members of the Authentication Committee of the Estate of Jean-Michel Basquiat: Richard Marshall, Larry Warsh, John Cheim, and Nora Fitzpatrick, as well as Jeffrey Deitch and Gérard Basquiat.

Enrico Navarra's indispensable support made an enormous difference to the quality of this exhibition, and we thank him for his extraordinary assistance and knowledge. Tony Shafrazi, Leo Malca, and particularly Annina Nosei, the artist's first representative in New York, and other ardent admirers of Basquiat have been helpful in many ways, with information, documentation, and excellent advice. Particularly warm thanks to Julian Schnabel, as well as to Larry Gagosian. Needless to say, without the support of the artist's many collectors, this exhibition would have been impossible to realize, and we thank them all, particularly the Stephanie and Peter Brant Foundation, the Schorr Family Collection, as well as Edythe L. and Eli Broad and the Broad Art Foundation, who have all shown great seriousness and insight in their commitment to Basquiat's work.

Our colleagues Peter Marzio and Barry Walker of the Museum of Fine Arts, Houston, and Jeremy Strick, Paul Schimmel, and Alma Ruiz of the Museum of Contemporary Art, Los Angeles, are owed our warmest thanks for their support throughout the organization of the exhibition's tour.

I would be remiss if I did not acknowledge the hard work of the *Basquiat* co-curators—Marc Mayer, project director, Fred Hoffman, Kellie Jones, and Franklin Sirmans—in providing fresh and engaging new perspectives on this complex artist. The works they gathered together and the great many new ideas they have drawn from this exceptional material will confirm Basquiat's prominence in the present and the future.

It is with pride that I thank our national sponsor, JPMorgan Chase, an outstanding corporate citizen of Brooklyn and a great friend to the arts, for its munificent support of this exhibition. We are grateful for their generosity, professionalism, and friendship. We also thank the Brooklyn Museum's Richard and Barbara Debs Exhibition Fund, Contemporary Art Council, and Iris and B. Gerald Cantor Foundation/Andrew W. Mellon Foundation Publication Endowment.

For the ongoing support of the Museum's Trustees, we extend special gratitude to Robert S. Rubin, Chairman, and every member of our Board. Without the confidence and active engagement of our Trustees, it would not be possible to initiate and maintain the high level of exhibition and publication programming exemplified by *Basquiat*.

Arnold L. Lehman
Director, Brooklyn Museum

PREFACE AND ACKNOWLEDGMENTS

The first time I saw a painting by Jean-Michel Basquiat, I was an undergraduate art history student keen on the Italian Baroque. A crazy and technically insolent picture, at first sight it felt like a crash course on modern art given by a brainy "club kid." I was caught off guard, as if a stranger had rudely interrupted a conversation, and I didn't know what to make of it. Like everyone else at the time, I thought first of Expressionism, and the picture made sense, academically, for a moment. But once I had taken in the cartoonish rusticity of its making, with graphically wild figures in a quarrelsome palette, the picture began to feel more recent than modern art, and unaccountably familiar. Had this, it even occurred to me, been pulled together in a trance by an artist fan of a good punk band? (I didn't much care for punk and wouldn't hear of hip-hop for years.) Though casual in the extreme, it never actually surrendered to sloppiness, which would have undermined the balanced compositional density the artist seemed to be going for. And the painter appeared to have his rowdy surface under control, which brought a more French strain of Expressionism to mind; a bit too aggressively self-confident, perhaps, yet skillful, I supposed, and not unpleasant. But what was the painting about?

I could not stop looking at it. Ultimately, I was overcome by a sense that I was standing in front of something emotionally genuine—but I understood little else about it. What this artist was showing me I believed to be a true thing, but also cryptic, evasive, and noisy. An insistently hand-made object, it was unapologetically new and, I had to admit, representative of my own cacophonic moment in time. Full of risky ideas and recycled attitudes, all mixed up with palpable feelings, the picture finally gave me an unexpected thrill. It was 1984, and the title of the painting was *Notary*. Basquiat had made it the previous year, when he was twenty-two.

I like to think that a passion for contemporary art, which would determine my eventual career, grew from this formative experience. Afterward, I began seeking out new art that, like Basquiat's, might again interrupt my mental conversation with the past. In the intervening years, though, like many others who respect Basquiat's achievement, I have had too many opportunities to regret his extra-artistic fame, so little of it having anything to do

with what I believe to be his extraordinary achievements. Among the most prolific of brilliant twentieth-century artists, Basquiat was also among the shortest-lived. There is nothing to celebrate in this fact, and it has gotten in the way of levelheaded appreciations of his exceptional gifts. Between the sentimentality such lives inspire and the critical disdain sentimentality attracts, it has been hard for many of us to see with much clarity what and how he painted.

Basquiat left us with an extraordinarily complex body of work. He evolved very quickly as an artist, but in a back-and-forth fashion, revisiting old ideas as frequently as he developed new ones, while also creating unique pictures, or tiny groups of them, that do not seem to have discernible echoes elsewhere in the work. As a result of his complex evolution, there are any number of ways to tell the story of his career, with many sub-plots to be encountered along the way. For the purpose of this exhibition, however, it seemed important to keep it lucid, and to rely on the artist's strongest and clearest achievements, rather than following out all the various byways. There is much to be gained, after all, in getting this story told effectively, rather than absolutely exhaustively. For if the exhibition succeeds in giving the artist his due, it will help alter the way we see the ending of the twentieth century's artistic saga just enough to create greater interest in Basquiat and to foster more exhibitions in his own country, like the many seen abroad in recent years. Most important, it will provide our museum colleagues with a convincing reason, and perhaps the urge, to seek out and acquire key examples of Basquiat's work and include them in the story of art that their collections tell.

———————

Four very different and complementary perspectives have gone into the organization of this exhibition, and the essays gathered here exemplify them. Kellie Jones gives us a broadly cross-cultural sense of Basquiat, an articulate artist who knew who he was, where he came from, and for whom he spoke. Franklin Sirmans shows us a man of many gifts and explores how the various

cultural interests that informed his work, notably music, came from his own experience. Fred Hoffman sees a greater and deeper ambition at work in some of Basquiat's finest paintings and introduces us to a sophisticated humanist, an artist with a soul. For my part, I hoped to situate Basquiat at the bracing final episode of modernism, as its ultimate exemplar. I am grateful to each of my collaborators for widening our critical perspective on the artist. Basquiat's artistic legacy is astonishingly large and various. We hope that some sense of his reach has been made evident here.

In bringing this project to realization, we have relied on the active support of a number of key individuals. Our thanks go first to Gérard Basquiat, whose confidence in us has made this exhibition possible. We acknowledge as well the invaluable help of Jeffrey Deitch, Enrico Navarra, Géraldine Pfeffer-Levi, Nathalie Prat, Peter Brant, Jean Bickley, Leo Malca, Herbert and Lenore Schorr, Tony Shafrazi, Larry Warsh, Annina Nosei, Larry Gagosian, Richard Rodriguez, Julian Schnabel, and the many other collectors, gallerists, and friends whose generosity with information and documents has enriched this project immeasurably. We also acknowledge Richard D. Marshall, who organized the first museum survey exhibition of Jean-Michel Basquiat. We all stand on his curatorial shoulders.

Of the many Brooklyn Museum colleagues who have been instrumental in bringing this exhibition and book to fruition, I must single out Arnold Lehman, whose ambition for the project and commitment to its realization were essential to its success; Charlotta Kotik and Moriah Evans, who provided invaluable preparatory research; Clare Weiss and Robin Weglinski, who very ably continued the research and contributed a great deal to its successful organization; Sarah Timmins DeGregory and Megan Doyle Hurst, whose hard work and sharp eyes have made so much possible; and Leslie Brauman, who coordinated the exhibition's funding. In countless ways, James Leggio, our gifted editor, shepherded this book into existence. We are grateful to him and to all the staff members of the Brooklyn Museum who made this project their own.

Marc Mayer

BOTTOMLESS P

ALL OF OR SECOND R'SUN SCO TRIP

MARY YOUNG SPER

\bigcirc ↓↓ a

HOLLYWOOD

MASTER ↑

SUNSET \bigcirc

STRIP PATIO SHONES

URINE HIGHWAY DIVIDER

SIX PO IDAHOE POTATO

600 DOLLARS IN DIMES

VARIOUS MEATS AND PORKS

GRILLED CHEESE FRIED SALAMI

MEAT LOAF 244 70

SCO ↑↑ BROASTED FIELDS
 ↓
 CHICKEN BOOM
 TURKEY BOOM

HONEY DIP DONUTS
 ↓ ↓

MOLSHER
MSSR SUMMER

SSENGR

CRO MANGO

OF MASS CRO-MAG

ROCET SHP

ROCET FIELD

VERY SAD TRA GIGURE OF GOEK
ORIGINS ↓↓

↓ 1906 SA AND UZZTT
↓ BRT BCRCP THIS

TEARNESS S

MOST

MY LUE BASC

MADONNA HA →
 ROOSTER
↑
THE FRENSCT
 PRESENT →

MORE LASS BAM B

BASQUE REGION

ROCAT

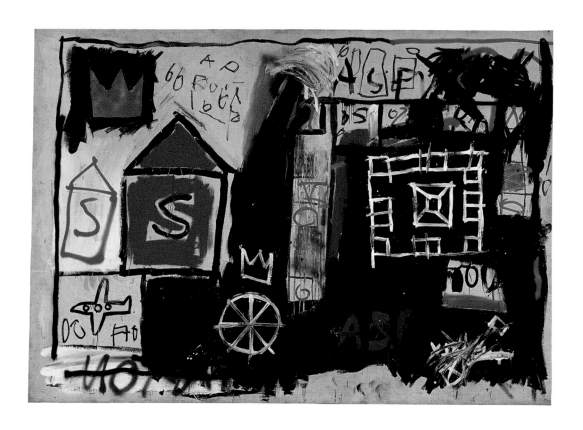

Untitled
1981
Acrylic and spray
paint on canvas
79 x 111 inches
(200.5 x 282 cm)
Collection of
Annina Nosei

Untitled
1981
Acrylic, spray paint
and oil paintstick
on canvas
86 x 104 inches
(218.5 x 264 cm)
The Stephanie and
Peter Brant Foundation,
Greenwich, Connecticut

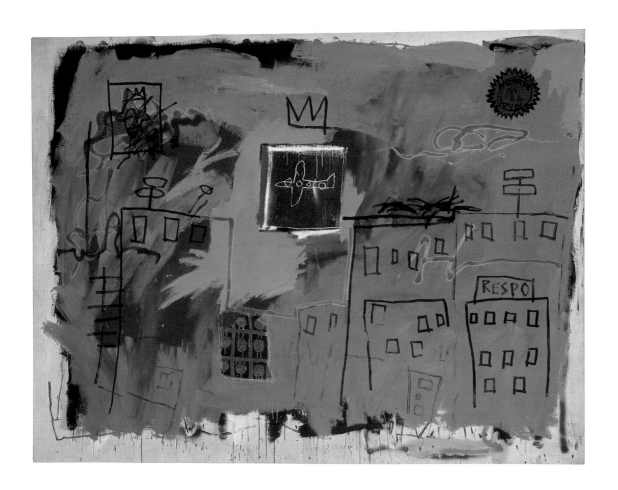

Untitled
(We have decided ...)
1979–80
Acrylic, blood, ink,
and paper collage
on paper
16¾ x 14 inches
(41.3 x 35.6 cm)
Collection of
Enrico Navarra

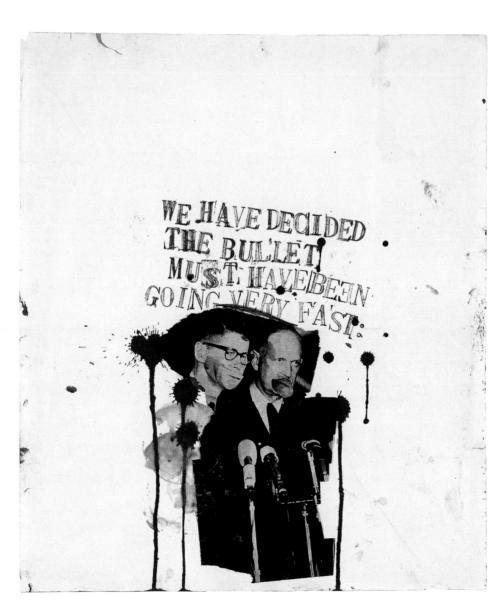

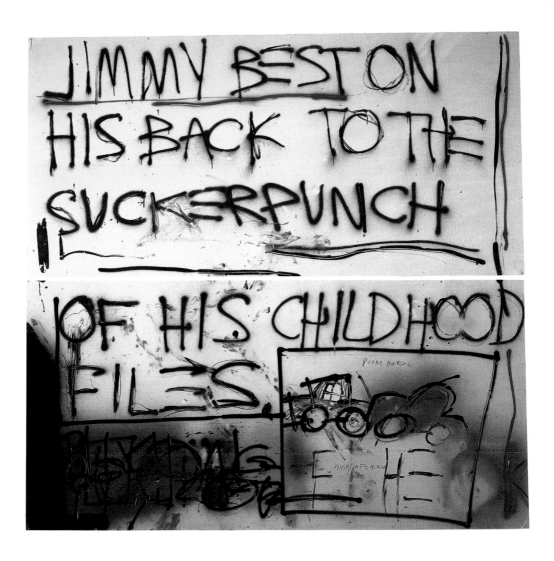

Jimmy Best ...
1981
Spray paint and
oil paintstick on metal,
two panels
96 x 96 inches
(244 x 244 cm) overall
Collection of Tsong-Zung Chang

Untitled
1980
Acrylic and oil
paintstick on canvas
43 x 71 inches
(109 x 180.5 cm)
The Stephanie and
Peter Brant Foundation,
Greenwich, Connecticut

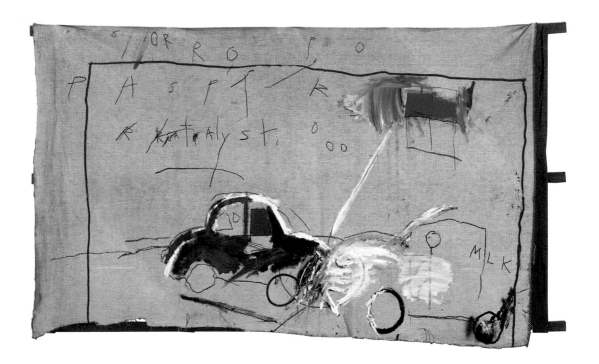

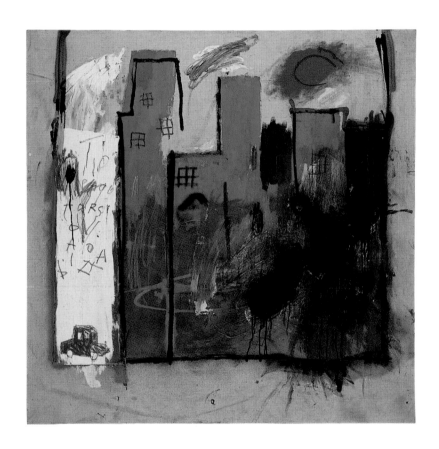

Untitled
1980–81
Acrylic, spray paint,
and oil paintstick
on canvas
48 x 48 inches
(122 x 122 cm)
The Estate of
Jean-Michel Basquiat

Untitled
1981
Oil paintstick, color
transfer on printed paper, and collage
on paper
35 x 30 inches
(88.9 x 76.2 cm)
Collection of Larry Gagosian

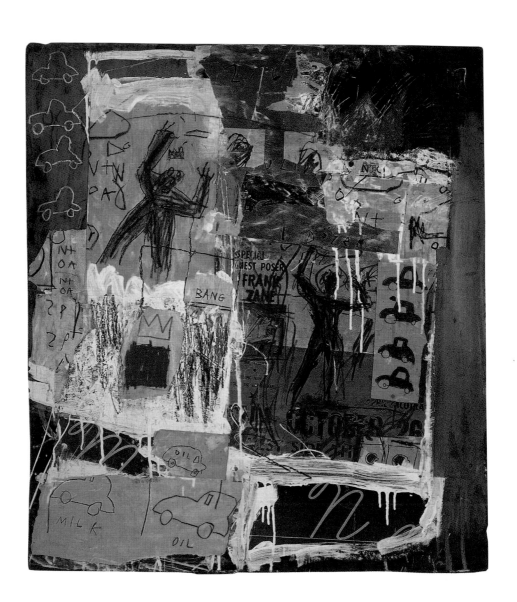

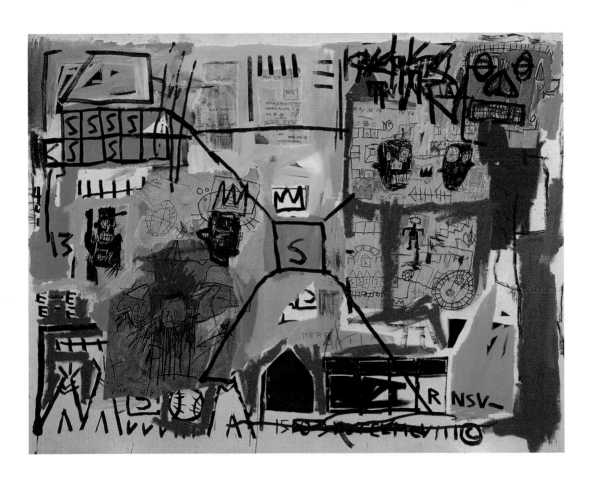

Untitled
1981
Acrylic, marker,
paper collage, oil
paintstick, and
crayon on canvas
48 ½ x 62 inches
(123 x 157.5 cm)
The Schorr Family
Collection

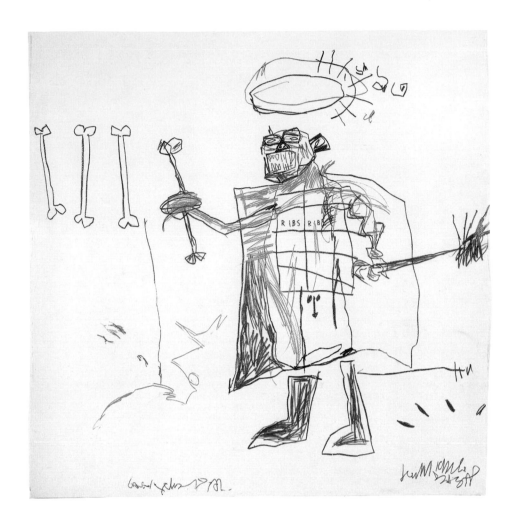

Ribs, Ribs
1982

Oil paintstick on paper
104 x 96 inches
(264 x 244 cm)
The Stephanie and
Peter Brant Foundation,
Greenwich, Connecticut

Untitled
(Helmet)
1981
Acrylic and oil
paintstick
9 x 8 x 13 inches
(22.8 x 20.3 x 33 cm)
Collection of Leo Malca

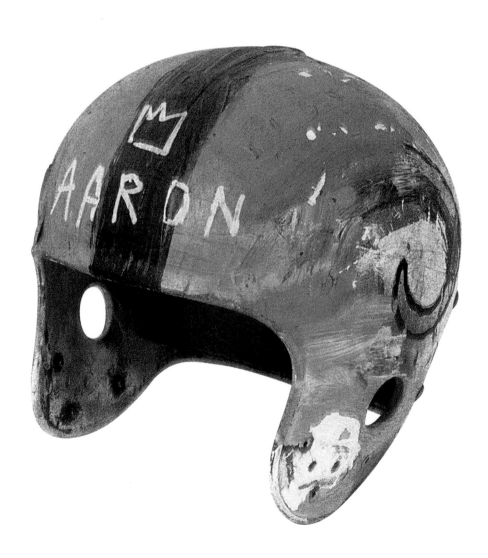

Untitled
1981
Acrylic, oil, oil
paintstick and gold
leaf on found window
38 x 34 x 2¼ inches
(96.5 x 87 x 5.5 cm)
Collection of Leo Malca

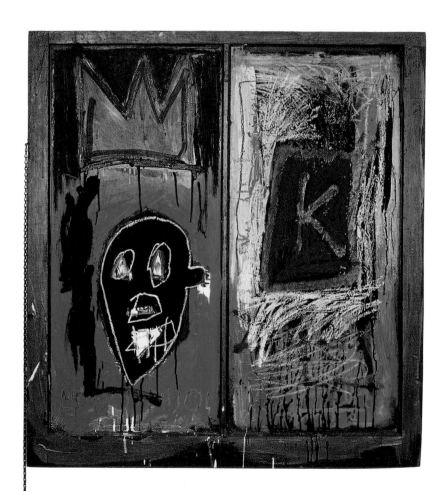

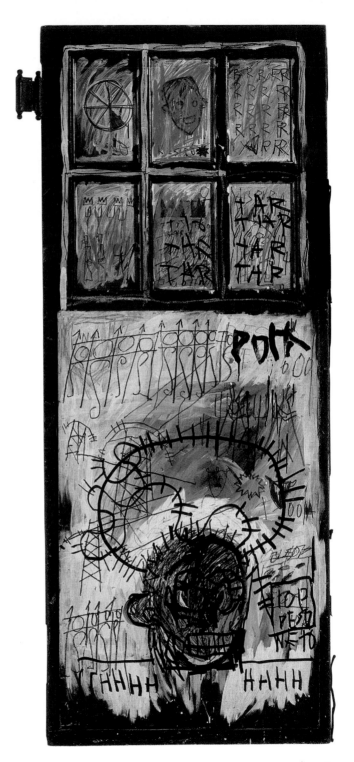

Pork
1981
Acrylic and oil
paintstick on
found door
83 x 34 inches
(211 x 85.5 cm)
Private collection

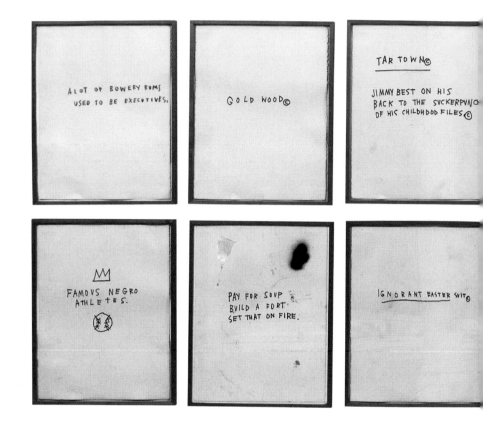

A LOT OF BOWERY BUMS USED TO BE EXECUTIVES.

GOLD WOOD©

TAR TOWN©

JIMMY BEST ON HIS BACK TO THE SUCKERPUNC OF HIS CHILDHOOD FILES©

FAMOUS NEGRO ATHLETES.

PAY FOR SOUP BUILD A FORT SET THAT ON FIRE.

IGNORANT EASTER SUIT©

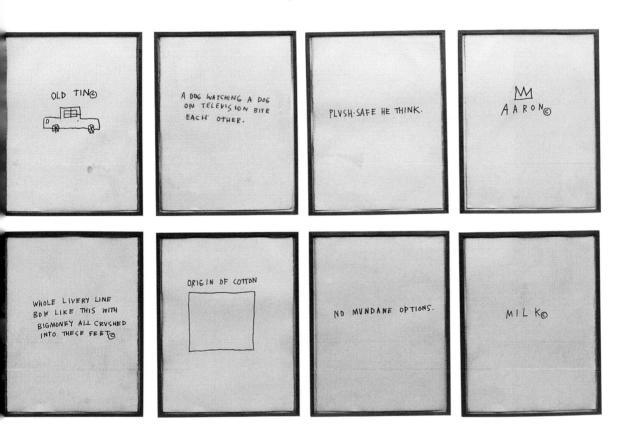

Untitled (Suite of Fourteen Drawings)
1981

Ink, crayon, and
acrylic on paper
30 x 22 inches
(76.2 x 55.9 cm) each
The Stephanie and
Peter Brant Foundation,
Greenwich, Connecticut

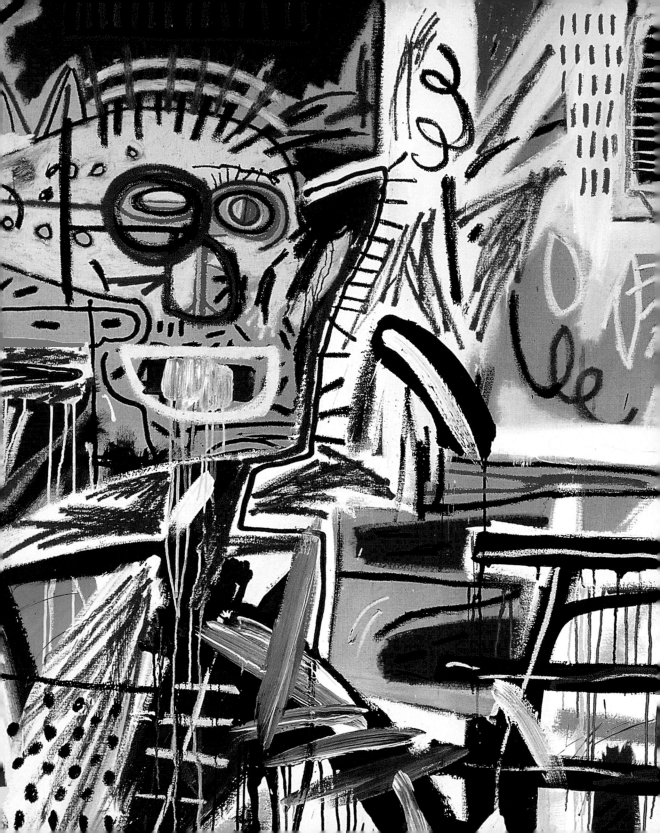

Philistines
1982
Acrylic and oil
paintstick on canvas
72 x 123 inches
(183 x 312.5 cm)
Collection of Mr. and
Mrs. Thomas E. Worrell, Jr.

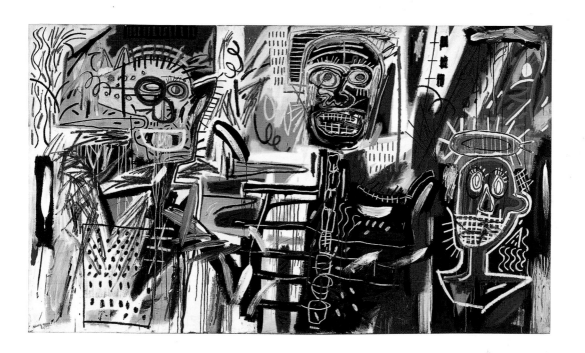

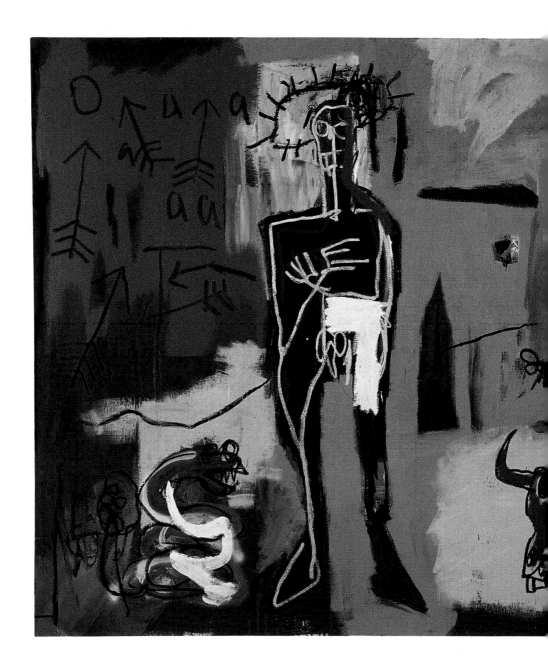

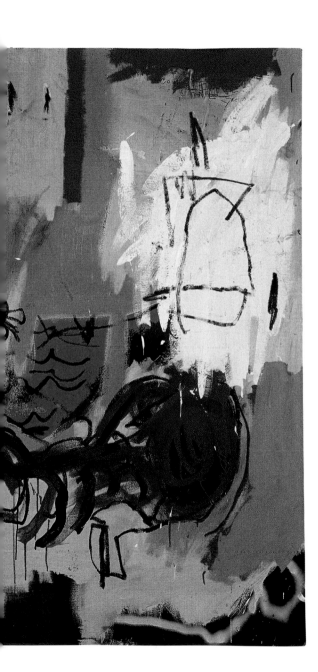

Acque Pericolose
1981
Acrylic, oil paintstick,
and spray paint
on canvas
66 x 96 inches
(167.5 x 244 cm)
The Schorr Family
Collection; on long-term
loan to the Princeton
University Art Museum

Per Capita
1981
Acrylic and oil
paintstick on canvas
80 x 150 inches
(203 x 381 cm)
The Stephanie and
Peter Brant Foundation,
Greenwich, Connecticut

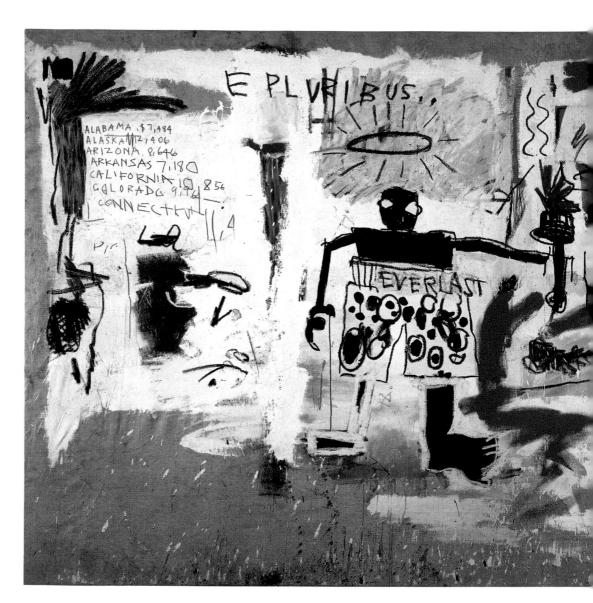

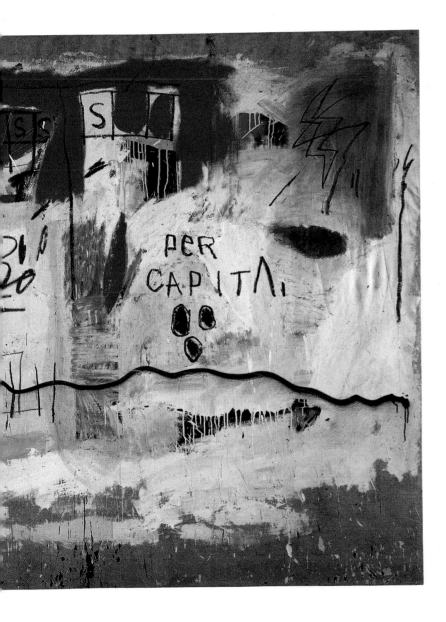

*Irony of the
Negro Policeman*
1981

Acrylic and oil
paintstick on wood
72 x 48 inches
(183 x 122 cm)
Collection of Dan
and Jeanne Fauci

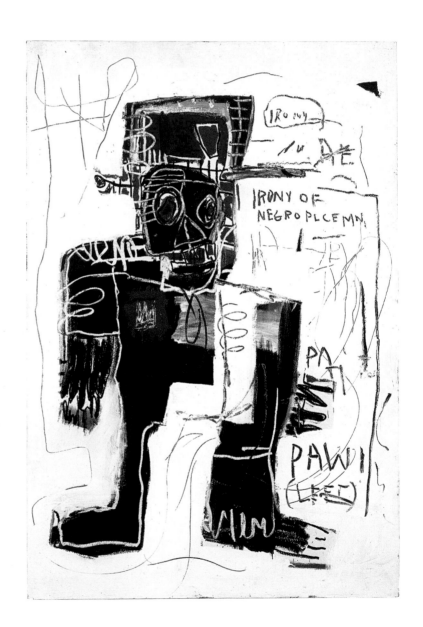

Arroz con Pollo
1981

Acrylic and oil
paintstick on canvas
68 x 84 inches
(172.5 x 213.5 cm)
The Stephanie and
Peter Brant Foundation,
Greenwich, Connecticut

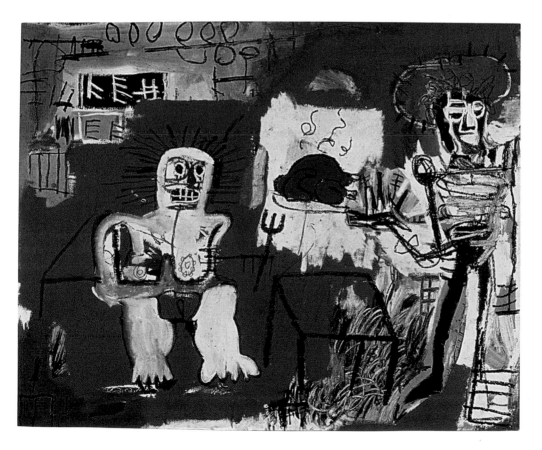

Peso Neto
1981
Acrylic, oil paintstick,
and paper collage
on canvas
72 x 94 inches
(183 x 239 cm)
Collection of Mr. and
Mrs. Thomas E. Worrell, Jr.

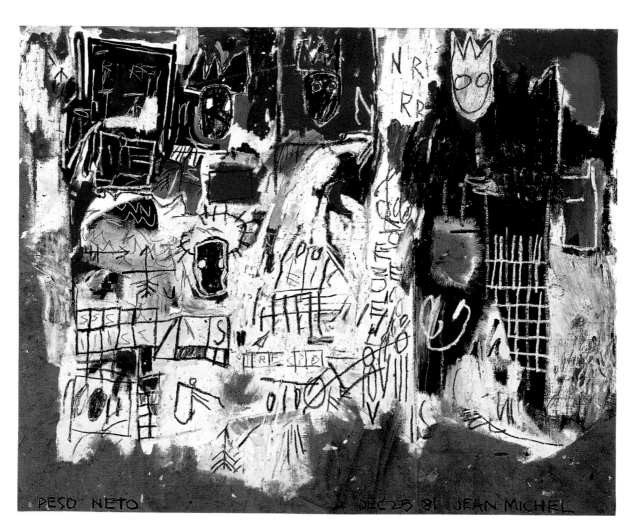

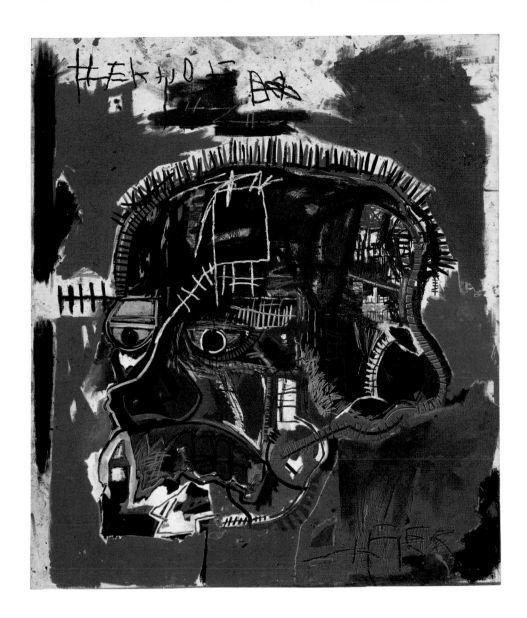

Untitled
(Head)
1981
Acrylic and oil paintstick
on canvas
81 ½ x 69 ¼ inches
(207 x 175.9 cm)
The Eli and Edythe
L. Broad Collection,
Los Angeles

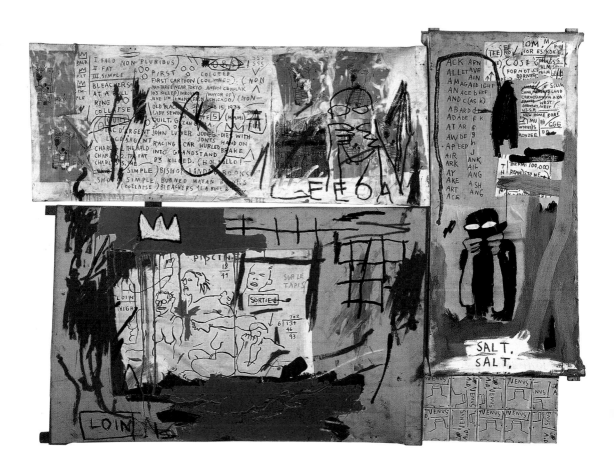

*Piscine versus
the Best Hotels*
1982

Acrylic, oil paintstick,
and photocopy
collage on canvas,
four panels
62 1/4 x 82 3/4 inches
(162 x 210.5 cm) overall
The Schorr Family Collection

36

Jawbone of an Ass
1982
Acrylic, oil paintstick,
and paper collage
on canvas mounted on
tied wood supports
60 x 84 inches
(152.5 x 213.5 cm)
The Estate of
Jean-Michel Basquiat

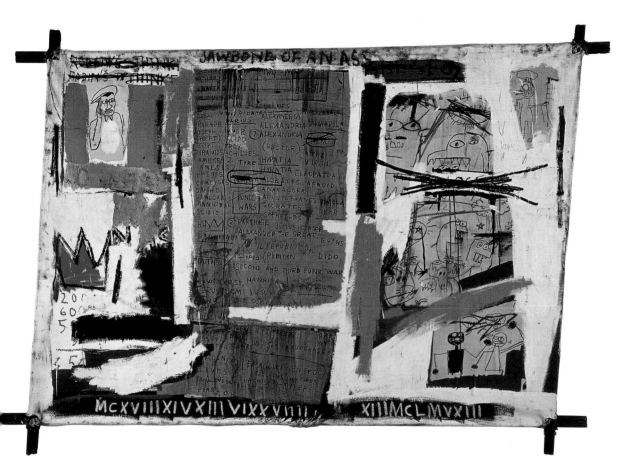

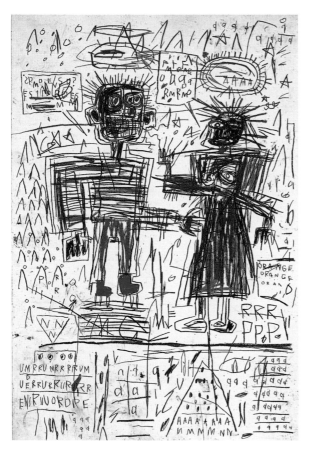

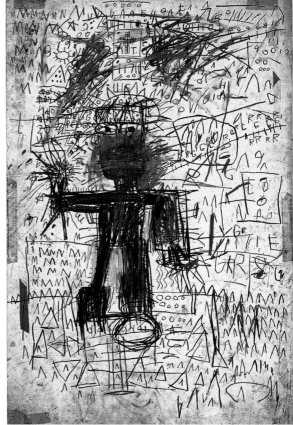

*Self-Portrait
with Suzanne*
1982

Oil paintstick on paper
60 x 40 inches
(152.4 x 101.6 cm)
The Stephanie and
Peter Brant Foundation,
Greenwich, Connecticut

Untitled
1982

Oil paintstick and
ballpoint pen on paper
60 x 40 inches
(152.4 x 101.6 cm)
The Stephanie and
Peter Brant Foundation,
Greenwich, Connecticut

Untitled
1982

Oil paintstick
on paper
60 x 40 inches
(152.4 x 101.6 cm)
Collection of Leo Malca

Untitled
1982

Oil paintstick
on paper
60 x 40 inches
(152.4 x 101.6 cm)
The Schorr Family
Collection; on long-term
loan to the Princeton
University Art Museum

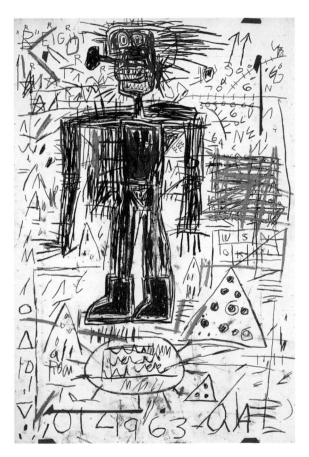

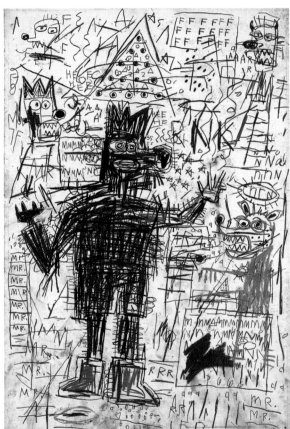

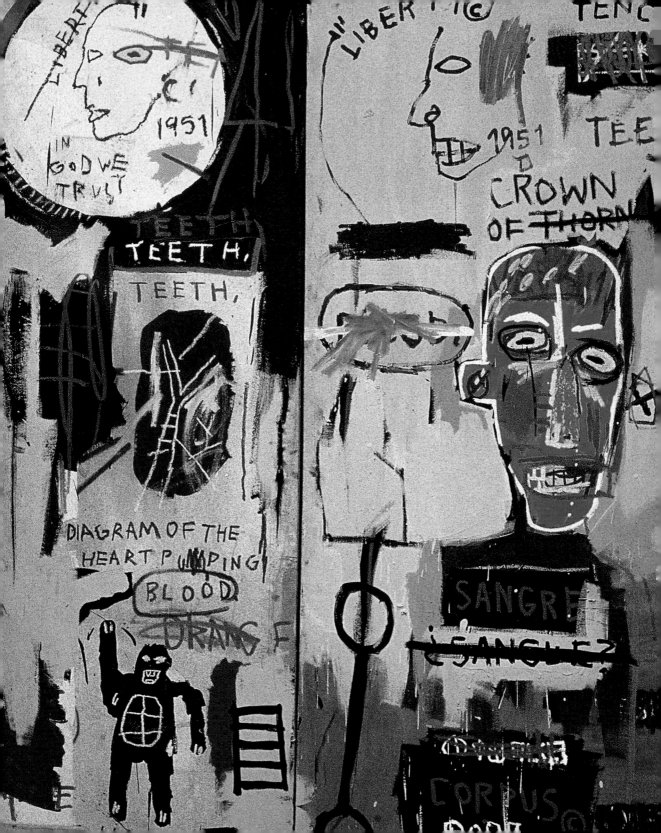

What I liked were: absurd paintings, pictures over doorways, stage sets, carnival backdrops, billboards, bright-colored prints, old-fashioned literature, church Latin, erotic books full of misspellings, the kind of novels our grandmothers read, fairy tales, little children's books, old operas, silly old songs, the naïve rhythms of country rimes.

I dreamed of Crusades, voyages of discovery that nobody had heard of, republics without histories, religious wars stamped out, revolutions in morals, movements of races and continents; I used to believe in every kind of magic ...

—Arthur Rimbaud, from "The Alchemy of the Word,"
A Season in Hell (1873), trans. Paul Schmidt

Basquiat in History

Marc Mayer

As the twentieth century recedes, our objectivity toward it increases. It was, of course, the century of modernism, which amounted to a pervasive and dominant secular culture. Artistically, however, the modernist century began with the provocatively irrational clamor of Expressionism with its nostalgic desire to construct a radically simplified world of the "primitive."

Instead of mining the past of Western art for its subject matter, as their forebears had, modern artists in the industrialized centers of Europe and, later, America pilfered their way through great hordes of artifacts from the material culture of all humanity—with a clear preference for those of tribal societies—which they found in such repositories of colonial exploitation as museums, libraries, world's fairs, and department stores. They roamed the world without needing to leave their modern cities, from which sprang a steady flow of stimulating novelties and fertile ideas. From there, modern art quickly went on to develop ever more cerebral forms of abstraction to their logical exhaustion just beyond mid-century, only to meet its end before an alien, time-based medium called video.

Though Jean-Michel Basquiat's work may in these respects seem related to certain features of modernism, of course his career took place not at its dawn but at its dusk. By the time Basquiat became professionally active, around 1981, the high modernist tradition may not have quite lost its social cachet, thanks to equally high prices, but its cultural authority was gone, replaced by the pragmatism of what had become an intellectually ambitious and academically buttressed profession.

Evidence of that change came with the waning authority of the art object itself. For example, the objects that the Pop artists had made in the 1960s were deliberately

Detail of *In Italian*, 1983 (p. 115)

41

indistinguishable from popular culture and commercial imagery, undermining a key modernist hierarchy. On a different front, feminists, among others, had resisted the elitist "commodity fetishism" of such traditional artistic media as painting and sculpture, preferring more effective means—like video, guerrilla posting, and performance—of broadly disseminating their urgent humanist message, further downgrading the role of the object. And even the direct heirs of the modernist tradition, the Minimalists and Conceptualists, had almost given up making objects altogether, certainly with their hands, often involving themselves instead in ponderous ontological meditations that had no physical manifestation. As the seventies ended, there was hardly anything left in this rarified realm of material culture that could actually qualify as material.

And all the while, Marxist theory, modern art's faithful companion, had attended its development throughout the century with a running commentary that gradually eroded the art object's prestige into the bargain, defining it as merely the most elitist of tradable commodities—the apex of the "cultural industries" that served triumphant capital.

It was in this climate, at this moment in art history, that the twenty-year-old Jean-Michel Basquiat turned from spraying gloomy poetic slogans on the walls of Lower Manhattan to making pictures to sell in SoHo. They were among the most ambitious paintings in a generation.

BASQUIAT'S EIGHTIES

Just in time to benefit from a muscular economy, after the long, dispiriting decade of the seventies, with its dying cities and vanishing fuel; and ready to please a society grown fervently unashamed of conspicuous luxury, a generation of artists emerged that had no interest in following the dour modernist logic any further into oblivion. Gregarious and well-educated object makers, eighties artists were blessedly "postmodern" and quite happy to create commodities with their own hands that others might fetishize to the point of sale. They made their own art world, too, and figured out how to reach the public without relying on either curators or dealers, who wasted no time, however, in catching up with some of them. In great numbers, they returned to figurative painting, while others of them

turned to elaborately crafted abstractions and to the making of fancy and witty objects of all kinds. For its part, the market returned noisily to new art, expanding to a newsworthy degree with collectors tripping over each other to buy out whole shows, each successive auction season bringing more astounding results for the work of young artists. We now recall the eighties, Basquiat's only decade, as an unusual moment when it seemed that the art world commercially centered in New York would continue to expand indefinitely. Not only did the new art available for public enjoyment suggest limitless variety, amid an unprecedented proliferation of galleries and publications, but there was also every reason to believe that the wallets open to the art world were bottomless.

Yet, with the close of the modernist period, art history began to feel anxiously complete. The aesthetic exhilaration of the 1980s may well have been the result of lifting the daunting burden of late modernism's moribund brand of formal rigor from the shoulders of artists and art lovers alike; and art certainly seemed to be reinventing itself, unencumbered by the old rules, free to rifle once more with impunity through the global baggage of art history. The 1980s have been called, with reason, the "retrospective decade," for their freewheeling reexamination of earlier styles. But, for all the enthusiasm, optimism, and wealth, as cultural moments go this one was uncomfortably posthumous. Through the chronic nostalgia of postmodernist historicism, unnervingly, we saw art's life flash before our eyes.

Jean-Michel Basquiat was a key artist for this anomalous time, and he was recognized immediately as someone who embodied the new spirit, someone capable of surviving the modernist denouement and bringing art back to life. His work was widely admired during the 1980s, from his very first exhibition, and continues to make financial news long after his death. Before he was twenty-five years old, his name was known throughout the contemporary art communities of North America, Europe, and Japan. Nothing can explain this sudden success better than admitting that he deserved it and that art history needed an artist very much like him. But only now, from the vantage of time and with our perspective on the twentieth century as a whole, can we begin to understand why his work remains unique today and why it was considered exemplary in 1983.

fig. 1
Mitchell Crew
1983
Acrylic, oil paintstick,
and paper collage on
canvas with exposed wood
supports and metal chain,
three panels
71 ½ x 137 ¾ inches
(181.6 x 349.9 cm) overall
Private collection

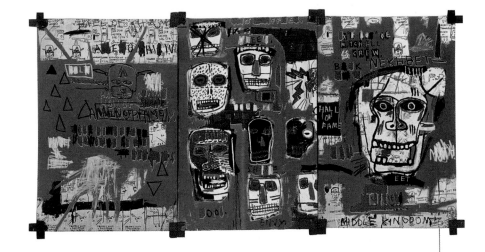

Though he was to many the epitome of the eighties artist, Basquiat was not in fact typical. For one thing, he was self-taught, which was unusual for a successful artist in the age of proliferating university art departments with celebrity faculty members. For another, relatively few American fine artists were still being taught seriously how to draw, paint, or even compose pictures, unless they intended to become commercial illustrators. These were precisely Basquiat's natural gifts, however, which he had developed assiduously since childhood.

While the 1980s announced a return to figuration and object-making, many artists, lacking traditional training, used mechanical aids like projectors and photographs; or they subcontracted production, following the example of Minimalist sculptors like Richard Serra and Donald Judd; or, as in a great many cases, simply burst into painting, regardless of talent or skill. Indeed, far too many pictures made and exhibited during this period looked like the work of people who had become painters overnight, as indeed they had. Many eighties artists, the pampered children of parents who had grown up during the Great Depression and World War II, tended to be more generically talented than specifically disciplined. Like many of his friends, Basquiat could have just as easily focused his attention on poetry, music, or acting, as he was known to have the attributes then considered necessary. And Basquiat's early work does indeed betray the hallmarks of having

erupted from someone who had suddenly decided to go for it, so to speak, as a painter, fearlessly and with Neo-Expressionist abandon. But even these first works are not compromised by the typical amateurish impatience of the time. Within months, they became breathtakingly good.

THE LAST MODERNIST

Basquiat was the rare artist who could marry an exuberant spontaneity with a firm command of art materials. If the high quality of his work is not at all representative of the early eighties Neo-Expressionist idiom, his impulse certainly is. Fittingly, his work has turned out to be among the few American examples from this abundant period to remain compelling. We can even go so far as to say that he provided history with a credible image for that moment, though it is hard to choose which one of his highly diverse works could serve as the actual icon of the era.

Basquiat had more than just the right skills at the right time. He also had knowledge and a thirst for more. He used art as a way to gain greater knowledge, and to process what he knew about history, about the cultural richness of the African Diaspora and of his Caribbean roots specifically, and about the epic historical struggle of African Americans. He knew about music, especially jazz and nascent hip-hop, and about sports, particularly

boxing and baseball, and he explored this knowledge iconographically. Beyond the personal cultural references of his immediate experience, though, Basquiat's interests were voraciously broad and his more complex paintings let loose a tumult of unrelated information. Like the other artists who revived painting, he also knew that handmade art could confer a talismanic power on its subject, and he celebrated the black musicians and athletes who inspired him by painting dedicatory works that were like fresh flowers placed on their graves. He certainly knew about art history, through books and the many museums of his native New York City, notably the Brooklyn Museum, where an artistically inclined youngster could get a fairly comprehensive experience of world art firsthand. Perhaps ironically, albeit without irony on his part, he displayed a clear fondness for expiring modernism, and many of his works maintain a sub-textual argument with his predecessors, full of corrections, challenges, homages, and some spectacular showing off.

Basquiat was certainly not alone in his inclusive interest in modernism. "Appropriation" was the word used to categorize the imitations and blatant copies of modernist icons and other art from the past that emerged during those years in the work of artists like Sherrie Levine, Mike Bidlo, Cindy Sherman, Elaine Sturtevant, and others who populated this peculiarly retrospective moment. It could be understood as a way to turn the tables on hegemonic Western art, giving modernists a taste of their own appropriation, which they had exacted upon non-Western, non-white, and even non-male cultures (in the case of motifs borrowed from the many pictorial and decorative traditions developed by women). It also served as the more critical, pictorial equivalent of the historicism then popular among postmodernist architects. Their strategy, whereby modernism recedes into the mists of history—its seductive power deflated, stripped of any ahistorical advantage, and disabused of the ethnic neutrality upon which its authority might once have been based— consisted simply in listing modernism in a glossary of equally generic styles. The relationship of eighties artists to modernism was an ambivalent one, which distinguished it from the kinds of revivalism witnessed in the nineteenth century. Unlike imitating a Gothic style for socially progressive ends, as the Arts and Crafts Movement had done, copying Jackson Pollock or Walker

Evans was, by comparison, a more defensively cynical strategy, one with both intellectual and commercial ends.

Appropriation was to modernism what Pop art was to popular culture—that is, an imitative borrowing hard to differentiate from its source. If Basquiat belonged to a generation that rebelled against the dilapidated logic of modernism in an effort to save art, admittedly he did it more as a revivalist than as a revisionist; like a good son, he preferred to attend to modernism's unfinished business, to solve some of its lingering problems, as if preparing it for a proper retirement. Basquiat's gambit is analogous to that of his appropriationist colleagues and relevant to that discourse, yet irreconcilably distinct. Unlike the more academic strategies of his contemporaries, there is a total absence of the scholar's irony in his work. His rejection of the chaste intellectual coolness of late modernism is unconditional by comparison. If he preferred to fashion a warm-blooded reprise of early modernism's faux primitivism—itself having been a dissenting reaction to the highfalutin trickery of academic painting—he did not try to imitate early modern art so much as attempt to contribute to the canon.

By the time his personal style had fully matured, at the preposterously early age of twenty-two, Jean-Michel Basquiat had successfully avoided amateurism, historicism, academicism, cynicism, and irony, the gauntlet of aesthetic hazards peculiar to his time. It is all the more astonishing, then, that he succumbed to neither sentimentality nor nostalgia as he breathed life back into the modernist impulse. His success, both intellectual and aesthetic, as well as his uniqueness, is based on the paradoxical equilibrium of a practice that was at once modernist and postmodernist, conscious and self-conscious.

Basquiat's modernism was authentic and original. He displayed many of the values, interests, and strengths of artists such as Pablo Picasso, Henri Matisse, Ernst Ludwig Kirchner, Jean Dubuffet, Robert Rauschenberg, Joan Miró, Willem de Kooning, and Andy Warhol, enshrined in the pantheon of his local Museum of Modern Art, as if he imagined his work hanging next to theirs, an updated and distinctive example of the tradition. But it also betrays a self-conscious awareness that modernism was looking pretty haggard as a cultural enterprise, and that art must tackle other issues if it would make it to the twenty-first century in one piece. For someone with

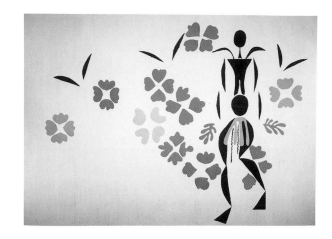

fig. 2
Henri Matisse
(French, 1869–1954)
La Négresse
1952
Paper collage on canvas
178 3/4 x 245 1/2 inches
(453.9 x 623.3 cm)
National Gallery of Art,
Washington, D.C.
Ailsa Mellon Bruce Fund,
1973.6.1

Basquiat's background, the principal issue was the direct representation of an African cultural heritage in the artistic tradition of the West, where it had been forced into residence some three centuries before. As a distinct contributor to high culture, the African Diaspora had become rather well represented in literature, music, and dance over the century of institutional modernism, but had known mostly indirect tokenism in pictures, a proxy representation. And then, of course, in the 1980s, only a hermetically cloistered artist—something the sociable Basquiat was certainly not—could have been deaf to modernism's endless eulogies, which supplied the chatter for openings and art periodicals.

But Basquiat seems not to have been entirely convinced just yet; he painted with a reformist zeal, as if to save art from the geriatric ailments of a modernist cause he respected, one that had come to art's rescue with great force at the beginning of the now fading century. Unlike so many of his contemporaries, Basquiat's defensiveness is not against world-weary modernism, but rather for it. And he strived to be an entirely new, if final, voice. As it turned out, modernism did not die out before producing a paradigmatically great black painter who was also irresistible to the art market.

PRIMITIVISM

How sad it would have been had Basquiat adopted, appropriation-style, an Africanizing "primitivism" from Picasso, Constantin Brancusi, or Fernand Léger. Imagine the awful fin-de-siècle satire had a talented young black artist crafted a pastiche of that pastiche. But Basquiat deftly avoided yet another trap, perhaps the most dangerous one, by inventing his own "primitive" style with a personal iconography based on contemporary American life, one that winks at an Africa he largely made up. If you look carefully, his winks in the direction of Expressionism are more cursory still, though the affinity is equally clear.

By his own admission, and by the evidence, Basquiat was fond of painting large, grotesque masks. In one interview, he even talked about struggling to resist the urge. But when he depicts explicitly African masks, as in *The Nile* (page 106) or *Mitchell Crew* (fig. 1), they are usually rendered as playful cartoons with little resemblance to the real thing, though they certainly have no relation to the prankster Picasso's cartoons of African masks, either; that would have felt too cheap a maneuver for a mind as subtle as Basquiat's. But then there are his emaciated, scarified, and almost extraterrestrial *griots*—a term for West African bards. Chilling fetishes, they exploit an American fantasy of an unrecorded ur-Africa of fear and sorcery. *Flexible* (page 140), for example, which belongs to a series of similar pictures, is a frightening scarecrow of a painting that, judging from the number of its variations, probably amused the artist no end.

Of course, Basquiat did not have to look far for updated "primitive" inspiration in the blighted New York of 1980. For one thing, the ubiquitous vigilante decorations of graffiti artists were the work of his own generation, although he was more of a fellow traveler than an actual practitioner. As a teenager, he had

preferred to vandalize with his haunting, cryptic poetry, which he signed "SAMO©," than to contribute yet another hallucinatory monogram to the Brooklyn-bound "D" subway cars. Not that the typical graffiti "tag" was rustic in any way. Deliberate and practiced, far more slick than raw, the tags also had a cheerful spontaneity in their favor that felt related somehow to a primordial decorative impulse. It was the city, more than any other source, that provided fodder for Basquiat's *art brut* sensibility. In those days, New Yorkers endured an apocalyptic barrenness in large parts of their city as successive federal administrations disregarded the urban infrastructure. Vast swaths of obsolete tenement neighborhoods, once filled with European immigrants and African Americans migrated from the South, were in ruins and thinly populated by squatters, among whom Basquiat lived briefly. Here, a faux-caveman style made a certain sense.

Basquiat's "primitivism" was the product of a keen wit and confident hands. It was just as much a performance as that given by European artists in trying it out eighty years earlier. A pose, an attitude, primitivism served a strategic purpose at either end of the century. For Matisse (fig. 2), it was an anti-academic posture, an antidote to the oppressively skillful aloofness of the hopelessly conservative *écoles* and *académies*. It arose from his solidarity with predecessors like Gauguin, the traveler to exotic islands, and van Gogh, the humble, tortured Christian—two brilliant modernist innovators who had not been honored when they lived. It was also an antidote for Basquiat when, in turn, the radical modernism developed by the likes of Matisse ended up, decades later, perversely detached from the discrete products of the hand, intolerant of human emotion, and forever shrinking from direct engagement with the world. Occasionally, Basquiat's efforts in Expressionist primitivism result in pictures of such disturbing psychological depth and emotional intensity, as in *La Colomba* (page 114), that they seem almost not to belong to art history at all but to the canon of great acting. Historically speaking, for both Matisse and Basquiat, it was time for an artist to make believe that he knew nothing at all but raw feeling. It was time to reconnect the primary sensations of color, shape, texture, and line to the primal fetish for plain handiwork and scary faces. Of course, it could only be a grinning deception.

Like Matisse, Basquiat is far too sly for his work actually to pass for *echt* primitive, but we are captivated by a masterly performance and by honorable intentions.

As it turned out, though, "primitivist" emulation of "tribal" cultures was really a studio exercise for European modernists, a warm-up that primed them to reestablish a more authentically homegrown art and that led eventually to abstraction. In the case of the German Expressionists of Die Brücke (fig. 3), for example, primitivism would lead them back to the innate northern bluntness that characterized their rural decorative customs. In the Paris of the next generation, with Dubuffet's *art brut*, the beige dirt of the Île-de-France found a voice. Basquiat's paintings are autochthonous to Brooklyn.

THE FORMALIST

Color was one of Basquiat's great strengths. Few American artists deserve as much attention for their manipulation of color; it has not been so prominent a feature of our aesthetics. The list of major American colorists is short. As a technician of color, John Singer Sargent is remarkable, though that is seldom remarked upon; certainly Georgia O'Keeffe and Stuart Davis have extraordinary moments, while Mark Rothko, Frank Stella, and Ellsworth Kelly deserve respect. But Basquiat, who resembles none of these artists, is exceptional even in their company. With direct and theatrically ham-fisted brushwork, he used unmixed color structurally, like a seasoned abstractionist, but in the service of a figurative and narrative agenda. Neither technically focused like Pollock or Claude Monet, nor lyrically inclined like Matisse or Franz Marc, Basquiat deployed his color architecturally, at times like so much tinted mortar to bind a composition, at other times like opaque plaster to embody it. Color holds his pictures together, and through it they command a room.

A picture like *In Italian* (page 115) is evidence enough that Basquiat was peerless in the New York of 1983 at deploying color for maximum effect. Without compromising his signature informality—the repetitions, the reconsiderations, the obliterations and the swarming, inscrutable notations—Basquiat delivers a painting here that is as satisfying as a first-rate Matisse, only bolder. The harmony in the bright, saturated,

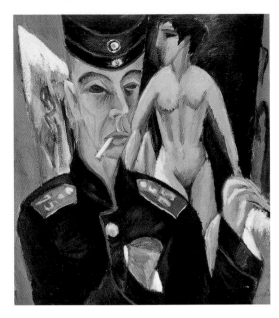

fig. 3
Ernst Ludwig Kirchner
(German, 1880–1938)
Self-Portrait as a Soldier
1915
Oil on canvas
27 1/4 x 24 inches
(69 x 61 cm)
Allen Memorial Art Museum,
Oberlin College, Oberlin, Ohio. Charles
F. Olney Fund, 1950.29

have seen, he could tie them together most effectively. A great many works are chromatically gorgeous, whatever their palette, while others are successfully hideous. One picture, say *Mitchell Crew* (fig. 1), might be suffocated in cerulean blue, while another, *Leonardo da Vinci's Greatest Hits* (page 59), which is fretted over with collaged drawings and opaque words, gets punctuated only here and there by a ribbon or two of color. Nor did Basquiat always find color a necessary element of picture-making; quite a few of his better-known works, such as *Santo versus Second Avenue* (page 71), are not about color at all, while *Pegasus* (page 157) is exclusively black and white. It is remarkable that someone so young could exhibit such a firm command of color—a notoriously difficult aspect of picture-making—without concentrating on it exclusively.

Basquiat understood color like few others and used it with unbridled temerity, but he was essentially a draftsman. He drew constantly, producing hundreds of drawings. In fact, his paintings are drawn as much as painted. Areas of color are scribbled in impatiently, while most everything else is described with quick, confident, linear strokes or, as Matisse sometimes liked to do, scratched into the wet color with the handle of his brush. If Basquiat had the facility to deploy the power of color, that did not mean that he also needed to spend a lot of time getting it on canvas; he wanted to be drawing. Ingres, the disciple of drawing, might have been pleased with him, while Delacroix, the priest of painterly color, could not have complained either.

Basquiat's increasing habit of gluing his drawings —or photocopied multiples of them—to canvas never seems incongruous because he simply continues to draw over and around them, albeit in paint and with larger

subtropical palette is not the work of an amateur; nor is the scale, with its fifty square feet of self-assurance.

In Italian is, however, perfectly incomprehensible, pictorially speaking. Essentially a set of almost random doodles, it is relentlessly flippant, like the bulk of Basquiat's corpus, reveling in goofy scrawling and clumsy smears. The twenty-two-year-old who painted *In Italian* created the finest pictorial expression of impudence. But it has more than that to recommend it. Sunny Floridian pinks, apple green, kindergarten yellow, and a wan pastel aqua may well frolic gaily on the surface, but they are hounded by their blackboard ground and menaced by a sinister red, which the artist qualifies by tossing into the painting the word BLOOD in three languages. He further darkens the mood by printing TEETH several times, improbably illustrated by Franklin D. Roosevelt in profile, who bares his own presidential teeth on the larger of two sketched dimes. The presence of these coins also gives Basquiat the opportunity to copyright the LIBERTY of American currency. This is some fairly disquieting bravura.

One exceptional feature of Basquiat's use of color is the baffling fact that he had no signature palette to speak of; nor, for that matter, was he prone to repeating particular combinations, so curious was he to try new relationships. He seemed to like bright, strong hues, but he used just as many dark and murky ones and, as we

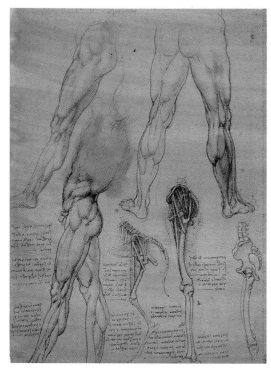

fig. 4
Leonardo da Vinci
(Florentine, 1452–1519)
*Studies of Legs of Man and
the Leg of a Horse* 1506–07
Pen, ink, and red chalk
on paper
11 $\frac{1}{4}$ x 8 inches
(28.5 x 20.5 cm)
Royal Library, Windsor
Castle, RL 12625r.

technique. Aside from his use of silkscreen to transfer his drawings to canvas, his only concession to mechanical reproduction was the trusty proletarian photocopier. Neither of these techniques affects his drawings directly in a formal sense, but rather serves them by quantitatively extending his busy hand into infinity. With many paintings literally covered in a tight, all-over grid of drawings, we might think of Carl Andre's tiles had they been printer's plates, or imagine the strict rectilinearity of a Mondrian undergoing a fit of glossolalia. When Basquiat provides his paintings with this inescapable, chattering ground of drawing, as he does in a great number of works, he promotes the traditional role of the preparatory sketch from a preliminary exercise of ratiocination to the ultimate manifestation. His increasing practice of gluing large, single drawings to canvas, moreover, as opposed to building up a ground from smaller drawings, emphasizes his position in this regard.

gestures. Quite a few pictures disorient the viewer by exploiting this shift in scale; in *Grillo* (pages 142–43), for example, the "micro" of the pencil drawing undergirds the "macro" of the painted drawing on dead-flat planes without perspective, and is then popped out into three dimensions for emphasis. Similarly, Basquiat's employment of Warhol's signature silkscreen method in an important group of paintings that includes *Melting Point of Ice* (page 117) enlists the Pop artist's classic late-modernist technique to make an ingenious new contribution to the heritage of early modernist formalism. By painting on and under drawings that he has silkscreened onto the canvas, Basquiat effectively conflates drawing and painting, anachronistically declaring a truce in the nineteenth-century rivalry of the Rubenists (pro-painting) and Poussinists (pro-drawing), while ironically producing unique works of hand-made art incorporating a form of mechanical reproduction. Because Basquiat bases the entire process on his own drawings, however, rather than found commercial imagery, Warhol's example is only dimly remembered in these works.

Basquiat knew not only how to draw, but what drawing meant within pictorial culture as its primordial

If we remember how Synthetic Cubist collage attempted to blur the boundaries between art and the world, by reframing actual tokens of modern life into wistful, abstract compositions, we see Basquiat instead preferring to create a hermetically closed system with his analogous procedure. He papers over all other voices but his own, hallucinating total control of his proprietary information as if he were the author of all he transcribed, every diagram, every formula, every cartoon character—even affixing the copyright symbol to countless artifacts of nature and civilization to stress the point—without making any allowances for the real-life look of the world outside his authorized universe. In "correcting" Cubist collage, Basquiat appears to have found the fly in the ointment of modern art, which had set it on its ineluctable death trip: art means never giving reality a chance to speak for itself.

fig. 5
Cy Twombly
(American, b. 1928)
The Italians
1961
Oil, pencil, and crayon
on canvas
78 5/8 x 102 1/4 inches
(199.5 x 259.6 cm)
The Museum of Modern Art,
New York. Blanchette
Rockefeller Fund, 504.69

Basquiat admired other draftsmen: Leonardo da Vinci for one (fig. 4), who is quoted repeatedly through the anatomical studies that Basquiat copied by hand, and which he then photocopied and antiqued, according to Fred Hoffman, by rubbing them underfoot; and through the *Mona Lisa*, which, nodding to Marcel Duchamp, he quoted in caricature. Cy Twombly is another (fig. 5). Twombly's influence on Basquiat is quite pronounced in the earliest work. We get a sense that Basquiat's indifference to demonstrating any Picasso-esque flair for drawing, despite his obsessive practice, is a permission he got from looking at Twombly. But drawing well was something that the most characteristic moderns tried hard to dissimulate. Long before Twombly attempted to evoke the sublime with scribbles and smears, both Picasso, the virtuoso son of an academic drawing master, and Matisse, who drew nearly every day of his life, affected an awkward, naive hand for much of their careers. In fact, one of modern art's great dramas is the spectacle of an ancient craft starting over from scratch. Basquiat's seductive power, like his predecessors', was based on the illusion that he lacked conventional skill, and his work would have made no sense were he to have cultivated a fancier hand. Like Kirchner before World War I, and for similar reasons, there is no trace of the studied or affected about Basquiat's art, which consisted of raw, personal speech.

MEANING

Although his work is usually characterized as exemplary of the Neo-Expressionist sensibility, in keeping with the artistic fashion of his time, confining Basquiat to Expressionism misses too much of his work's interest. If his speech is raw and personal, it is also unaccountable,

which Expressionists generally are not. The inscrutability of his work, the incongruous pictorial elements of the more complex pictures, with their run-on lists and cryptic iconography, remind me more of a latter-day Surrealism. The Surrealists explored—I should say exploited—the unconscious, the random, the primitive, and the insane, for aesthetic purposes, yes, but also in a Freudian attempt to glimpse a fundamental humanity deeply hidden beneath culture and history. And Surrealism, more than Expressionism, provided Basquiat's work with its occult dose of déjà vu. For that very reason, I can't help feeling that a painstaking analysis of Basquiat's symbols and signs is a trap that lures us away from the abstract and oneiric purpose of these pictures. They are not sending us coded messages to decipher iconologically, so much as confusing and disarming us at once with their discursive sleight of hand. And, as we see in his practice of silkscreening and photocopying his copywork drawings, Basquiat used them interchangeably like recycled decorative units in his compositions, following a logic more formal than iconographic.

Basquiat speaks articulately while dodging the full impact of clarity like a matador. We can read his pictures without strenuous effort—the words, the images, the colors, and the construction—but we cannot quite fathom the point that they belabor. Keeping us in this state of half-knowing, of mystery-within-familiarity, had been the core technique of his brand of communication since his adolescent days as the graffiti poet SAMO. To enjoy them, we are not meant to analyze these pictures too carefully. Quantifying the encyclopedic breadth of his research certainly results in an interesting inventory, but the sum cannot adequately

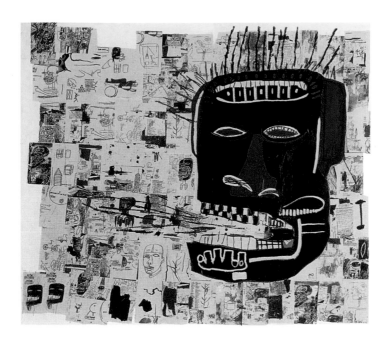

fig. 6
Glenn
1984
Acrylic, oil paintstick,
and paper collage
on canvas
100 x 114 inches
(254 x 289.6 cm)
Private collection

explain his pictures, which requires an effort outside the purview of iconography. We might also imagine that Basquiat did not need to exhaustively analyze his pictures either, although he clearly knew what he was doing in a general sense: he was endlessly crossing out words, writing them again, correcting, emphasizing, obliterating, inexplicably changing the subject, and pulling it all together with a grimacing mask. This elaboration of his work's indeterminacy—and not the uncooked technique that came to him without a struggle—is Basquiat's equivalent of Picasso's and Matisse's studied "primitivism," and at which he worked just as hard, given its thorough consistency. That is, he painted a calculated incoherence, calibrating the mystery of what such apparently meaning-laden pictures might ultimately mean.

To me, whether he was painting or drawing, Basquiat produced essentially two kinds of pictures, which I loosely refer to as "icons" and "spells," respectively. In many of the first group of works, which I call "icons," he almost indolently summons his dead heroes, one by one, athletes and musicians mostly, arbitrarily attaching their names to stick-like figures or rudimentary masks. These are simple and quickly dashed-off objects for the most part, like exaggeratedly workaday *ex votos*, and often made with a single color.

One exception is *St. Joe Louis Surrounded by Snakes* (page 76), in which the subject is easily recognizable, though sparely described with a cursive line. He also made more generic icons, the countless large and elaborately monstrous heads. *Glenn* (fig. 6), or the doleful *Eyes and Eggs* (page 64), or the chilling *In This Case* (fig. 7), are such pictures. Some of these are convincingly menacing, some pathetic, but none are properly humorous. A good deal of Basquiat's black stick-figure/mask pictures are self-portraits, whether titled that way or not; we can recognize him by his signature spiky-dread hairstyle. Even more of these icons, however, have no particular sitter, and we might presume that their point is broadly existentialist in nature, showing a black man as a universal human paradigm, emoting furiously if often without clear pictorial or narrative purpose, but otherwise under an ennobling crown or a sanctifying halo.

Basquiat's "icons," especially the more complex ones, seem improvised and spontaneous, as you would expect of an invocation, or of graffiti, for that matter. Here is another connection to Surrealism, or more closely to the kind of abstraction that grew out of it, wherein a semiconscious state of production was preferred, as in the 1950s schools of Paris and New York. The many works in this "icon" category have a familiar ritual

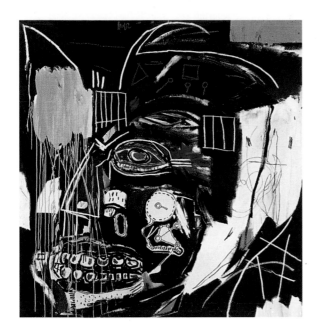

fig. 7
In This Case
1983
Acrylic and oil paintstick
on canvas
$77\frac{1}{4}$ x 74 inches
(196.2 x 188 cm)
Private collection

function, not unlike the West African sculptures and masks that Basquiat collected when he traveled there, the functional Vodoun and Santería figurines of his Caribbean roots that descended from them, or Western religious icons and statuettes meant to embody a given saint or represent Jesus Christ. Angels, crowns, haloes, devils, saints, martyrs—all figure prominently in Basquiat's work, if more generically than in (and disengaged from) the Catholic lore of his Hispanic background. The Christian artistic tradition was developed to chasten, instruct, and exalt; we watch Basquiat rehearse, with an almost absurd potency, the instrumental inadequacy of such morally functional art from beyond the introverted rigors of modernism and the garrulous ironies of postmodernism. With the hybrid iconography that he developed from his complex heritage, he attempted to add Charlie Parker, Jackie Robinson, and Joe Louis to a wobbly, generic pantheon of saints while such gestures might still have meaning.

It is no more farfetched to see Basquiat operating within the Christian tradition than from within the modernist. With a Puerto Rican–American mother and a Haitian-American father, he was a middle-class, multi-ethnic, multi-lingual Brooklynite child of the African Diaspora. Many iconographic traditions were as legitimately his to manipulate and explore as were

Gray's Anatomy, or Leonardo's; or the hobo symbols he found in Henry Dreyfuss's *Symbol Sourcebook*. In a democratic and free universe, all cultures and all information belonged to him as a consumer of knowledge and producer of cultural artifacts. In a sense, this is a key feature of modernism, beginning with the Enlightenment, Diderot's encyclopedia, and the invention of the United States of America. Basquiat's relationship to the *meaning* of his references and quotations is less to the point than is his understanding of the pictorial *use-value* of that meaning—as a compositional element, as a disarmingly familiar pictorial technique, or as an efficient sign. Like the inveterate sinner Paul Gauguin before him (figs. 8, 9), working among the religious Bretons and Tahitians, Basquiat tried to retain the power, if not the meaning, of cults, both ancient and modern, whatever their origin, through schematic caricature, or by making it up to suit. Stirring works like *Untitled (Baptism)* (fig. 10) will be familiar to those who have seen religious paintings, but unlike them, and like good modern art, they make no attempt to guide our thoughts and actions.

Aside from the hagiographic and existentialist agenda of his icons, how do Basquiat's more elaborate history paintings—the group that I half-teasingly call his "spell" pictures—function? Do they also have a

51

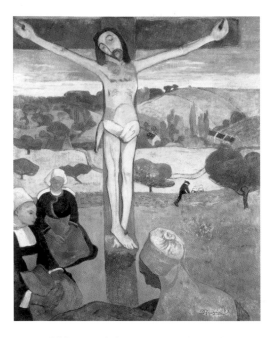

fig. 8
Paul Gauguin
(French, 1848–1903)
Yellow Christ
1889

Oil on canvas
36 1/4 x 28 7/8 inches
(92.1 x 73.4 cm)
Albright-Knox Art Gallery,
Buffalo. General Purchase
Funds, 1946:4

purpose? Whatever their purpose may be, again, it is nothing if not abstract. Taking his more descriptive titles as a point of departure—say *The Nile* (page 106), or *Undiscovered Genius of the Mississippi Delta* (pages 110–11), or *Price of Gasoline in the Third World* (fig. 11)—there is not much in the actual pictures, if anything at all, that would satisfy our expectations. If we stretch our imagination very far, perhaps a couple of half-hearted references here or there in the "spells" might remind us of the stated subject, but Basquiat's purpose is clearly to disappoint anyone who has taken his titles at face value: these are abstractions, if residually figurative ones. Their spell-like quality can derive from the viewer's hypnotic helplessness before legible, though unintelligible images. But with the word "spell," I am referring specifically to the artist's level of concentration, as we imagine him chanting in the background as if in a trance, somewhere deep in these perfectly confusing and endlessly fascinating works.

The spell-like incantations are everywhere in this corpus, but what do they invoke? In a turbulence of severed votive units, chaos is set upon the world of images: body parts, machine parts, parts of speech, figures, groups, cartoons, exclamatory symbols, declarations, official seals, farmyard animals, trailing lines, graphs, numbers, scientific diagrams, formulas,

and countless orphaned words. We cannot but be lost in these parti-colored charms, strictly mediated by the artist in his disorienting funhouse of originals and copies. No longer are we *flâneurs*, lingering in the modern idyll of the avuncular Matisse, with his "*luxe, calme et volupté.*" Basquiat puts us at the end of time, where he concocts an apocalyptic delirium worthy of Rimbaud.

WORDS

My opening citation of Rimbaud wasn't casual. The young French proto-Surrealist poet used language in a revolutionary way before abandoning poetry at the age of twenty-one. Like him, Basquiat also abandoned poetry at about the same age, but it was only then that his use of language became innovative.

Whether responding to the formal exhaustion of painting over the century and a half of modernist experimentation, or through a Marxist disdain for the intoxicated commodification of art, so much work from the 1960s and 1970s used text, as it used earthworks and performance, to stifle trade and obliterate the fetish object. The use of text, sometimes attended by mundane documentary photographs, was one of the hallmarks of the 1970s essayist aesthetics of dissent that the art

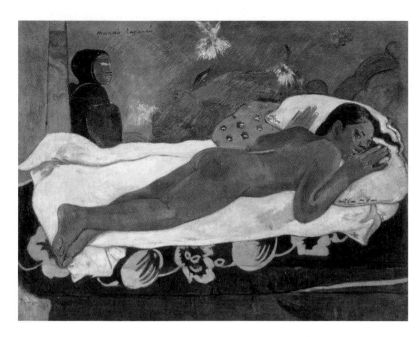

world tolerated, if the market did not, largely because it was the preferred idiom of the period's more interesting and original artists: Lawrence Weiner, Dan Graham, Vito Acconci, Alighiero y Boetti, Marcel Broodthaers, Douglas Huebler, Joseph Kosuth, and others. The one-time poet Basquiat, however, true to his generation's nostalgia for the artist as celebrity fetish-maker, rearticulated Conceptualism's stoic use of text to make another original aesthetic point: if it is possible to produce cool and ontologically penetrating visual art by abstaining from images, it is equally possible to make robust, uncouth, and emotionally charged pictures using text. Basquiat thus noticed an important defect in the method employed by the previous generation of artists, which had entailed an abdication to literature of their rights and privileges as independent cultural producers.

In an era of creative ebullience like the 1980s, cool and dry came to mean oppressive. Basquiat's use of text amounts to a full-scale Situationist *détournement*—the anti-establishmentarian technique developed by French dissidents of the 1960s—of turning the propaganda of authority back on itself. Not unlike Gauguin, who based his progressive aesthetics on the same subject matter— namely, the picturesque Christianity of the Breton peasants—as his conservative rivals, Basquiat used words, once regarded as the opposite of pictures,

precisely to help him reinstate a pictorial foundation for contemporary visual art.

Many of Basquiat's finest pictures are full of words, as well as images; a number are words alone, like his two *Discography* paintings (pages 84, 85)—essentially half-remembered, daydreamy transcriptions of information on two favorite jazz album covers—which may well be mild satires of Joseph Beuys's blackboard diagrams (fig. 12). In purely plastic terms, Basquiat integrated text into his pictorial project more successfully than any other artist of his generation, perhaps because of the harmonious affinity of written and drawn marks produced by a single hand. His use of language is, predictably, the most telling area in Basquiat's work, if we take him at his faux-primitive word and imagine him playing a role rather than speaking for himself. If its repetitions fail to convince us that he was not in full control of his faculties (unlike an actual "outsider" artist belaboring the expression of his madness), they succeed in more important ways. *Notary*, *Bird on Money*, *Jawbone of an Ass* (pages 37, 108–09, 178)—these are all magnificent and brilliantly controlled pseudo-gibberish. They recall the scat singing of his beloved jazz, except in recognizable words (and paint). And yet they announce themselves to be, and even feel like, real information. Quite a few of Basquiat's paintings

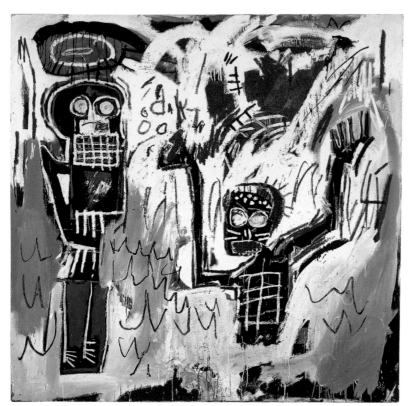

fig. 10
Untitled (Baptism)
1982
Acrylic, oil paintstick, and paper collage on canvas
92 x 92 inches
(233.5 x 233.5 cm)
Private collection

and a great many of his drawings are thick with words that appear related to each other logically, but that never choose to progress beyond the state of raw expression and teasing suggestion. Strangely, we cannot say that Basquiat was inarticulate, for we always seem to find him on the verge of actual communication and deliberately frustrating us once more.

Untitled of 1983 (page 107) is a thicket of words in three panels, almost certainly produced through the psychoanalytic/Surrealist techniques of stream of consciousness and free association. There are perplexing references to Nero, Marco Polo, and Miles Davis, but also to radium, tin, and the wax wings of Icarus. Most of the language in this picture, however, as in quite a few others, refers to the human body, and the work is essentially a list of anatomical parts accompanied by four faces and a partial figure borrowed from Picasso's *Les Demoiselles d'Avignon* (fig. 13). There

are also numbers and crowns, and many words are obliterated with lines, while most of them either end or begin with an arrow, each pointing in a different direction. These argumentative arrows pull the enumerated body apart. Drawn and quartered as if by incantation, the body is not shown disintegrated, but rather is described as such in words on canvas, and in a carefully itemized accounting. This exploded compositional technique is seen in countless pictures by Basquiat, which nevertheless retain a pleasing all-over balance, just a few ideas removed from both Jackson Pollock's drips and Mary Kelly's *Post-Partum Document* (1973–79).

Basquiat knew that language is incompatible with a truly international aesthetic strategy—if you can't read it, how can it mean anything to you?—and his pictures are occasionally multilingual, though not like a Lawrence Weiner, for example, whose multilingual texts serve as an index of his expanding audience. Basquiat's

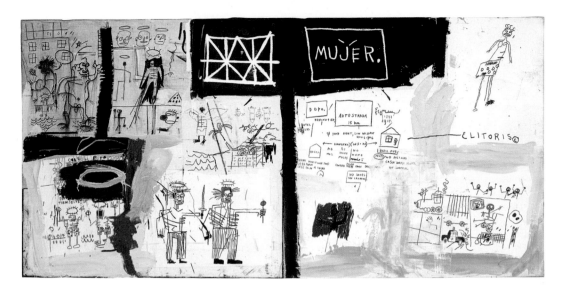

fig. 11
*Price of Gasoline
in the Third World*
1982
Acrylic, oil paintstick,
and paper collage
on canvas, two panels
60 x 120 inches
(152.5 x 305 cm) overall
Private collection

multilingualism matches his indecipherable libretto-paintings, but it reflects his personal experience, his own identity, and his growing interaction with a much larger world than his childhood Brooklyn, rather than facilitating the world's experience of his work. As we have seen, that was not his purpose.

YOUTH

A final exemplar of modernism, Jean-Michel Basquiat also stands among the most consistently interesting artists of the postmodern and, ironically, post-internationalist period of what rapidly became an increasingly global art world soon after his death. Not only because of his multiple ethnicity, his complex and quintessentially New York culture, or because of his affinities with early modernism, Basquiat remains of

interest because he appears, more and more, to have understood his time and how the artistic present of the 1980s had come about.

His sophistication as an artist was exceptional. For example, the many abstract passages of unusual beauty in his paintings show that he would have had considerable success working in that idiom, had it still been fashionable in the 1980s. But such passages demonstrate not only that he understood how abstract paintings were made. More important, he knew that abstraction was a technique that could be applied to different circumstances and purposes throughout the arts. Thus, his use of language convincingly demonstrated that text was not pictorially neutral; he showed us that the written word could convey emotional and psychic states *pictorially*, as part of a larger figural program, or in isolation, as a paradoxically mute incident upon an otherwise blank canvas. He used his

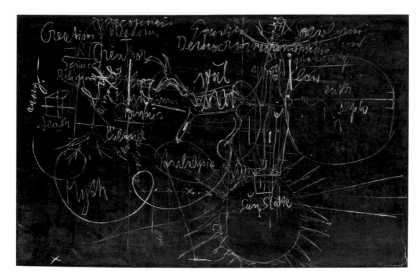

fig. 12
Joseph Beuys
(German, 1921–1986)
Untitled
(Sun State)
1974

Chalk on slate
47 1/2 x 72 inches
(120.7 x 183 cm)
The Museum of Modern Art,
New York. Gift of Abby Aldrich
Rockefeller and acquired
through the Lillie P. Bliss
Bequest (by exchange), 369.84

tumbling lists of half-obliterated words, his banner phrases, and the satire of copyrighted body parts as if they were the equal partners of the histrionic *guignol* figures who populate his pictures. There is something fundamentally pure about his closed world, and something unmistakably raw about his loquacious, blurted career.

Like Rimbaud, Basquiat exuded a charismatic vitality and precocious wisdom, in his case about picture-making, that many people saw immediately and continue to admire. Certainly Warhol recognized such qualities, as had Verlaine with Rimbaud. And, as Basquiat's controversial collaborations with Warhol demonstrate unequivocally, he was no one's acolyte, either (fig. 14). Those collaborations are indeed anomalous in the corpus of either artist, and they are not popular. But they are important as that rare thing, the creaking hinge between two very different generations and two irreconcilable sensibilities, which makes them hard to look at. Their very existence, as implausible as they appear, within an art history strictly compartmentalized by schools, generations, and nationalities, speaks to the difference between artists and their art, and to the natural affinity between people who have chosen the same profession, regardless of how incompatible the zones of activity open to them may have been.

But there are other differences that distinguish artists, ones that are also rendered explicit by their collaboration. Unlike Warhol's, Basquiat's work feels more independent of time (though of course it was not), and it shows when both artists activate the same surface. This is the case with Rimbaud versus Verlaine as well, whose "collaboration," an excerpt of which provides this essay's epigraph, also leaves us with an aftertaste of reckless youth mocking a sympathetic elder. Basquiat and Rimbaud are not only different artists by comparison with their so-called mentors: they are different *kinds* of artists. Basquiat's multifarious art references, the astonishingly eclectic variety in the content of his work, as if it knew everything, and the unpredictability of his frequent next moves make him quite difficult to apprehend as an artistic "subject." He appears to be functioning outside the historical framework that Warhol inhabits so comfortably. Clearly, though, he is also the artist as the "viewer viewed," like an actor who fascinates as much for himself as for his skill at portraying someone else, which accounts for the discomfort we sometimes feel in front of his explicitly self-conscious works, with all their depictions of eyes; they seem to know we are looking.

As with so much else in his work, we see in this ambivalence between the furtive subject and the

56

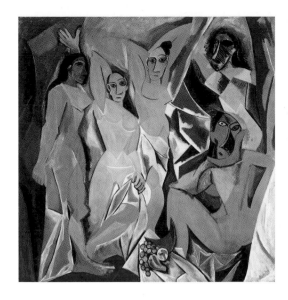

fig. 13
Pablo Picasso
(Spanish, 1881–1973)
Les Demoiselles d'Avignon 1907
Oil on canvas
96 x 92 inches
(243.9 x 233.7 cm)
The Museum of Modern Art,
New York. Acquired through
the Lillie P. Bliss Estate, 333.39

fig. 14
Basquiat with Andy Warhol, 1984

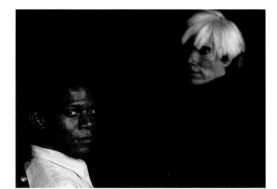

adamant self the ambition of modernist humanism expressing itself pictorially. That is, here, the sentient person exercises his freedom to feel, to know, and to express the world *through* himself—processing it all in his own hand—without regard for hierarchies of cultural authority and without running the risk of being "spoken for," or otherwise censored, but with the nagging anxiety that this freedom and these rights are new and vulnerable and must, therefore, be claimed aloud. For the descendant of people subjugated by force and then subordinated by the historical legacy of that subjugation, Basquiat's technique of inviting and then deflecting subjective recognition is an effective declaration of independence, as it also is when youth spurns parental expressions of empathy by saying, in effect, "You don't know me, but I know you."

It may well be for his youth that the mercurial Basquiat is remembered above all, and I do not mean this sentimentally. Yes, he died very young, but he could have continued for several years to speak for youth on the stage of high culture, and he could have met with even more success before settling into a mid-career that may, or may not, have sustained the art world's interest. We can certainly speculate on what his maturity might have wrought, but it is hard to picture how it could have been more astonishing than what he

actually accomplished. A sophisticated and thoughtful artist with great resources of concentration, possessed of an unusual pictorial intelligence and an uncanny sense of unfolding history and of how to avoid its traps, Jean-Michel Basquiat was an articulate and prolific spokesman for youth: insatiably curious, tirelessly inventive, innocently self-deprecating because of youth's inadequacies, jealously guarding his independence, typically disappointed by the inherited world he defensively mocked, yet filled with adulation for his heroes. His work is likely to remain for a long time as the modern picture of what it looks like to be brilliant, driven, and young.

Jesse
1983
Acrylic, oil paintstick,
graphite, and paper
collage on canvas
mounted on wood
supports
85 x 71 inches
(216 x 180.5 cm)
Collection of John McEnroe

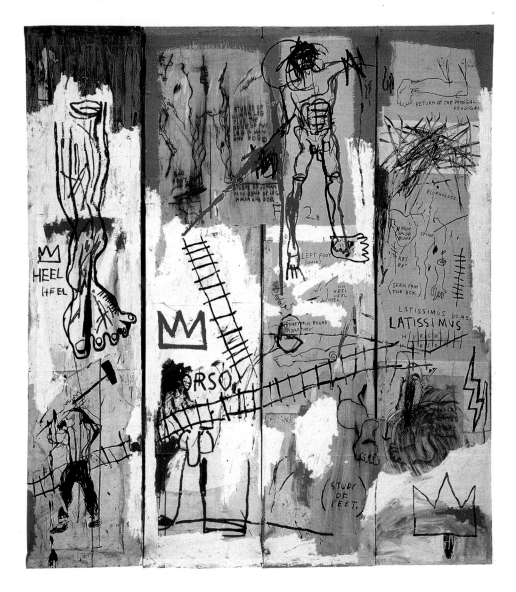

▸ *Leonardo da Vinci's Greatest Hits*
1982

Acrylic, oil paintstick, and paper collage on canvas, four panels
84 x 78 inches (213.4 x 198 cm) overall
The Schorr Family Collection; on long-term loan to the Princeton University Art Museum

Untitled
1982
Oil paintstick on paper
43 x 31 inches
(109 x 79 cm)
Collection of Leo Malca

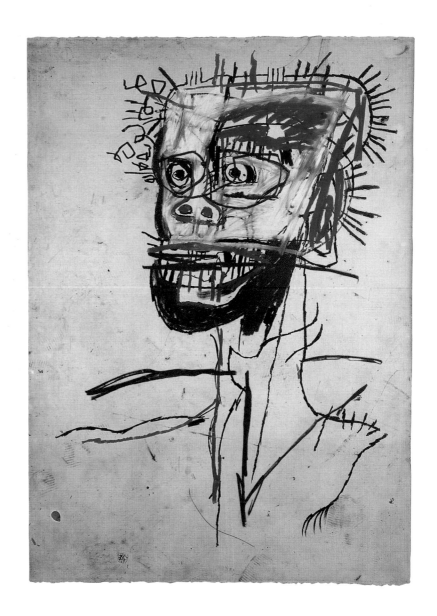

Untitled
1982
Oil paintstick on paper
30 x 22 inches
(76.2 x 55.9 cm)
Private collection

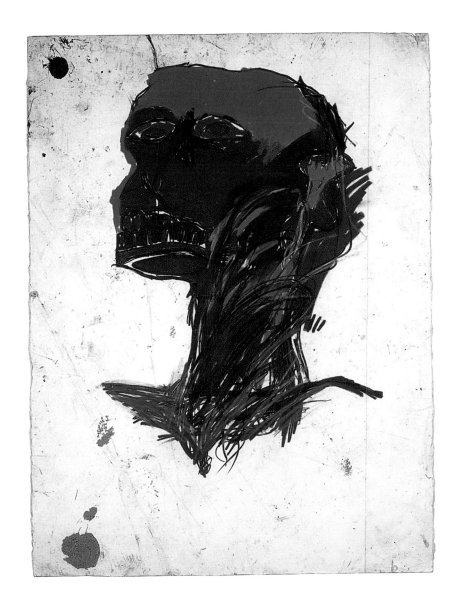

*Three Quarters
of Olympia Minus
the Servant*
1982
Acrylic, oil paintstick,
graphite, and paper
collage on canvas
mounted on tied
wood supports
48 x 44 inches
(122 x 113 cm)
The Estate of
Jean-Michel Basquiat

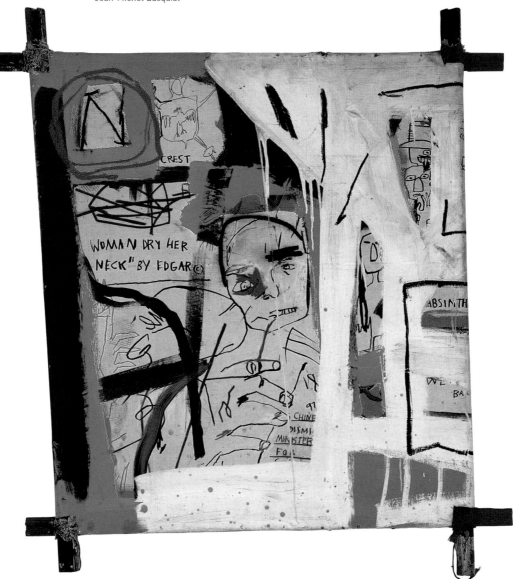

Untitled
(Maid from Olympia)
1982
Acrylic, oil paintstick,
and paper collage
on canvas mounted
on tied wood supports
48 x 30 inches
(122.5 x 76 cm)
Private collection

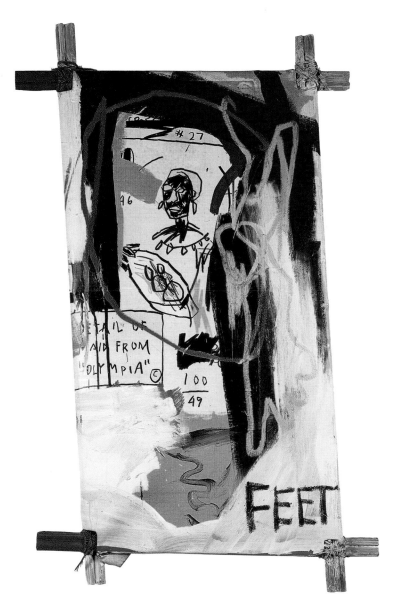

Eyes and Eggs
1983

Acrylic, oil paintstick,
and collage on
cotton, two panels
119 x 97 inches
(302.5 x 246.5 cm) overall
The Eli and Edythe
L. Broad Collection,
Los Angeles

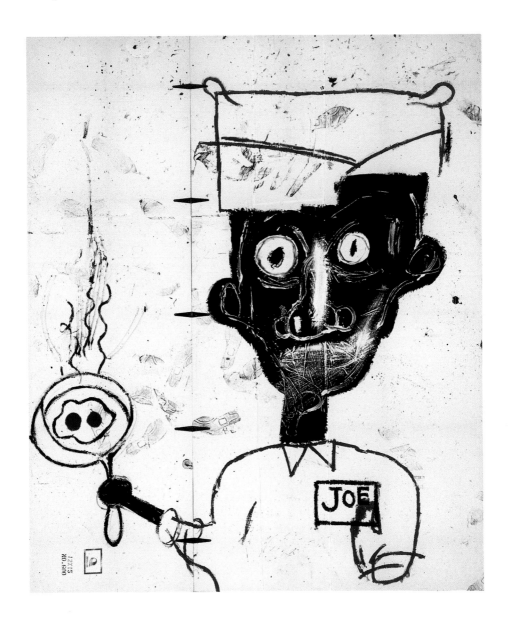

Obnoxious Liberals
1982

Acrylic and oil
paintstick on canvas
68 x 102 inches
(172.7 x 259.1 cm)
The Eli and Edythe
L. Broad Collection,
Los Angeles

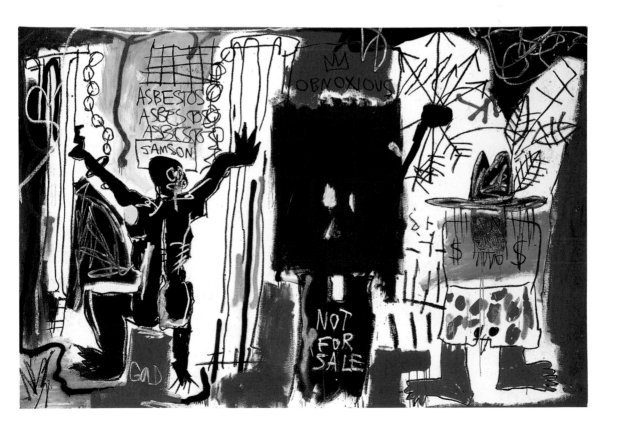

*Untitled
(Black Tar and
Feathers)*
1982

Acrylic, spray paint,
oil paintstick, tar,
and feathers on
wood, two panels
108 x 92 inches
(274 x 233.5 cm) overall
Private collection

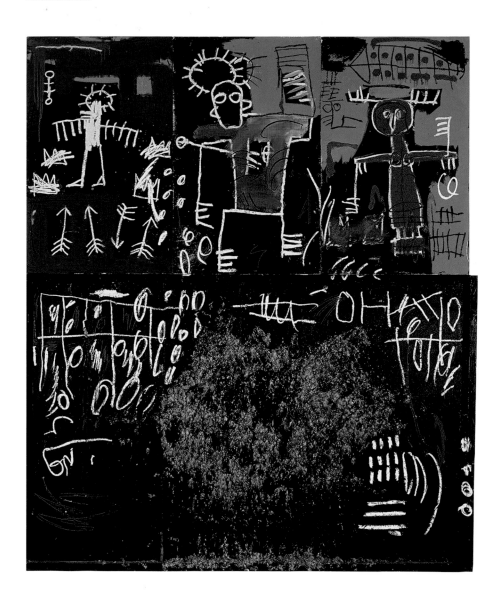

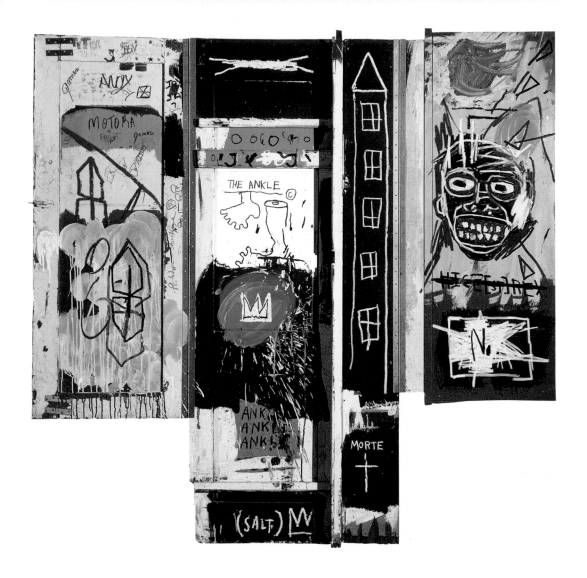

*Portrait of the
Artist as a
Young Derelict*
1982
Acrylic, oil, ink, and oil
paintstick on wood
80 x 82 inches
(204 x 208.5 cm) overall
Private collection

Native Carrying
Some Guns, Bibles,
Amorites on Safari
1982
Acrylic and oil paintstick
on canvas mounted on
wood supports
72 x 72 inches
(183 x 183 cm)
Collection of Hermes Trust,
courtesy Francesco Pellizzi

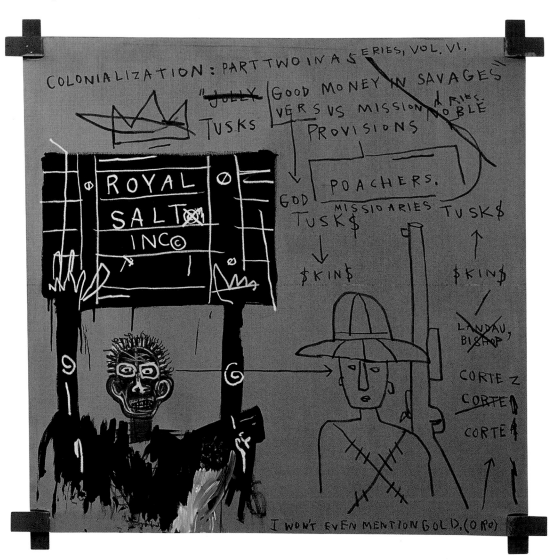

Hollywood Africans
1983
Acrylic and oil paintstick
on canvas
84 x 84 inches
(213.4 x 213.4 cm)
Whitney Museum of
American Art, New York.
Gift of Douglas S. Cramer,
84.23

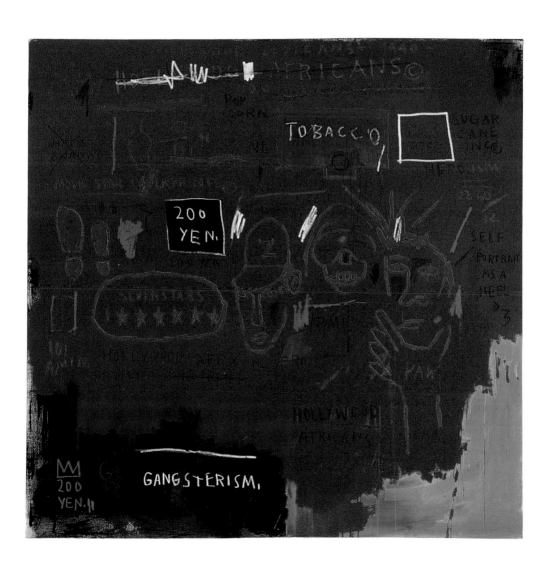

Head of a Fryer
1982
Acrylic and oil paintstick
on wood and canvas
mounted on wood
24 x 17¼ x 18 inches
(61 x 44 x 45.5 cm)
Private collection

*Santo versus
Second Avenue*
1982
Acrylic, oil paintstick,
and paper collage
on canvas mounted
on tied wood supports
54 x 42 inches
(137 x 106.5 cm)
Collection of Patrick
and Mia Demarchelier

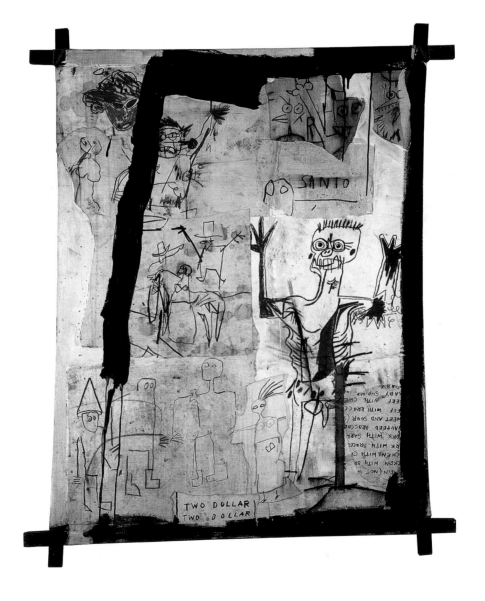

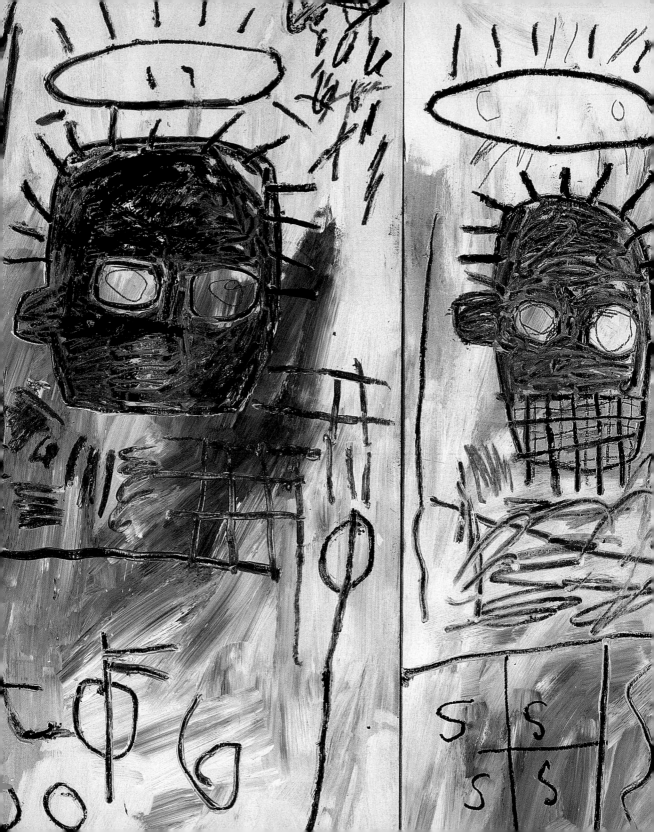

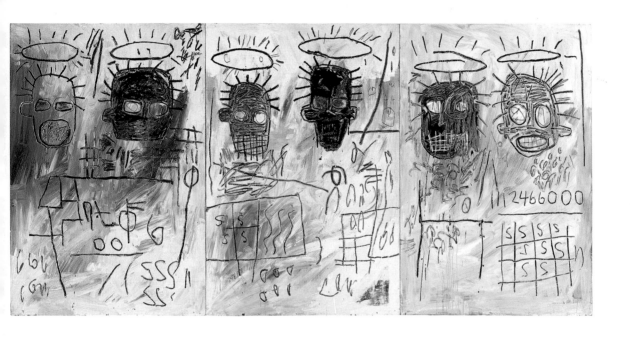

Six Crimee
1982
Acrylic and oil paintstick on masonite,
three panels
70 x 140 inches
(178 x 366 cm) overall
The Museum of Contemporary Art,
Los Angeles. The Scott D. F. Spiegel
Collection, 91.14A-C

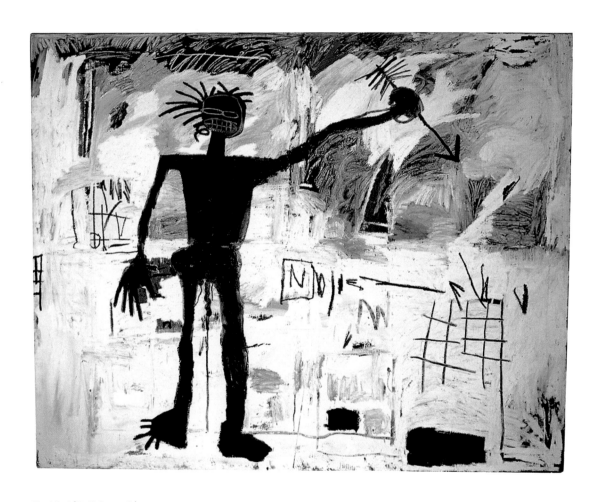

Untitled (Self-Portrait)
1982
Acrylic and oil
paintstick on linen
76 x 94 inches
(193 x 239 cm)
Private collection

*Boy and Dog
in a Johnnypump*
1982
Acrylic, oil paintstick,
and spray paint
on canvas
94 ½ x 165 ½ inches
(240 x 420.5 cm)
The Stephanie and
Peter Brant Foundation,
Greenwich, Connecticut

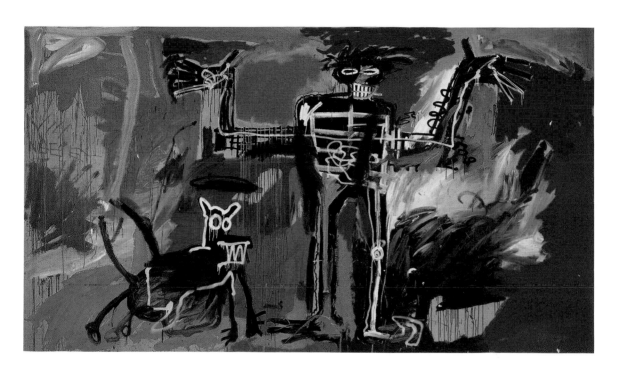

St. Joe Louis
Surrounded by Snakes
1982
Acrylic, oil paintstick,
and paper collage
on canvas
40 x 40 inches
(101.5 x 101.5 cm)
The Stephanie and
Peter Brant Foundation,
Greenwich, Connecticut

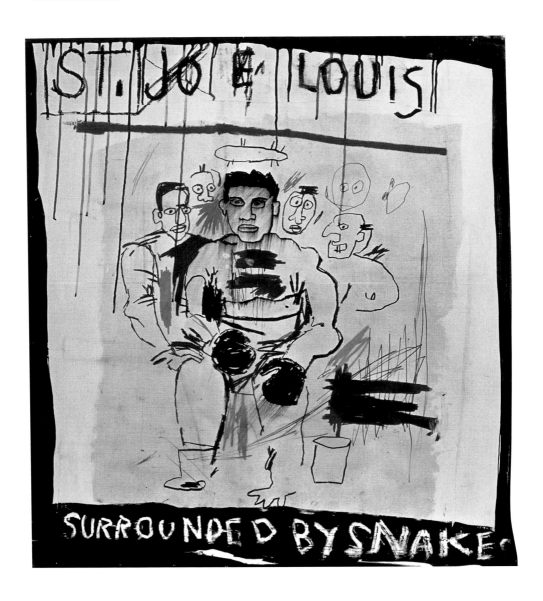

*Untitled
(Sugar Ray Robinson)*
1982
Acrylic and oil paintstick
on canvas
42 x 42 x 5 inches
(106.5 x 106.5 x 11.5 cm)
The Stephanie and
Peter Brant Foundation,
Greenwich, Connecticut

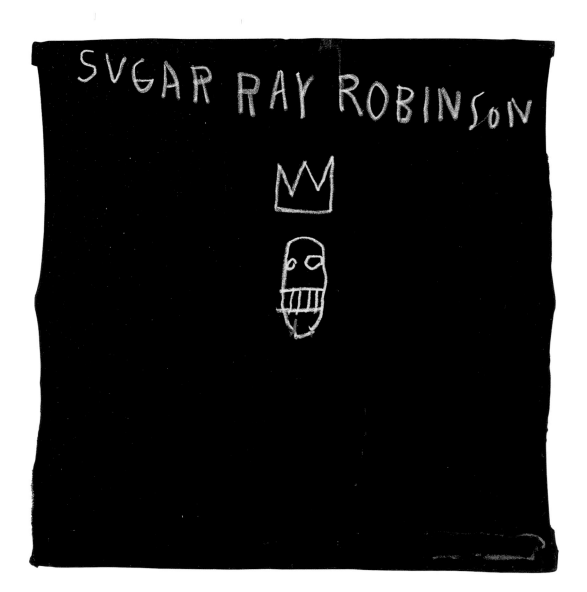

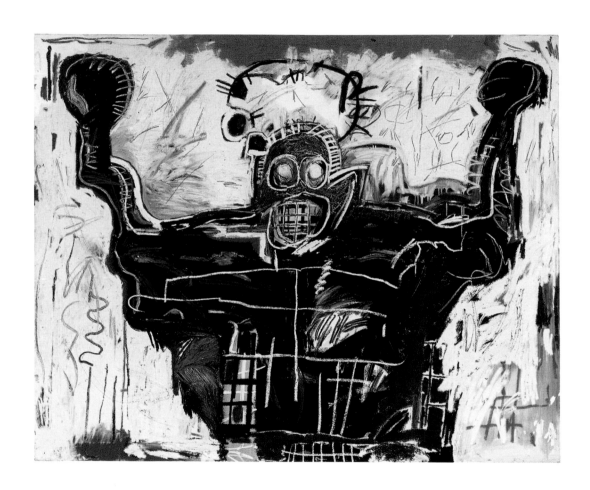

Untitled (Boxer)
1982
Acrylic and oil
paintstick on linen
76 x 94 inches
(193 x 239 cm)
Private collection

Baby Boom
1982

Acrylic, oil paintstick,
and paper collage
on canvas mounted
on tied wood supports
49 x 84 inches
(124.5 x 213.5 cm)
The Stephanie and
Peter Brant Foundation,
Greenwich, Connecticut

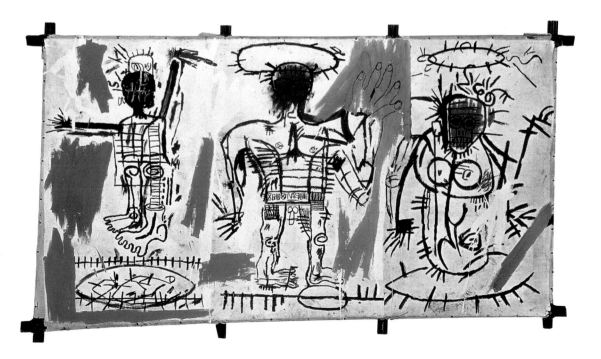

(opposite)
Charles the First
1982
Acrylic and oil
paintstick on canvas,
three panels
78 x 62 inches
(198 x 158 cm) overall
The Estate of
Jean-Michel Basquiat

CPRKR
1982
Acrylic, oil paintstick,
and paper collage
on canvas mounted
on tied wood supports
60 x 40 inches
(152.5 x 101.5 cm)
Collection of
Donald Baechler

Trumpet
1984

Acrylic and oil
paintstick on canvas
60 x 60 inches
(152.4 x 152.4 cm)
Private collection;
courtesy the Norton
Museum of Art, West
Palm Beach, Florida

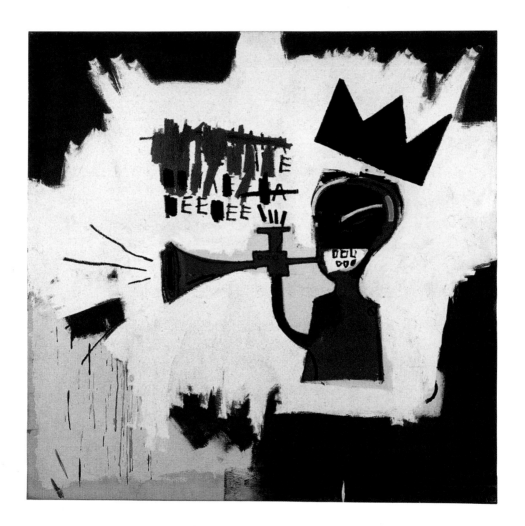

Max Roach
1984
Acrylic and oil
paintstick on canvas
60 x 60 inches
(152.4 x 152.4 cm)
Private collection

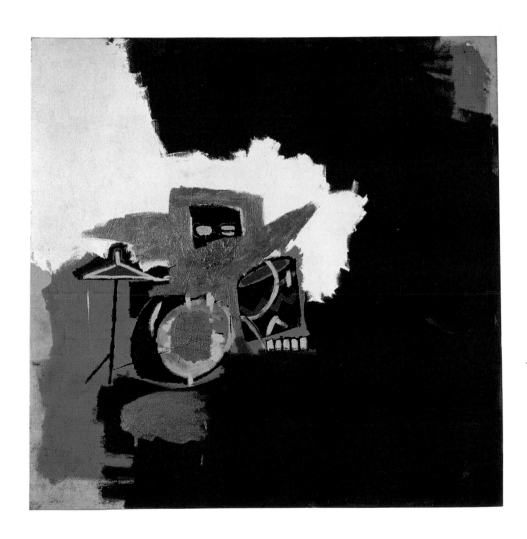

Discography (One)
1983
Acrylic and oil
paintstick on canvas
66 x 60 inches
(167.6 x 152.4 cm)
Private collection

CHARLIE PARKER REE BOPPERS.

MILES DAVIS : TRUMPET CHARLIE PARKER ALTO SAX
DIZZY GILLESPIE / TRUMPET (KOKO) ONLY, PIANO
SADIK HAKIM, PIANO THRIVING ON A RIFF, KOKO ONLY
CURLY RUSSELL, BASS · MAX ROACH, DRUMS—
RECORDED IN NEW YORK WOR STUDIOS—
NOV. 26 1945. —

"BILLIES BOUNCE"
"BILLIES BOUNCE"
BILLIES BOUIVCE"

WARMING UP A RIFF
"BILLIES BOUNCE"

BILLIES BOUNCE
IVOWS THE TIME
NOWS THE TIME
NOWS THE TIME
IVOWS THE TIME
THRIVING ON A RIFF
THRIVING ON A RIFF
MEANDERING

KOKO

KOKO

SIDE A
SIDE B
SIDE C
SIDE D

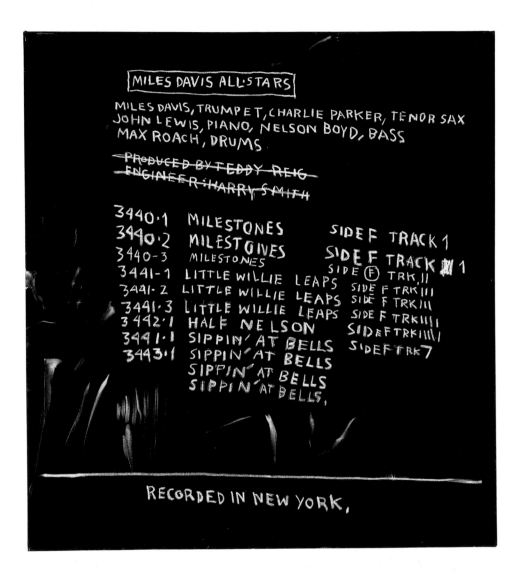

Discography (Two)
1983
Acrylic and oil
paintstick on canvas
66 x 60 inches
(167.6 x 152.4 cm)
Private collection

Now's the Time
1985

Acrylic and oil
paintstick on wood
$92\frac{1}{2}$ inches
(235 cm) diameter
The Stephanie and
Peter Brant Foundation,
Greenwich, Connecticut

TIME"©

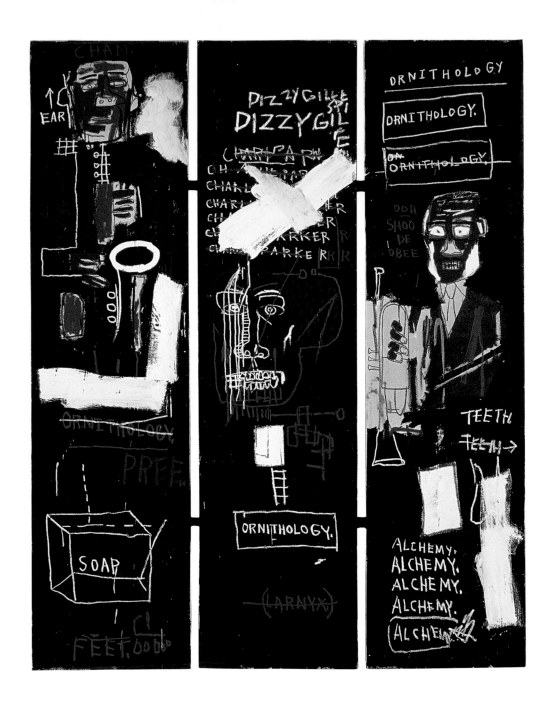

(opposite)
Horn Players
1983
Acrylic and oil paintstick
on canvas mounted on
wood supports, three panels
96 x 75 inches
(244 x 190.5 cm) overall
The Broad Art Foundation,
Santa Monica, California

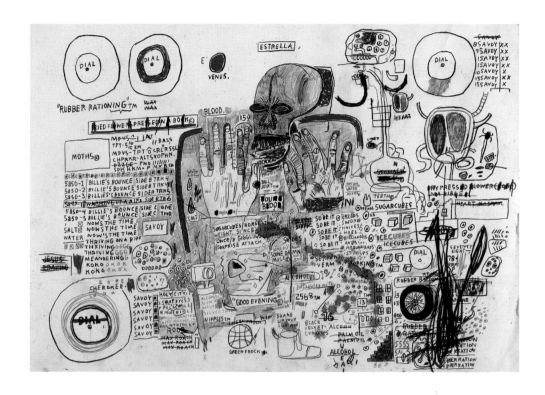

Untitled
1985

Graphite and colored
pencil on paper
30 x 42 inches
(76.2 x 106.7 cm)
The Schorr Family
Collection

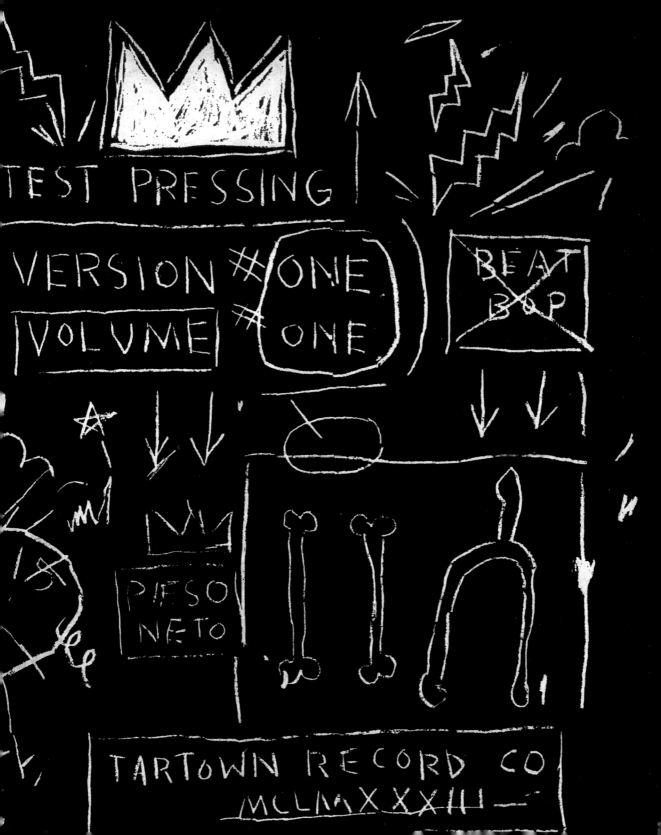

TEST PRESSING

VERSION #ONE
VOLUME #ONE

BEAT
B&P

PIESO
NETO

TARTOWN RECORD CO
MCLMXXXIII

Music is our witness, and our ally. The beat is the confession, which recognizes, changes and conquers time. Then, history becomes a garment we can wear and share, and not a cloak in which to hide; and time becomes a friend.
—James Baldwin[1]

Music lives in time, unfolds in time. So does ritual.
—Evan Eisenberg[2]

Because [Basquiat] slaps palms with time, time slaps back affectionately.
—Robert Farris Thompson[3]

In the Cipher

Basquiat and Hip-Hop Culture

Franklin Sirmans

As these three epigraphs suggest, Jean-Michel Basquiat made time a friend in his art. He accomplished this largely by incorporating certain ideas from music and performance—temporal art forms—into his paintings and drawings. Yet that is only one aspect of his work that made it so important to the intersecting music and art worlds of his time, and to the history of contemporary art. Amid the subject matter of stick-figured B-boys with X-ray eyes, poets and *griots*, a pantheon of heroes and villains, and a singular concentration on the image of words, Basquiat's work is a critical assault on notions of conventional wisdom about death, history, and the creative impulse. Between 1978, the year he left his family's home in Brooklyn for good, and 1988, the year he died, Basquiat's boundary-crossing art was a witness and an ally to one of the most seminal periods of innovation in American culture.

Basquiat's early career, in particular, synthesized performance, music, and visual art in a way that was then unprecedented and is now unparalleled. Nod your head to this: no artist has ever so profoundly embodied a cultural movement as Jean-Michel Basquiat personified hip-hop culture in its brilliant infancy—of course, before the term was ever coined. If you know what I mean by hip-hop, then you probably don't own one of Basquiat's paintings, but you may feel them in a way that their owners may not.

In hiphop, we don't have a sense of sacredness about our music yet. Hiphop is in the purest form of African tradition, orally related, and we don't have no books that can tell you the shit you need to feel. Our education has come from outside the classroom, from our dance to our murals. Fuck the Sistine Chapel—we've done the third rail. You see

Detail of "Beat Bop" cover (p. 103)

91

fig. 1
Fab 5 Freddy and Basquiat,
New York, 1980

what I'm saying? Risking our lives for a ten-piece on the third rail. Michelangelo, we are with you—do you hear me? Picasso, we are with you—do you hear me?[4]

This is not to fool the fool into thinking that hip-hop is one of those inexplicable, innate, black-magic kinds of things seemingly emerging as if by chance. Yet Basquiat had to deal with exactly that perception, the kind of thinking that perhaps led Peter Schjeldahl to remark: "I would not have expected from a black artist Basquiat's vastly self-assured grasp of New York big-painting aesthetics—generally the presentation of mark-making activities as images of themselves in an enveloping field ... I would have anticipated a well schooled white hipster behind the tantalizing pictures."[5]

While certainly game to "New York big-painting aesthetics," Basquiat's art—like the best hip-hop—takes apart and reassembles the work that came before it. That is to say, it dismantles its historical precedents by showing mastery over their techniques and styles, and puts them to new uses, in which the new becomes the final product layered over the past. In this case, his compendium of sources broadly includes the history of Western painting, along with "primitive" art; and, using them as starting points, he set out to represent the present, in both his subject matter (a politics of decolonization or liberation) and style (Neo-Expressionism). In evaluating how Basquiat transformed his sources, critics sometimes forget that, as Michael Eric Dyson writes, "From sports to fashion, from music to film, innovations in American art owe a debt to the creativity of black culture."[6] Thus Roberta Smith, writing in *The Village Voice*—though she later did a 180-degree turn of opinion—saw only "savvy imitation and illustrational stylishness" on Basquiat's part in 1982.[7] Yet the then twenty-four-year-old Fab 5 Freddy (fig. 1), interviewed by Suzi Gablik in the fall of

1982, offered a more informative view: first and foremost, he said, "Jean-Michel's work is a direct attack on fine art, mocking all schools of modern art."[8] In other words, his work is not so much an imitation of modern art as a barbed critique of it. But this was sometimes lost on the early commentators. Having seen as much, David Bowie eventually spoke of the inanity of much early criticism of Basquiat by saying that "All young black men in white worlds know more about white than white know about black."[9]

———

Reading the early paintings to which Smith and Schjeldahl refer, one must ponder Basquiat's metaphorical genealogy as a dark-skinned Haitian–Puerto Rican boy-man whose paintings embrace "a disguised form of critique that goes back to slavery," as Lydia Yee said with regard to David Hammons.[10]

The specific nature of the critique embedded in hip-hop, as seen in the work of both Hammons and Basquiat, is elaborated by Tricia Rose:

Rap music is, in many ways, a hidden transcript. Among other things, it uses cloaked speech and disguised cultural codes to comment on and challenge aspects of current power inequalities. Not all rap transcripts directly critique all forms of domination; nonetheless, a large and significant element in rap's discursive territory is engaged in symbolic and ideological warfare with institutions and groups that symbolically, ideologically and materially oppress African Americans. In this way, rap music is a contemporary stage for the theater of the powerless. On this stage, rappers act out inversions of status hierarchy, tell alternative stories of contact with police and the educational process, and draw [emphasis

fig. 2
Gringo Pilot (Anola Gay)
1981

Acrylic, oil paintstick,
and graphite on paper
81 x 103 inches
(205.7 x 261.6 cm)
The Stephanie Seymour
Collection, courtesy
The Stephanie and
Peter Brant Foundation,
Greenwich, Connecticut

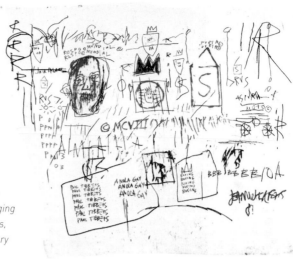

*added] portraits of contact with dominant groups
in which the hidden transcript inverts/subverts the
public, dominant transcript. Often rendering a nagging
critique of various manifestations of power via jokes,
stories, gestures, and song, rap's social commentary
enacts ideological insubordination.*[11]

Hip-hop went beyond the specifics of the moment, amounting at its best not simply to music and lyrics but to an extended, volatile criticism of contemporary culture. Popular music's power as a social critique should not be taken lightly. As Plato said, "The introduction of a new kind of music must be shunned as imperiling the whole state, since styles of music are never disturbed without affecting the most important political institutions."[12]

Basquiat's notebooks of the late 1970s and earliest finished works from 1980–83, particularly, draw on and tap into the rich tradition of African American poetry and the spoken word, from the ancestral call and response of the bass drum to the ring shout of slavery, to the "dozens" and the blues of the early twentieth century, to the cipher (or circle) of B-boys rapping that coincided with Basquiat's earliest output. From *Hollywood Africans* to *Gold Griot* and *Undiscovered Genius of the Mississippi Delta* (pages 69, 110–11, 146), purveyors of the word are beatifically elevated in paint and often crowned. Surrounding these figures are Basquiat's trademark lists of words spat in paint, visually stuttered, repeated and often crossed out, to be read as incantations with a pause for thought and breath: in other words, beats that control the flow of the composition.

Despite these other affinities, it was the classic graffiti tradition to which many critics tried to attach Basquiat's name. While graffiti stylistically and conceptually constitutes one of the earliest signs, and

an integral element, of hip-hop, the emphasis that its "writers" put on line and color as abstract elements was, and often remains, closer to modernist debates over originality and formalist innovation. As Fab said in 1982, "Graffiti symbolizes people doing what they want to do, but there's no profane language, no political statements. It's only names. Like if Jackson Pollock were around, he'd love it."[13] While the graf of the early eighties, with its often psychedelic cartooning and relative lack of political statement, was more inclined to a pop style, there was no mistaking the dual enterprise of street poetry and fine art that Basquiat was attempting to define. Rene Ricard noted the distinctiveness of his project in 1981: "Jean-Michel's don't look like the others. His don't have that superbomb panache that is the first turn-on of the pop graffitist. Nor does his marker have that tai chi touch. He doesn't use spray but he's got the dope, and right now what we need is information."[14]

The early work *Gringo Pilot (Anola Gay)* (fig. 2), one of Basquiat's first to be published,[15] shows his critical edge. It looks like a torn piece of a wall, ripped from the top-left corner down toward the center of the paper, covered in parts with acrylic and oilstick. All of his early subjective elements are there: the title refers pointedly to a historic event, and names the plane, the *Enola Gay*, that dropped the atomic bomb on the Japanese city of Hiroshima during World War II; the "gringo" (white) pilot of the American bomber is identified in the lower left-hand corner as Paul Tibbets. The word BOXING is

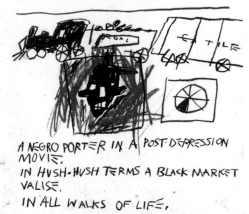

THIS LAND USED TO BE IN COTTON
THIS LAND USED TO BE IN VEGETABLES
NOW IT'S IN TOBACCO —

A NEGRO PORTER IN A POST·DEPRESSION
MOVIE,
IN HUSH·HUSH TERMS A BLACK MARKET
VALISE,
IN ALL WALKS OF LIFE,

fig. 3
Untitled
1981
Oil paintstick on paper
24 x 17¾ inches
(61 x 44.5 cm)
Private collection

written; an image of a baseball, an "s" in a house, and several crowns also appear with the words RESPO MUNDIAL (world response). Right there with Goya's *Third of May 1808* (1814), Manet's *Execution of Maximilian* (1867), and Picasso's *Guernica* (1937), *Gringo Pilot* takes on the atrocities of war with compelling force, and it delivers the evil truth in text and image.

As *Gringo Pilot* suggests, Basquiat's poetics were acutely political and unabashedly direct in their commentary on colonialism, racism, and class warfare. From the witty aphorisms penned under the name SAMO—such as SAMO© AS AN END TO BOOSH-WAH-ZEE FANTASIES, and THIRD WORLD TRICKED BY CHRISTIANITY, and SAMO AS AN ALTERNATIVE 2 PLAYING ART WITH THE "RADICAL CHIC" SECT ON DADDY'S $ FUNDS—to drawings like *Untitled* of 1981 (fig. 3), Basquiat's visual lyrics were spat with paint and metaphorical fire: A NEGRO PORTER IN A POST DEPRESSION MOVIE, IN HUSH-HUSH TERMS A BLACK MARKET VALISE IN ALL WALKS OF LIFE.

Aside from the "explicit lyrics" of these public wall writings and early drawings, it is Basquiat's overall inventiveness in marrying text and image—with words cut, pasted, recycled, scratched out, and repeated—that speaks to the innovation inherent in the hip-hop

moment of the late 1970s. When it was all about two turntables and a microphone, likewise Basquiat began with simple, readily available tools: paper, pens and a Xerox machine. It is this rich, discursive context that prompted Greg Tate to call Basquiat "hip hop's greatest contribution to modernism (and vice versa)."[16] Robert Farris Thompson opined that "Afro-Atlantist extraordinaire, [Basquiat] colors the energy of modern art (itself in debt to Africa) with his own transmutations of sub-Saharan plus creole black impress and figuration. He chants print. He chants body. He chants them in splendid repetitions."[17]

And, while the language content of his works evokes the emcees, rappers, and *griots* that he would refer to in paint, Basquiat was much more like a turntablist, spinning narratives in the paintings. We can truly read Basquiat as a deejay in his approach to making art: "Because his artistry comes from combining other people's art, because his performance is made from other musician's performances, the DJ is the epitome of a postmodern artist. Quite simply, DJing is all about mixing things together ... lifting forms and ideas that are already around and combining them creatively."[18] And as Lydia Yee has noted of Basquiat, "Like a DJ, he adeptly reworked Neo-Expressionism's clichéd language of gesture, freedom, and angst and redirected Pop art's strategy of appropriation to produce a body of work that at times celebrated black culture and history but also revealed its complexity and contradictions."[19]

Basquiat's work incorporates the touchstones of hip-hop, elucidated elsewhere by Tate as a

historically conscious response to urban erasure, a salvage operation of sorts that involves referencing and rethinking materials, iconography, history, Futurism, metropolitan space, mass cultural, pop cultural worlds,

fig. 4
Untitled
(Two Heads on Gold)
1982
Acrylic and oil
paintstick on canvas
80 x 125 inches
(203 x 317.5 cm)
Private collection

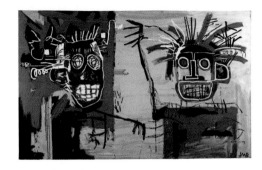

and the corporatization of the human population's subconscious. The question, then, of whether hip hop has a visual face is less a matter of finding representative objects than understanding hip hop as a critique of the packaging of human existence and human existential possibility... when we choose to speak of hip hop in loftier, more grand and grandiose terms, we like to act as if this term hip hop *can be read as a branch of a philosophy as well. Jean-Michel Basquiat's art refuses to make a distinction between the vernacular and the cognitive, the cruel populous streets and the lonely garret. Hip hop, as Basquiat so eloquently made clear, is about mapping an urban subconscious—anybody's urban subconscious. Hip hop is about Afrikanization and reverse colonization.*[20]

If Basquiat was rapping in those early drawings, he was making hip-hop in his subsequent paintings, especially by 1982, when he had the space to work large and the money for materials. While many of the bigger works from 1981, for instance the most celebrated— *Acque Pericolose, Arroz con Pollo* (pages 28–29, 33), and *Untitled (Two Heads on Gold)* (fig. 4), all shown at his first New York solo show at Annina Nosei in March 1982—represented Basquiat's first large-scale, purely figurative Neo-Expressionist paintings, it is the seminal *Per Capita* (pages 30–31) that best shows the young artist's synergy of appropriation, poetry, drawing, and painting. In *Per Capita* Basquiat delivers much of the information that would consume his work for the next five years: the marriage of text and image, abstraction and figuration, and historical information mixed with contemporary commentary. At the center of the canvas is a haloed boxer, identified by his Everlast shorts, holding a torch between the words E PLURIBUS and PER CAPITA. I can't look at it now without thinking

of Muhammad Ali, though it was painted twenty-four years ago.

Later, in 1982, Basquiat would create three canvases devoted to the boxing triumvirate of Joe Louis, Sugar Ray Robinson, and Cassius Clay. (As with Basquiat's early identification as SAMO, Clay took the name Muhammad Ali to differentiate between stages of his career—both fully aware of the currency in their names and the construction of their personae.) While those three paintings, all more or less the same size, were obvious homages to men who had derived their power initially from success in sport and the accompanying worship of their fans, they were all symbolic of heroism in American race relations. Adding to his pantheon of heroes, Basquiat also painted a portrait of the great black photographer James Van Der Zee,[21] while *Charles the First* and *CPRKR* (pages 80, 81), both dedicated to the jazz great Charlie Parker,[22] further demonstrate Basquiat's affinity for music and musicians. And, as with his fondness for portraying athletes, there was no question about his allegiance to his subjects—all progressive artists, black men who lived as he did, with time, and the assertion of their genius.

By the end of 1982, seething portraits of historical injustice such as *Native Carrying Some Guns, Bibles, Amorites on Safari* (page 68) and *All Colored Cast (Parts I and II)* (fig. 5) demonstrated where the young artist was coming from. Calling out injustice and calling names, Basquiat's paintings were full-frontal attacks on power structures and systems of racism, subject matter common to the rappers and emcees who were then making hip-hop.

Basically, Basquiat couldn't make a bad painting in 1982. In a number of works made from 1982 through late 1984, the dynamic mixing of music and art reached its height.

95

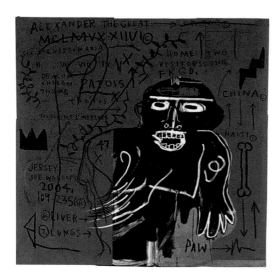

fig. 5
*All Colored Cast
(Part II)*
1982
Acrylic and oil
paintstick on canvas
60 x 60 inches
(152.5 x 152.5 cm)
Private collection

Charles the First (page 80) from 1982 marks the first instance of what would become a near obsession with early death: on it, Basquiat inscribes the life years of the infant Pree Parker, Charlie's daughter, who died of pneumonia at the age of two and whose loss marked a downward spiral in the life of Parker (he would himself not survive past the following year).

In *Jawbone of an Ass* (page 37), from the same year, Basquiat's ability to recognize and play with the historical past in Western art is evident in the cartoon of Rodin thinking, which appears amid textual references to Carthage, Alexander the Great, Hannibal, Savonarola, Machiavelli, Homer, Scipio, Caesar, and Cleopatra. The battles alluded to are given contemporary form in a passage in the bottom-right corner, where two classic Basquiat boxers, one black, one white, duel, their competing cartoon bubbles overhead.

As if softening up the art crowd for the blows to come, rope-a-doping them into a soft submission, Basquiat held the heavy punches for later. For now, he had more than arrived. The ascent itself was dizzying. Even in our speedy moment, when we consider the amount of success and work, it is fairly disconcerting. Imagine how it was for the artist who was a mere twenty-one years old at the beginning of 1982. Having blown up in the *Times Square Show* of June 1980, Basquiat had backed up his star status in 1981's celebrated *New York/New Wave* exhibition, at PS 1. With no MFA degree (the art world's certification that

someone is to be taken seriously), Basquiat had his first European solo exhibition in May 1981 and then stole the show *Public Address* among artists like Jenny Holzer, Barbara Kruger, and his friend Keith Haring (fig. 6), at the Annina Nosei Gallery in October of the same year. In what might be the equivalent of a musician winning five Grammys two years in a row, in March 1982 Basquiat had his first one-artist exhibition in New York (Nosei) and his first solo show in Los Angeles, both greeted by rave reviews. In June 1982, he was included in the Documenta 7 exhibition in Kassel alongside established artists such as Joseph Beuys, Gerhard Richter, Cy Twombly, and, of course, Andy Warhol, as one of the youngest artists ever. Basquiat had arrived, and he knew it. In September he had his first solo at Galerie Bruno Bischofberger in Zurich. One thing left to do: cap it off by going back to where it all began.

While his paintings had brought him international fame and the glamorous life, it was Basquiat's roots in New York that defined his work. The canvases were gritty like the city, not the Swiss countryside. Their gritty character was evident in his less than precious treatment of surface and support: as if to belittle the values of those who cherished his work, he would walk on the canvases, tear the paper of drawings, and build supports from found materials, imbuing his art with the memory of lived life—with the blood, sweat, and tears of his presence. And that character is one reason why Basquiat's work continues to hold an important place in urban culture (walking down St. Mark's Place today reveals more than a few imitators of his art in new generations). Thus, it is no surprise that at the moment when fame first exerted its stranglehold on his life, Basquiat returned to a small gallery on the streets of the Lower East Side, renowned for cross-cultural gatherings, graf writers, and a raw architectural presence.

fig. 6
Basquiat and Keith Haring,
New York, 1987

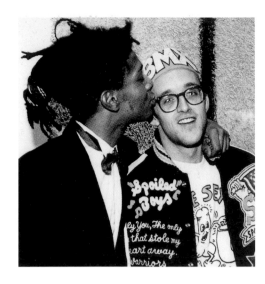

In November 1982, against Nosei's advice, Basquiat presented new work at the Fun Gallery, the small Lower East Side alternative space run by Bill Stelling and Patti Astor, both likewise concerned with the mixing of art and music from uptown to downtown. In its short existence the gallery did shows with Brathwaite, Haring, Kenny Scharf, and Futura 2000. Works in the show included *Jawbone of an Ass*, *Three Quarters of Olympia Minus the Servant*, and *Charles the First* (pages 37, 62, 80), which were among his favorites and which he kept for his personal collection.

From late 1982 to the end of 1983, he created some of the most self-assured works of his entire career, paintings that often embodied the critical attitudes and methods of hip-hop. While I say these works are self-assured, noting that many of them are his most politically astute and demanding, I would also suggest that Jean-Michel found a groove. Basquiat knew how to work that groove for all it was worth. He knew what moved the crowd, and he knew what the collectors wanted. Did he bring it to them? Of course, yet always on his own terms. As Haring remarked: "People got paid and people made money. Much to some people's dismay, Jean-Michel was not only a genius in his work but he was also very clever about the selling of his pictures."[23]

At this point, though, Basquiat may have thought: "Nothing to be gained here" (a phrase used in his paintings), having seen that "the gift and the curse" are often the same thing. Barry Michael Cooper has noted that, in reference to the work *Profit I* (fig. 7): "The crashing symbolism (Byzantine halo-ringed around the trademark grimacing doodle-head; a backdrop of crossed-out mathematical figures, tic-tac-dough apocrypha; the roman numerals '1981') strikes a chord of suspicion that *Profit I* (One?) is actually 'I, Profit,' a blistering self-portrait. As if JMB has peeped game ...

the ones who make you ... corpulent with filthy lucre and fabulousness can't wait to watch you wretch with spiritual anorexia."[24]

FROM SAMO TO "BEAT BOP"

In June 1978, after several other attempts, Basquiat left home for good. "Jean-Michel was planning to be a star," his father told me in 1992.[25] Though as early as 1977, Basquiat had met Warhol and Henry Geldzahler at the SoHo restaurant WPA, the Pandora's box of New York City's nightlife had not yet been opened.[26]

In 1977, under the pseudonym SAMO (fig. 8), Basquiat had begun hitting downtown Manhattan areas near clubs and galleries with his spray-painted aphorisms. A couple of years later, Jeffrey Deitch pointedly remarked on the nexus between music and art in his observation that SAMO's "disjointed street poetry marked a trail for devotees of below-ground art/rock culture."[27] Though generalizing, Deitch's remark begins to touch on the consequence of Basquiat's transition from the unadulterated and nerdy doodler who would rather not be in school to an artist combining the best of pop poetry (emceeing) with the visuality of contemporary art. First publicized in a well-known *Village Voice* scoop by Philip Faflick, the producers of the SAMO writing were identified only by their first names, Jean and childhood friend Al (Diaz). "SAMO is the logo

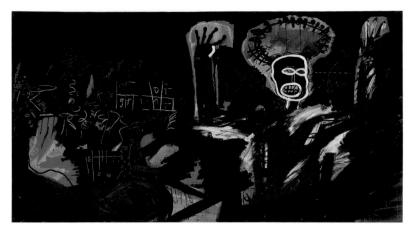

fig. 7
Profit I
1982
Acrylic and spray
paint on canvas
87 x 157 inches
(220 x 400 cm)
Private collection

of the most ambitious—and sententious—of the new wave of Magic Marker Jeremiahs," said Faflick.[28]

SAMO (for "same old," or "same old shit") marked the witty sayings of a precocious and worldly teenage mind that, even at that early juncture, saw the world in shades of gray, fearlessly juxtaposing corporate commodity structures with the social milieu he wished to enter: the predominantly white art world.

Thanks to his girlfriend, Jennifer Stein, Basquiat found himself at Stan Peskett's Canal Zone on the night of April 29, 1979. Located at 533 Canal Street, where Stein lived, was the loft of Peskett, an Englishman who was "trying to catch light in a bottle," Fab 5 Freddy said. "He was trying to manufacture a Warhol-type factory scene and franchise it out across the country so that he could become really famous for having done this thing."[29] That night, Basquiat came out as the producer of the ubiquitous SAMO writings, executing a piece on the wall.

Not only was Fab there (who became his ace friend, introducing him to Glenn O'Brien, who ran the cable access show *TV Party*; fig. 9), but Basquiat also met Lee Quinones as well as Michael Holman (a.k.a. Wordman), who was filming the event. After hitting it off, while neither knew how to play an instrument, that night Holman and Basquiat decided to start a band. Initially called Channel 9 with Shannon Dawson, then Test Pattern, the group eventually became Gray (fig. 10), with other members Wayne Clifford, Nick Taylor, and

sometimes Felice Rossen. Holman readily admits, "It wasn't about the level of playing, it was about the sound,"[30] though Gray's "noisy" mix of electronics and live sound was a hit, mixing the chaos of punk with the improv of jazz. It was a perfect fit for Basquiat's remixing of street and Western philosophy. While Holman and Fab were living double-consciousness between hip-hop and downtown culture, Basquiat's embrace happened more slowly, though with as much passion. Countless people have spoken of Basquiat's ability to soak up information. "The thing about Jean-Michel is that he had this ability to absorb the history of things, almost in days," Fab said.[31] And in true hip-hop fashion, he would incorporate what he needed.

The bridge between punk and hip-hop was also noted by the superstar producer Malcolm McLaren, who in 1982 said, "I think punk rock is more alive in Harlem, in some respects, than it is in Bracknell."[32] It was Holman who introduced McLaren to Afrika Bambaataa in 1981. Of course, at this point the popularity and cultural cachet of punk were ceding to hip-hop as the choice music of youth culture. Hip-hop legend Bambaataa, with his remixes of German synth-pop, and McLaren, the man behind the Sex Pistols, together signaled the potential and unity of that moment. While Fab and Basquiat remembered being the only blacks in the room at the Mudd Club, the reverse was often true uptown. Fab said, "At first, people was buggin' when they first seen the punk rockers. Blacks and Latinos looked at them like they crazy ... but when that music hit, you just see everybody tearing they ass up

98

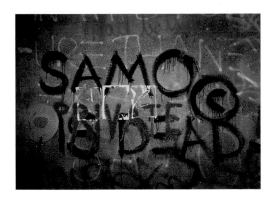

fig. 8
SAMO graffiti, New York, n.d.

fig. 9
Basquiat with Glenn O'Brien
on the set of *TV Party*, 1979

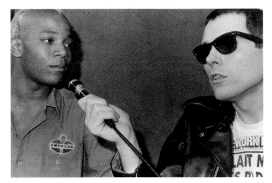

dancing."[33] Says Dick Hebdige, "Basquiat had as much right to pull the terror face on us as the gangsta-rappa LL Cool J, whose rage, in the words of Barry Michael Cooper, 'caricatures the anger of black male teenagers ... [and] makes punk rock's tantrums look like something from *Captain Kangaroo*.'"[34]

As much as SAMO was the vehicle for Jean-Michel to get from Brooklyn to the Mudd Club and the Lower East Side scene, the group Gray was a vehicle to get hype and popularity within that scene. Although the band lasted only from May 1979 to August 1980 (just after the *Times Square Show*), playing the Mudd Club (where he would meet and date Madonna at this time; fig. 11), Tier 3, and Hurrah's, it was an integral part of Basquiat's ascendancy. "We rehearsed like two times a week, but we were a tightly knit group of friends, we didn't just play together," said Holman.[35]

Yet, it was with Fab that Basquiat's lingering effect on music firmly took hold. The two ended up working together on Glenn O'Brien's *TV Party*, where Fab was a cameraman and Basquiat a frequent guest, then on the movie *New York Beat* (fig. 12), which was filmed in December 1980–January 1981 and released as *Downtown 81* in 2000 (written by O'Brien, produced by Maripol, and directed by Edo Bertoglio). And it was Fab who later introduced Basquiat to Rammellzee, Toxic, and A-One. Through O'Brien, they both met Debbie Harry, which led to both young artists being cast in Blondie's classic, seminal video "Rapture" in 1981. "We were hanging out a lot with Glenn after shooting *TV Party*, and that was how we connected with Blondie.

Deborah Harry and Chris Stein became patrons. During this period, we kind of set up this whole cultural exchange thing,"[36] Fab said.

After the 1982 Fun Gallery show, Basquiat spent a good part of the winter in Los Angeles, bringing along Toxic and Rammellzee, commemorated in the 1983 paintings *Hollywood Africans* (page 69) and *Hollywood Africans in Front of the Chinese Theater with Footprints of Movie Stars* (fig. 13).

───────────

While jazz musicians and singers, including Miles Davis, Dizzy Gillespie, Max Roach, Billie Holiday, Leon "Fats" Waller, and most significantly Charlie Parker, were constants in Basquiat's paintings from 1983 to 1985, it was the subject of bebop that found resonance most particularly in paintings like *Trumpet, Max Roach, Now's the Time*, and *Horn Players* (pages 82, 83, 86–87, 88). Focusing on the bebop generation of artists, also a subject Basquiat and Fab tangled on, these paintings give visuality to the aural invention of the master jazz players. Not coincidentally, Basquiat named his one musical recording "Beat Bop" (fig. 14).

In the same year, 1983, that Basquiat dropped "Beat Bop," Fab starred in the film *Wild Style*, two of the most sampled hip-hop productions of the last twenty years. That same year, Run-DMC's first single, "It's Like That," came out on Profile Records and the Beastie Boys released "Cooky Puss"; both groups were soon to be incorporated under Russell Simmons's Def Jam label. The rest is history, though suffice it to say here that

99

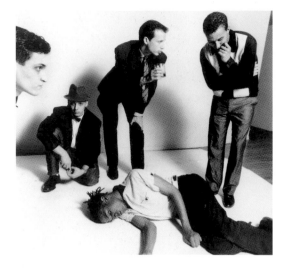

fig. 10
The band Gray: Vincent Gallo, Justin Thyme, Nick Taylor, Michael Holman, and (on floor) Basquiat, 1980

fig. 11
Martin Burgoyne, Basquiat, and Madonna, 1983

the music known as hip-hop passed through a pivotal moment in 1983 and 1984, the first point where the music and the culture became big money. And afterward, Basquiat again may have sensed, "Nothing to be gained here."

"Beat Bop" is a nightmarish conversation piece, spat, chanted, and incanted by Rammellzee, playing a character/thug player so hip to the game, the lyrics could have been written today, and K-Rob, a thoughtful youth trying to stay straight and narrow against the temptations of the street. Over the dense and often nasal rhymes is a deep, moody, industrial soundscape of brooding rhythms and disjointed melodies. It is a New York City filled with poverty, violence, and apathy across class lines. Yet, like Grandmaster Flash and the Furious Five's "The Message" (1983), with "the beat from the depths of hell," the song bears witness to the rumblings, underground, of a creative flowering the likes of which New York City may never see again. "'Beat Bop' ... yielded a prophetic classic—one that foretold the juxtaposition of raging meditative rapper and embattled backing track that Public Enemy would later refine to perfection," said Greg Tate.[37] More recently, think of Geto Boys' 1994 track "My Mind's Playing Tricks on Me": "I sit alone in my four-cornered room staring at candles"

It is no surprise that within this world Basquiat evoked a sense of history, one that knew the commodity structure of black genius. His list of heroes is no secret; homages abound in the paintings. "Since I was seventeen, I thought I might be a star. I'd think about all my heroes, Charlie Parker, Jimi Hendrix ... I had a romantic feeling of how people had become famous," he told Cathleen McGuigan in the 1985 New York Times Magazine cover story (see fig. 15).[38] In addition to his own statement, there are countless canvases referring to a history and genealogy of tragic, black, heroic figures. From Toussaint L'Ouverture to Charlie Parker, Basquiat's shoutouts to a past he recognized in himself seem endless.

As Rick Powell has noted, "In his self-published pamphlet, Black Is a Color (c. 1968), the artist Raymond Saunders lashed out at the 'uptown critics' and 'politico-sociologists' who, in this era of the heightened black conscience, burdened African American artists with civil rights battles, an eternal pessimism, and narrow inquiries that led nowhere."[39] It was a color (blind) theory built on a premise, of course. Saunders's own paintings embraced what many would identify as a black aesthetic tendency. Like Jean-Michel Basquiat after him, and more so than Romare Bearden's seamless representations, Saunders's collages are a cut-and-paste affair built on sampling and ambiguous juxtapositions of paint and found materials: receipts, advertisements—in short, detritus. One person might cite the influence of Arte Povera, and another might posit the history of soul food and Creole cultures.

100

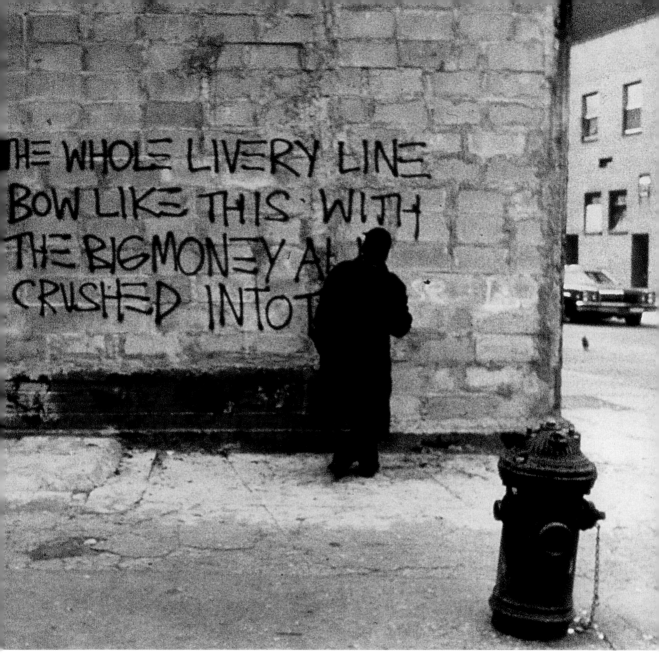

fig. 12
Basquiat writing graffiti
in the film *Downtown 81*
(New York Beat), 1980–81,
directed by Edo Bertoglio

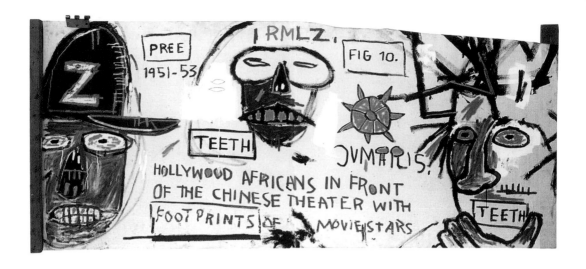

This cultural remixing is prophetic of what Basquiat accomplished in his own work in a matter of ten years.

Many of Basquiat's last paintings from 1987 and 1988 include text passages marking a return to the exact phrases from his underground career as SAMO, such as THE WHOLE LIVERY LINE BOW LIKE THIS WITH THE BIG MONEY ALL CRUSHED INTO THESE FEET, which appears in *Light Blue Movers* (fig. 16). The poetry of those words and others with more political import becomes chilling when we consider he left us less than a year later. The phrases COWARDS WILL GIVE TO GET RID OF YOU and NOTHING TO BE GAINED HERE appear in *Riddle Me This, Batman* (page 151), and a black figure looks ominous, sitting behind the wheel of a big red car that has just lost a tire, in the dark, textless painting *Untitled* of 1987 (page 173). And there's *Exu* (pages 160–61), guarding the crossroads between the human and the divine. *Eroica II* (page 159),[40] with the text MAN DIES written in passages throughout the canvas's left side, juxtaposed with a heavy list of thoughts on the right, is particularly resonant.

Though it may sound clichéd, I am convinced that when Basquiat painted *Riding with Death* (page 153), he wanted to say something, do something, that would have been the ultimate step-off. In my mind, it means that he would have taken time off, like his friends in Blondie, who waited sixteen years between albums, or like Maripol and Edo, who waited twenty years to finance and green light the film *New York Beat* with its new title, *Downtown 81*. Like Fab, he might've told the art world to kiss his black ass and become an international ambassador of hip-hop, with a © on the licensing of any visual material accompanying new music. There would be no buffoonery allowed in hip-hop and we would all be grateful. Jean-Michel often dabbled in cartoonish and child-like caricature, but you could never call his figures buffoons. The X-rays of his stick figures might pierce your soul, the clenched teeth may eat you up, but it's always a matter of game recognizing game, and it's always done with dead-certain dignity.

When Henry Geldzahler asked Jean-Michel in 1983, "Is there anger in your work now?," he replied: "It's about 80% anger." "But there's also humor," Geldzahler continued hopefully. To which Basquiat answered, "People laugh when you fall on your ass. What's humor?"[41]

102

fig. 13
*Hollywood Africans
in Front of the Chinese
Theater with Footprints
of Movie Stars*
1983
Acrylic and oil paintstick on
canvas mounted on wood
supports
35 1/2 x 81 1/2 inches
(90 x 207 cm)
The Estate of
Jean-Michel Basquiat

fig. 14
Front and back cover
art by Basquiat for
"Beat Bop," 1983, a
recording he produced
and directed

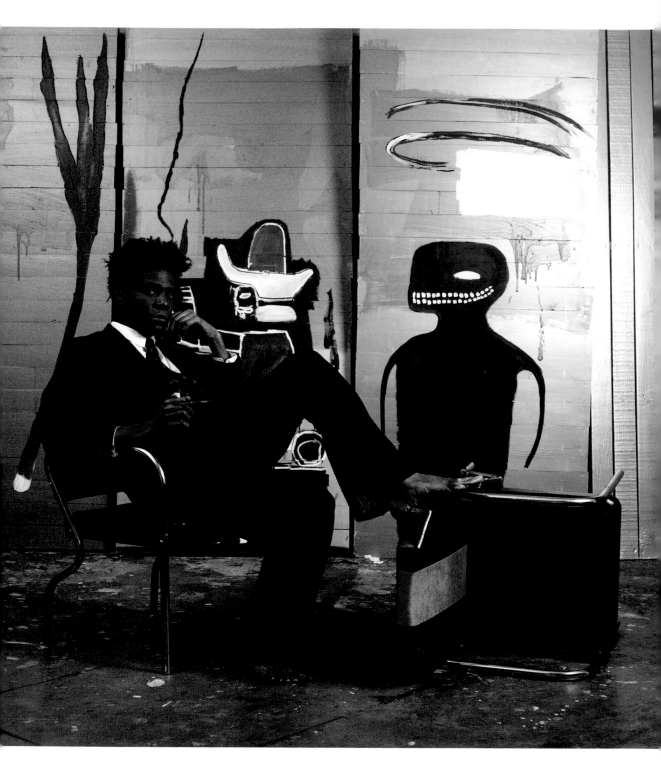

fig. 15
Basquiat in his studio, 1985.
An almost identical image
from the same photo shoot
appeared on the cover of *The
New York Times Magazine*,
February 10, 1985.

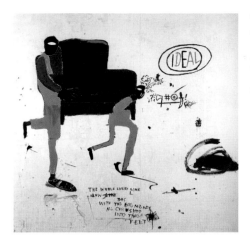

fig. 16
Light Blue Movers
1987
Acrylic and oil paintstick
on canvas
108 x 112 1/4 inches
(274 x 285 cm)
Private collection

NOTES

For JP and the family. Thanks for
the insight: MAD, WC, TG, GS, KJ,
GT, and FB.

1. James Baldwin, cited in James
 Campbell, *Talking at the Gates:
 A Life of James Baldwin* (Berkeley:
 University of California Press, 2002).

2. Quoted in Bill Brewster and
 Frank Broughton, *Last Night a
 DJ Saved My Life: The History of
 the Disc Jockey* (New York: Grove
 Press, 1999), p. 4.

3. Robert Farris Thompson,
 "Activating Heaven: The Incantatory
 Art of Jean-Michel Basquiat," in
 Jean-Michel Basquiat (New York:
 Mary Boone–Michael Werner
 Gallery, 1985), unpaginated.

4. Greg Tate in conversation with the
 producer Djindi Brown, "In Praise
 of Shadow Boxers: The Crises of
 Originality and Authority in African-
 American Visual Art vs. The Wu-
 Tang Clan," in *Other Narratives*
 (Houston: Contemporary Arts
 Museum, 1999), p. 39.

5. Peter Schjeldahl, "Paint the Right
 Thing," *Elle*, November 1989,
 pp. 214–16.

6. Michael Eric Dyson, "We Never
 Were What We Used to Be: Black
 Youth, Pop Culture, and the Politics
 of Nostalgia," in his book *Race
 Rules: Navigating the Color Line*
 (New York: Vintage, 1997), p. 115.

7. Roberta Smith, "Mass
 Productions," *The Village Voice*,
 March 23, 1982, p. 84. Cited
 in Lorraine O'Grady, "A Day at
 the Races: Basquiat and the
 Black Art World," *Artforum* 31
 (April 1993), pp. 10–12.

8. Fred Brathwaite (Fab 5 Freddy),
 quoted in Suzi Gablik, "Report from
 New York: The Graffiti Question," *Art
 in America* 70 (October 1982), p. 36.

9. David Bowie, "Basquiat's Wave,"
 Modern Painters 9 (Spring 1996),
 p. 46.

10. Lydia Yee, "Breaking and Entering,"
 in *One Planet under a Groove: Hip
 Hop and Contemporary Art* (New
 York: Bronx Museum of the Arts,
 2001), p. 18.

11. Tricia Rose, quoted in Yee,
 "Breaking and Entering," p. 18.

12. Plato, *The Republic*, book 4,
 (§1386); quoted in Brewster and
 Broughton, *Last Night a DJ Saved My
 Life*, p. 362.

13. Fred Brathwaite, quoted in Gablik,
 "Report from New York: The Graffiti
 Question," p. 39. Similarly, in 2001,
 writing about the Museum of
 Modern Art's Jackson Pollock
 retrospective for *The Village Voice*,
 Richard Goldstein discussed the
 exhibition with graffiti legend
 Case 2, whose picture and their
 conversation were central to
 the article.

14. Rene Ricard, "Radiant Child,"
 Artforum 20 (December 1981), p. 41.

15. First published ibid., p. 35.

16. Tate, "In Praise of Shadow Boxers,"
 unpaginated.

17. Thompson, "Activating Heaven,"
 unpaginated.

18. Brewster and Broughton, *Last
 Night a DJ Saved My Life*, p. 14.

19. Yee, "Breaking and Entering," p. 19.

20. Greg Tate, "Graf Rulers/Graf
 Untrained," in *One Planet under
 a Groove*, p. 38.

21. Arranged by Diego Cortez. Van Der
 Zee's photographs of Basquiat
 accompanied Henry Geldzahler's
 interview with Basquiat ("Art: From
 Subways to SoHo, Jean-Michel
 Basquiat," *Interview* 13 (January
 1983), pp. 44–46). See M. Franklin
 Sirmans, "Chronology," in Richard
 Marshall et al., *Jean-Michael
 Basquiat* (New York: Whitney
 Museum of American Art, 1992),
 p. 241.

22. The painting *Charles the First*
 did not refer to King Charles I
 of England, as asserted by
 Mark Francis of the Fruitmarket
 Gallery (see *Jean-Michel Basquiat:
 Paintings, 1981–1984* (Edinburgh:
 The Fruitmarket Gallery, 1984,
 unpaginated)), but rather to
 Charlie Parker.

23. Keith Haring, "Remembering
 Basquiat," in *Basquiat*, ed. Franklin
 Sirmans (New York: Tony Shafrazi
 Gallery,1999), p. 58.

24. Barry Michael Cooper, "Larry Scott
 Paints New Life into Hip Hop's
 Dead," posted January 8, 2004,
 Africana.com/reviews/arts.

25. Gérard Basquiat, interview with
 the author, February 4, 1992.

26. Henry Geldzahler, interview with
 the author, March 16, 1992.

27. Jeffrey Deitch, "Jean-Michel
 Basquiat," *Flash Art* 16 (May 1982),
 p. 49.

28. Philip Faflick, "SAMO© Graffiti:
 Boosh-Wah or CIA?" *The Village
 Voice*, December 11, 1978, p. 41.

29. Fred Brathwaite, interview with the
 author, August 1999.

30. Michael Holman, interview with the
 author, January 30, 1992.

31. Fred Brathwaite, interview with the
 author, August 1999.

32. Malcolm McLaren, quoted in
 Brewster and Broughton, *Last
 Night a DJ Saved My Life*, p. 248.

33. Ibid., p. 252.

34. Dick Hebdige, "Welcome to the
 Terrordome: Jean-Michel Basquiat
 and the 'Dark' Side of Hybridity," in
 Marshall et al., *Jean-Michel Basquiat*,
 pp. 64–65. The cuddly rapper LL
 Cool J has by now had his own
 family-based sitcom and appeared
 in countless popular movies.

35. Michael Holman, interview with the
 author, January 30, 1992.

36. Fred Brathwaite, interview with the
 author, August 1999.

37. Greg Tate, "Black Like B.," in
 Marshall et al., *Jean-Michel
 Basquiat*, p. 58.

38. Cathleen McGuigan, "New Art,
 New Money: The Marketing of an
 American Artist," *The New York
 Times Magazine*, February 10,
 1985, p. 29.

39. Richard J. Powell, *Black Art and
 Culture in the 20th Century* (New
 York and London: Thames &
 Hudson, 1996), p. 125.

40. With the onset of his deafness,
 and before composing his Third
 Symphony, the *Eroica*, in 1804,
 Beethoven claimed that it was only
 in order to fulfill his artistic potential
 that he did not commit suicide.

41. Henry Geldzahler, "Jean-Michel
 Basquiat" (1983), reprinted in
 Geldzahler, *Making It New: Essays,
 Interviews, and Talks* (New York:
 Turtle Point Press, 1994), p. 205.

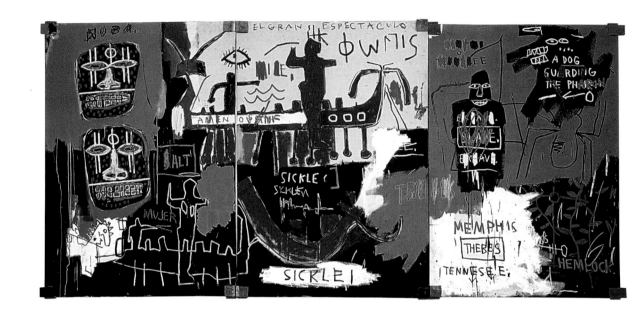

The Nile
1983

Acrylic and oil paintstick
on canvas mounted on wood
supports, three panels
68 x 141 inches
(172.5 x 358 cm) overall
Private collection,
courtesy Enrico Navarra

Untitled
1983
Acrylic and oil
paintstick on canvas
mounted on wood
supports, three panels
96 x 72 inches
(243.8 x 182.9 cm)
Collection of Anette
and Udo Brandhorst

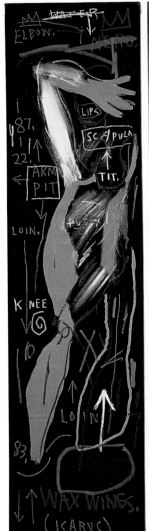
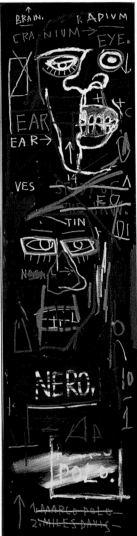
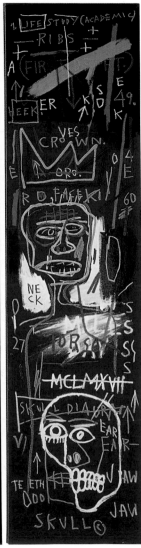

Notary
1983
Acrylic, oil paintstick,
and paper collage
on canvas mounted
on wood supports,
three panels
71 x 158 inches
(180.5 x 401.5 cm) overall
The Schorr Family
Collection; on long-term
loan to the Princeton
University Art Museum

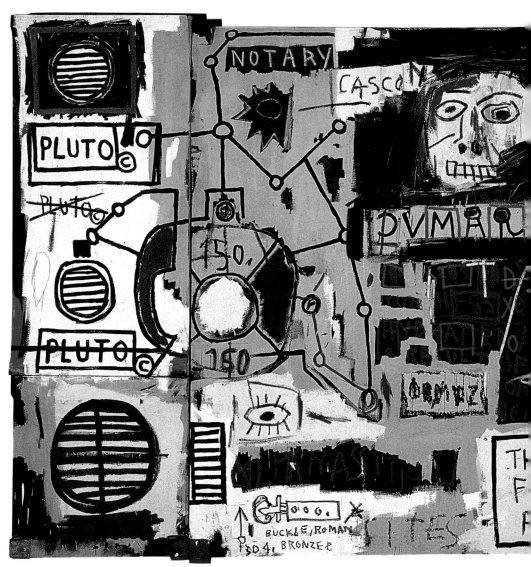

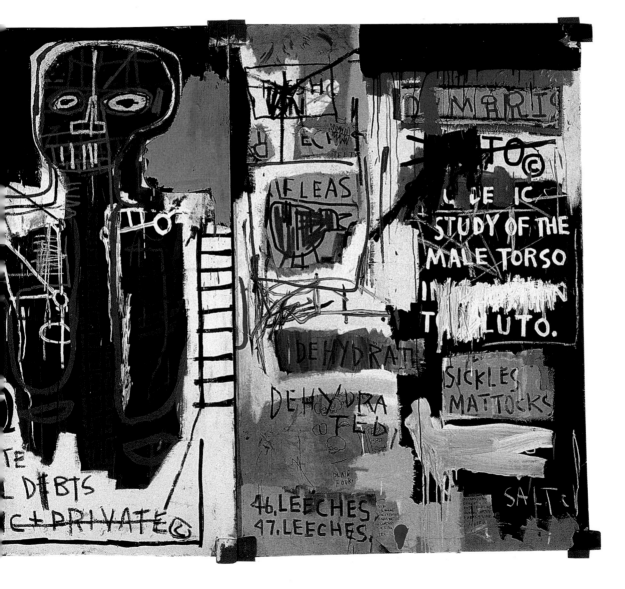

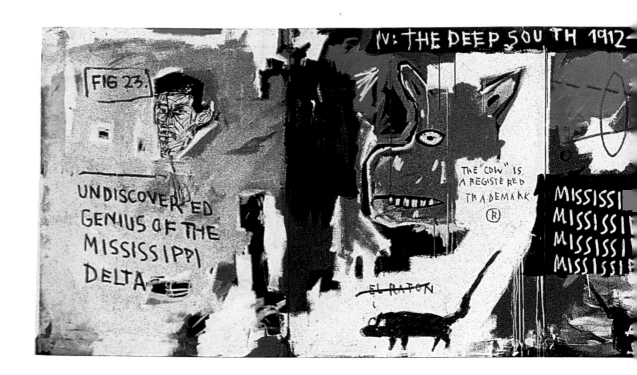

Undiscovered Genius
of the Mississippi Delta
1983
Acrylic, oil paintstick,
and paper collage
on canvas, five panels
48 x 184 inches
(121.9 x 467.4 cm) overall
The Stephanie and
Peter Brant Foundation,
Greenwich, Connecticut

110

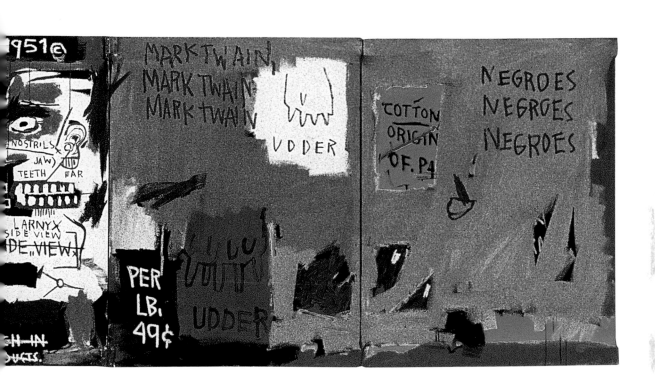

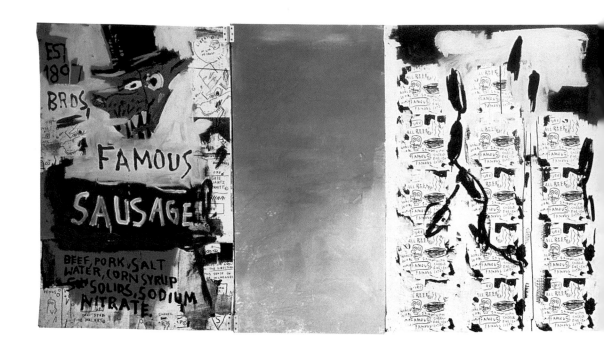

Brother's Sausage
1983
Acrylic, oil paintstick,
and photocopy collage
on canvas, six panels
48 x 230 inches
(121.9 x 584.2 cm) overall
The Stephanie and
Peter Brant Foundation,
Greenwich, Connecticut

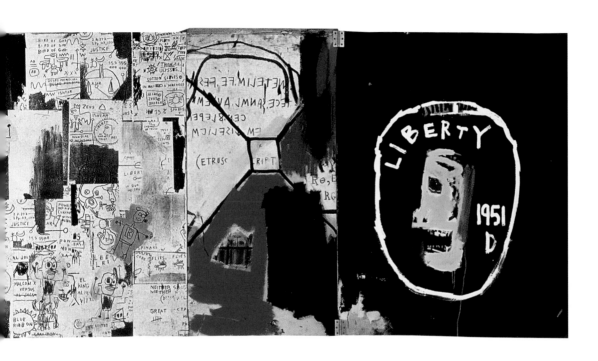

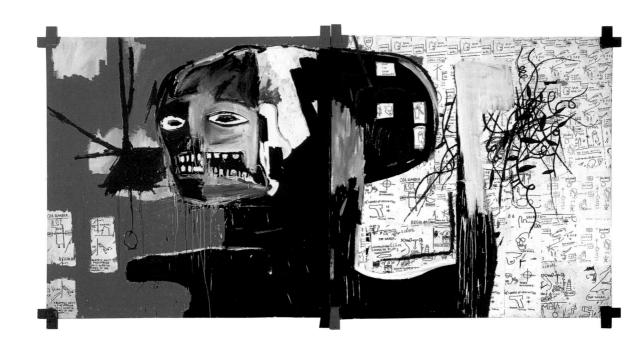

La Colomba
1983
Acrylic, oil paintstick,
and photocopy collage
on canvas mounted on
wood supports, two panels
72 x 144 inches
(183 x 366 cm) overall
Collection of Arthur
and Jeanne Cohen

In Italian
1983

Acrylic, oil paintstick,
and marker on canvas
mounted on wood
supports, two panels
89 x 80 inches
(225 x 203 cm) overall
The Stephanie and
Peter Brant Foundation,
Greenwich, Connecticut

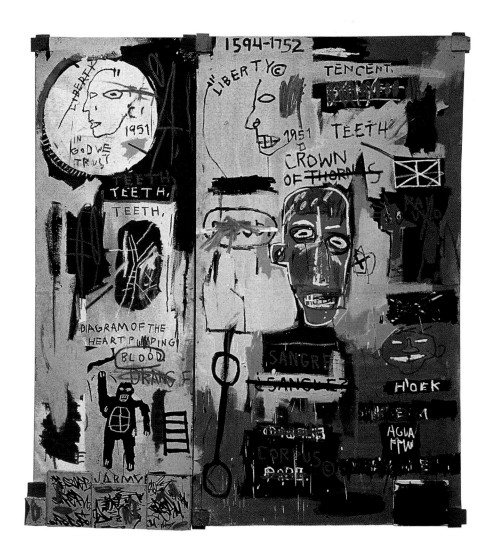

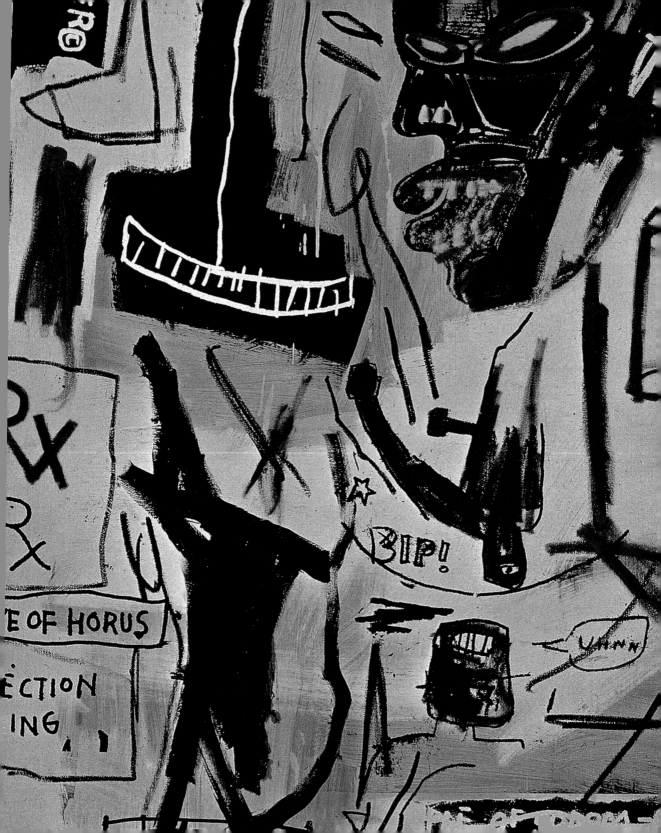

Melting Point of Ice
1984
Acrylic, oil paintstick,
and silkscreen on canvas
86 x 68 inches
(218.5 x 172.5 cm)
The Broad Art Foundation,
Santa Monica, California

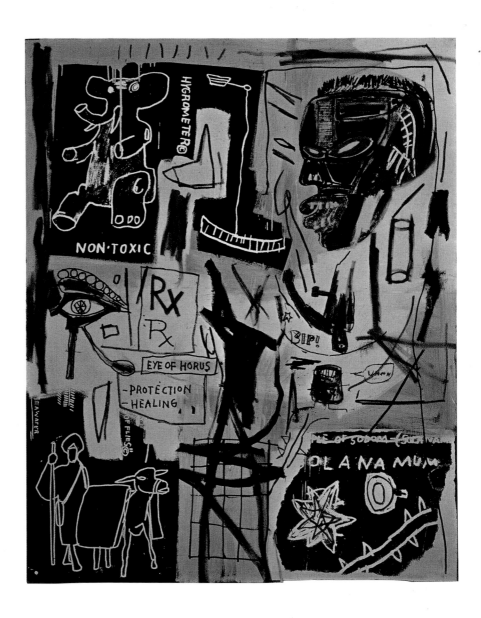

Tuxedo
1982
Silkscreen on canvas
102¾ x 59¾ inches
(260.8 x 151.8 cm)
Edition of ten
Courtesy Tony Shafrazi
Gallery, New York

Untitled (Crown)
1983

Acrylic, ink, and paper
collage on paper
20 x 29 inches
(50.8 x 73.7 cm)
Collection of Leo Malca

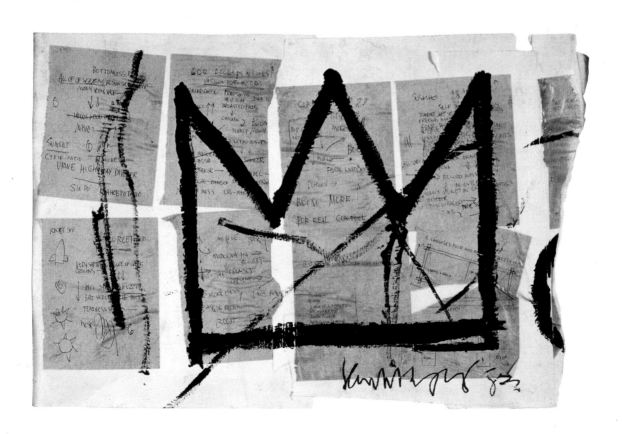

Untitled
(Plaid)
1982

Oil paintstick and
ink on paper
$19\frac{5}{8}$ x $15\frac{1}{2}$ inches
(49.8 x 39.4 cm)
Whitney Museum of
American Art, New York.
Purchase, with funds from
Mrs. William A. Marsteller,
The Norman and Rosita Winston
Foundation, Inc., and the
Drawing Committee, 91.15

Untitled
(Quality)
1982

Oil paintstick and
ink on paper
$19\frac{1}{2}$ x $15\frac{1}{2}$ inches
(49.5 x 39.4 cm)
Whitney Museum of
American Art, New York.
Purchase, with funds from
Mrs. William A. Marsteller,
The Norman and Rosita Winston
Foundation, Inc., and the
Drawing Committee, 91.16

Untitled
(Mostly Old Ladies)
1982
Oil paintstick and
ballpoint pen on paper
20 x 16 inches
(50.8 x 40.6 cm)
The Stephanie and
Peter Brant Foundation,
Greenwich, Connecticut

Untitled
(Cheese Popcorn)
1982
Oil paintstick and
ballpoint pen on paper
20 x 16 inches
(50.8 x 40.6 cm)
The Stephanie and
Peter Brant Foundation,
Greenwich, Connecticut

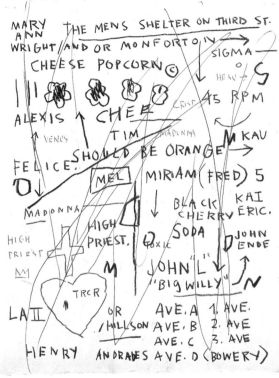

Untitled
(Jackson)
1982

Oil paintstick and
ballpoint pen on paper
20 x 16 inches
(50.8 x 40.6 cm)
The Stephanie and
Peter Brant Foundation,
Greenwich, Connecticut

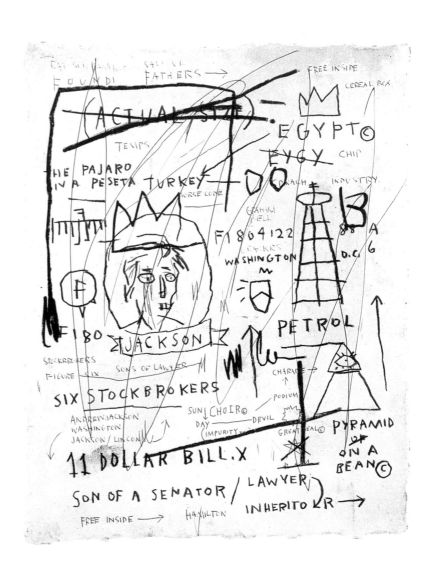

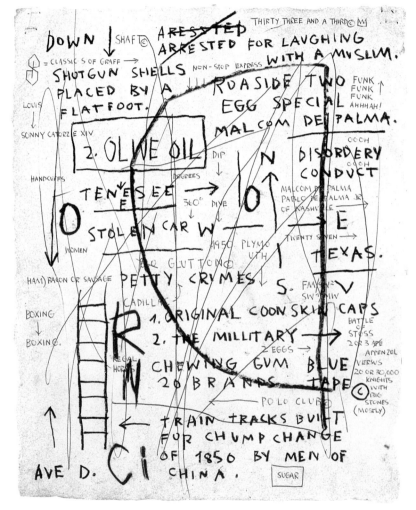

*Untitled
(Olive Oil)*
1982
Oil paintstick and
ballpoint pen on paper
20 x 16 inches
(50.8 x 40.6 cm)
The Stephanie and
Peter Brant Foundation,
Greenwich, Connecticut

Untitled (from the
Blue Ribbon series)
1984
Acrylic and silkscreen
on canvas
66 x 60 inches
(167.6 x 152.4 cm)
The Schorr Family Collection

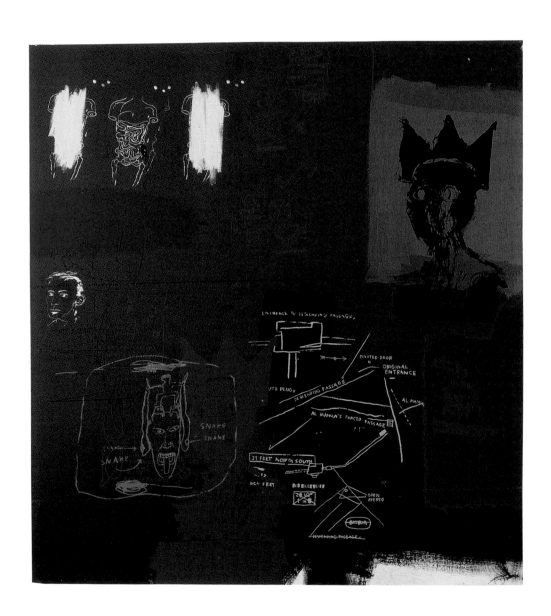

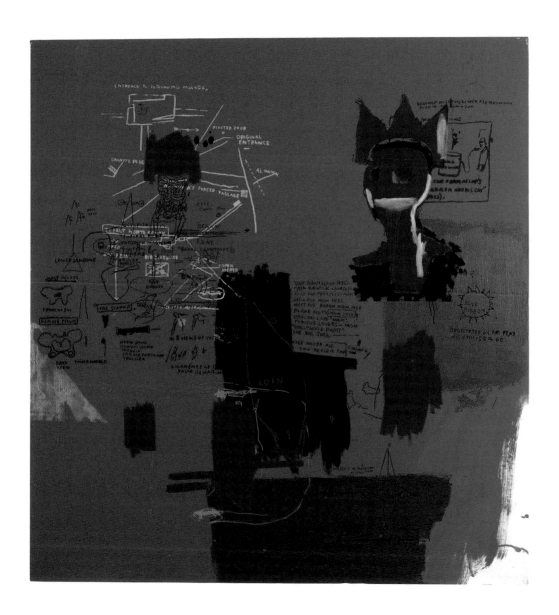

Untitled (from the
Blue Ribbon series)
1984
Acrylic and silkscreen
on canvas
66 x 60 inches
(167.6 x 152.4 cm)
The Schorr Family Collection

Untitled (collaboration
with Andy Warhol)
1984
Silkscreen and oil
paintstick on canvas
116 x 165¼ inches
(294.5 x 420.3 cm)
The Estate of
Jean-Michel Basquiat

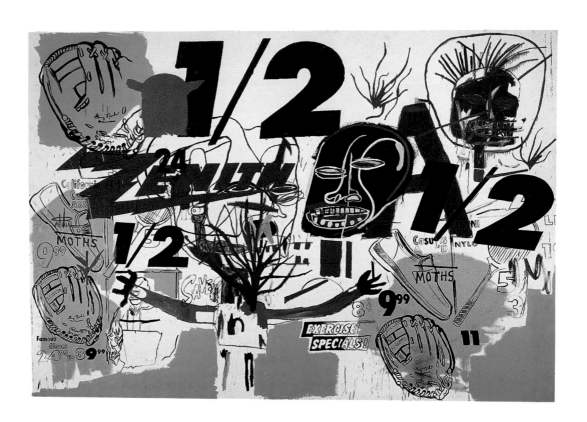

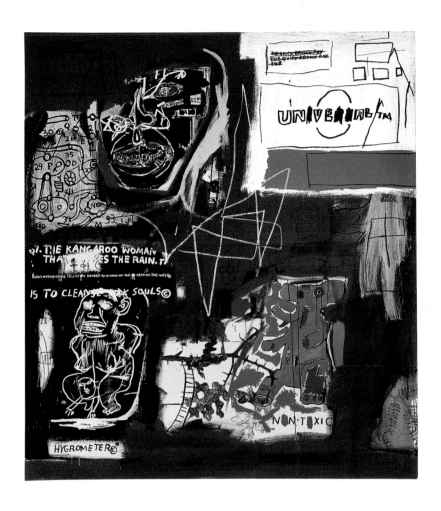

Sienna
1984

Acrylic and oil
on canvas
88 x 77 inches
(223.4 x 195.6 cm)
Private collection

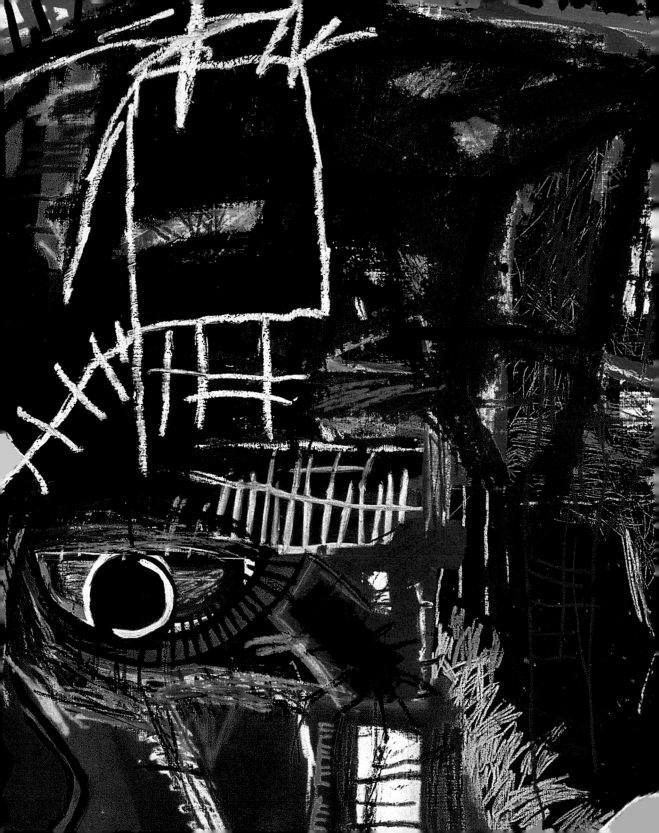

The idea that the soul will join with the ecstatic
Just because the body is rotten—
That is all fantasy.
What is found now is found then.
If you find nothing now,
You will simply end up with an apartment in the City of Death.

—Kabir[1]

The Defining Years

Notes on Five Key Works

Fred Hoffman

Underlying Jean-Michel Basquiat's sense of himself as an artist was his innate capacity to function as something like an oracle, distilling his perceptions of the outside world down to their essence and, in turn, projecting them outward through his creative acts. This recognition of his role first manifested itself in street actions wherein, under the tag name of SAMO, he transformed his own observations into pithy text messages inscribed on the edifices of the urban environment. This effort quickly became the basis for his early artistic output, including a series of text-image drawings executed in early 1981 (pages 24–25). Containing a single word, a short phrase, or a simple image referring to a person, event, or recent observation, each drawing refined an external perception down to its core.

As an exhibiting painter, Basquiat was informed by the same process of distillation—in both his work's content and its stylistic strategy. His paintings proclaimed the existence of a more basic truth locked within a given event or thought. As his career unfolded, the young artist applied the same intense scrutiny previously reserved for the world around him to the emotional and spiritual aspects of his own being.

Beginning in the early part of 1981, when he was barely twenty years of age, Basquiat went through what would be a defining period in his career. Homing in on the possibilities implicit in drawing from his own life experiences as a means of addressing larger human concerns, he produced five key works over an eighteen-month period: *Untitled (Head)* (1981), *Acque Pericolose* (1981), *Per Capita* (1981), *Notary* (1983), and *La Colomba* (1983). These works not only offer insight into this period in Basquiat's career, but also reveal the depth of his concern for portraying spiritual experience. Though

Detail of *Untitled (Head)*,
1981 (p. 35)

129

much has been written about the artist's almost mythic persona and his role in revitalizing the New York art world in the early 1980s, little discussion has focused on the works' irrefutable power to transcend the individual and address broader issues and universal themes.

In pursuing these key works, their way of handling dualities—that is, fundamentally opposing ideas or belief systems—can be seen as an underlying pictorial strategy for the artist. In this regard, I note the 1981 drawing depicting balancing scales with the words GOD and LAW positioned below the two scales (fig. 1). Basquiat saw that drawing as capturing what was for him the dichotomy that existed between the freedom of expression demanded by his own creative activity and the requirements of societal responsibility.

Many of the dualities suggested in his work evolve out of the recognition of his predicament as a young black man in a white art world. Having worked closely with the artist in the production of his editioned silkscreens as well as his first unique paintings utilizing silkscreen-generated imagery, I became acutely aware of the extent of Basquiat's concern for incorporating the dichotomy between black and white into both the content and the strategies of his artistic production. A primary example is the artist's fraught self-transformation from black to white in the untitled silkscreen on canvas of 1983:[2] in the original artwork,[3] the artist depicted a black head set on top of a ground of texts and images; but the silkscreen reverses the positive imagery and texts, turning everything originally depicted in black into white, and everything white into black. Basquiat throughout his career focused on other suggestive dichotomies, including wealth versus poverty, integration versus segregation, and inner versus outer experience. This examination of five key paintings will show how Basquiat's handling of such dichotomies came to define his work.

UNTITLED (HEAD)

Sometime in the early months of 1981, Basquiat began a painting depicting an oversized head extending across the pictorial field, an image that had no precedent in earlier sketches, drawings, or paintings. Showing little regard for either physiognomic accuracy or individual likeness, Basquiat chose to emphasize the expressive qualities of the head. With its public presentation, this painting declared Basquiat's arrival as a new and authentic voice in the world of contemporary art.

Unlike many of his later paintings, which were completed quickly, Untitled (Head) (page 35) was begun and then put aside for several months,[4] to be completed later in the year.[5] One can only speculate about the reasons for this hesitation, but several individuals close to the artist—including myself and Annina Nosei, the artist's dealer at the time—suspect that this young, unseasoned artist hesitated to complete the work because he was caught off guard, possibly even frightened, by the power and energy emanating from this unexpected image. Others had a comparable reaction, later in the year, shortly after the work was first publicly exhibited.

While the painting was presented in the artist's debut exhibition in New York in 1982 as Untitled, when it entered the collection of its current owners a few months later the zword "Skull" had been appended to the designation Untitled and has accompanied the painting ever since, through numerous exhibitions.[6] This renaming represents a misinterpretation of the work that may be attributable to both the uniqueness of its subject matter and the way it is presented. Most likely, the change in title was the result of confusing the work with the more traditional iconography of the memento mori, in which a skull implies death. However, Basquiat's head—having little, if any, precedent in

fig. 1
Untitled (God/Law)
1981
Oil paintstick
on paper
$10\frac{3}{4}$ x $8\frac{1}{2}$ inches
(27.3 x 21.6 cm)
Collection of Leo Malca

modern art history—requires more careful analysis. Close inspection reveals that this head, unlike a skull, is alive and responsive to external stimuli; as such, it seems alert to our world while simultaneously allowing us to penetrate its psycho-spiritual recesses. Basquiat's representation of a single enlarged head is a breakthrough. The visual information it contains provides insight into many of the strategies of dichotomy the artist would adopt over the following eighteen months.

Untitled (Head) depicts the left upper and lower teeth, possibly accounting for the work's misinterpretation as a skull by some. But the painting clearly also depicts functioning facial features as well: the left ear, both eyes, and the nose. There is even a suggestion of hair. While the handling of these features could hardly be characterized as realistic, neither are they grossly distorted or misrepresented. Rather, the way they are portrayed clarifies the artist's intent in depicting a vitally interactive being fully in possession of the means to process external stimuli. That is, the artist also reveals less tangible aspects of the head, such as the subtle neural pathways connecting the sense organs to their internal processor. This concern for sensory and cognitive activity negates the interpretation of the head as an inanimate skull. What this work ultimately captures is the fluidity between external and internal— the complex, living processes connecting seeing, hearing, smelling, and knowing.

Untitled (Head) indicates that, from the outset, Basquiat was fascinated by greater realities than meet the eye. This work introduces the unique X-ray-like vision he brought to his subjects. His work appears to break down the dichotomy between the external and the internal, intuiting and revealing the innermost aspects of psychic life. In this way, the artist extends the concern for spiritual truths advanced most notably by the Abstract Expressionists four decades earlier. This

formative generation of American artists sought to capture man's inherent nature and deal with the question of identity by reasserting "man's natural desire for the exalted, for a concern with our relationships to the absolute emotions.... We are freeing ourselves of the impediments of memory, association, nostalgia, legend, myth.... The image we produce is the self-evident one of revelation."[7] Artists with these aspirations, such as Mark Rothko, Clyfford Still, Jackson Pollock, and Barnett Newman, attempted to represent a world beyond that which is identified solely with physical experience. Though Basquiat came from a completely different social milieu and historical context, he was similarly engaged in the pursuit of fundamental truths. However, he did not achieve this through abstraction, but through newly discovered possibilities for representation. As he pursued his creative activities, the young painter recognized that his breakthroughs would occur in direct relationship to his ability to penetrate intuitively the façade of physical form and appearance and allow other truths and realities to surface.

ACQUE PERICOLOSE

If *Untitled (Head)* announced Basquiat's arrival, the magnitude of that event was only enhanced by the realization of two other works within a matter of weeks. The first of these was *Acque Pericolose* (pages 28–29). Depicting a single black male figure (a subject that would reappear throughout Basquiat's oeuvre), it represents the first time the artist undertook complex narrative subject matter. The work centers on a full-length male nude whose arms are folded across his chest and who is placed in a vaguely defined landscape setting, midway between a coiled snake and a seemingly decomposing cow with two flies hovering over the remains of its head. The figure's head, arms, and hands reveal a Cubist-inspired reductivism used as a means to organize as well as consolidate the information included.

The mystery and power of this haunting figure are reinforced by the rich, atmospheric landscape into which it has been placed. To the right of the central figure, multiple hints of sky and subtle tonal modulations suggesting atmospheric effects invite the viewer to enter a hospitable space of sensual pleasure. By contrast, the shrill tones of red, orange, and yellow appearing on the other side of the figure allude to something other than realism. These colors are not employed for their representational credibility but for their expressive power and symbolic associations: while the artist's color certainly exudes sensuality, possibly even the hint of earthly pleasure, its chromatic intensity connotes an apocalyptic world of fire and upheaval.

A comparable duality is asserted by the brushwork and handling of line. The cow's skeletal remains are represented through a half dozen paint-loaded black brushstrokes along with a very few lines drawn in oil paintstick. However, it is unclear whether the animal is represented as alive or dead, since thinly layered sepia brown brushstrokes also suggest corpulent mass. While the artist's subtle modeling of form suggests life, his equally adept use of line suggests a moment of transition from life to death. A coiled snake and a pair of hovering flies imply imminent death, a reading echoed by the artist's inclusion of the Greek symbols alpha and omega interspersed between arrows pointing both to the earth and to the heavens. Basquiat's inclusion of these dichotomous symbols, here used consistently with their rich iconographic history, alludes to "the beginning and the ending" (Revelation 1:8) as expressed in religious and spiritual texts and traditions.

Acque Pericolose (or *Poison Oasis*, as the work has often been called)[8] hints at mortality. The image of a towering, nude male figure—with long, flowing dreadlocks that in places become intertwined with (and consequently are often confused with) the accompanying halo—not only stands as the artist's representation of the transcendence of the mortality of human flesh, but in its details also reveals the artist's insight into the means of achieving such a state. In what may be interpreted as Basquiat's first major self-portrait, the artist has depicted himself as vulnerable, yet possessed of pride and authority.[9] Thus, the man's arms are positioned across his chest in a gesture symbolically associated with self-surrender—a sense of being at peace with himself even though he is surrounded by death and upheaval.

This inner harmony is ratified by the halo hovering above and behind the figure's head.[10] The preponderance of halo or crown-like imagery in Basquiat's oeuvre asserts a spiritual aspect to the work, but the specific meaning of this symbolism thus far remains largely unexplained. It should be kept in mind that his use of such symbolism changed over time. By 1982, Basquiat had more or less replaced the halo with a personalized, even trademark, image of a three-pointed crown. The crown often accompanied a figure but occasionally appeared on its own throughout the remainder of the artist's career. The intent behind this symbol is revealed in the 1982 silkscreen on canvas called *Tuxedo* (page 118), in which a crown is the culminating image atop tiers of texts and images alluding to diverse political, historical, social, and cultural events. The crown hovering over manifestations of the temporal/phenomenal world signifies a "going beyond," or transcendence, as suggested by the numerous ladders and arrows leading up to it.[11]

In *Acque Pericolose*, the artist's juxtaposition of the figure's head and a radiant orb implies inward reflection—the figure consumed by a transformative force or power. This reading is supported by the inclusion of a small, lit flashlight (or torch) positioned vertically alongside the figure's head. This image was Basquiat's affirmation of the mind's central role in self-realization.[12] This simple yet profound understanding of the role of the mind is the basis of all spiritual pursuit. In Basquiat's case, the use of symbolic references of

this kind was entirely intuitive and did not incorporate any particular religious doctrine. His symbolism of the mind does, however, roughly correspond, for example, to Christ's response to Mary Magdalene as given in apocryphal sources: she asks "how one who sees a vision knows it to be true—through the soul or through the spirit? The Savior answered and said, one does not see through the soul, nor through the spirit, but the mind which is between the two: that is what sees the vision."[13] In this light, Basquiat's depiction of himself—as alone and stripped bare at the crossroads between life and death—takes its place alongside countless representations of saints and historical figures at their moments of self-realization.

That a man of less than twenty-one years was able to capture convincingly his own mortality is in itself noteworthy. That he could instill this subject with such credibility, and at the same time acknowledge the enlightenment of the soul, is nothing less than remarkable.

PER CAPITA

The isolated male figure announced in *Acque Pericolose* in the middle of 1981 underwent a significant transition over the subsequent twelve months. While this iconic subject was first represented as a raw, fully exposed, and humbled youth, it quickly morphed within a series of paintings, each depicting a now fully mature male figure filling a significant portion of the pictorial field and accompanied by a compendium of symbolic references. Indicative of newfound power and emerging identity, these works were Basquiat's declaration of artistic freedom of expression. Showing the assimilation of figure, text, and symbolic references into compelling narrative content, this group of works largely became the basis for the artist's public reception.

Per Capita (pages 30–31) is Basquiat's third major painting from 1981. It depicts a single male figure wearing Everlast boxing shorts, positioned halfway between a vaguely defined cityscape and a surrounding pictorial field of abstract atmospheric effects. The work evolved out of an earlier group of untitled works that I refer to as Cityscapes, which were the first artworks Basquiat executed in a strictly studio context.[14] Each of the Cityscapes contains aspects of the pictorial techniques and imagery previously used in his graffiti

works executed under the SAMO tag in 1979 and 1980. Unleashed at the moment of his initial public recognition (first in Diego Cortez's *Times Square Show*, then through Basquiat's lead role in Glenn O'Brien's film *New York Beat*), *Per Capita* initiates the iconography of male boxers, red and black warriors, and other male figures evincing heroic, even exalted, gestures that characterize some of his most recognized paintings, including *Untitled (Self-Portrait)*,[15] *Boy and Dog in a Johnnypump* (1982), *Untitled (Boxer)* (1982), and *Profit I* (1982) (pages 74, 75, 78, 98).

The iconographic breakthroughs of *Per Capita* were a result of the artist's pursuit of specific pictorial strategies. As part and parcel of this newfound concern for thematic content, Basquiat implemented two new devices, both of which would become mainstays of his pictorial vocabulary. In addition to exploring the integration of image and text, Basquiat discovered more complex and elaborate means of "layering" the distinct planes of illusionistic space created by form, color, line, and atmospheric effects into a unified composition. These strategies became especially pronounced through the artist's practice of collaging both original and photocopied drawings directly onto the canvas. While there are no collaged drawings in *Per Capita*, this work signaled to the artist the possibility of introducing new source material in his quest for the unification of text and image. The subsequent introduction of a collaged ground not only facilitated the union of image and text but enabled a more seamless integration of an "exterior" world into the fictive pictorial realm. Basquiat also reaffirmed what he had initially resolved in *Acque Pericolose*—that by applying thin, subtly modulated hues, he could build up rich atmospheric effects, thereby creating an arena in which his figures could breathe and interact. Thus text-image integration and pictorial layering went hand in hand. Enhanced by the artist's experience as a graffiti tagger, in which he reveled in the pictorial qualities of walls overlaid with layers of history (including the words Basquiat himself might apply), these new artistic discoveries reached their first phase of resolution in *Per Capita*.

Having synthesized his means of expression, Basquiat felt comfortable adapting a number of well recognized, even populist symbols for his personal iconography.[16] In *Per Capita*, the Latin words E PLURIBUS—part of the motto "E pluribus unum,"

133

meaning "out of many, one"—are inscribed in the
topmost portion of the painting. These words are often
associated with the image of a hand holding a bouquet
of flowers and are found on the Great Seal of the United
States, where they refer to the historical unification of
the thirteen original American colonies into one Union,
and they also appear on U.S. currency. By including
E PLURIBUS along with, in the upper left, a partial
alphabetical listing of states in the Union and the
respective per capita income of their citizens, Basquiat
points to the inequities of monetary distribution that
divide the wealthy (CALIFORNIA 10,856) and the
impoverished (ALABAMA $7,484), the dichotomy of
rich versus poor. *Per Capita* thereby extends the artist's
concern for the common people and their labor found in
many of his earliest paintings, such as an untitled work
(1981; The Museum of Contemporary Art, Los Angeles)
in which a prison inmate, wearing a number, holds a
rake or broom, the tool of his labor.

Throughout Basquiat's career, political and social
commentary functioned as a springboard to deeper
truths about the individual. Thus, in *Per Capita* the
radiating halo hovering over the black boxer's head
as he holds a burning torch in his left hand seems to
assert a universal theme. While the social-political
commentary is undeniable, that does not adequately
reflect the totality of the work. Equally, the inclusion of
a lit torch—replacing the more traditional "E pluribus
unum" bouquet—could possibly refer to the torch
traditionally carried from ancient Olympia and used
at the ceremonies inaugurating Olympic competitions.
In view of the painting *Cassius Clay* (1982) and several
others devoted to the same subject, it would not be
far-fetched, then, to conclude that Basquiat's figure in
Per Capita, too, pays homage to the legendary Olympic
boxing champion and role model.[17] More important,

however, the nimbus and torch in *Per Capita* allude to
what the myth scholar Joseph Campbell called "a unity
that already exists,"[18] an underlying set of truths that
binds all peoples in all times. Seen this way, Basquiat's
black male—who first surfaces in *Acque Pericolose*,
finds definition and clarification in *Per Capita*, and is
subsequently developed in works such as *Untitled (Self-
Portrait)*, *Untitled (Boxer)*, and *Profit I* (pages 74, 78, 98)—
declares the birthright of all humankind: the idea
that each individual shares in, and is entitled to, his
or her "per capita" distribution of God-given rights
and responsibilities. It is this democratic ideal that
is proclaimed by Basquiat's champion as he enters
the stadium of self-realization.

NOTARY

By the spring of 1983, Basquiat was immersed in a
number of highly complex paintings using themes and
pictorial strategies developed over the previous eighteen
months. The culmination of these is *Notary* (pages
108–09), completed in New York in March 1983.

A comprehensive indicator of how the artist viewed
himself at the apex of his career,[19] *Notary* is a rich
compendium of figurative imagery and references
accompanied by an array of specific textual references
to Greek mythology, Roman history, African tribal
culture, systems of monetary exchange, and natural
commodities, as well as states of health and well-being.
The images and texts are presented as part of one
loosely unified web or network. Indeed, *Notary* may
be seen as a summation of the artist's interest in
integrating image and text, as well as painting and
drawing. In addition, the work evidences Basquiat's slow
and methodical building-up of the picture's surface,

134

layer upon layer—sometimes by painting over an image, sometimes by crossing one out; and in a few areas he allows traces of collaged silkscreen prints to be seen beneath the picture's surface.[20]

Notary, along with several other key works from this period, was painted using an unusual system of open stretcher bars; that is, the canvas picture support actually wraps behind the stretcher bars at the points where the bars cross each other. The stretcher bars overlap at the corners of the picture as well as on both top and bottom, where the three separate pieces of canvas butt together. This novel method frames the work's content in such a way as to declare that the fractured glimpses that the artist permits into his psyche require patience. Unraveling his non-hierarchical presentation takes time. With some physical junctions and transitional passages remaining hidden, the work's meaning unfolds only after hints and speculations are tested, slowly building up a more comprehensive set of conclusions.

The dual inscription of the word DUMARIUS[21] in *Notary* further suggests that Basquiat saw it as his obligation to guide us through his psychic self-portrayal. The word, which also appears in *The Nile* (page 106), executed at the same time, is derived from a Greek inscription that appeared in connection with the reproduction of an African rock painting in Burchard Brentjes's well-known reference on this subject;[22] Brentjes's discussion of the nomadic Blemyan tribe in the Eastern Sahara includes an image of Saint George accompanied by the Greek inscription (fig. 2). As Brentjes notes, disparate images scratched on the rocks by the Blemyans—including images of Egyptian gods, an ox with ancient Libyan decorated horns, Bedouin camels, and old Arabian altars, all depicted side by side—were the tribesmen's means of recording their presence at a specific location for the benefit of fellow tribesmen who would follow them. In essence, the images functioned as a seal, declaring the existence—both physical and spiritual—of the Blemyan tribesmen. Basquiat's reasons for including the reference are not documented, but in keeping with his self-image as an oracle—one who provides insight into a greater truth—it is likely, I feel, that he found not only affirmation of his own nomadic journey in the practices of an earlier black culture, but validation of his own artistic activities in the idea that one's marks and gestures could play a determining role in linking one person to another and guiding the passage of others.

Notary, then, can be seen as the summation of how Basquiat saw himself as he consolidated his creative achievements. Having mastered many of his formal strategies and extended his ability to address profound psychological experience, Basquiat revealed the depth of his own pathos in the work. *Notary* invites the viewer to penetrate visually into the core of the centrally positioned figure's nervous system, suggesting the introspection of an individual confronted by pain and suffering. Through text references to LEECHES, FLEAS, and PARASITES who are destined to DEHYDRATE, and diminish the FLESH of this MALE TORSO, it also shows the artist's vitality and energy being continually challenged by life-draining organisms. *Notary* concerns itself with the darker aspects of human existence, as suggested by no fewer than four references to the Roman god of the underworld, Pluto. So, as much as *Notary* reveals the artist's spiritual journey, it also exposes the plights and pitfalls along his path. The work can be seen as Basquiat's portrayal of his own inner turmoil—his grappling with the contradictions between a realization of profound inner truths and the responsibilities accompanying public notoriety—at the very moment that his art had obtained public recognition and market value. Hence the ambiguous, and perhaps apologetic, inscription borrowed from U.S. currency: THIS NOTE FOR ALL DEBTS PUBLIC + PRIVATE.

LA COLOMBA

La Colomba (page 114), painted at about the same time as *Notary*, also reveals anguish at this point in the artist's career. With this work Basquiat returned to the representation of a large head, similar to the one that eighteen months earlier had announced his debut. In contrast to *Untitled (Head)*, however, *La Colomba* also depicts the upper torso, including portions of the arms, and further distinguishes itself in its distortion of human physiognomy.

Particularly notable in *La Colomba* is the shape of the head. In naturalistic terms, the length of the head, from front to back, would appear to be more than twice its height; and the neck, wide enough to support two heads, looks awkward. The head seems grossly distorted, possibly even deformed. Yet, rather than

presume that such distortion exists purely as a means to evoke psychological content, we would do well to consider this image in relation to the simultaneous presentation of two different views in a canonical work such as Picasso's *Girl Before a Mirror* (fig. 3). In the Picasso painting, the youthful female figure filling the left half of the canvas contrasts with the depiction of an aged woman reflected in the mirror on the right. The duality has been interpreted as suggesting maturation or the passage of time. In the Basquiat painting, the left and right halves of the composition would seem to show two different views of the head, which meet at the center. Basquiat used this organizational device not for the intent of representing the passage of time, however, but as a means of distinguishing the externally oriented facial features (on the left) from the internal workings of the mind (on the right).

As with *Untitled (Head)*, the facial features of *La Colomba* mark the portals of sensory perception, admitting external stimuli, while the inside of the head suggests the capacity for the mind within to process the totality of experience. However, *La Colomba*, realized eighteen months later, enhances the drama unfolding between the internal and the external. Drips from the mouth, gestural slashes of red paint along the edge of the face, and the fact that the figure's right arm seems to have been amputated contribute to the sense of an extreme emotional state.

These features link this work to personal pathos of the kind expressed in *Notary*, but here the suggestions of physical pain and emotional suffering are offset by the artist's portrayal of the mind's inner recesses. In contrast to the amputated limb, a passage of white brushwork more or less extending the figure's other arm may be read as raising a symbolic white flag. In contrast to the anger and helpless rage consuming the

externally directed senses, seen on the left of the picture, the raised limb on the right, associated with the mind, appears engaged in an act of surrender to something that we do not see. Tellingly, the title *La Colomba* translates from the Italian as "The Dove,"[23] and while the symbolism traditionally associated with that bird refers to the peaceful resolution of a conflict, or good tidings, it can also be seen as signifying a victorious act of deliverance. In this way, perhaps, through the idea of deliverance, the work becomes linked to the artist's heroic black male figures.

To support this conclusion, we may note one of the many photocopied text drawings collaged into the painting. Directly below the back portion of the head, Basquiat refers to two biblical passages, writing: "1. REVELATION I, 11, 12 / 2. KINGS VII, 21, 22." The citation of the First Book of Kings, chapter 7, is especially helpful in deciphering *La Colomba* since it describes the construction of King Solomon's temple. Verses 21 and 22 refer to the construction of the left and right pillars in the porch of the temple; verse 22 reads (in King James): "And upon the top of the pillars was lily work: so was the work of the pillars finished." While this may account for the floral work to the right of the head in *La Colomba*,[24] we might nonetheless ask why the artist is at all interested in this particular passage of Scripture in the first place. As I have already said, he was rarely interested in any particular religious practice or its scriptural offerings. Nonetheless, his quotation of Scripture evidences his continual consumption of any and all source material that would support or validate his more intuitively discovered spiritual insights. Basquiat found in the symbolic architectural forms and their accompanying floral coronation of First Kings an expression of his own attempt at unifying the seemingly conflicting aspects of external experience (anguished

fig. 3
Pablo Picasso
(Spanish, 1881–1973)
Girl Before a Mirror
1932
Oil on canvas
64 x 51 1/2 inches
(162.3 x 130.2 cm)
The Museum of Modern Art,
New York. Gift of Mrs. Simon
Guggenheim, 2.38

facial features, a severed arm) and internal understanding (a white flag of surrender).

It seems doubtful that the young painter was concerned with the architecture of a historical temple, but perhaps the implied duality suggested by the two pillars, crowned by lilies, captured his imagination. By referring to the symbolism of this passage of Scripture, Basquiat was able to represent the duality of an external reality consumed by pain and suffering counterbalanced by surrender and an equally obtainable internal reality.

La Colomba's other scriptural citation, Revelation 1:11, also describes a kind of duality. The verse reads: "I am the Alpha and the Omega, the first and the last: and, What thou seest, write in a book, and send it unto the seven churches...." Some eighteen months after *Acqua Pericolose*'s reference to the union of a beginning (alpha) and end (omega), Basquiat returned to these symbols, perhaps as a means of envisioning his own transcendence of pain and suffering. At the top of *La Colomba*'s head sits a very small crown, the artist's trademark substitute for the halo of the spiritual realm. In the context of the artist's personal iconography, used consistently with crown symbolism in other portrayals of the inner life, Basquiat's coronation of the head of *La Colomba* alludes to the king's central role as the provider of the resolution of conflict. For in essence the king commands his position because he either provides security and peace (the resolution or absence of conflict) or rightly or wrongly makes his subjects believe that they are attainable.

La Colomba captures aspects of Basquiat's personal sense of depletion, and possibly even anticipates his eventual demise, but what elevates this work is the artist's implied understanding of the means to traverse the troubled ground of his life experience. Recalling his practice of crossing out words and images in works such as *Notary*, we realize that by negating

certain references, Basquiat was essentially declaring that he was, so to speak, "not this, not that." By so doing, he refused to be identified with the limiting, transitory nature of his own life experience. This particular practice in his art recognizes the way people have, as the Buddhist monk and scholar Bhante Henepola Gunaratana puts it, "arbitrarily selected a certain bundle of perceptions, chopped them off from the surging flow of experience, and conceptualized them as separate, enduring entities."[25] Understanding the burden of our individual "bundle of perceptions," Basquiat affirms the mind's ability to get beyond them. In such a state, all becomes one, one becomes all; distinctions and differentiations are extinguished. Basquiat had indeed reached this artistic and spiritual turning point. He was at peace with the world.

137

NOTES

I would like to acknowledge a number of people who have aided my work on the artist. These include my wife, Winter, for her editorial assistance; Paul Schimmel, Chief Curator, Museum of Contemporary Art, Los Angeles, for his direction of the content of this text; Lisa Mark, Director of Publications, Museum of Contemporary Art, Los Angeles, for her insightful editorial assistance; and Larry Gagosian, who, a great many years ago, first introduced me to Jean-Michel Basquiat.

1. From Kabir's poem "Think While You Are Alive," in Robert Bly, *The Winged Energy of Delight: Selected Translations* (New York: HarperCollins, 2004), p. 48.

2. *Untitled (Head)*, 1983, silkscreen on canvas, 57 1/2 x 75 inches (146.1 x 190.5 cm), edition of 10, published by New City Editions, Venice, California; first reproduced in Kynaston McShine, ed., *An International Survey of Recent Painting and Sculpture* (New York: The Museum of Modern Art, 1984), p. 48.

3. *Untitled*, 1982, graphite, crayon, and gouache on paper mounted on canvas, 96 x 126 inches (243.8 x 320 cm), collection of Fred Hoffman; reproduced in Richard Marshall et al., *Jean-Michel Basquiat* (New York: Whitney Museum of American Art, 1992), p. 144.

4. Annina Nosei, conversation with the author, November 10, 2003, New York.

5. The dating of this work has raised a certain degree of question. Most sources date it to 1981. The bill of sale, however, dating from 1982 from the Gagosian Gallery, Los Angeles, to its current owners gives a date of 1982. But based on the documentation of the Annina Nosei Gallery, where the work was first exhibited in March 1982, and on that gallerist's recollections and the recollections of other individuals who saw the work at the Annina Nosei Gallery, as well as on stylistic analysis, the work must be dated to 1981.

6. Most of the literature, including the catalogue of the last American retrospective (Marshall et al., *Jean-Michel Basquiat*), refers to this work as *Untitled (Skull)*. The Whitney retrospective catalogue most likely picked up the parenthetical subtitle from the loan form information supplied by the lender. Through extensive conversations with the registrar of the lender in January–April 2004, we have determined that the lender's titling of the painting as *Untitled (Skull)* is based on the title included in the original invoice that accompanied their purchase of the painting in 1982. The problem with subtitling it *Skull* becomes evident when one

considers just one recent interpretation of the work: Alain Jouffroy states, "There are fewer death heads at the beginning of the 1980s, except for this magnificent painting from 1981 called *Skull*, in which the skull keeps his eyes wide open like a living head" (Alain Jouffroy, "Le Grand Journal de guerre de Jean-Michel Basquiat /The Great War-Time Journal of Jean-Michel Basquiat," in *Jean-Michel Basquiat: Histoire d'une oeuvre/The Work of a Lifetime* [Paris: Fondation Dina Vierny–Musée Maillol, 2003], p. 27).

7. Barnett Newman, "The Sublime Is Now" (1948), in *Barnett Newman: Selected Writings and Interviews*, ed. John P. O'Neill (New York: Knopf, 1990), p. 173.

8. The work was titled *Acque Pericolose* on the back of canvas by the artist. The subtitle, not assigned by the artist, that has accompanied the work since its execution is *Poison Oasis*. While this subtitle does not necessarily reflect an incorrect interpretation of the painting, it is certainly not a literal translation of the title given by the artist; a literal translation would be "Dangerous Waters."

9. The conclusion that the image is a self-portrait is supported by comparing this figure to that depicted in another work painted at precisely this same time. *Arroz con Pollo* (page 33) represents the artist and his girlfriend from this period, Suzanne Mallouk. In both *Arroz con Pollo* and *Acque Pericolose*, the male figure is seen as X-rayed, simultaneously revealing corpuscular volume and skeletal underpinnings. *Arroz con Pollo* is one of only two works executed by the artist depicting a pair of male and female figures. Further establishing the identity of the figures in *Arroz con Pollo* is the 1982 drawing *Self-Portrait with Suzanne* (page 38), the only other work in which the artist depicts a pair of male and female figures.

10. An analysis of the numerous depictions of heads of male figures on top of which a circular or oblong form, with lines running away from or transecting its circumference, makes it clear that the artist's intent was the depiction of a halo

or nimbus and not, as has been suggested, a crown of thorns. In fact, there is no irrefutable example of the artist using the symbolic crown of thorns in any work of art. Rather, these radiating lines indicate rays of light, associated with illumination or realization. If there is an example of the nimbus actually having a dual function, including the representation of a crown of thorns, it may possibly be in the contemporaneous painting *Arroz con Pollo*, where the artist has depicted himself offering the fruits of his labor to his mate, who reciprocates by offering her breast for feeding.

11. A careful reading of *Tuxedo* (page 118) shows that throughout the tiers of text-images, the artist repeatedly includes references to an ascent toward a final arrival at the crown. Notably, images of ladders are placed on each of the lower three tiers of text-images. As further evidence of Basquiat's specific association of the crown with spiritual transcendence, it is noteworthy that in the silkscreen print *Back of the Neck* (1983, 57 1/2 x 103 inches [146.1 x 261.6 cm], edition of 24, published by New City Editions, Venice, California; reproduced in *Jean-Michel Basquiat* [New York: Vrej Baghoomian, 1989], pl. 69), which includes a hand-painted gold crown hovering over the depicted figure's deconstructed torso, the inclusion of the words BACK OF THE NECK refers not simply to human anatomy but, as the foremost Leonardo da Vinci scholar Carlo Pedretti has noted, to "the seat of the soul" (in conversation with Annina Nosei, November 17, 2003, concerning Basquiat's interest in Leonardo).

12. The author would like to acknowledge the comments of Lenore Schorr in helping to establish this conclusion. Herbert and Lenore Schorr acquired this work from the artist soon after it was completed. When asked if she had previously recognized and interpreted the image of the flashlight, Lenore acknowledged that she, too, had not previously considered it. Upon reflection, she quickly saw it as a flashlight and saw it as the artist's understanding

of the importance of the mind. As she put it, "For Jean, everything of value was in the mind" (conversation with the author, December 19, 2003).

13. Quoted in Elaine Pagels, *Beyond Belief: The Secret Gospel of Thomas* (New York: Random House, 2003), p. 104.

14. The characterization of a body of artworks produced in 1981 as Cityscapes is the present author's. These works include *Untitled*, 1981 (page 12); *Untitled*, 1981 (page 13); and *Untitled*, 1981, acrylic and spray paint on canvas, 80 x 80 inches (203 x 203 cm), collection of Herbert and Lenore Schorr.

15. The artist did not title this work. The subtitle *Self-Portrait* was given by the Annina Nosei Gallery, which sold the work.

16. The author acknowledges Leonhard Emmerling, *Basquiat* (Cologne: Taschen, 2003), p. 54, and the comments of Annina Nosei in interviews with the author, November 2003, January 2004, and March 2004.

17. Cassius Clay changed his name to Muhammad Ali in 1964. The artist's interest in the subject of the black boxer, and by extension his interest in "Famous Negro Athletes," is further seen in the paintings *St. Joe Louis Surrounded by Snakes*, *Untitled (Sugar Ray Robinson)* (pages 76, 77), and *Jersey Joe Walcott* (1982).

18. Joseph Campbell, *Thou Art That: Transforming Religious Metaphor*, ed. Eugene Kennedy (Novato, Calif.: New World Library, 2001), p. 27.

19. The discussion of this work in Emmerling, *Basquiat*, pp. 38 and 41, was considered by the present author.

20 *Notary* contains two sheets of the five-part silkscreen *Untitled (From Leonardo)*, which have been collaged onto the canvas. The five-part silkscreen (each sheet 34½ x 29½ inches [87.6 x 74.9 cm], printed on Okawara rice paper in an edition of 40) was produced at New City Editions, Venice, California, in 1983. It is unclear whether the artist collaged into the painting unsigned trial proofs or signed and editioned copies of the print.

21. Richard Marshall (*Jean-Michel Basquiat*, p. 23) was the first writer to identify the source of the artist's use of this word. While Emmerling's argument that *Notary* addresses the artist's new position as the vulnerable and almost helpless creator of financial value is relevant, other aspects of his argument are less convincing.

22. Burchard Brentjes, *African Rock Art*, trans. Anthony Dent (New York: J. M. Dent & Sons, 1970), pp. 88–89.

23. Given the artist's work and residency in Italy in 1981, as well as his frequent travels in Europe throughout his adult life, it would not be unusual for him to give this work an Italian title. As a further indication of the artist's interest in Italian titling of his work, another painting from precisely this same moment was given the title *In Italian*.

24. The same floral patterning occurs in *The Nile* (page 106), painted at precisely the same time.

25. Bhante Henepola Gunaratana, *Mindfulness in Plain English* (Boston: Wisdom Publications, 1993), pp. 144–45.

(opposite)
Flexible
1984

Acrylic and oil paintstick
on wood
102 x 75 inches
(259 x 190.5 cm)
The Estate of
Jean-Michel Basquiat

To Repel Ghosts
1986

Acrylic on wood
44 x 33 x 4 inches
(112 x 83 x 10 cm)
Collection of Pierre
Cornette de Saint Cyr

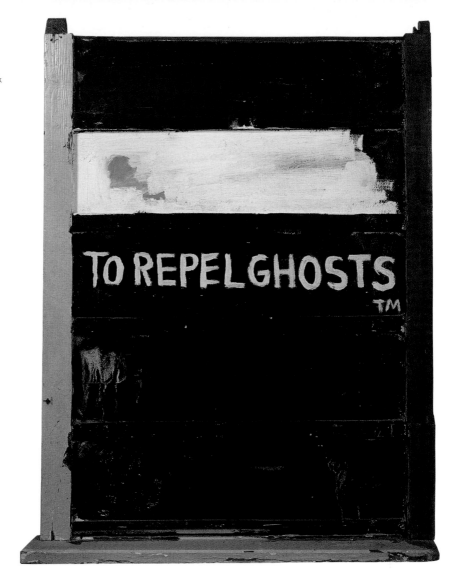

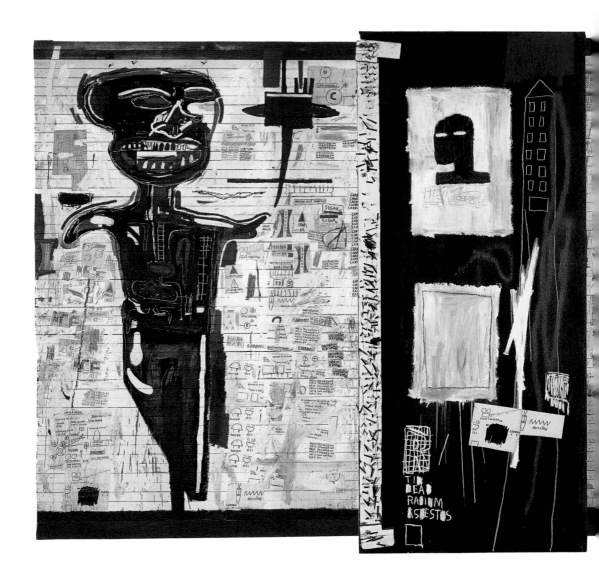

Grillo
1984
Acrylic, oil, photocopy
collage, oil paintstick,
and nails on wood
96 x 212 x 18 inches
(244 x 537 x 45.5 cm)
Private collection

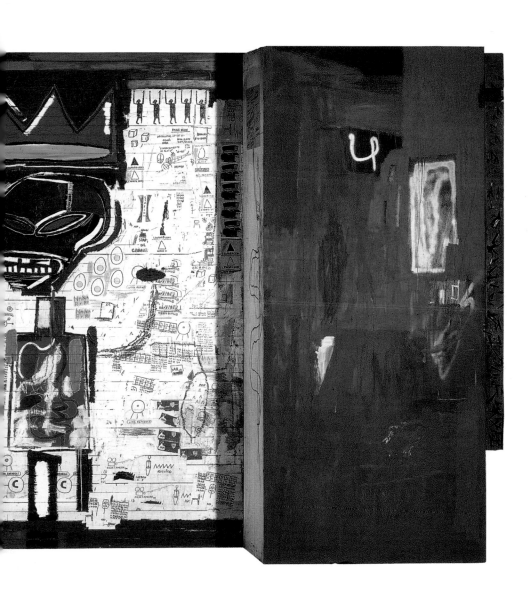

Untitled
1984

Oil, acrylic, and paper
collage on canvas
66 ¼ x 60 inches
(168.3 x 152.4 cm)
Private collection

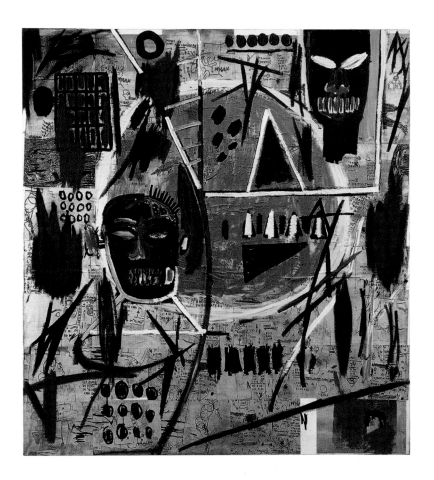

Untitled
(Caucasian/Negro)
1987
Graphite and oil paintstick
on paper
30 x 22 inches
(76.2 x 55.9 cm)
Collection of John Cheim

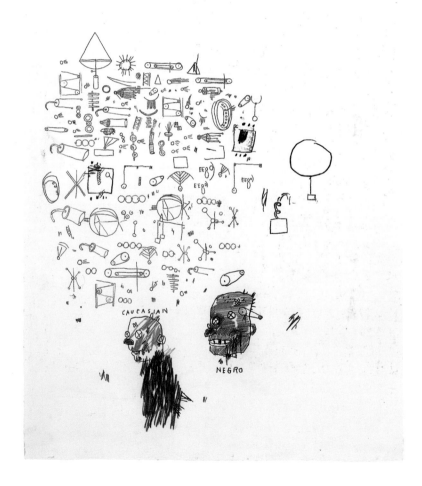

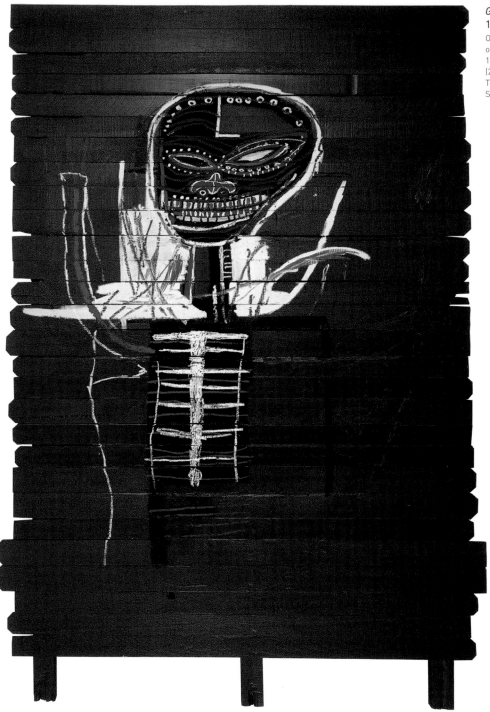

Gold Griot
1984
Oil and oil paintstick
on wood
117 x 73 inches
(297 x 185.5 cm)
The Broad Art Foundation,
Santa Monica, California

146

Jim Crow
1986
Acrylic and oil
paintstick on wood
81 x 96 inches
(206 x 244 cm)
Private collection

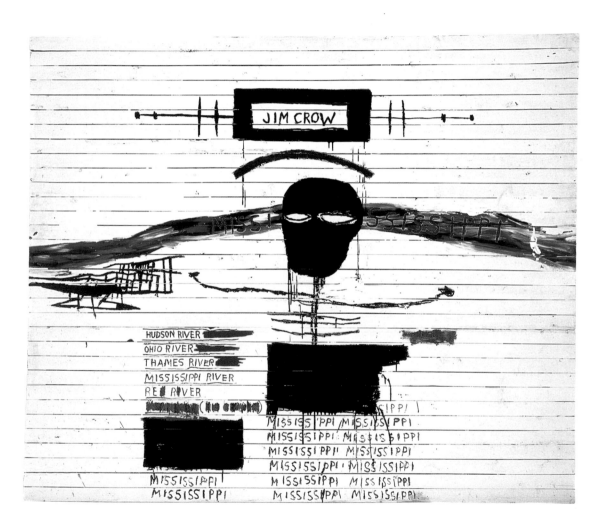

Victor 25448
1987
Acrylic oil paintstick,
wax, and crayon on paper
mounted on canvas
73 x 133 inches
(185.5 x 338 cm)
The Stephanie and
Peter Brant Foundation,
Greenwich, Connecticut

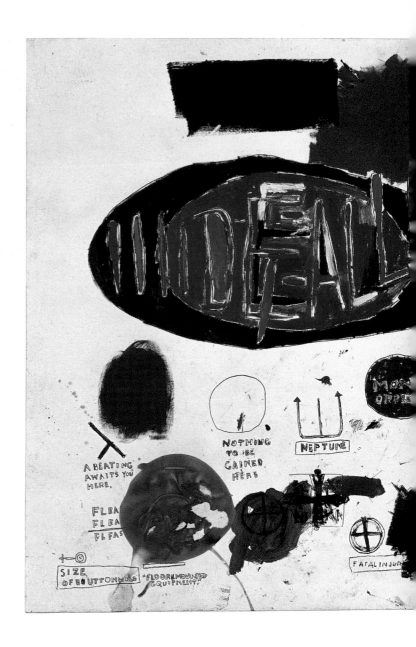

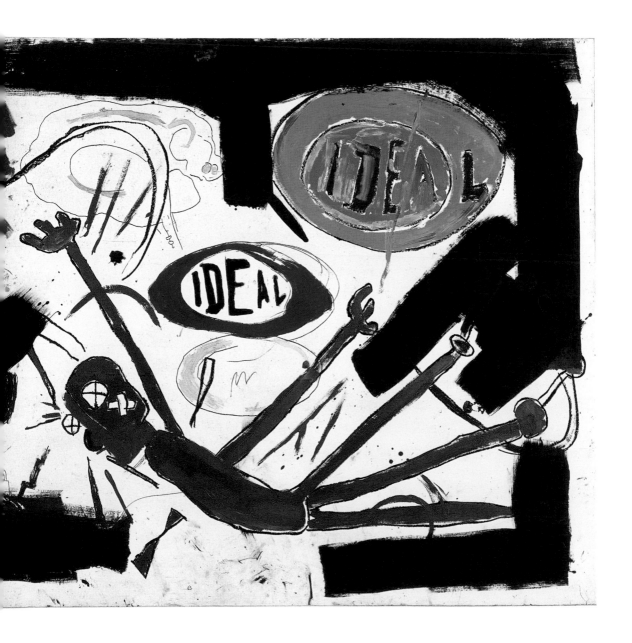

The Dingoes That
Park Their Brains
with Their Gum
1988
Acrylic and oil paintstick
on linen
100 x 114 inches
(254 x 289.5 cm)
Collection of Enrico Navarra

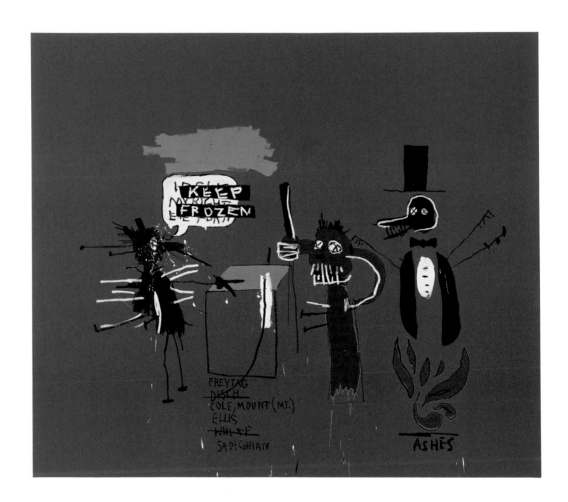

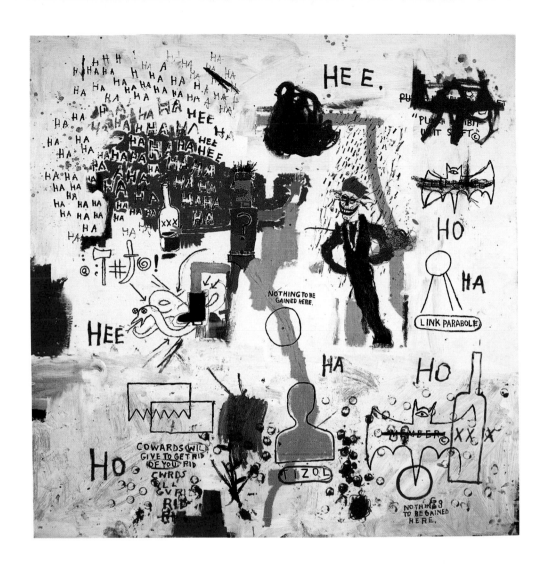

Riddle Me This, Batman
1987
Acrylic and oil paintstick
on canvas
117 x 114¼ inches
(297 x 290 cm)
Private collection, courtesy
Giraud Pissarro Ségalot

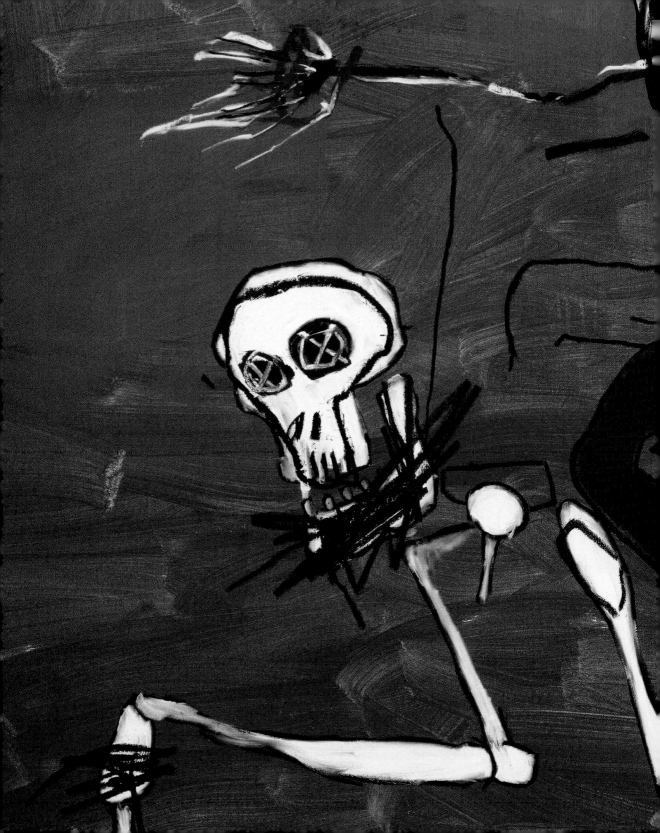

Riding with Death
1988
Acrylic and oil paintstick
on canvas
98 x 114 inches
(249 x 289.5 cm)
Private collection

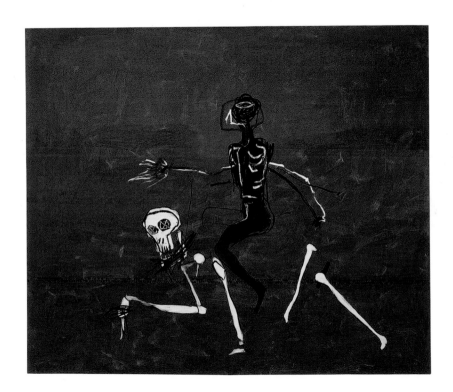

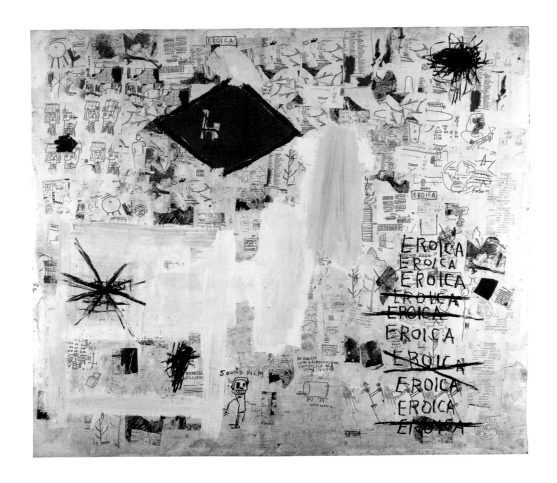

Eroica
1987

Acrylic, oil paintstick,
and photocopy collage on
paper mounted on canvas
90 x 107 inches
(228.5 x 271.5 cm)
Private collection

154

Gravestone
1987

Acrylic, oil, and
oil paintstick on wood,
three panels
55 x 67 x 22 inches
(140 x 172.4 x 55.9 cm) overall
Collection of Enrico Navarra

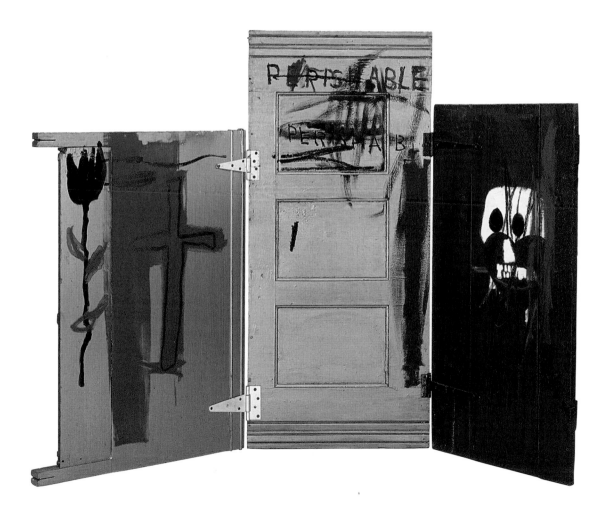

Untitled
1987

Acrylic, oil paintstick,
graphite, colored pencil,
and paper collage on paper
mounted on canvas
90 ¼ x 108 inches
(229.2 x 274.3 cm)
Collection of Dennis Hopper

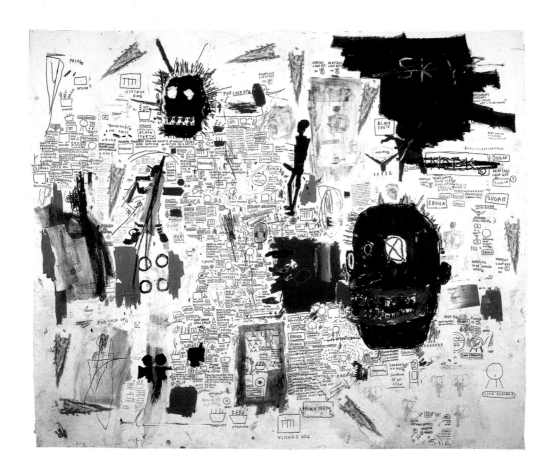

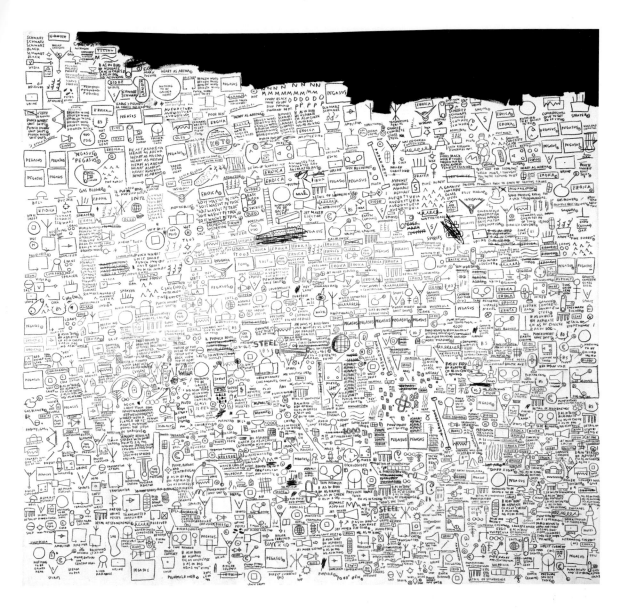

Pegasus
1987

Acrylic, graphite, and
colored pencil on paper
mounted on canvas
88 x 90 inches
(223.5 x 228.5 cm)
Collection of John McEnroe

Eroica I
1988
Acrylic and oil paintstick
on paper mounted on canvas
91 x 89 inches
(230 x 225.5 cm)
Collection of
Alberto Spallanzani

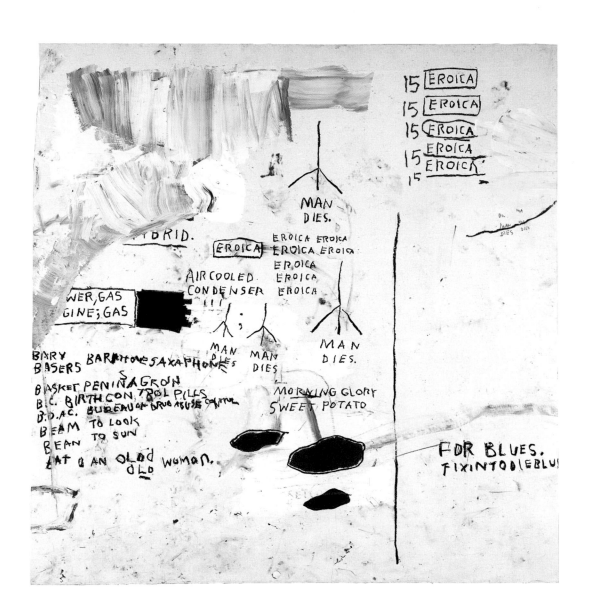

Eroica II
1988
Acrylic, oil paintstick,
and pencil on paper
mounted on linen
91 x 89 inches
(230 x 225.5 cm)
Courtesy of Leo Malca

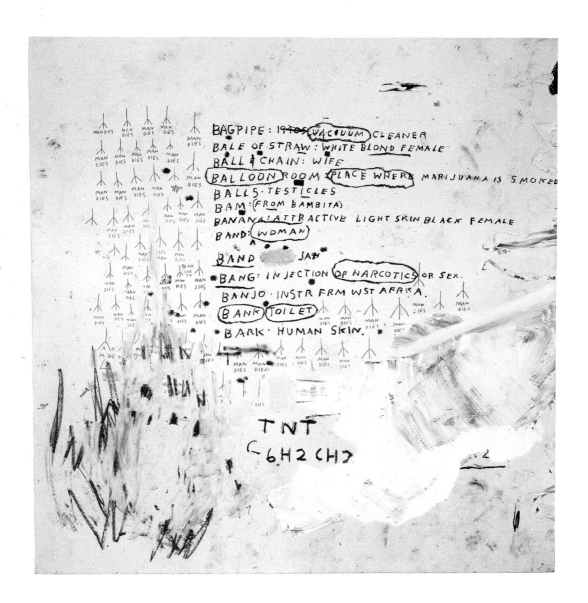

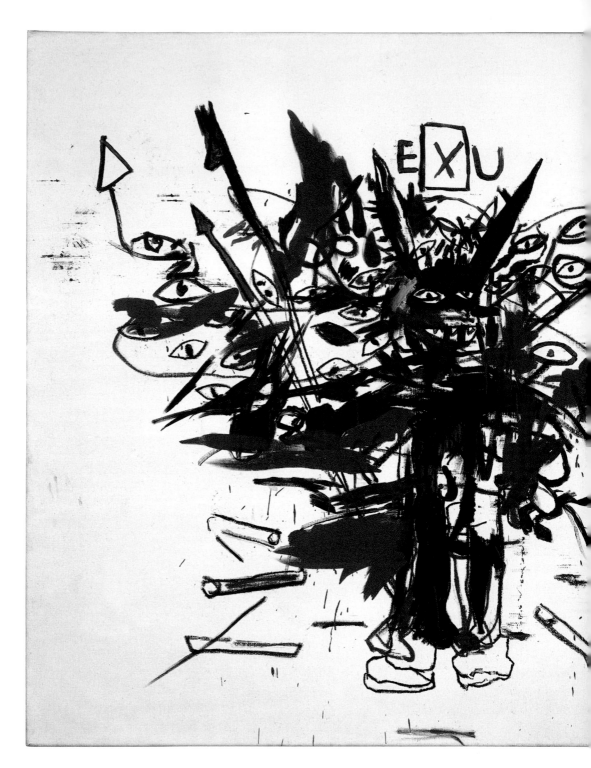

Exu
1988
Acrylic and oil paintstick
on canvas
79 x 100 inches
(199.5 x 254 cm)
Collection of Aurélia Navarra

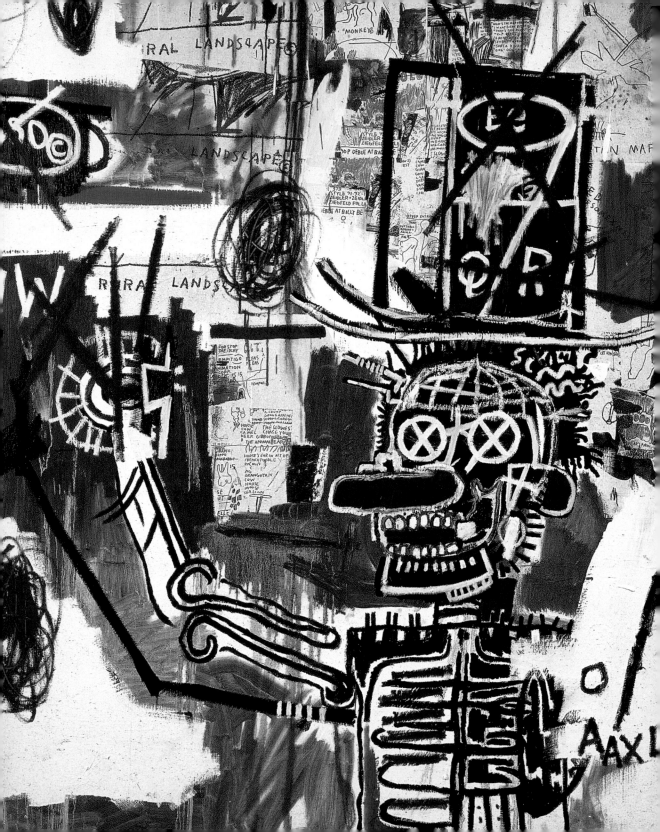

According to popular perception, both within the western metropolitan psyche and in the critical strategies of postcolonial discourse, the daydream of a diasporic community is always lodged in an imaginary locale, in an elsewhere, far from the articulate inscription of native utterance. It is usually symbolically invested, and ceaselessly organized outside the principalities of any originary geography.

—Okwui Enwezor[1]

Lost in Translation

Jean-Michel in the (Re)Mix

Kellie Jones

PRELUDE: QUESTIONS FOR CURATORS

1: Did you know Jean-Michel Basquiat?

On the Reverend Dr. Martin Luther King, Jr., holiday I get my inspiration for this essay from a friend's five-year-old son, G, who has just learned about MLK in school. He refers to him interchangeably as Dr. King, Dr. Martin Luther King, and Martin. "And did you know, Mami, he got shot?"

2: How well did you know Jean-Michel Basquiat?

Everyone has a Jean-Michel story. It wouldn't be a Jean-Michel show without one. Mine is this. I met him on the dance floor at a Spike Lee party at the Puck Building in '87.... We wuz on top of the world. Or as Ntozake said, "We wuz girlz together." We rocked and rolled in the eighties, when kolored wuz king (yit agin). But Jean-Michel wuz in another realm, in the stratosphere.... Anyway, there I wuz on the dance floor and Fab 5 Freddy introduces us. He says, "This girl's a curator" (translation: "This girl's a curator, and low and behold she's kolored"). But did he say I could dance?

Detail of *Después de un Puño*, 1987 (p. 176)

163

fig. 1
King Pleasure
1987
Acrylic on canvas
$49\,\frac{1}{2}$ x $39\,\frac{1}{2}$ inches
(126 x 100 cm)
Private collection

THE ARTIST IN THE WORLD

For many years now the art of Jean-Michel Basquiat has commanded some of the highest prices of any African American artist in United States history. Like that of most of his African American compatriots, his work was under-appreciated by U.S. cultural institutions during his lifetime. And also as with so many others, both he and his oeuvre were more palatable after his death. But the irony is that with price tags in the millions, it is doubtful that many of these works will ever get into these same hallowed (hollowed?) halls except through the magnanimity of some private individuals.

But it is not just prices that are high, or that Basquiat has made it into the realm of famous art-star ancestors, commanding cash, recognition, and respect. The real deal is that Basquiat's aesthetic presence, his vision, his impact and effect, are, in the words of sixties R & B legends the Temptations, "So high you can't get over it, so low you can't get under it."[2] Or, as the anthropologist Grey Gundaker has argued about dynamic African American cultures generally, "[T]he fruits of the relatively new enterprise of African American studies suggest that there is too much information on too many levels—and too much more to learn—to expect anything less than a wide-ranging network of connections."[3]

Indeed, there is much more to Basquiat's work and intellect than meets the eye. He was a master of seemingly exposing things—the skeleton, the infrastructure, the core language of art and life—yet at the same time he occluded origins, influences, and skill with layers of a frenetic, always-in-a-hurry style.

He is, of course, an exquisite painter, as seen in the minute details that swim to the surface in works such as *Leonardo da Vinci's Greatest Hits* (page 59) or the

self-assured figure in *St. Joe Louis Surrounded by Snakes* (page 76). But he also created engaging color-field surfaces, as in *King Pleasure* (fig. 1). The drawings are phenomenal as well: some are spare, economical meditations, distillations of an idea into the meanderings of line; others are dense with deposits of marks and words. Basquiat's almost overwhelming wordplay points to the profound conceptualism of his project, which is also visible in his rare three-dimensional objects. A piece like *Untitled (Helmet)* (fig. 2), with black hair glued to a football helmet, riffs on David Hammons's decade-long project in a similar vein (check out Hammons's *Nap Tapestry*, 1978). Basquiat's *Self-Portrait* (1985) reveals a surface cluttered with bottle caps that also echoes Hammons's *Higher Goals* of the same year, a take on sports as both ghetto exit strategy and unattainable dream of black manhood. This dialogue with Hammons suggests Basquiat's ease in speaking on the conceptual plane. It shows he didn't have to be, but rather chose to be, a painter.

Part of Basquiat's strategy of occlusion was "playing the primitive." Selling shirts and objects in Washington Square Park. Affixing his name to urban corners, a middle-class boy from Brooklyn in the guise of graffiti artist. Like John Guare's protagonist, the gay hustler Paul, in the play *Six Degrees of Separation*, who makes his way into restricted social circles and homes

164

by (mis)representing himself as the son of the actor Sidney Poitier, Basquiat cruised into the art world on the runaway subway train of graffiti, which was fueled in part by the stirrings of eighties multiculturalism. Basquiat's success and his investment in and comments on the art world's star-making process play a part in his fascination with brands and trademarks. As the cultural critic José Esteban Muñoz has written, the tag IDEAL, which appears in the late work, points at once to a nationally recognized brand name of a toy maker, to the false moral value placed in consumer products, and to the artist himself, the "I" who not only "deals" in "the same consumer public sphere," but makes his way, rising to the top of the art-world heap.[4]

Basquiat and multiculturalism were the right combination, in the right place, at the right time. Indeed the critic Greg Tate has argued the same of Jimi Hendrix, who infused the British rock scene with new blood at a crucial moment. As Tate writes of Basquiat and crew at the turn of the 1980s, "Poised there at the historical moment when Conceptualism is about to fall before the rise of the neoprimitive upsurge ... hiphop's train-writing graffiti cults pull into the station carrying the return of representation, figuration, expressionism, Pop-artism, the investment in canvas painting, and the idea of the masterpiece."[5] Yet interestingly, as Tate also reminds us, Basquiat arrives not with the waves of bold color that signal outlaw urban painting, hues that would later characterize his own canvases, but with spare texts sprayed in black on peeling walls; he comes to us "as a poet" (fig. 3).[6]

As Marc Mayer and Fred Hoffman point out in their essays in this book, there is no question that Jean-Michel Basquiat, though he sometimes chose to obscure the fact, knew how to "paint Western art," and was a formidable part of that tradition. Yet American painting, specifically, and the Western art tradition in general were only one source of Basquiat's aesthetic. As Tate writes, "Initially lumped with the graffiti artists, then the Neo-Expressionists, then the Neo-Popsters, in the end Basquiat's work evades the grasp of every camp because his originality can't be reduced to the sum of his inspirations, his associations, or his generation.... He has consumed his influences and overwhelmed them with his intentions."[7] Indeed Basquiat is imbricated in, and draws on, not only the story of Western mark- and art-making but the immense history of the globe itself,

fig. 2
Untitled (Helmet)
1981
Acrylic and hair
on football helmet
9 x 8 x 13 inches
(22.8 x 20.3 x 33 cm)
Private collection

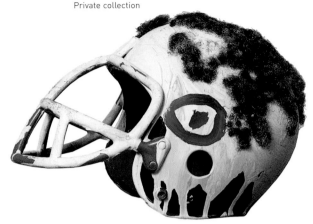

In Italian, as one painting tells us (page 115), as well as in Greek, English, Ebonics, French, and Spanish. These paintings display modernity in their very facture but also overwhelmingly in their content. They constitute a chronicle of the world in modern form, connected through waves of history and histories of power. As the scholar Arjun Appadurai has pointed out, artists like Basquiat "annex the global into their own practices of the modern."[8]

To the extent that Basquiat is a New World citizen and an African American, he inherits a hybridized African culture that is a key ingredient in the cultures of the Americas. Speaking of the Cuban artist Wifredo Lam (fig. 4), the curator Gerardo Mosquera has discussed modernism as "space to communicate Afro-American cultural meanings."[9] A plethora of African civilizations arriving on American shores in continuous waves (as well as over them) from the seventeenth through the nineteenth centuries is carried in "religious-cultural complexes"[10] like Santería, Vodoun, Candomblé, and Shango, and I would add Hoodoo, as well as through folktales, gesture, performance, and aspects of attendant material culture production. Rather than seeing these as struggling "survivals," Mosquera speaks of African culture "on the other side of the Atlantic" as flexible, appropriative, transformational,

fig. 3
*Untitled
(Series of Poems)*
1979–80

Ink on paper
11 1/4 x 9 inches
(28.6 x 22.9 cm) each
Collection of Aurélia Navarra

and dynamic, leading finally to Lam and his creative dialogues with the Caribbean and African Negritude poets in the fashioning of a "neological construction of a black paradigm," or a twentieth-century, modernist, diasporic culture.[11]

The cultural critic Stuart Hall sees the New World of the Americas as a "primal scene" not simply of the encounter of cultures but of displacement and migration, and as one originary site of diaspora.[12] For Hall, within this geographic and psychic space "Africa, the signified which could not be represented directly in slavery, remained and remains the unspoken unspeakable 'presence' in Caribbean culture."[13] While this may seem to be the antithesis to Mosquera (and perhaps represents the differences of the Caribbean seen from Anglophone Jamaica and Hispanic Cuba respectively), Hall's focus on the "unspoken" and "unspeakable" African life of the New World derives more from its dialectical relationship to the overdetermining European presence there, "which is endlessly speaking—and endlessly speaking us." And he asks, "[H]ow can we stage this dialogue [with Europe] so that, finally, we can place it, without terror or violence, rather than being forever placed by it?"[14]

One aspect of Basquiat's genius was his ability to "consume his influences and overwhelm them with his intentions," as Tate has noted; that is, not to be placed by European tradition but to place and reassign *it,* to remind us that Europe as it appears on this side of the pond is "always-already fused, syncretized"; in other words, it is a version of Europe in the process of becoming American.[15] His skill was also in his energetic articulations of the "neological construction of a black paradigm," as outlined by Mosquera.

However, Basquiat's mischievous, complex, neologistic side, with regard to the fashioning of

modernity and the influence and effluence of black culture, is often elided by critics and viewers—lost in translation. The establishment of a comfortably canonical body of his work obscures the places where he connects with those "religious-cultural complexes" whether as material, performative, or gestural subjects. For example, thematics such as "Negro" athletes and black jazz musicians give a place and a face to Basquiat's blackness and his masculinity in the work. Certain related history paintings, such as *Undiscovered Genius of the Mississippi Delta* (pages 110–11), are also fairly easily digestible forms of black culture. Through the lens of multiculturalism, these scenes visually signify blackness, are already overdetermined, and as self-contained, U.S. black history can be assigned to "the margins of modernism"[16] as hermetically sealed dioramas of, dare I write it, "the other." As I have argued elsewhere, art by black people is often seen as the conscience of Western humanism, a role that a work like *Native Carrying Some Guns, Bibles, Amorites on Safari* (page 68) seems to easily fulfill.[17] And as Hall suggests, *haute couture* (and luxury objects like art) can always be supplemented by the air of sophistication carried by the black transgressive.[18]

But even *Native Carrying Some Guns, Bibles, Amorites on Safari* has its eye toward the global, alluding to imperialistic adventures that repeated themselves worldwide, and not just in the move from Africa to the U.S. The excess in Basquiat's work—the parts that cannot be so easily contained in the African American context of the U.S. or the centuries of Western painting—reasserts itself in the context of diaspora, in the outernational culture that is at ease crossing borders and oceans. As the scholar Nicholas Mirzoeff points out, it is art with a "multiple viewpoint," that exchanges "the one-point perspective of Cartesian

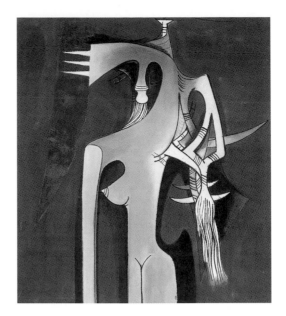

fig. 4
Wifredo Lam
(Cuban, 1902–1982)
Zambezia, Zambezia
1950

Oil on canvas
$49\,^3/_8$ x $43\,^5/_8$ inches
(125.4 x 110.8 cm)
Solomon R. Guggenheim
Museum, New York.
Gift, Mr. Joseph Cantor,
74.2095

rationalism for a forward looking, transcultural and transitive place from *which to look and be seen*" (my emphasis).[19] And so the action that moves through Basquiat's painting is dialogic; it is an interactive process "between individuals, communities, and cultures" caught in the exchange of glances, the parrying of visuality and visibility.[20] It is this space of multiplicity and immense variability, this site of hybridity, and *mestizaje*,[21] not in the biological but the cultural sense, that has been consistently elided from Basquiat's oeuvre. It is this inheritance of the diaspora, which Hall finds in the "primal" site of the Caribbean, that Basquiat inherits in his Haitian and Puerto Rican routes to Brooklyn.

SEMIOTIC IMAGINATION

One overlooked aspect of Basquiat's oeuvre that somehow cannot be contained by either his identification as an African American citizen of the U.S. or as a Western painter is the preponderance of Spanish-language messages woven throughout the paintings and drawings over the entire span of his career. In my own marking of Basquiat as African American I refer back to the wider connotations of this term as engaged by Gerardo Mosquera. In his writings, Mosquera speaks of culture and peoples of the Americas (and more specifically the Caribbean) that display African cultural inheritances as "Afro-American," following not from the U.S. example but from the Latin American framework of Afro-Cuban, Afro-Brazilian, and so on. Let us not forget that more than ninety percent of the African peoples who arrived in the Americas as the result of the transatlantic slave trade landed in Latin America and the Caribbean, not

the U.S., making the term *African American* even more appropriate in that context.

Like that great "political activist, bibliophile, collector, librarian, and figure of the Harlem Renaissance" Arturo Alfonso Schomburg—who at times in his life used an anglicized version of his name, Arthur A. Schomburg—Basquiat can be easily claimed by black U.S. and Puerto Rican communities.[22] And that's not even getting to the Haitian side. However, as Greg Tate reminds us about Basquiat's captivation of the art world, "[I]t would be the Haitian boy-aristocrat with the properly French name who'd get to set their monkey-ass world on fire."[23]

Spanish is spoken by over 265 million people worldwide and more that 17 million in the U.S. alone.[24] In the U.S. context, some have viewed the Spanish language as reflecting private spaces and/or the migrant's nostalgia for home, family, the past; it is the voice of self-knowledge "in which people realize themselves in the act of speaking," a dynamic of interaction with others in "the plaza," as opposed to English, which is construed as the primary *lingua franca* of transnational commerce.[25] Spanish implies "a whole notion of conversation as pleasure, as dialogue, as intellectual inquiry, as social event, as ritual."[26] Language in this sense is not adopted for its pragmatics, to get from point A to point B in the quickest, most expedient

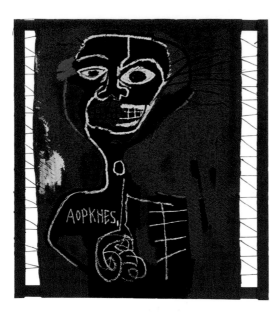

fig. 5
Cabeza
1982
Acrylic and oil paintstick
on blanket with exposed
wood supports and twine
66¾ x 60 inches
(169.5 x 152.4 cm)
Private collection

manner, as often with English. Instead, with Spanish "there is a ludic element. There is a mystical element, there is a whole level of imagination; language for the sake of imagining, of inventing, of playing."[27] The passageway between the private realm and that of the public eye is the street: the space of code-switching (Spanish-to-English-to-Spanish-to ...), Spanglish, or, in the Chicano context, the slang of *Calo*.

Other observers see Spanish as a form of communication that operates in both the private and public arenas of the U.S. In the latter case, print culture and, later, mass media have unified this community in the public realm. This has been the case, particularly in what is now the U.S. Southwest, since the sixteenth century. Indeed, the Spanish language can be seen as a discursive identity functioning as a site of cohesion apart from national origin or race. And beginning in the late twentieth century, nearly half the world's migrants have been women. This is crucial for us here because it is generally "women who determine the child's mother tongue."[28]

From the vantage point of the early twenty-first century, Spanish has certainly moved beyond isolated islands (or plazas) of speakers dotting the U.S. With the news in 2003 that Latinos were now the largest "minority" population of this country, the Spanish language has become more and more integral to the fabric of our national life, from the shores of Hollywood and the star

power of Jennifer Lopez, to the Latin Grammy Awards broadcast from Miami, to almost every service industry, from banks to telephone companies, to major store chains, where we are given the option, "Para servicio en español por favor oprima el número dos."[29] Magazines like *Business Week* have devoted special issues to the "Hispanic Nation." And even more interestingly for our purposes here, *Black Enterprise*—that organ of African American economic strivers—has made the apparent phenomenon of *black* Latinos a cover story.[30] Almost twenty years after he left us, Basquiat would perhaps have been gratified to see how much his vision has been recognized as a key aspect of contemporary life.

Spanish appeared in Basquiat's work from the beginning. Robert Farris Thompson has observed that Basquiat was fluent in the language, learned from his mother, Matilde, and honed while living in Puerto Rico for several years in the mid-1970s.[31] Printed words like POLLO (chicken), CABEZA (head), and MUJER (woman) surface repeatedly in his paintings. Some, like LECHÓN (pork) or GUAGUA (bus), are terms identified with the Caribbean, and in the case of the latter, specifically Puerto Rico. Parts of Basquiat's lexicon connote public space and reflect his fascination with commerce, such as PESO NETO (net weight) and ORO (gold).

In *The Nile* (page 106), one of Basquiat's epic paintings, the artist connects the history of the U.S. with that of the ancient world by using black subjects as icons or avatars of the forces of historical change. In the left panel, the word NUBA, denoting one of the earliest African cultures, floats above two masks. At the right, Greece and Egypt rise to prominence in the words THEBES, HEMLOCK, PHARAOH, and MEMPHIS. The Egyptian presence is further inscribed with hieroglyphs (an eye, waves), papyrus ships, and female figures seen in three-quarter view; the word NILE is

fig. 6
Dos Cabezas
1982
Acrylic and oil paintstick
mounted on tied wood
supports
60 x 60 inches
(152.5 x 152.5 cm)
Private collection

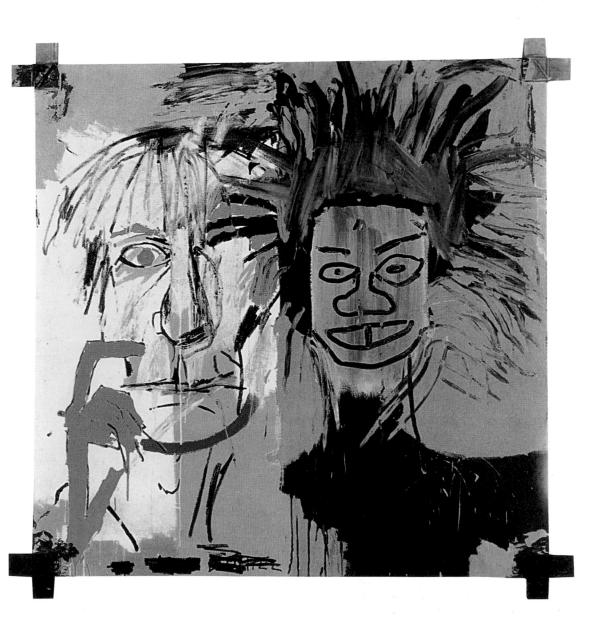

fig. 7
Basquiat painting *Gold Griot*,
1984 (p. 146)

crossed out. The third presence is American. We have
not only Memphis of old but Memphis, Tennessee; the
sickle cell trait floats across the water both above and
below an image of a sickle-like tool that is also a ship.
Yet in each of the three panels, words in Spanish appear
as well. One of the silhouetted females on the left is
identified with MUJER, her male counterpart on the
right faces forward with ESCLAVO and SLAVE on his
chest, crossed out; centered at the top, the artist has
named this panorama of history, blackness, and slavery
EL GRAN ESPECTÁCULO (the grand spectacle). But
the term ESPECTÁCULO also reads in a mass-media,
kitschy sort of way, attached to the riotous display of
Spanish-language variety shows or car sellathons; we
are returned to commerce.[32]

"They called us graffiti but they wouldn't call him
graffiti. And he gets as close to it as the word means
scribble-scrabble. Unreadable. Crosses out words,
doesn't spell them right, doesn't even write the damn
thing right" (Rammellzee).[33] From this fragment, it seems
that fellow painter Rammellzee did not approve of his
friend's way with words, perhaps connecting Basquiat's
actions to the continual elimination of black people
from records both historical and contemporary.[34] In the
nineteenth century, Mirzoeff tells us, diasporas were

configured as troublesome bodies existing outside
national boundaries and controls, excess citizenry that
needed to be restricted, resettled—crossed out.[35] As a
black man painting, and painting, and painting himself
into view, Basquiat and his work demonstrate an
"interrogation of persistent erasure and the denial of
agency,"[36] or selfhood that engulfs the subject who is
a black, male, Caribbean, American, Spanish-speaking
artist. But Basquiat takes this trope and reverses it by
visibly embracing invisibility. Robert Farris Thompson's
observation that "Jean-Michel cancels to reveal"[37] indeed
reflects what the artist told him in an interview: "I cross
out words so you will see them more: the fact that they
are obscured makes you want to read them."[38] Basquiat's
works are amazing in the scope of their form and content,
as well as in their sheer numbers, making a case for a
corpus that is both "transnational and translational."[39]

Many of the paintings that speak to us *en español*
speak to us in more intimate terms that revolve around
family, community, and food. *Arroz con Pollo* (page 33),
for instance, is one of Basquiat's few paintings showing
the intimate interactions of a heterosexual couple,
outside the worlds of masculine identity codified in
sport or commerce.[40] It has a quasi-religious profile as
the female figure offers her breast in sustenance to the
male, a prophet crowned with a halo; the male figure
in turn serves up a steaming plate of chicken. The dish,
rice and chicken (which gives the painting its title), is
a staple throughout Latin America—comfort food. The
painting itself was made in Puerto Rico.[41]

Professor bell hooks has argued that the pain she
perceives in Basquiat's work comes from the artist's
concentration on the realm of masculinity to the
exclusion of a counterbalancing female life-world.[42] The
scholar José Esteban Muñoz, however, has critiqued
this position as one that opens itself to heterosexist

fig. 8
Gri Gri
1986
Acrylic on canvas
70 x 56 inches
(178 x 142 cm)
Private collection

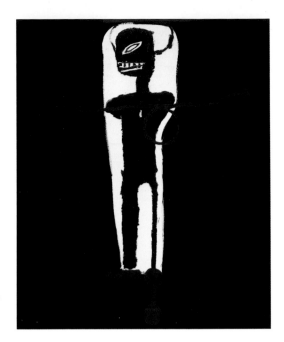

thinking; the communion of men should not always
be seen as a negative force. As he has written,
"Representing the complicated and dire situation of
black masculinity in U.S. culture is important cultural
work that should not be disavowed as a limitation."[43]
It should not be presumed that "female influences and
inspirations" can be arrayed to fill "his lack," Muñoz
continues, "assuming a spectator or critic can ever *know*
what such forces might be."[44]

Basquiat's "mother tongue" is Spanish. Not
necessarily in the sense that he grew up in Puerto Rico
or Brooklyn speaking it exclusively, but in the sense that
his mother, Matilde Basquiat, was a black Puerto Rican
woman. The majority of the words he uses in his art, of
family, food, and community, are ones that link him back
to that world of intimacy; they create a link with the
Spanish-speaking world, and the realm of the mother.
If we want to speculate on what might constitute some
female forces in Basquiat's work, it would be the
continuous chatter *en español*.

Basquiat's canon revolves around single heroic
figures: athletes, prophets, warriors, cops, musicians,
kings, and the artist himself. In these images the head
is often a central focus, topped by crowns, hats, and
halos. In this way the intellect is emphasized, lifted up
to notice, privileged over the body and the physicality
that these figures—black men—commonly represent in
the world. With this action the artist reveals creativity,
genius, and spiritual power. Basquiat has at least four
paintings that use some form of the word *cabeza* (head)
in their title. In the earliest *Cabeza* (fig. 5), the black
figure painted on a gold ground doesn't only seem to
grimace through clenched teeth, but to smile. The
contrasting background offers something new: exposed
stretchers and a surface crafted from a quilted blanket.
Dos Cabezas (fig. 6) from the same year is a double

portrait of the artist with Andy Warhol. As Muñoz has
pointed out, in this canvas Basquiat envisions himself
as equal to his friend and mentor by painting the figures
roughly the same size; here they are intellectual
partners. But it is also a gesture of interculturation in
which Basquiat makes Warhol speak *en español*. It is a
voice of intimacy for Basquiat as well: the voice of the
mother who herself was an artist, and inspired and
promoted her son's creativity. As the artist recounted,
"I'd say my mother gave me all the primary things. The
art came from her."[45] The language of intimacy is thus
the same as that of the intellect, and it is read through
the accent of the mother.

CHARMED LIFE

Okwui Enwezor has taken issue with the widespread
belief in contemporary art circles that the show
Magiciens de la Terre (Centre Georges Pompidou, Paris,
1989) is paradigmatic of today's global exhibition
practice. As he comments, "The discourse in 'Magiciens'
was still very much dependent on an opposition within
the historical tendencies of modernism in Europe—
namely, its antipathy to the 'primitive' and his functional

171

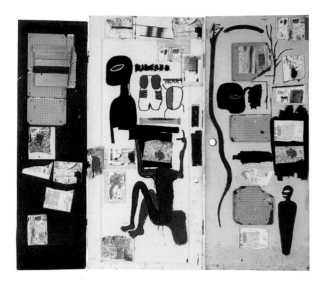

fig. 9
J's Milagro
1985
Acrylic, oil paintstick,
photocopy collage,
and metal on wood
80 x 90 inches
(203 x 228.6 cm)
Private collection

objects of ritual, and, along with this process of dissociation of the 'primitive' from the modern, its attempt to construct exotic, non-Western aesthetic systems on the margins of modernism."[46] I would certainly agree with him on this account. Yet I also find that placing the marker for "globalism" in exhibitions at this starting point erases earlier transatlantic practices, at least on the part of African American artists, from Edmonia Lewis's Italian exhibitions and residency in the nineteenth century, to the coterie of artists of the African Diaspora connected to the Harlem Renaissance and Negritude movements in the early twentieth century—as well as, more recently, the 1980s investment in multiculturalism in the U.S., later documented in exhibitions such as *The Decade Show: Frameworks of Identity in the 1980s* (New York, 1990), and the dialogue between black British and black American artists during that same era, which was both intercultural and international in scope.

However, I believe as well that there is a place for art that celebrates spiritual and metaphysical sources, and that this type of practice should not be "off limits" because of our concerns with white Western confusion about who we might be. (Robert Colescott, Kara Walker, and numerous others, have jumped squarely into similar *caca* around the specter of black stereotypes for exactly this reason.) All peoples and cultures have and require a connection to the otherworldly and the divine, to make it

through life or even just the day. And so it is from this premise that I argue that Jean-Michel, toward what would unfortunately mark the ending of his amazingly creative career, drew more of such signs into his art, using objects and notions that tapped historical frameworks of African spiritual systems and their power. They were charms to ward off pain and death and to fight for life and strength on a mystical plane.

Basquiat's canon of heroic masculinity revolves around the year 1982, one of his most productive. But later, as the work progressed, it is clear that the artist was painting his way out of this, or perhaps painting into new structures that could combat the isolation that Tate has characterized as the "flyboy in the buttermilk"; he was painting into a space of communion, community, and connectivity. It was a place in which Basquiat was not only a (Western) painter and (black) man; it was a realm where he could claim all that was excess to those axes of identity, where he could open himself out to the entire broad spectrum of his creativity and his soul. And he accomplished this in part by way of those "religious-cultural complexes" outlined by Mosquera, whose mark-making traditions are "symbolization[s] of the unity of life ... where everything appears interconnected because all things—gods, spirits, humans, animals, plants, minerals—are charged with mystical energies and depend on and affect everything."[47]

In 1984 Basquiat created two works that link back to previous structures and yet move him simultaneously onto another plane. *Gold Griot* (page 146; see also fig. 7) presents us with one of Basquiat's iconic figures, his skeleton revealed, crowned by a grinning/grimacing head that provides the major painterly focus for the image. It floats on gold-toned wooden slats that form a rectangular ground. In many ways it mirrors *Cabeza* (fig. 5), its black figure shimmering on a golden surface,

fig. 10
Untitled
1987
Acrylic and oil paintstick
on canvas
74 x 94 inches
(188 x 238.8 cm)
Private collection

the structure not only of the body but of the painting revealed, the smooth round head, grin/grimace, and large, all-seeing eyes. Within this formal play between these two works is the semiotic and cultural one, wherein the intellect and creativity of the Spanish mother (tongue) connect to the figure of the West African oral historian, custodian of the nation's stories, a keeper of the past who charts a vision for the future.

Gold Griot is also related to another work made the same year called *Grillo* (pages 142–43). Formally, it seems markedly different; for one thing, *Grillo* is quite massive, three times as long as the other; in places it looms out a foot and a half from the wall. In English, we would rhyme the word "grillo" with "Brillo," as in the cleaning products made famous by Andy Warhol's boxes. In Spanish, however, "ll" produces the sound of the letter "y." Basquiat's *Griot* and *Grillo* are therefore punning homophones; they are transliterations in which words from one language are transposed into another. Basquiat (a musician as well) has given them the same sonic sensation and assigned them similar meanings.

In both paintings we see the same smooth-headed power figure. In *Grillo*, however, the figurative element is doubled: one body sports a crown and the other a halo composed of a black wood bar topped with spiky nails. Indeed, the strips of nails adding visual interest to the canvas recall the Nkisi power figures of the Kongo peoples of which Robert Farris Thompson writes in *Flash of the Spirit* (1983). Thompson and Basquiat met in 1984 (introduced, as I was, by Fab 5 Freddy). Basquiat's interest in Thompson's phenomenal work on Africa, America, and the Black Atlantic world led him to commission the scholar to write something for one of his shows at the Mary Boone Gallery, which took place in early 1985.[48] In the heavily collaged areas of *Grillo* we see references to Thompson's *Flash*, and particularly to

icons of power found there: the cosmic Nsibi writing and the leopard-skin power symbols of the Niger Delta, the Rada religion of Haiti, the Yoruba gods Esu (the trickster of the crossroads) and Ogun (war).

Jumping ahead two years, we come across *Gri Gri* (fig. 8), again stylistically somewhat dissimilar yet taxonomically following directly from the 1984 works. Uncharacteristically, the artist limits his palette to four colors: red, black, white, and brown. The tone here is muted, almost simplistic, dark, and to some eyes just plain uninteresting. No darting linear patterns, save for the central figure's bar-like bared teeth. A single, almond-shaped eye leads us back through the genealogy of its brothers in *Cabeza*, *Gold Griot*, and *Grillo*. But this figure in profile has more in common with another that begins to come into view around this time. We can find it on the upper edge of a green painted panel in *Grillo*, a simple, black, mask-like head with eyes like ellipses. In *J's Milagro* (fig. 9) the eye socket is filled in with red and the figure is more clearly articulated to resemble a superhero.

A Gri-Gri (sometimes spelled *gris-gris* in the French) is a Hoodoo charm, part of African American ritual and conjuring practices often associated with New Orleans. When a revolution created the first black republic in the Western hemisphere, in the early nineteenth century, slave owners fled Haiti with their human property for this other outpost of their culture in the Americas, reinforcing French and New World African production in architecture, food ways, and spiritual practices. Where *J's Milagro* (i.e. Jean-Michel's Miracle)[49]

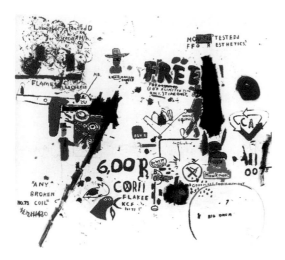

fig. 11
To Be Titled
1987
Acrylic and oil paintstick
on canvas
106 1/4 x 112 inches
(270 x 284.5 cm)
Private collection

is busy, full of texture, and somewhat disjunctive, *Gri Gri* does its work quietly, without calling too much attention to itself; but its halo puts us on notice. In 1972 Betye Saar created a work called *Gris-Gris Box*. As with much of her work, its energy comes from ancestors, in this case her Louisiana forebears. It is strikingly similar to the Basquiat piece made not quite fifteen years later. Its central black figurative form has features that grimace and grin with a red mouth, and it regards the outside world through the half-lidded eyes of trance and power. In Saar's piece these powerful eyes partially ring the construction, giving us no doubt as to its intentions.

Elsewhere, I have linked Saar's *Gris-Gris Box* taxonomically to perhaps her most famous work, *The Liberation of Aunt Jemima*, also from 1972. Both share a central black female figure laden with props of power; one brings with her strong magic and the other wields strength from the barrel of a gun.[50] Similarly, Basquiat's Gri-Gri reappears in other works and in other guises, and as such is what has been called a "'hyperquote,' an artifact generating multiple intertextual references."[51] It shows up again in a collaborative work with Warhol, *Untitled (Motorbike)* (1984–85), where Muñoz reads its appearance as signaling "the black presence that has been systematically denied from this representational practice. These primitive jet-black images look only vaguely human…. Through such representations Basquiat ironizes the grotesque and distortive African American" images of the black body. The "smooth lines" of Warhol's silkscreen, Muñoz argues, become "a *vehicle*

for Basquiat's own political and cultural practice."[52] And indeed the Gri-Gri is positioned in the driver's seat of Warhol's printed motorcycle.

In 1987 Gri-Gri drives itself into yet another context, that of Basquiat's cartoon culture. In *Untitled* of 1987 (fig. 10), the black figure steers a bright red car with yellow and blue accents. Though possibly broken down, with a missing tire laid to one side, the vehicle has sprouted green wings to whisk it heavenward. The hue of the wings is almost identical to that of an image proclaimed as the LONE RANGER in *To Be Titled*, of 1987 (fig. 11), whose black mask turns him into Gri-Gri. Indeed, in *Untitled* of 1987 Gri-Gri is transformed into a superhero traveling via Batman's Batmobile (forms of the superhero's emblem, the "Bat Signal," are found throughout Basquiat's work). In *Riddle Me This, Batman* (page 151) from the same year, Gri-Gri shows up seemingly as an outline, a beige tone shadow of his former self. Beneath this chimera is the word TIZOL, the name of the Puerto Rican trombonist who figured in a number of Duke Ellington's bands and brought us major compositions such as "Caravan" and "Perdido."[53]

Muñoz has applied his brilliant thesis on disidentification to the cultural work of comics. The "disidentificatory" process is a "third mode of dealing with dominant ideology, one that neither opts to assimilate within such a structure nor strictly opposes it"[54] but "works on and against dominant ideology."[55] Strategies of disidentification allowed two Jewish cartoonists, Jerry Siegel and Joe Shuster, to create the character Superman, a "dark-haired alien," during the 1930s at the same moment that the term *Übermensch* (super-man) was being used to denote Hitler's Aryan "master race." Like Brazilian modernist artists' philosophy of *antropófagia* (cannibalism) in the 1920s, it is a device that allows one to consume the dominant

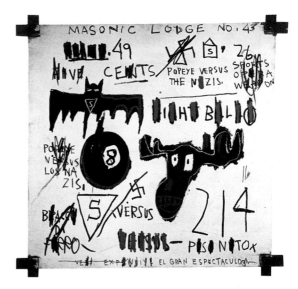

fig. 12
Television and Cruelty to Animals
1983
Acrylic and oil paintstick on paper mounted on canvas with tied wood supports
60 x 60 inches
(152.4 x 152.4 cm)
Private collection

culture, recombine its useful and powerful bits in new aesthetic formulas, and discard the rest. It permits young black boys like Basquiat and young Jewish ones like Shuster and Siegel to identify with Superman in their own way, shape, and form. Writing on Basquiat's *Television and Cruelty to Animals* (fig. 12), Muñoz discusses how the artist brings Superman (as logo) into the picture to fight Nazism, displaying the artist's own knowledge of the superhero's original, if hidden, task. In this relatively small painting (five by five feet) the artist creates another epic, another EL GRAN ESPECTÁCULO (written across the bottom right), bringing in reinforcements for Superman in the figures of Batman and Popeye, the latter battling racism in both English and Spanish—POPEYE VERSUS THE NAZIS inscribed in the top right and then, further down on the left, POPEYE VERSUS LOS NAZIS. In the later works, the powers of African gods clearly become conflated with those of Western superheroes. In *Grillo,* Basquiat articulates his fascination with the Yoruba war deity, Ogun, by repeating his avatars, IRON and BLADE. On the left side of the painting, referring again to Ogun, he writes, HE IS PRESENT IN THE SPEEDING BULLET. The connection with Superman's likeness to ammunition ("faster than a speeding bullet") was not lost on the artist, and in fact, was probably an amazing discovery that allowed him to link his love for comics and his obsession with the histories of the black diaspora.[56]

EXIT, STAGE LEFT

In contrast to the protective forces of Gri-Gri and other charms found in paintings toward the end of Basquiat's life, there are additional works that show (his) struggle. The difference is particularly evident in the eyes of his painted figures. The elliptical eye shape, unmistakable in pieces like *Gri Gri* and *Griot,* are half-lidded to marshal and conceal their power. In contradistinction, the villain (the Riddler) in *Riddle Me This, Batman,* for example, has round eyes that are X-ed out; he is drunk or poisoned from the beverage with a triple-X label that he holds in his right hand. Similarly, in *Victor 25448* of 1987 (pages 148–49), a man with a bandaged face and the same disk-like eyes that repeat the X pattern falls to the floor, red blood spurting everywhere and partially covering the phrase FATAL INJURY. In *Después de un Puño* (After a Punch) of 1987 (fig. 13), the figure with the unseeing eyes is large and upright, skeletal but yet somehow also formal in his looming, stovepipe-style top hat.

The curator Richard Marshall has noted several reference books that Basquiat drew inspiration from in composing the dense catalogue of symbols that made up his work. One such source was Henry Dreyfuss's 1972 *Symbol Sourcebook.*[57] Among Dreyfuss's collected lexica are "Hobo Signs," simple pictographs, "chalk or crayon signs" drawn on "fences, walls and doors, which conveyed messages such as 'dangerous neighborhood,' 'easy mark, sucker' and 'vicious dog here.'"[58] Certainly Basquiat could have considered such mark-makers forerunners of his own graffiti tagging cohort. Two of the hobo images incorporate a top hat, signifying in one instance "a gentleman lives here" and in another "these are rich people." But I would argue that the guy in Basquiat's *Después de un Puño* is another kind of

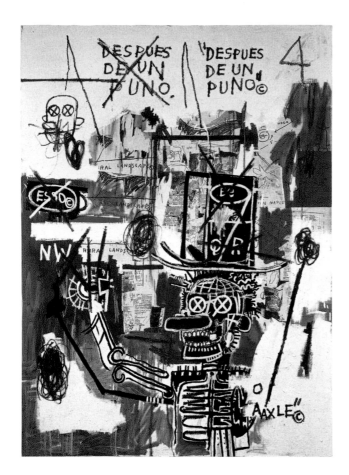

fig. 13
Después de un Puño
1987

Acrylic, oil paintstick,
and photocopy collage
on canvas
85 x 61 inches
(215.5 x 153.5 cm)
Private collection

caballero, the regal and fatal Baron Samedi, Vodoun's keeper of cemeteries. In a photograph taken by his friend Tseng Kwong Chi in 1987, the year of *Después* and mere months before his death, Basquiat poses provocatively with a toy gun to his head in front of an unfinished painting showing the word VICTOR several times followed by various numeric combinations denoting the catalogue numbers of a discography and connecting us as well to *Victor 25448,* Basquiat's portrait of the fatally injured man. In the photograph, on a table loaded with brushes and paint, are also other things: a sculpture of seeming non-Western facture, and three drums, two of them Yoruba *batas,* the famous ritual "talking drums." Again, evidence of protective avatars.

Baron Samedi appears as early as 1982 in a less skeletal, more human guise in *The Guilt of Gold Teeth* (fig. 14). Yet Basquiat invoked death in some of his earliest paintings, including *Bird on Money* (fig. 15), in which the words PARA MORIR (in order to die) appear next to a drawing of Brooklyn's Green-Wood Cemetery, where Basquiat would indeed be laid to rest. In *Portrait of the Artist as a Young Derelict* (page 67) the word MORTE (dead, in French) and a cross are inscribed over a black, boxy shape; it is surely a coffin, "buried" as it is below a towering New York skyscraper.

Among Basquiat's last paintings is a six-by-eight-foot canvas that to some may seem unprepossessing. At its center is a single fox-like creature, a wily coyote caught in a whirlwind, smiling from the eye of a storm. His head is surrounded by the eyes of power, which have appeared as Egyptian hieroglyphs (*The Nile*) and the elliptical stare of Gri-Gri. Above the smiling head floats the word EXU from which the piece takes its title (*Exu,* pages 160–61). Exu, the Brazilian/Portuguese spelling of

fig. 14
*The Guilt of
Gold Teeth*
1982

Acrylic, oil paintstick,
and spray paint
on canvas
$94\frac{1}{2}$ x $165\frac{1}{2}$ inches
(240 x 420.5 cm)
Private collection

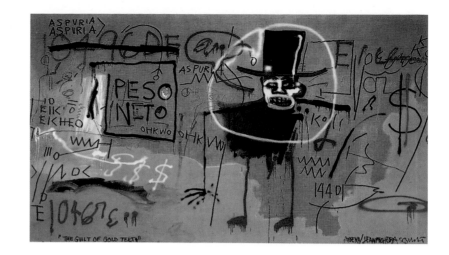

the god also known as Esu and Eleggúa, is the Yoruba
and New World African god of the crossroads; it is only
through him that one can seek audience with other
forces. And because he is known as a trickster, it's
anyone's guess if you'll get there. Interestingly, the
X in EXU is boxed in, held not within the circle of the
saucer-like eyes Basquiat reserves for the beaten down,
but within a box of containment. Speaking of Eleggúa's
elusive appearance in the paintings of Wifredo Lam,
Mosquera writes, "[T]he mutant sense of Lam's
paintings, where everything seems to transform itself
into another unexpected thing, could be related to the
god."[59] Or not. The boxed-in X of EXU could be the
containment of the forces of death (the coffin). Or not.
Rewind. Remix. The circular saucer-eyes that seem
nonresponsive, dead, crossed out, also riff on Kongo
culture's Four Moments of the Sun, the cosmogram
for the continuity of life.[60] Basquiat includes the sign
repeatedly in *Grillo*; nearby wait the words ESU, EXU,
and BABALAO (priest). As Muñoz movingly writes:

*Basquiat understood the force of death and dying
in the culture and tradition around him; his art was
concerned with working through the charged relation
between black male identity and death. He, like Van Der
Zee, understood that the situation of the black diaspora
called on a living subject to take their dying with them.*

*They were baggage that was not to be lost or forgotten
because ancestors, be they symbolic or genetically
linked, were a deep source of enabling energy that death
need not obstruct.*[61]

Enwezor reminds us that the diaspora is a place
caught, at different times and to various degrees, between
"speech and its attendant untranslatability," as people
and their languages, gestures, codes travel the globe from
the comfort of familiar places toward the challenges that
await in unknown landscapes.[62] Yet in the twenty-first
century, he insists, there is no need to perpetuate the
same circular debates and "paradigms of lack that have
persistently enfolded the body and subjectivity of the
disrecognized figure of the subalternate by asking the
same old question: 'can the subaltern speak?'"—or, do
non-dominant bodies possess tongues and other tools
for communication, and are they allowed to use them?
Instead, the question thrown back in the opposing court is
rather, "Can the subaltern be heard?"[63] For those whose
ears are "culturally prepared"[64]—*es pleno amor ... y poder.*[65]

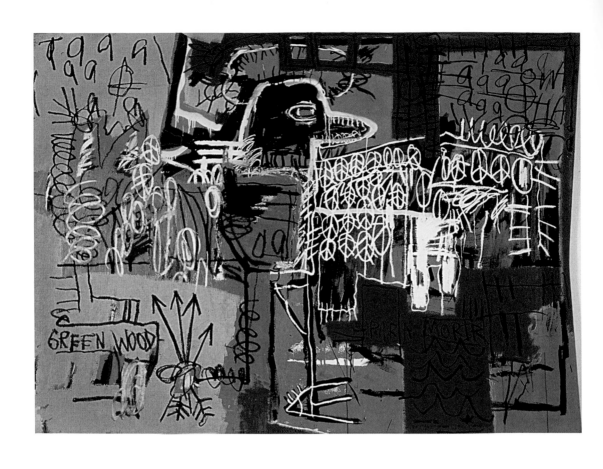

fig. 15
Bird on Money
1981
Acrylic and oil paintstick
on canvas
66 x 90 inches
(167.5 x 228.5 cm)
The Rubell Family Collection

NOTES

For RFT and for Simon and Solomon, translating the twenty-first century.

1. Okwui Enwezor, "A Question of Place: Revisions, Reassessments, Diaspora," in Salah Hassan and Iftikhar Dadi, eds., *Unpacking Europe: Towards a Critical Reading* (Rotterdam: Museum Boijmans Van Beuningen, 2001), p. 234.

2. This line comes from the song "Psychedelic Shack." However, the phrase originally appeared in the spiritual "Rock My Soul in the Bosom of Abraham." Thanks to Barry Mayo for help with the Temptations reference.

3. Grey Gundaker, *Signs of Diaspora/Diaspora of Signs: Literacies, Creolization, and Vernacular Practice in African America* (New York: Oxford University Press, 1998), p. 8.

4. José Esteban Muñoz, "Famous and Dandy Like B. 'n' Andy: Race, Pop, and Basquiat," in Jennifer Doyle, Jonathan Flatley, and José Esteban Muñoz, eds. *Pop Out: Queer Warhol* (Durham: Duke University Press, 1996), p. 161.

5. Greg Tate, "Nobody Loves a Genius Child: Jean-Michel Basquiat, Flyboy in the Buttermilk," in *Flyboy in the Buttermilk: Essays on Contemporary America* (New York: Simon & Schuster, A Fireside Book, 1992), p. 236.

6. Ibid., p. 239.

7. Ibid., p. 241.

8. Arjun Appadurai, *Modernity at Large: Cultural Dimensions of Globalization* (Minneapolis: University of Minnesota Press, 1996), p. 4; quoted in Nicholas Mirzoeff, "The Multiple Viewpoint: Diasporic Visual Cultures," in Mirzoeff, ed., *Diaspora and Visual Culture: Representing Africans and Jews* (London and New York: Routledge, 2000), p. 6.

9. Gerardo Mosquera, "Eleggúa at the (Post?)Modern Crossroads," in Arturo Lindsay, ed., *Santería Aesthetics in Contemporary Latin American Art* (Washington D.C.: Smithsonian Institution Press, 1996), p. 228

10. Ibid., p. 226.

11. Ibid., pp. 227, 230.

12. Stuart Hall, "Cultural Identity and Diaspora," in Mirzoeff, ed., *Diaspora and Visual Culture*, p. 30.

13. Ibid., p. 27.

14. Ibid., pp. 29, 30.

15. Ibid., p. 30. I use the word *American* here in its most encompassing sense, to suggest the cultures of the entire Americas.

16. Okwui Enwezor, quoted in "Global Tendencies: Globalism and the Large-Scale Exhibition," *Artforum* 42, no. 3 (November 2003), p. 154.

17. Kellie Jones, "(Un)Seen and Overheard: Pictures by Lorna Simpson," in *Lorna Simpson* (London: Phaidon Press, 2002), p. 77.

18. Hall, "Cultural Identity and Diaspora," p. 26.

19. Ibid.

20. Ella Shohat and Robert Stam, "Narratavizing Visual Culture: Towards a Polycentric Aesthetics," in Nicholas Mirzoeff, ed., *Visual Culture Reader* (New York: Routledge, 1996), p. 46; quoted in Mirzoeff, "The Multiple Viewpoint," p. 6.

21. Spanish, meaning "racial mixture," as in the French *métis*, or the English *miscegenation*.

22. Roberto P. Rodríguez-Morazzani, "Beyond the Rainbow: Mapping the Discourse on Puerto Ricans and 'Race,'" in Antonia Darder and Rodolfo D. Torres, eds., *The Latino Studies Reader: Culture, Economy, and Society* (Malden: Blackwell Publishers, 1998), p. 145.

23. Tate, "Nobody Loves a Genius Child," p. 236.

24. Rosaura Sánchez, "Mapping the Spanish Language along a Multiethnic and Multilingual Border," in Darder and Torres, eds., *The Latino Studies Reader*, p. 110.

25. Coco Fusco and Guillermo Gómez Peña, "Bilingualism, Biculturalism, and Borders," in Fusco, *English Is Broken Here: Notes on Cultural Fusion in the Americas* (New York: New Press, 1995), pp. 151–53. A version of this dialogue first appeared in *Third Text* in 1989.

26. Ibid., p. 152.

27. Ibid., p. 153.

28. Sánchez, "Mapping the Spanish Language along a Multiethnic and Multilingual Border."

29. In hip-hop music, African American artists have also incorporated words in Spanish, usually slang. Puff Daddy ("All About the Benjamins") and Missy Elliott ("Work It"), for instance, have both used the term *chocha*, a reference to female genitalia. Because many radio producers don't understand these words, they are often played unedited over the airwaves.

30. *Business Week*, March 15, 2004; and *Black Enterprise* 34 (February 2004).

31. Robert Farris Thompson, "Royalty, Heroism, and the Streets" in Richard Marshall et al., *Jean-Michel Basquiat* (New York: Whitney Museum of American Art, 1992), p. 29.

32. *Untitled (El Gran Espectáculo)* and *Untitled (History of Black People)* were other earlier titles for the work. The new title, *The Nile*, comes from simply checking the verso of the painting and finding Basquiat's original designation written there.

33. Quoted in Tate, "Nobody Loves a Genius Child," p. 236.

34. If these were indeed Rammellzee's concerns, they were not unfounded. Several years later, Julian Schnabel's film *Basquiat* (1996) offered a vision of an artist who had no black/Latino community, where graffiti, hip-hop (and even punk rock), and multiculturalism did not exist. Instead, "Basquiat" becomes a foil for the Schnabel character (played by Gary Oldman). The film's one redeeming quality was a stellar performance by Jeffrey Wright in the title role.

35. Mirzoeff, "The Multiple Viewpoint," p. 2.

36. Enwezor, "A Question of Place," p. 241.

37. Thompson, "Royalty, Heroism, and the Streets," p. 32.

38. Ibid., p. 32.

39. Homi Bhabha, *The Location of Culture* (London: Routledge, 1994), p. 198; quoted in Enwezor, "A Question of Place," p. 242.

40. Thanks to Franklin Sirmans for pointing this out.

41. Richard Marshall, "Repelling Ghosts," in Marshall et al., *Jean-Michel Basquiat*, p. 18.

42. To a certain extent, hooks's perception of pain is based on her misreading of Basquiat's frenetic Expressionism as painful disarticulation of the body, which I am not quite convinced of. See bell hooks, "Altars of Sacrifice: Re:Membering Basquiat," in hooks, *Art on My Mind: Visual Politics* (New York: New Press, 1995), pp. 35–48; first published in *Art in America* 81 (June 1993).

43. Muñoz, "Famous and Dandy like B. 'n' Andy," p. 175.

44. Ibid.

45. Jean-Michel Basquiat, quoted in M. Franklin Sirmans, "Chronology," in Marshall et al., *Jean-Michel Basquiat*, p. 233. Gérard Basquiat also states, "His mother got him started and she pushed him. She was actually a very good artist" (ibid.).

46. Enwezor "Global Tendences," p. 154.

47. Mosquera, "Eleggúa at the (Post?)Modern Crossroads," p. 230.

48. Thompson "Royalty, Heroism, and the Streets," pp. 31–32.

49. Milagros are also Latin American religious folk objects and come in the form of stamped metal charms. Most often they depict body parts and are offered to saints as a request for healing.

50. See Kellie Jones, "Black West: Thoughts on Art in Los Angeles," in Margo Crawford and Lisa Collins, eds., *New Thoughts on the Black Arts Movement* (New Brunswick, N.J.: Rutgers University Press, forthcoming).

51. Mirzoeff, "The Multiple Viewpoint," p. 8.

52. Muñoz, "Famous and Dandy like B. 'n' Andy," p. 164.

53. Tizol's compositions in the 1930s are often seen as laying the groundwork for the explosion of Latin jazz in the 1940s. Basquiat also showed the figure of Tizol as part of the Ellington Band in a drawing from a bit earlier, *Untitled (Harlem Airshaft)* (1984), the year of Tizol's death.

54. Muñoz, "Famous and Dandy like B. 'n' Andy," p.147.

55. Michel Pecheaux, *Language, Semantics, and Ideology* (New York: St. Martin's Press, 1982); quoted ibid.

56. Basquiat's references to Ogun come directly from Thompson's *Flash of the Spirit*, including the phrase "he is present in the speeding bullet" (p. 53). The book was first published in 1983, with the paperback following in 1984. The painting *Grillo* is dated 1984. Basquiat, ever on the cutting edge, obviously read the book within the first year or so of its publication.

57. Henry Dreyfuss, *Symbol Sourcebook: An Authoritative Guide to International Graphic Symbols* (New York: McGraw Hill, 1972).

58. Marshall, "Repelling Ghosts," p. 23.

59. Mosquera, "Eleggúa at the (Post?)Modern Crossroads," p. 231.

60. See Thompson, *Flash of the Spirit*, chapter 2: "The Sign of the Four Moments of the Sun: Kongo Art and Religion in the Americas."

61. Muñoz, "Famous and Dandy like B. 'n' Andy," pp. 168–69.

62. Enwezor, "A Question of Place," p. 240.

63. Ibid., p. 241.

64. Robert Farris Thompson, "The Song That Named the Land: The Visionary Presence of African American Art," in Robert V. Rozelle, Alvia Wardlaw, and Maureen A. McKenna, eds., *Black Art, Ancestral Legacy: The African Impulse in African American Art* (Dallas: Dallas Museum of Art, 1989), p. 98; quoted in Mirzoeff, "The Multiple Viewpoint," p. 7.

65. "it is complete love ... and power." Thanks to William Cordova for assistance with this translation and for his encyclopedic knowledge of Basquiat in general.

Pages 180–211:
Untitled (The Daros Suite of Thirty-two Drawings)
1982–83
Acrylic, oil paintstick, pastel,
crayon, charcoal, and pencil
on paper, 32 sheets
$22\frac{1}{2}$ x 30 inches
(57 x 76.5 cm) each
Daros Collection, Switzerland

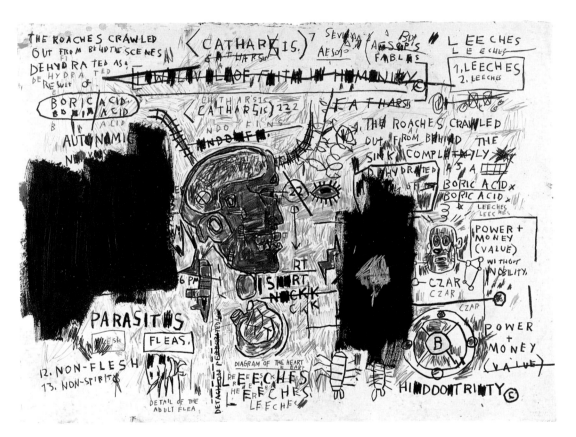

Leeches

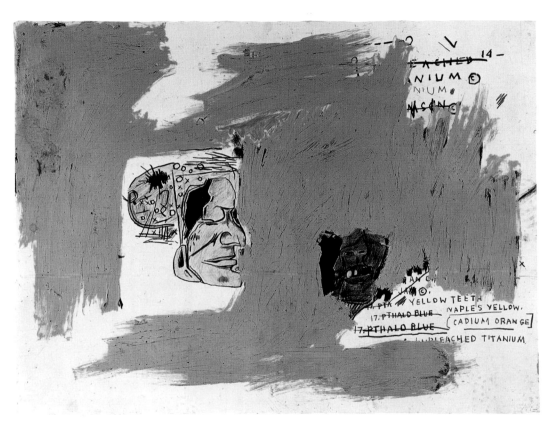

Unbleached Titanium

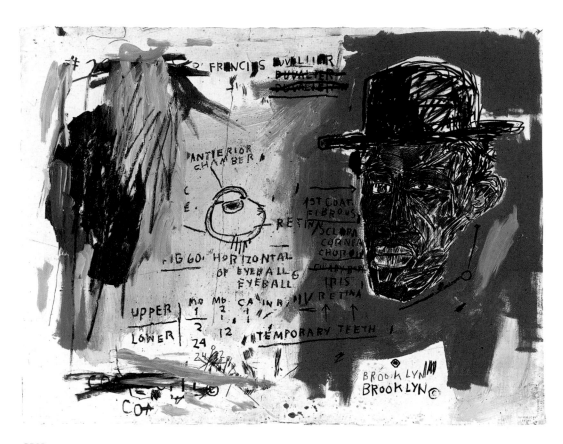

PPCD

Napoleon Stereotype as Portrayed

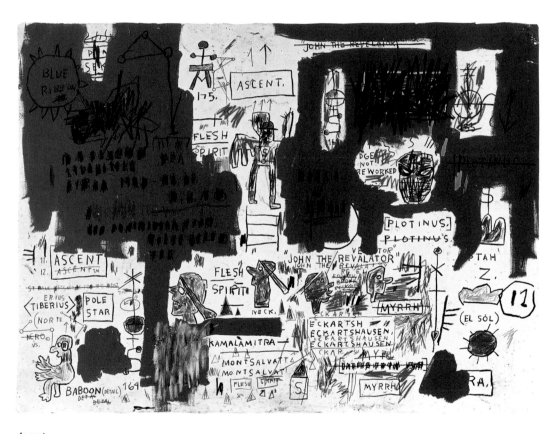

Ascent

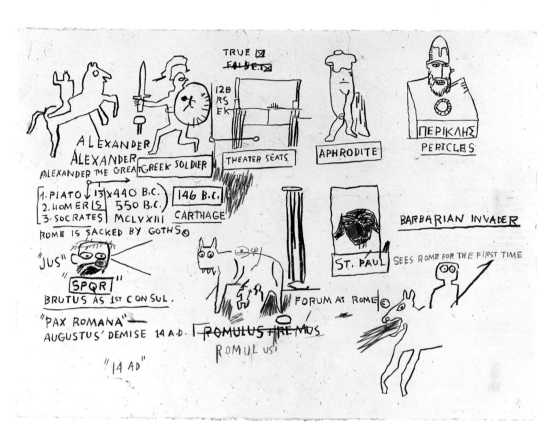

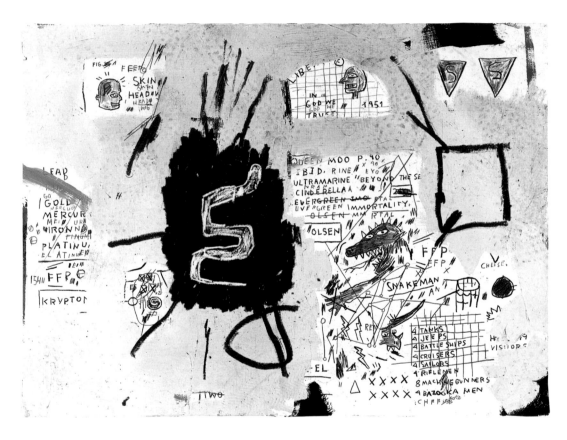

Snakeman

Eye of Troof

Formless

MACAO, CHINA 124
MACHIAVELLI, NICCOLO 74,88,89,103.
MADISO N

Savonarola

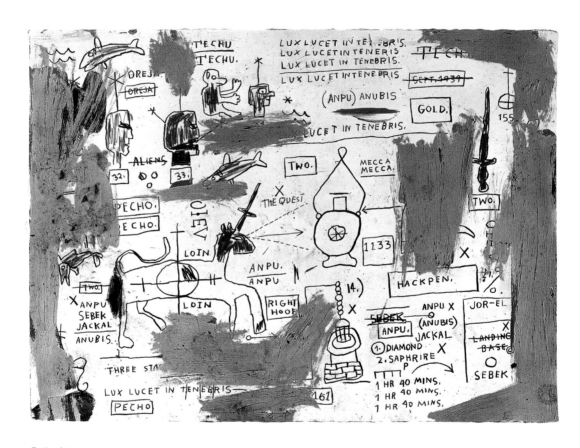

Techu-Anpu

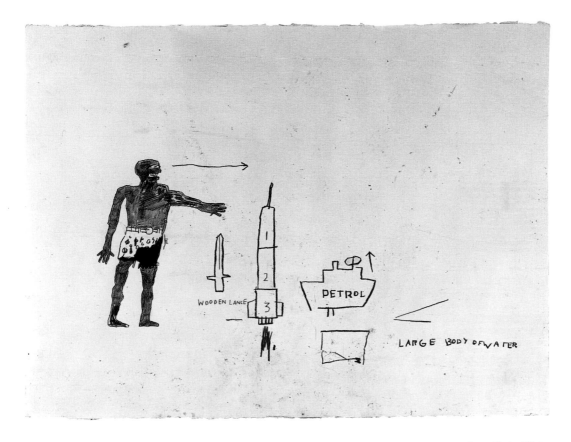

Large Body of Water

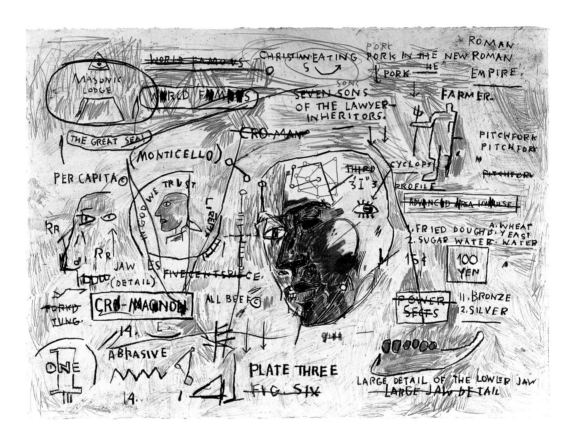

Monticello

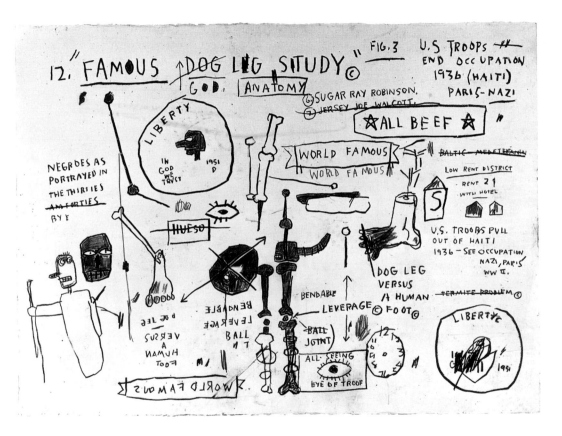

Dog Leg Study

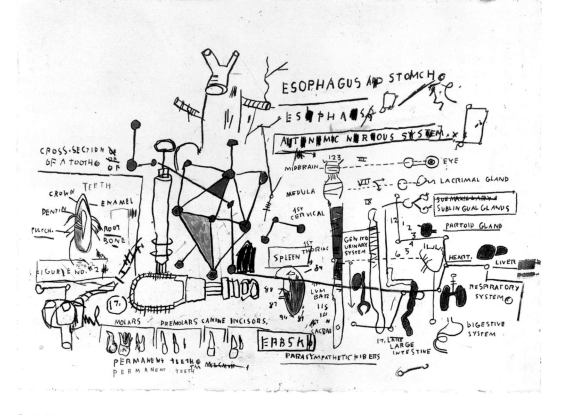

Peptic Ulcer

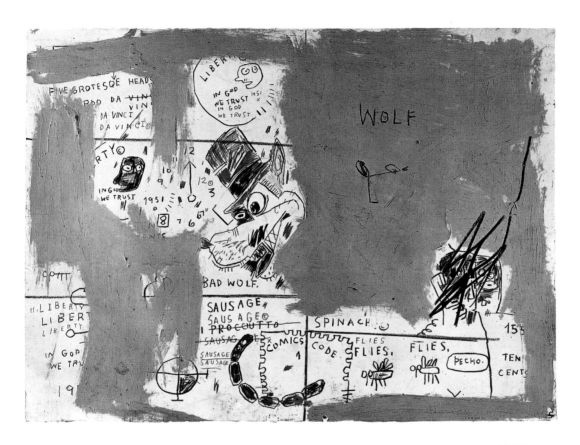

Wolf Sausage

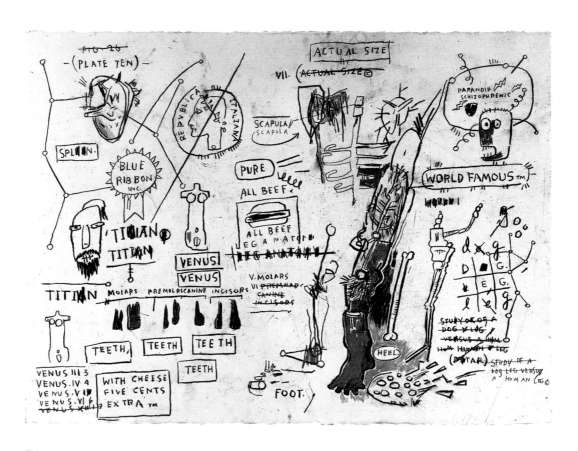

Titian

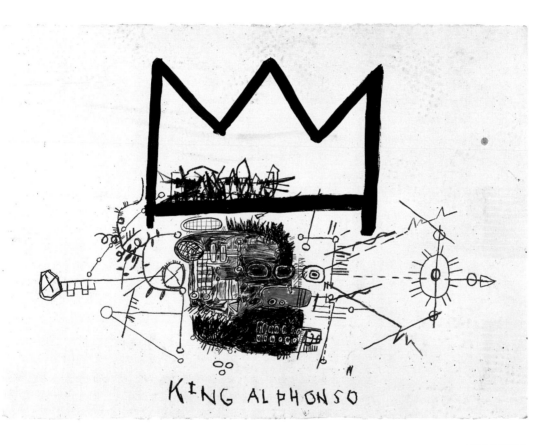

King Alphonso

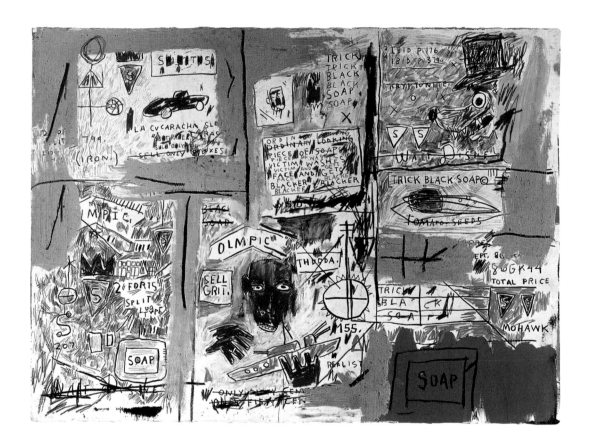

Olympic

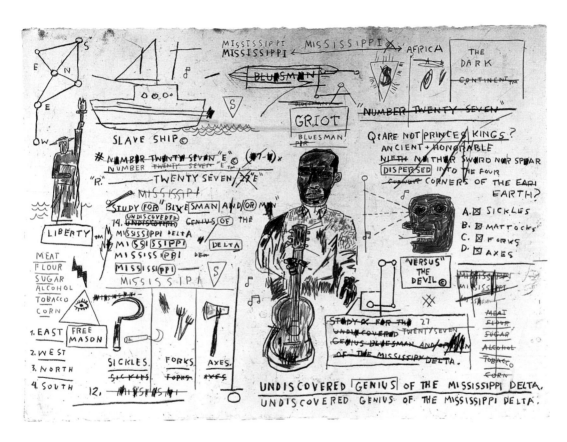

Undiscovered Genius

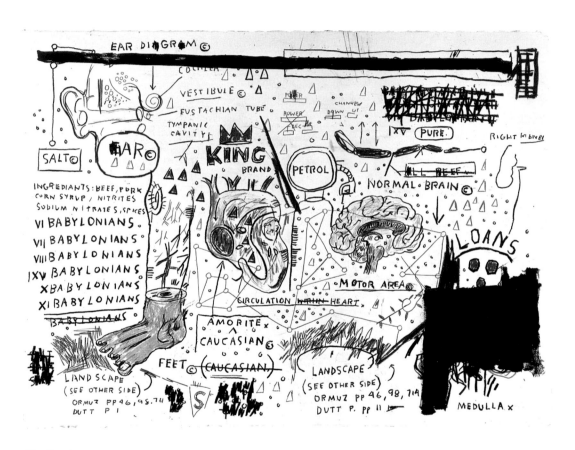

King Brand

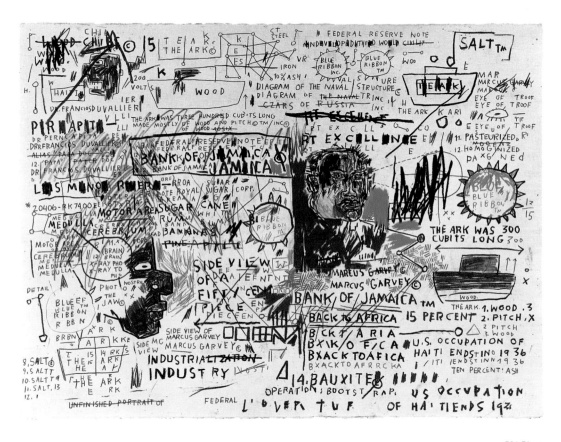

50¢ Piece

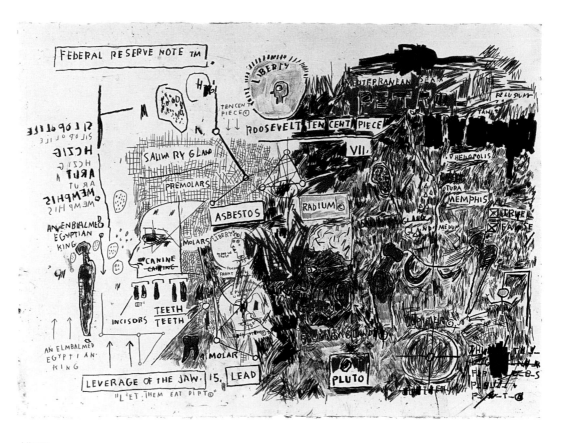

Liberty

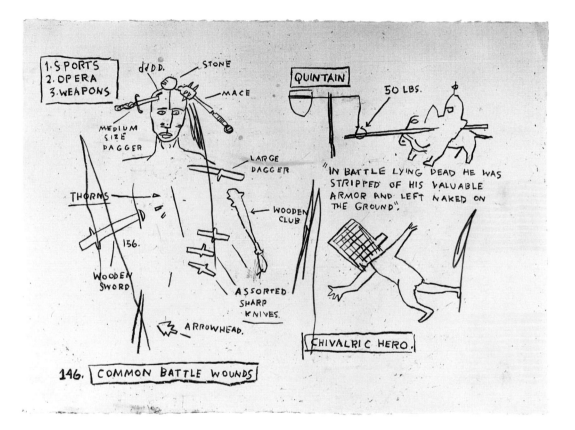

1. SPORTS
2. OPERA
3. WEAPONS

STONE

MACE

MEDIUM SIZE DAGGER

LARGE DAGGER

THORNS

156.

WOODEN SWORD

WOODEN CLUB

ASSORTED SHARP KNIVES.

ARROWHEAD.

146. COMMON BATTLE WOUNDS

QUINTAIN

50 LBS.

"IN BATTLE LYING DEAD HE WAS STRIPPED OF HIS VALUABLE ARMOR AND LEFT NAKED ON THE GROUND".

CHIVALRIC HERO.

Mace

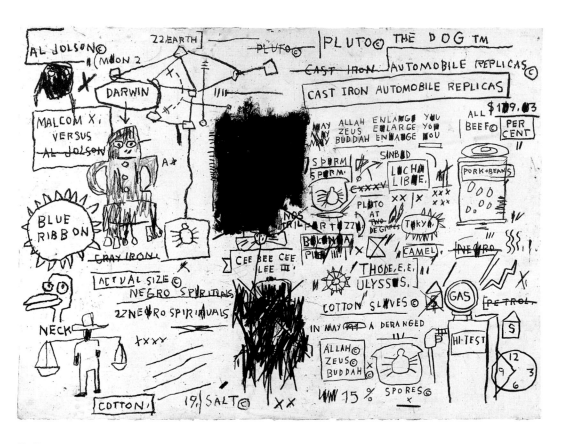

Replicas

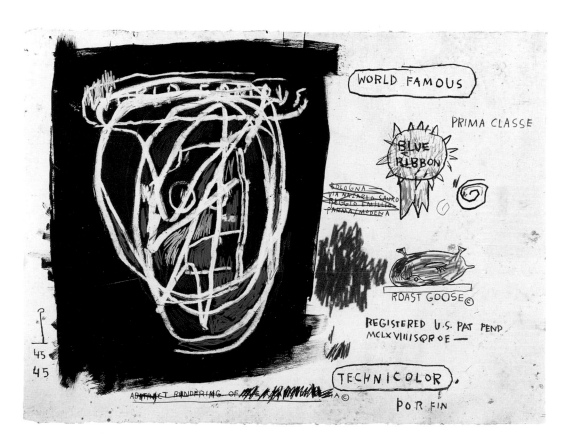

Roast

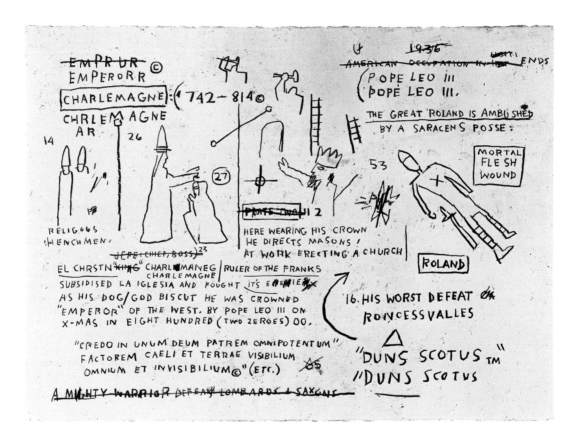

Bishop

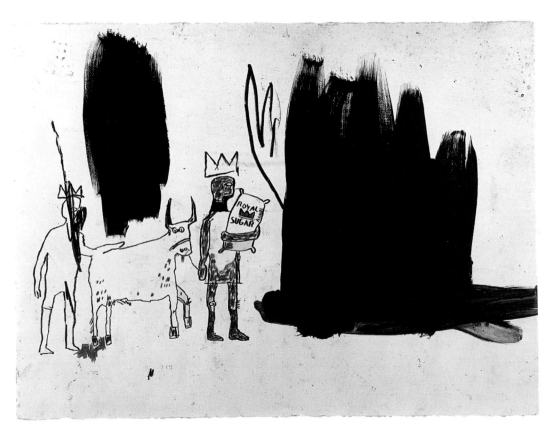

Dwellers in the Marshes

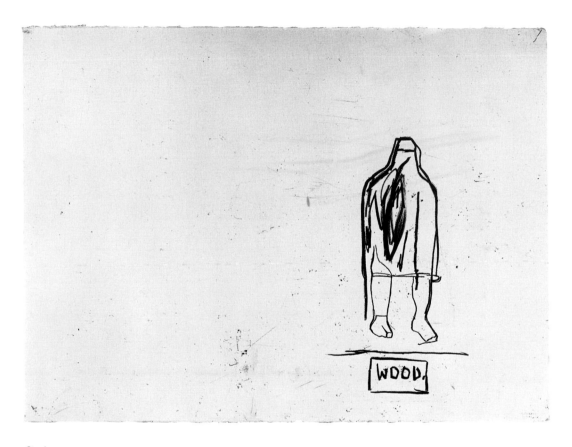

WOOD.

Steel

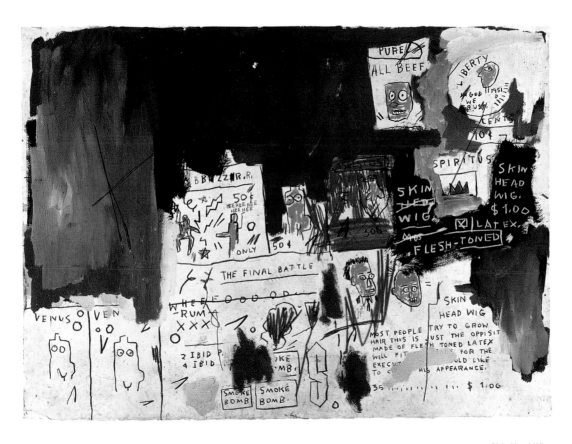

Skin Head Wig

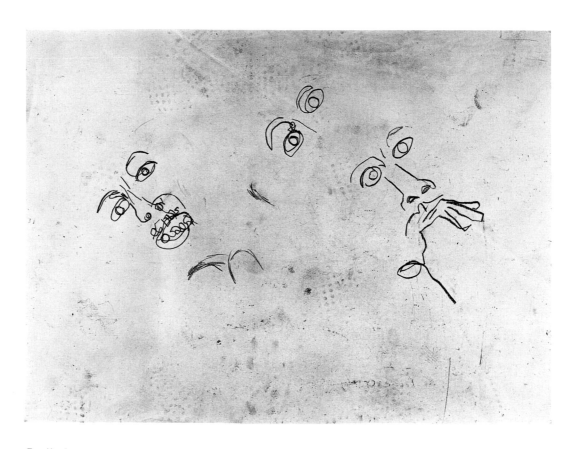

Tree Version

Boxer Rebellion

JEAN-MICHEL BASQUIAT

Born December 22, 1960, Brooklyn, New York

Died August 12, 1988, New York, New York

For a detailed biographical chronology, see M. Franklin Sirmans, "Chronology," in Richard Marshall et al., *Jean-Michel Basquiat* (New York: Whitney Museum of American Art, 1992), pp. 233–50.

EXHIBITION HISTORY

ONE- AND TWO-ARTIST EXHIBITIONS AND COLLABORATIONS

1981

Galleria d'Arte Emilio Mazzoli, Modena. *SAMO.* May 23–June 20.

1982

Annina Nosei Gallery, New York. *Jean-Michel Basquiat.* March 6–April 1.

Larry Gagosian Gallery, Los Angeles. *Jean-Michel Basquiat: Paintings.* April 8–May 8.

Galerie Bruno Bischofberger, Zurich. *Jean-Michel Basquiat.* September 11–October 9.

Galleria Mario Diacono, Rome. *Jean-Michel Basquiat.* October 23–November 20. Brochure.

Fun Gallery, New York. *Jean-Michel Basquiat.* November 4–December 7.

Galerie Delta, Rotterdam. *Jean-Michel Basquiat.* December. Catalogue.

1983

Annina Nosei Gallery, New York. *Jean-Michel Basquiat.* February 12–March 3.

Larry Gagosian Gallery, Los Angeles. *Jean-Michel Basquiat: New Paintings.* March 8–April 2.

West Beach Café, Venice, California. *Jean-Michel Basquiat.* May–June.

Galerie Bruno Bischofberger, Zurich. *Jean-Michel Basquiat.* September 24–October 22.

Akira Ikeda Gallery, Tokyo. *Jean-Michel Basquiat.* November 14–December 10. Catalogue.

1984

Mary Boone Gallery in cooperation with Galerie Bruno Bischofberger, New York. *Jean-Michel Basquiat.* May 5–26. Catalogue.

The Fruitmarket Gallery, Edinburgh. *Jean-Michel Basquiat: Paintings, 1981–1984.* August 11–September 23, 1984. Traveled to Institute of Contemporary Arts, London, December 14–January 27, 1985; Museum Boymans-van Beuningen, Rotterdam, February 9–March 31, 1985. Catalogue.

Galerie Bruno Bischofberger, Zurich. *Collaborations: Jean-Michel Basquiat, Francesco Clemente, Andy Warhol.* September 15–October 13. Catalogue.

Carpenter + Hochman Gallery, Dallas. *Jean-Michel Basquiat: New Paintings.* September 20–October 20.

1985

Akira Ikeda Gallery, Tokyo. *Collaborations: Jean-Michel Basquiat, Francesco Clemente, Andy Warhol.* January 14–31. Catalogue.

Galerie Bruno Bischofberger, Zurich. *Jean-Michel Basquiat.* January 19–February 16. Catalogue.

University Art Museum, University of California, Berkeley. *Jean-Michel Basquiat.* January–March 1985. Traveled to La Jolla Museum of Contemporary Art, May 4–June 16. Catalogue.

Akira Ikeda Gallery, Nagoya. *Jean-Michel Basquiat: Drawings.* February 12–March 9.

Mary Boone–Michael Werner Gallery, New York. *Jean-Michel Basquiat.* March 2–23. Catalogue.

Tony Shafrazi Gallery, New York. *Warhol and Basquiat: Paintings.* September 14–October 19.

Akira Ikeda Gallery, Tokyo. *Jean-Michel Basquiat: Paintings.* December 2–25. Catalogue.

Annina Nosei Gallery, New York. *Jean-Michel Basquiat: Paintings from 1982.* December 14–January 9, 1986.

1986

Larry Gagosian Gallery, Los Angeles. *Jean-Michel Basquiat.* January 7–February 8.

Fay Gold Gallery, Atlanta. *Jean-Michel Basquiat: Drawings.* February 7–March 5.

Galerie Bruno Bischofberger, Zurich. *Jean-Michel Basquiat: Drawings.* April 26–June 30.

Galerie Thaddaeus Ropac, Salzburg. *Jean-Michel Basquiat: Bilder, 1984–86.* July 27–August 31. Catalogue.

Akira Ikeda Gallery, Tokyo. *Collaborations: Jean-Michel Basquiat and Andy Warhol.* September 8–30. Catalogue.

Centre Cultural Français d'Abidjan, Abidjan, Ivory Coast. *J. M. Basquiat.* October 10–November 7.

Akira Ikeda Gallery, Nagoya. *Jean-Michel Basquiat: Drawings.* November 5–29.

Galerie Bruno Bischofberger, Zurich. *Collaborations: Jean-Michel Basquiat and Andy Warhol.* November 15–January 17, 1987.

Kestner-Gesellschaft, Hannover. *Jean-Michel Basquiat.* November 28–January 25, 1987. Catalogue.

Galerie Delta, Rotterdam. *Jean-Michel Basquiat.* November.

1987

Galerie Daniel Templon, Paris. *Jean-Michel Basquiat.* January 10–February 7.

Akira Ikeda Gallery, Tokyo. *Jean-Michel Basquiat: New Works.* February 7–28. Catalogue.

Tony Shafrazi Gallery, New York. *Jean-Michel Basquiat: Drawings.* May 23–June 13.

Galerie Thaddaeus Ropac, Salzburg. *Jean-Michel Basquiat: Drawings.* June 6–31.

PS Gallery, Tokyo. *Jean-Michel Basquiat.* October 8–December 4. Catalogue.

1988

Galerie Yvon Lambert, Paris. *Jean-Michel Basquiat.* January 9–February 10.

Galerie Beaubourg, Paris. *Jean-Michel Basquiat: Peintures, 1982–1987.* January 9–February 16.

Galerie Hans Mayer, Düsseldorf. *Jean-Michel Basquiat: Neue Arbeiten.* January 12–March 15.

Galerie Michael Haas, Berlin. *Jean-Michel Basquiat.* February 5–March 12.

Vrej Baghoomian Gallery, New York. *Jean-Michel Basquiat.* April 29–June 11.

Galerie Thaddaeus Ropac, Salzburg. *Jean-Michel Basquiat: Paintings, Drawings.* June 15–July 26.

Fay Gold Gallery, Atlanta. *Jean-Michel Basquiat: Important Drawings.* September 6–October 4.

Mayor Rowan Gallery, Mayor Gallery, and David Grob Limited, London. *Collaborations: Andy Warhol, Jean-Michel Basquiat.* November 21–January 21, 1989. Catalogue.

Gallery Schlesinger Limited, New York. *Jean-Michel Basquiat: Paintings.* November.

Annina Nosei Gallery, New York. *Jean-Michel Basquiat: Memorial Exhibition.* December 3–January 14, 1989.

1989

Rooseum, Malmö, Sweden. *Jean-Michel Basquiat / Julian Schnabel.* April 8–May 28. Catalogue.

Kestner-Gesellschaft, Hannover. *Jean-Michel Basquiat: Das zeichnerische Werk.* September 15–October 23. Catalogue.

Didier Imbert Fine Art, Paris. *Warhol-Basquiat: Collaborations.* September 28–November 25. Catalogue.

Vrej Baghoomian Gallery, New York. *Jean-Michel Basquiat.* October 21–November 25. Catalogue.

Dau al Set, Galeria d'Arte, Barcelona. *Jean-Michel Basquiat.* October–November. Catalogue.

Galerie Enrico Navarra, Paris. *Jean-Michel Basquiat.* November 8–December 31. Catalogue.

1990

Galerie Le Gall Peyroulet, Paris. *Jean-Michel Basquiat: Oeuvres sur papier.* January 23–March 3.

Galerie Fabien Boulakia, Paris. *Basquiat.* September 27–November 3, 1990. Catalogue.

Ho-Am Gallery, Seoul. *Jean-Michel Basquiat and Andy Warhol.* October 1–31.

Robert Miller Gallery, New York. *Jean-Michel Basquiat: Drawings.* November 3–December 1. Catalogue.

Tony Shafrazi Gallery, New York. *Keith Haring, Jean-Michel Basquiat: Paintings.* December 15–January 26, 1991.

1991

PS Gallery, Tokyo. *Jean-Michel Basquiat: Oil Paintings, Drawings, Etc.* March 4–May 17.

Sonje Museum of Contemporary Art, Kyongju, Korea. *Andy Warhol and Jean-Michel Basquiat.* September 14–October 20. Traveled to The National Museum of Contemporary Art, Seoul, November 1–30. Catalogue.

Galerie de Poche, Paris. *Jean-Michel Basquiat: Oeuvres sur papier.* December 5–28.

1992

Vrej Baghoomian Gallery, New York. *Jean-Michel Basquiat.* February 8–March 7.

Galerie Eric van de Weghe, Brussels. *Jean-Michel Basquiat.* April 9–May 23. Catalogue.

Musée Cantini, Marseille. *Jean-Michel Basquiat: Une Rétrospective.* July 4–September 20. Catalogue.

The Metropolitan Museum of Art, New York. Installation of *Nu-Nile* and *Untitled (Palladium Painting).* On loan from the Estate of Jean-Michel Basquiat, October 19–April 22, 1993.

Whitney Museum of American Art, New York. *Jean-Michel Basquiat.* October 23–February 14, 1993. Traveled to the Menil Collection, Houston, March 11–May 9, 1993; Des Moines Art Center, May 22–August 15, 1993; Montgomery Museum of Fine Arts, November 18, 1993–January 9, 1994. Catalogue.

1993

Alpha Cubic Gallery, Tokyo. *Jean-Michel Basquiat.* March. Catalogue.

Salon de Mars, Paris. Booth of Galerie Enrico Navarra. March.

Gallery Sho Contemporary Art, Tokyo. *Jean-Michel Basquiat.* May 11–June 6. Catalogue.

Galerie Bruno Bischofberger, Zurich. *Jean-Michel Basquiat.* June 10–September 11.

Newport Harbor Art Museum, Newport Beach, Calif. *Jean-Michel Basquiat.* July 10–September 12.

FAE, Musée d'Art Contemporain, Pully-Lausanne, Switzerland. *Jean-Michel Basquiat.* July 10–November 7. Catalogue.

Tony Shafrazi Gallery, New York. *Jean-Michel Basquiat: Paintings.* November 20–January 8, 1994.

Musée-Galerie de la Seita, Paris. *Jean-Michel Basquiat: Peinture, dessin, écriture.* December 17–February 26, 1994. Catalogue.

Galerie Delta, Rotterdam. *Jean-Michel Basquiat.*

1994

Henry Art Gallery, University of Washington, Seattle. *Jean-Michel Basquiat.* February 18–April 28.

Mount Holyoke College Art Museum, South Hadley, Mass. *Jean-Michel Basquiat: The Blue Ribbon Paintings.* September 8–December 22. Traveled to Wadsworth Atheneum, Hartford, January–March 1995; The Andy Warhol Museum, Pittsburgh, April 12–September 17, 1995; Museum of Contemporary Art, Miami, October 15–December 8, 1996. Catalogue.

Johnson County Community College, Gallery of Art, Overland Park, Kans. *Jean-Michel Basquiat.* September 11–October 18. Brochure.

Robert Miller Gallery, New York. *Jean-Michel Basquiat: Works in Black and White.* November 15–January 7, 1995.

1995

Centre Gallery, Miami-Dade Community College, Wolfson Campus, Miami. *Two Cents: Works on Paper by Jean-Michel Basquiat and Poetry by Kevin Young.* October 20–January 14, 1996. Traveled to Castellani Art Museum, Niagara University, Niagara Falls, February 11–March 31, 1996; University of Memphis, April 19–June 22, 1996; University of South Florida Art Museum, Tampa, July–August 1996; Otis Gallery of Art and Design, Los Angeles, September 14–October 19, 1996; Austin Museum of Art, November 1996–January 1997. Catalogue.

1996

Museum Fridericianum, Kassel. *Collaborations: Warhol, Basquiat, Clemente.* February 4–May 5. Traveled to Museum Villa Stuck, Munich, July 25–September 29. Catalogue.

Robert Miller Gallery, New York. *J-M Basquiat: Bodies and Heads.* February 6–March 9.

The Serpentine Gallery, London. *Jean-Michel Basquiat.* March 6–April 21. Catalogue.

Galerie Enrico Navarra, Paris. *Jean-Michel Basquiat: Peintures.* April 2–June 12.

Galeries Lucien Durand–Enrico Navarra, Paris. *Jean-Michel Basquiat: Oeuvres sur papier/Works on Paper.* May 3–June 15. Catalogue.

Palacio Episcopal, Málaga. *Jean-Michel Basquiat.* May 16–July 7. Catalogue.

Galeria Luisa Strina, São Paulo. *Jean-Michel Basquiat: Obras sobre papeis.* May–June.

Galerie Bruno Bischofberger, Zurich. *Jean-Michel Basquiat.* June 1–August 31.

The Bruce Museum, Greenwich, Conn. *Basquiat.* August 4–September 8.

Tony Shafrazi Gallery, New York. *Jean-Michel Basquiat: A Tribute; Important Paintings, Drawings and Objects.* September 21–November 23.

Quintana Gallery, Coral Gables, Fla. *Jean-Michel Basquiat: 1980–1988.* December 17–February 21, 1997. Catalogue.

1997

Kaohsiung Museum of Fine Arts, Kaohsiung, Taiwan. *Jean-Michel Basquiat.* January 26–April 27. Traveled to Taichung Museum, Taichung, Taiwan, May 4–June 4. Catalogue.

Gagosian Gallery, New York. *Andy Warhol and Jean-Michel Basquiat: Collaborations.* March 15–April 26.

Fondation Dina Vierny–Musée Maillol, Paris. *Jean-Michel Basquiat: Oeuvres sur papier/Works on Paper.* May 23–September 29. Catalogue.

Gallery Hyundai, Seoul. *Jean-Michel Basquiat.* July 15–August 17. Catalogue.

Art Beatus Gallery, Vancouver. *Jean-Michel Basquiat.* September 10–October 14. Catalogue.

Mitsukoshi Museum, Tokyo. *Jean-Michel Basquiat.* October 28–November 24. Traveled to MIMOCA, Marugame, Japan, April 18–May 31, 1998. Catalogue.

Parco Gallery, Tokyo. *King for a Decade: Jean-Michel Basquiat.* July 22–September 17. Catalogue.

Galerie Sho, Tokyo. *Jean-Michel Basquiat.* October 1–November 15.

Big Step Inc., Osaka. *Jean-Michel Basquiat.* October 16–21.

Museo Nacional de Bellas Artes, Buenos Aires. *Jean-Michel Basquiat: Obras sobre papel.* December 8–February 13, 1998. Catalogue.

1998

Gagosian Gallery, Los Angeles. *Jean-Michel Basquiat: Paintings and Drawings, 1980–1988.* February 12–March 14. Catalogue.

Museu de Arte Moderna, Recife, Brazil. *Jean-Michel Basquiat: Obras sobre papeis.* April 1–May 31. Catalogue.

Tony Shafrazi Gallery, New York. *Jean-Michel Basquiat.* April 25–May 30.

Pinacoteca do Estado, São Paulo. *Jean-Michel Basquiat: Pinturas/Obras sobre papeis.* June 16–August 23. Catalogue.

Galerie La Tête d'Obsidienne, Fort Napoléon, La Seyne-sur-Mer, France. *Jean-Michel Basquiat.* June 26–August 14. Brochure.

Galerie Jérôme de Noirmont, Paris. *Jean-Michel Basquiat: Témoignage, 1977–1988.* October 2–November 27. Catalogue.

Galería Maeght, Barcelona. *Jean-Michel Basquiat: 1980–1988.* October 27–November 28.

1999

Kunsthaus Wien, Vienna. *Jean-Michel Basquiat.* February 11–May 2. Catalogue.

Centre Culturel L'Espal, Le Mans, France. *Jean-Michel Basquiat.* April 29–June 15. Catalogue.

Civico Museo Revoltella, Trieste. *Jean-Michel Basquiat.* May 15–September 15. Catalogue.

Fondazione Bevilacqua La Masa, Venice. *Basquiat a Venezia.* June 9–October 30. Catalogue.

Stadtgalerie, Klagenfurt, Austria. *Jean-Michel Basquiat: Werke auf Papier/Works on Paper.* June 18–September 26. Catalogue.

Galleria Dante Vecchiato, Forte dei Marmi, Italy. *Basquiat.* July 10–August 5. Traveled to Galleria Dante Vecchiato, Cortina d'Ampezzo, Italy, August 6–29. Catalogue.

Tony Shafrazi Gallery, New York. *Jean-Michel Basquiat: Selected Paintings and Drawings.* October 1–November 13.

Fondazione Mudima, Milan. *Basquiat.* October 14–November 30.

Museo Civico Castel Nuovo, Naples. *Basquiat a Napoli.* December 19–February 27, 2000. Catalogue.

Arizona State University Art Museum, Tempe. *Face Off: Paintings by Michael Ray Charles and Jean-Michel Basquiat.* December 10–April 2000.

2000

Stephen Lacey Gallery, London. *Jean-Michel Basquiat.* February 16–March 18.

Galerie Enrico Navarra, Paris. *Jean-Michel Basquiat: Peintures.* April 27–July 8.

Galerie Frédéric Gollong, Saint-Paul-de-Vence, France. *Jean-Michel Basquiat: Dessins originaux.* June 2–30.

Galerie Sho, Tokyo. *Jean-Michel Basquiat.* September 1–October 14.

Galería Haydeé Santamaría, Casa de las Américas, and Museo del Ron, Fundación Havana Club, Havana. *7a Bienal de La Habana: Jean-Michel Basquiat.* November 17–January 10, 2001. Catalogue.

2001

PICTUREshow Galerei, Berlin. *Jean-Michel Basquiat: Hits on Paper/Arbeiten auf Papier.* July 12–September 23.

Museum Würth, Künzelsau, Germany. *Jean-Michel Basquiat: Gemälde und Arbeiten auf Papier/Paintings and Works on Paper: The Mugrabi Collection.* September 27–January 1, 2002. Catalogue.

Il Prisma Galleria d'Arte, Cuneo, Italy. *Jean-Michel Basquiat a Cuneo.* October 1–30. Catalogue.

2002

Chiostro del Bramante, Rome. *Jean-Michel Basquiat: Dipinti.* January 20–March 17. Catalogue.

Museo Nacional Centro de Arte Reina Sofía, Madrid. *Andy Warhol - Jean-Michel Basquiat - Francesco Clemente: Obras en colaboración.* February 5–April 29. Catalogue.

Marcel Sitcoske Gallery, San Francisco. *Basquiat Editions.* February 7–23.

Spike Gallery, New York. *Jean-Michel Basquiat: War Paint.* April 13–June 15. Catalogue.

Gagosian Gallery, Los Angeles. *Andy Warhol, Jean-Michel Basquiat: Collaboration Paintings.* May 23–June 22.

Galerie Sho Contemporary Art, Tokyo. *Exhibition of Andy Warhol and Jean-Michel Basquiat: Rare Collections.* October 21–December 21.

2003

Pollock Gallery, Meadows School of the Arts, Southern Methodist University, Dallas. *Jean-Michel Basquiat: Works from the May Collection.* February 24–March 29.

Fondation Dina Vierny–Musée Maillol, Paris. *Jean-Michel Basquiat: Histoire d'une oeuvre.* June 27–October 23. Catalogue.

Galerie Sho Contemporary Art, Tokyo. *Raymond Saunders / Jean-Michel Basquiat.* September–November.

Jablonka Galerie, Cologne. *Jean-Michel Basquiat: Paintings.* October 29–January 31, 2004.

2004

Castellani Art Museum, Niagara University, Niagara Falls. *Jean-Michel Basquiat: An Intimate Portrait.* March 5–May 31. Photographs by Nicholas Taylor. Brochure.

Hood Museum of Art, Dartmouth College, Hanover, N.H. *Crossing Currents: The Synergy of Jean-Michel Basquiat and Ouattara Watts.* March 30–June 6.

SELECTED GROUP EXHIBITIONS

1980

Colab (Collaborative Projects Incorporated) and Fashion Moda, organizers. *Times Square Show.* 41st Street and 7th Avenue, New York. July.

1981

P.S.1, Institute for Art and Urban Resources, Long Island City, New York. *New York/New Wave.* February 15–April 5.

The Mudd Club, New York. *Lower Manhattan Drawing Show.* February 22–March 15.

The Mudd Club, New York. *Beyond Words: Graffiti Based-Rooted-Inspired Works.* April 9–24.

Annina Nosei Gallery, New York. *Public Address.* October 31–November 19.

Annina Nosei Gallery, New York. *Group Show.* December 19–January 24, 1982.

1982

University Art Gallery, San Diego State University. *Body Language: Current Issues in Figuration.* March 13–April 10. Catalogue.

University Fine Arts Galleries, School of Visual Arts, Florida State University, Tallahassee. *New New York.* March 17–April 17.

Traveled to Metropolitan Museum and Art Centers, Coral Gables, Florida, July 9–August 30. Catalogue.

Galleria Civica del Comune di Modena. *Transavanguardia: Italia/America.* March 21–May 2. Catalogue.

Mura Aureliane da Porta Metronia a Porta Latina, Rome. *Avanguardia/Transavanguardia, 68–77.* April–July. Catalogue.

Sidney Janis Gallery, New York. *New Work.* May 5–June 3.

Marlborough Gallery, New York. *The Pressure to Paint.* June 4–July 9. Catalogue.

Annina Nosei Gallery, New York. *Group Show.* June 5–30.

Alexander F. Milliken Gallery, New York. *Fast.* June 11–July 15. Catalogue.

Galerie Delta, Rotterdam. *Strange People.* June 15–July 15.

Museum Fridericianum, Kassel. *Documenta 7.* June 19–September 23. Catalogue.

Blum Helman Gallery, New York. *Drawings.* June 23–July 30.

Sidney Janis Gallery, New York. *The Expressionist Image: American Art from Pollock to Today.* October 9–30.

213

The Chrysler Museum, Norfolk, Va. *Still Modern After All These Years.* October 22–December 12. Catalogue.

Kestner-Gesellschaft, Hannover. *New York Now.* November 26–January 23, 1983. Traveled to Kunstverein München, Munich, February 2–March 6; Musée Cantonal des Beaux-Arts, Lausanne, March 30–May 15; Kunstverein für die Rheinlande und Westfalen, Düsseldorf, July 22–August 28. Catalogue.

Annina Nosei Gallery, New York. *Group Show.* December 18–January 6, 1983.

1983

Tony Shafrazi Gallery, New York. *Champions.* January–February. Catalogue.

Whitney Museum of American Art, New York. *1983 Biennial Exhibition.* March 15–May 29. Catalogue.

Monique Knowlton Gallery, New York. *Intoxication.* April 9–May 7.

Kunstmuseum Luzern, Lucerne. *Back to the USA: Amerikanische Kunst der Siebziger und Achtziger.* May 29–July 31. Traveled to Rheinisches Landesmuseum (organizer), Bonn, October 27–January 15, 1984; Württembergischer Kunstverein, Stuttgart, April–June. Catalogue.

Annina Nosei Gallery, New York. *Group Show.* June 11–July 29.

Brooklyn Army Terminal, New York. *Terminal New York.* September 24–October 30. Brochure.

Fashion Moda, Bronx, New York. *Food for the Soup Kitchens.* October 1–15.

Seibu Museum of Art, Tokyo. *Mary Boone and Her Artists.* October 6–18. Catalogue.

Greenville County Museum of Art, Greenville, S.C. *From the Streets.* October 25–November 20.

Galerie Beyeler, Basel. *Expressive: Malerei nach Picasso.* October–December. Catalogue.

Fine Arts Museum of Long Island, Hempstead, N.Y. *Written Imagery Unleashed in the Twentieth Century.* November–January 1984.

Sidney Janis Gallery, New York. *Post-Graffiti.* December 1–31.

Mary Boone–Michael Werner Gallery, New York. *Paintings: Georg Baselitz, Jean-Michel Basquiat, Troy Brauntuch, Francesco Clemente, Eric Fischl, Jörg Immendorff, Per Kirkeby, Markus Lüpertz, A. R. Penck, Sigmar Polke, David Salle, Julian Schnabel.* December 3–31. Brochure.

1984

New York City Department of Cultural Affairs. *Van Der Zee Memorial Show: James Van Der Zee, 1886–1983.* February 1–March 2.

Akira Ikeda Gallery, Nagoya. *Painting Now: Jean-Michel Basquiat, Sandro Chia, Francesco Clemente, Enzo Cucchi, David Salle, Salomé, Julian Schnabel.* March 5–31. Catalogue.

Sidney Janis Gallery, New York. *Modern Expressionists: German, Italian and American Painters.* March 10–April 7.

Galleria Comunale d'Arte Moderna, Bologna. *Arte di frontiera: New York Graffiti.* March 17–May 7. Traveled to Palazzo delle Exposizioni, Rome, September 11–October 21. Catalogue.

Center Gallery of Bucknell University, Lewisburg, Pa. *Since the Harlem Renaissance: 50 Years of Afro-American Art.* April 13–June 6. Traveled to The Amelie A. Wallace Art Gallery, State University of New York, College at Old Westbury, November 1–December 9; Munson-Williams-Proctor Institute Museum of Art, Utica, N.Y., January 11–March 3, 1985; The Art Gallery, University of Maryland, College Park, March 27–May 3, 1985; The Chrysler Museum, Norfolk, Va., July 19–September 1, 1985; Museum of Art, Pennsylvania State University, University Park, September 22–November 1, 1985. Catalogue.

Contemporary Art Society of the Indianapolis Museum of Art. *Painting and Sculpture Today.* May 1–June 10. Catalogue.

Musée d'Art Contemporain de Montréal. *Via New York.* May 8–June 24. Catalogue.

The Museum of Modern Art, New York. *An International Survey of Recent Painting and Sculpture.* May 17–August 19. Catalogue.

The Aldrich Museum of Contemporary Art, Ridgefield, Conn. *American Neo-Expressionists.* May 20–September 9. Catalogue.

Area, New York. *Art.* May 1984.

Williard Gallery, New York. *Drawings by Eleven Artists.* September 5–October 6.

Hirshhorn Museum and Sculpture Garden, Smithsonian Institution, Washington, D.C. *Content: A Contemporary Focus, 1975–1984.* October 4–January 6, 1985. Catalogue.

Kitakyushu Municipal Museum of Art, Kitakyushu, Japan. *Painting Now: The Restoration of Painterly Figuration.* October 6–28. Catalogue.

Institute of Contemporary Art, University of Pennsylvania, Philadelphia. *The East Village Scene.* October 12–December 2. Catalogue.

Rijksmuseum Kröller-Müller, Otterlo. *Little Arena: Drawings and Sculptures from the Collection Adri, Martin and Geertjan Visser.* October 13–November 25. Catalogue.

Musée d'Art Moderne de la Ville de Paris. *Figuration Libre France/USA.* December 21–February 17, 1985.

Neue Galerie-Sammlung Ludwig, Aachen. *Aspekte amerikanischer Kunst der Gegenwart.* Traveled to Nordjyllands Kunstmuseum, Aalborg; Henie-Onstad Art Center, Høvikodden; Mittelrheinisches Landesmuseum; Städtische Galerie, Schloss Oberhausen, Oberhausen. Catalogue.

1985

Kunsthalle Tübingen. *7000 Eichen.* March 2–April 14. Traveled to Kunsthalle Bielefeld, June 2–August 11. Catalogue.

Grande Halle du Parc de la Villette, Paris. *Nouvelle Biennale de Paris.* March 21–May 21. Catalogue.

Seattle Art Museum. *States of War.* April 18–June 23. Catalogue.

Annina Nosei Gallery, New York. *The Door.* June 7–July 7. Catalogue.

Parkhausrondelle and Segantini Museum, Saint-Moritz. *Das Oberengadin in der Malerei.* June 20–October 20. Catalogue.

Annina Nosei Gallery, New York. *Drawing the Line: Painting.* September 21–October 17.

Frankfurter Kunstverein, Frankfurt am Main. *Vom Zeichnen: Aspekte der Zeichnung, 1960–1985.* November 19–January 1, 1986. Traveled to Kasseler Kunstverein, Kassel, January 15–February 23, 1986; Museum Moderner Kunst, Vienna, March 13–April 27, 1986. Catalogue.

Knight Gallery, Spirit Square Arts Center, Charlotte, N.C. *Drawings.* December 20–February 7, 1986.

1986

Fort Lauderdale Museum of Art. *An American Renaissance: Painting and Sculpture since 1940.* January 12–March 30, 1986.

Whitney Museum of American Art at Equitable Center, New York. *Figure as Subject: The Last Decade; Selections from the Permanent Collection of the Whitney Museum of American Art.* February 13–June 4. Catalogue.

The Art Institute of Chicago. *75th American Exhibition.* March 8–April 27. Catalogue.

Setagaya Art Museum, Tokyo. *Naivety in Art.* March 30–June 15. Catalogue.

Holman Hall Art Gallery, Trenton State College, Trenton, N.J. *Contemporary Issues III.* April 2–25.

Louisiana Museum of Modern Art, Humlebaek, Denmark. *Portrait af en samler/Portrait of a Collector: Stephane Janssen.* April 5–May 11. Traveled to the University Art Museum, California State University, Long Beach, January 27–March 8, 1987. Catalogue.

Mokotoff Gallery, New York. *Heads.* April–May.

Suermondt-Ludwig-Museum und Museumverein, Aachen. *Zeichen, Symbole, Graffiti in der aktuellen Kunst: Sammlung Jung III.* July 6–August 17. Catalogue.

Galerie Barbara Farber, Amsterdam. *Esprit de New York: Paintings and Drawings.* July 18–24.

Schirn Kunsthalle, Frankfurter Kunstverein, Frankfurt am Main. *Prospect 86: Eine internationale Ausstellung aktueller Kunst.* September 9–November 2. Catalogue.

The Art Museum Association of America, San Francisco. *Focus on the Image: Selections from the Rivendell Collection.* Traveled to Phoenix Art Museum, October 5–February 7, 1987; The University of Oklahoma Museum of Art, Norman, April 25–August 30, 1987; Munson-Williams-Proctor Institute Museum of Art, Utica, New York, September 27, 1987–March 20, 1988; University of South Florida Art Galleries, Tampa, April 17–September 10, 1988; Lakeview Museum of Art and Sciences, Peoria,

Illinois, October 1, 1988–January 2, 1989; University Art Museum, California State University, Long Beach, January 30–May 28, 1989; Laguna Gloria Art Museum, Austin, June 25, 1989–January 2, 1990. Catalogue.

Galerie Delta, Rotterdam. *Group Show.* November 4–30.

Wellesley College Museum, Wellesley, Mass. *1976–1986: Ten Years of Collecting Contemporary American Art; Selections from the Edward R. Downe, Jr., Collection.* November 13–January 18, 1987. Catalogue.

Akira Ikeda Gallery, Nagoya. *Drawings: Basquiat, Chia, Clemente, Condo, Cucchi, Hunt, Schnabel, Serra, Stella, Sultan, Haraguchi, Yamamoto, Yoshimoto, Wakabayashi.* December 8–28.

Fred L. Emerson Gallery, Hamilton College, Clinton, N.Y. *Collection Peter Brams: Jean-Michel Basquiat, Gilbert & George, Milan Kunc, David McDermott & Peter McGough, Philip Taaffe, Rosemary Trockel.* December 12–January 25. Traveled to Lamont Gallery, Phillips Exeter Academy, Exeter, N.H., February 13–March 16, 1987. Catalogue.

1987

Los Angeles County Museum of Art. *Avant-Garde in the Eighties.* April 23–July 12. Catalogue.

Centre Culturel et Artistique, Montrouge, France. *32e Salon de Montrouge.* May 6–June 9.

Fashion Moda, Bronx, New York. *The East Village Force de Frappe Comes to the South Bronx.* May 9–June 1.

Forte Belvedere, Florence. *America Europa dalla collezione Ludwig.* July 4–October 4. Catalogue.

56 Bleecker Gallery, New York. *16 @ 56: Summer Salon.* July 28–August 28.

San Antonio Art Institute. *The Frederick R. Weisman Collection: An International Survey.* September 16–October 16.

Akira Ikeda Gallery, Nagoya. *Relief & Sculpture: Basquiat, Brown, Chia, Hunt, Scharf, Schnabel, Stella, Suvero, Wakabayashi, Haraguchi, Yamamoto, Sakuji Yoshimoto.* September 16–October 31.

Wilhelm-Hack-Museum, Ludwigshafen, Germany. *New York Graffiti.* September 17–October 25. Catalogue.

Anne Plumb Gallery, New York. *Logos.* December 19–January 23, 1988.

1988

Bridge Center for Contemporary Art, ElPaso, and New Mexico State University, Las Cruces. *An Eclectic Eye: Selections from the Frederick R. Weisman Art Foundation.* January 11–December 14. Traveled to Cheney Cowles Art Museum, Spokane, Wash., January 6–February 12, 1989; Boise Art Museum, April 15–June 11, 1989; University of Wyoming Art Museum, Laramie, June 25–October 22, 1989; Virginia Beach Center for the Arts, November 13, 1989–January 28, 1990; Gibbes Art Gallery, Charleston, S.C., March 9–May 4, 1990.

Museum of Art, Rhode Island School of Design, Providence. *1900 to Now: Modern*

Art from Rhode Island Collections. January 22–May 1, 1988. Catalogue.

Whitney Museum of American Art at Equitable Center, New York. *Figure as Subject: The Revival of Figuration Since 1975.* February 13–June 4. Traveled to Erwin A. Ulrich Museum of Art, Wichita State University, Wichita, Kans., April 6–June 12; The Arkansas Arts Center, Little Rock, June 24–August 21; Amarillo Art Center, Amarillo, Tex., September 10–October 22; Utah Museum of Fine Arts, University of Utah, Salt Lake City, November 13–January 15, 1989; Madison Art Center, Madison, Wis., February 4–March 26, 1989. Brochure.

Galería Berini, Barcelona. *Collectiva 1.* February 25–March 30. Catalogue.

Paula Allen Gallery, New York. *Rebop.* April 26–May 27.

Boca Raton Museum of Art, Boca Raton, Fla. *After Street Art.* April 29–May 29. Catalogue.

Galerie La Défense Art 4, Paris. *L'Art contemporain à la Défense: Les Années 80 vues par 5 galeries.* September 23–November 6. Catalogue

1989

Rosa Esman Gallery, New York. *Modern and Contemporary Master Drawings.* January 6–28.

Tony Shafrazi Gallery, New York. *Words.* January 21–February 18.

Hofstra Museum, Hofstra University, Hempstead, N.Y. *1979–1989: American, Italian, Mexican Art from the Collection of Francesco Pellizzi.* April 16–May 26. Traveled to Lehigh University Art Galleries, Ralph Wilson Gallery, Bethlehem, Pa., September 8–November 2. Catalogue.

Yokohama Museum of Art. *The Chase Manhattan Bank Collection, 1974–1989.* June 18–October 1.

Daniel Weinberg Gallery, Los Angeles. *A Decade of American Drawing, 1980–1989.* July 15–August 26.

Artis, Monte Carlo. *Maîtres modernes et contemporains.* July 31–September 15.

The Washington Project for the Arts, Washington, D.C. *The Blues Aesthetic: Black Culture and Modernism.* September 14–December 9. Traveled to California Afro-American Museum, Los Angeles, January 12–March 4, 1990; Duke University Museum of Art, Durham, N.C., March 23–May 20, 1990; Blaffer Gallery, University of Houston, June 8–July 31, 1990; The Studio Museum in Harlem, New York, September 16–December 30, 1990. Catalogue.

Edward Totah Gallery, London. *Selected Americans.* November 28–December 16, 1989.

Joseph Helman Gallery, New York. *Cross.* December 13–January 6, 1990.

1990

Galerie Hadrien-Thomas, Paris. *Sélection américaine.* January 10–February 24.

Douglas Drake Gallery, New York. *Par Hasard: A Changing Installation of Recent Acquisitions.* February 3–24.

Michael Kohn Gallery, Santa Monica. *Gesture and Signature.* May 12–June 10.

Museum of Contemporary Hispanic Art, The New Museum of Contemporary Art, and The Studio Museum in Harlem, New York. *The Decade Show: Frameworks of Identity in the 1980s.* May 12–August 19, 1990. Catalogue.

Galerie Hans Mayer, Düsseldorf, at the Basel Art Fair. *21 Jahre Internationale Kunstmesse Basel/Art 21 '90.* June 13–18.

Marc Richards Gallery, Los Angeles. *Faces.* June 29–July 28.

Fay Gold Gallery, Atlanta. *Summer: Works on Paper.* June–August.

Nippon Convention Center, International Exhibition Hall, Tokyo. *Pharmakon '90.* July 28–August 20. Catalogue.

Tony Shafrazi Gallery, New York. *The Last Decade: American Artists of the 80s.* September 15–October 27. Catalogue.

The Aldrich Museum of Contemporary Art, Ridgefield, Conn. *Language in Art.* October 20–January 6, 1991.

Cavaliero Fine Arts, New York. *Works on Paper.* November 1–30.

Frank Bernarducci Gallery, New York. *Quickdraw: American Master Drawings Since 1959.* November 2–December 1.

1991

Whitney Museum of American Art, New York. *The 1980s: A Selected View from the Permanent Collection of the Whitney Museum. of American Art.* January 16–March 24.

Setagaya Art Museum, Tokyo. *An Aspect of Contemporary Art.* April 2–May 6.

Museum of Contemporary Art, Wright State University, Dayton, Ohio. *Words & #s.* April 7–May 10. Catalogue.

Enrico Navarra Gallery, New York. *Selected Works.* May 6–June 20.

San Jose Museum of Art, San Jose, Calif. *Compassion and Protest: Recent Social and Political Art from the Eli Broad Family Foundation Collection.* June 1–August 25. Catalogue.

Whitney Museum of American Art at Philip Morris, New York. *Drawings Acquisitions, 1980–1991: Selections from the Permanent Collection of the Whitney Museum of American Art.* June 12–September 5. Brochure.

Robert Miller Gallery, New York. *Portraits on Paper.* June 25–August 2.

Museo de Arte Contemporáneo, Monterrey, Mexico. *Mito y Magia en América: Los Ochenta.* June–September. Catalogue.

Duke University Museum of Art, Durham, N.C. *Art of the 1980s: Selections from the Collection of the Eli Broad Family Foundation.* September 20–January 5, 1992.

Institute of Contemporary Art, University of Pennsylvania, Philadelphia. *Devil on the Stairs: Looking Back on the Eighties.* October 4–January 5, 1992. Traveled to The Forum and Washington University Gallery of Art, Saint Louis, February 1–March 22, 1992; Newport Harbor Art Museum, Newport Beach, Calif., April 16–June 21, 1992. Catalogue.

Philippe Briet Gallery, New York. *Domeníkos Theotokopoulos: A Dialogue.* December 5–January 25, 1992.

Tony Shafrazi Gallery, New York. *A Passion for Art: Watercolors and Works on Paper.* December 7–January 25, 1992.

Annina Nosei Gallery, New York. *Works on Paper.* December 10–January 7, 1992.

Palazzo delle Albere, Trento, Italy. *American Artists of the 80s.* December 18–March 1, 1992. Catalogue.

1992

Bomani Gallery and Jernigan Wicker Fine Arts, San Francisco. *Paris Connections: African American Artists in Paris.* January 14–February 29. Catalogue.

Musée d'Art Moderne de la Communauté Urbaine de Lille, Villeneuve d'Ascq, France. *Yvon Lambert collectionne.* January 18–April 20. Catalogue.

The Museum of Modern Art, New York. *Allegories of Modernism: Contemporary Drawings.* February 16–May 5. Catalogue.

Philippe Briet Gallery, New York. *An Exhibition for Satyajit Ray.* April 1–May 16.

The Richard and Marieluise Black Center for Curatorial Studies, Bard College, Annandale-on-Hudson, New York. *Passions and Cultures: Selected Works from the Rivendell Collection, 1967–1991.* April–October. Brochure.

Whitney Museum of American Art, Downtown Branch, New York. *The Power of the City/The City of Power.* May 20–July 10. Catalogue.

Gesellschaft für Moderne Kunst am Museum Ludwig, Cologne. *Ars pro Domo: Zeitgenössische Kunst aus Kölner Privatbesitz.* May 22–August 9. Catalogue.

Whitney Museum of American Art, New York. *Gifts and Acquisitions in Context.* May 22–September 20.

Haenah-Kent Gallery, New York. *Jean-Michel Basquiat, Jonathan Borofsky, Richard Bosman, Kang So Lee, Terry Winters.* June 6–July 10. Catalogue.

Musée d'Art Moderne et Contemporain, Nice. *Le Portrait dans l'art contemporain.* July 3–September 27.

Espace de l'Art Contemporain, Château de Mouans-Sartoux, France. *Le Cri et la raison.* July 6–November 22.

Bellas Artes, Santa Fe. *Baziotes to Basquiat ... and Beyond.* August 20–September 30.

Fundação Cultural de Curitaba/Museo de Gravura, Curitaba, Brazil. *X Mostra da Gravura, Curitaba/Mostra America.* October 16–December 6.

Fukui Fine Arts Museum, Fukui, Japan. *Dream Singers, Story Tellers: An African-American Presence. Organized by the New Jersey State Museum.* November 6–December 2. Traveled to Tokushima Modern Art Museum, January 23–March 7, 1993; Otani Memorial Art Museum, Nishinomiya, April 10–May 9, 1993; New Jersey State Museum, Trenton, August 7, 1993–March 20, 1994.

1993

Thread Waxing Space, New York. *I Am the Enunciator.* January 9–February 27.

Tony Shafrazi Gallery, New York. *Extravagant: The Economy of Elegance.* January 30–February 27. Traveled to Russisches Kulturwentrum, Berlin, May 7–June 27.

Fine Arts Gallery, University of California, Irvine. *The Theater of Refusal: Black Art and Mainstream Criticism.* April 8–May 12. Traveled to Richard L. Nelson Gallery, University of California, Davis, November 7–December 17, and University Art Gallery, University of California, Riverside, January 9–February 27, 1994. Catalogue.

Tony Shafrazi Gallery, New York. *1982–1983: Ten Years After.* May 7–July 30.

Halle Tony Garnier, Biennale d'Art Contemporain de Lyon, Lyon. *Et tous ils changent le monde.* September 3–October 13. Catalogue.

1994

San Antonio Museum of Art. *The Harmon and Harriet Kelley Collection of African American Art.* February 4–April 3. Catalogue.

Aspen Art Museum. *The Shaman as Artist/The Artist as Shaman.* February 10–April 10. Catalogue.

The Aldrich Museum, Ridgefield, Conn. *Art in the Present Tense: The Aldrich's Curatorial History, 1964–1994.* May 15–September 18.

Ueno Royal Museum, Tokyo. *Against All Odds: The Healing Powers of Art.* June 17–25. Traveled to The Hakone Open-Air Museum, Tokyo, Japan, July 13–August 14.

Irish Museum of Modern Art, Dublin. *From Beyond the Pale: Art and Artists at the Edge of Consensus.* September 23–January 15, 1995. Catalogue.

Galerie Jérôme de Noirmont, Paris. *Maîtres modernes et contemporains.* October 6–December 6. Catalogue.

1995

The Bruce Museum, Greenwich, Conn. *A New York Time: Drawings of the Eighties.* January 22–April 23. Catalogue.

Musée d'Art Moderne de la Ville de Paris. *Passions privées.* December 19–March 24, 1996. Catalogue.

1996

Fondation Cartier pour l'Art Contemporain, Paris. *Comme un oiseau.* June 19–October 13. Catalogue.

The Museum of Modern Art, New York. *Thinking Print: Books to Billboards, 1980–1995.* June 20–September 10.

Galerie Beaubourg, Vence, France. *Quelques impressions d'Afrique.* July 8–November 30. Catalogue.

John McEnroe Gallery, New York. *Bill Traylor, Philip Guston, Jean-Michel Basquiat, Gary Komarin.* September 13–October 26. Catalogue.

1997

Galerie Delta, Rotterdam. *35 Jaar: Delta Werken.* March 22–June 15.

Malca Fine Art, New York. *In Your Face: Keith Haring, Jean-Michel Basquiat, Kenny Scharf.* June 17–August 30. Catalogue.

Kirin Plaza, Osaka. *Basquiat + Haring + Scharf from the Leo Malca Collection.* August 7–September 6.

Chiostro del Bramante, Rome. *American Graffiti.* October 3– December 8. Catalogue.

Galerie Delta, Rotterdam. *Jean-Michel Basquiat, Keith Haring, Kenny Scharf.* October 30–November 20.

1998

Gagosian Gallery, Beverly Hills. *Paintings and Drawings, 1980–1988.* February 12–March 14.

PaceWildenstein, Beverly Hills. *30th Anniversary of Mr. Chow: Portrait Collection.* February 14–28. Catalogue.

Yokohama Museum of Art. *Oeuvres sur papier et photographies: La Collection Yvon Lambert; Dialogue avec des artistes contemporains.* April 11–June 21. Catalogue.

Kunsthalle Wien, Vienna. *Crossings: Kunst zum Hören und Sehen.* May 29– September 13.

Carré d'Art, Nîmes. *Au fil du trait: De Matisse à Basquiat.* June 26– September 27. Catalogue.

Gagosian Gallery, New York. *Portraits Obscured.* July 20–September 12.

Galerie Thaddaeus Ropac, Salzburg. *Ensemble moderne: Das moderne Stilleben.* July 25–August 31.

1999

Staatliche Kunsthalle Baden-Baden. *Bad-Bad: That Is a Good Excuse.* April 18–June 20. Catalogue.

Contemporary Arts Museum, Houston. *Other Narratives.* May 15–July 4. Catalogue.

La Biennale di Venezia, Venice. *48 Esposizione Internazionale d'Arte.* June 13–November 17. Catalogue.

San Jose Museum of Art, San Jose, Calif. *Piecing It Together: A Visual Journal.* September 26–January 9, 2000.

Whitney Museum of American Art, New York. *The American Century: Art and Culture, 1900-2000. Part 2, 1950-2000.* September 26–February 13, 2000. Catalogue.

Palazzo Bricherasio, Turin. *Pittura dura: Dal Graffitismo alla Street Art.* November 24–January 30, 2000. Catalogue.

Galerie Enrico Navarra, Paris. *Portrait Collection of Mr. Chow.* December 1– January 10, 2000. Catalogue.

Aspen Art Museum. *20 Years, 20 Artists.* Catalogue.

2000

Halle Saint-Pierre, Paris. *Haiti: Anges et démons.* March 20–June 30. Catalogue.

Tony Shafrazi Gallery, New York. *Off White.* May 18–June 12.

Institut d'Art Contemporain, Lyon. *Et l'art se met au monde.* June 23– October 29.

Fondation Maeght, Saint-Paul, France. *Le Nu au XXe siècle.* July 4–October 30. Catalogue.

2001

Katonah Museum of Art, Katonah, N.Y. *Jazz and Visual Improvisations.* January 21–April 15. Catalogue.

Museum of Contemporary Art, North Miami. *Mythic Proportions: Painting in the 1980s.* February 16–May 13. Catalogue.

Los Angeles County Museum of Art. *Jasper Johns to Jeff Koons: Four Decades of Art from the Broad Collections.* October 7–January 6, 2002. Traveled to the Corcoran Gallery of Art, March 16– June 3, 2002; Museum of Fine Arts Boston, July 28–October 20, 2002; Museo Guggenheim Bilbao, February 15– September 7, 2003. Catalogue.

C & M Arts, New York. *Naked since 1950.* October 11–December 8. Catalogue.

Bronx Museum of the Arts, New York. *One Planet under a Groove: Hip Hop and Contemporary Art.* October 26–March 3, 2002. Traveled to Walker Art Center, Minneapolis, July 14–October 13, 2002; Spellman College Museum of Art, Atlanta, spring 2003; Villa Stuck, Munich, October 18, 2003–January 11, 2004. Catalogue.

2002

Galerie Jérôme de Noirmont, Paris. *Accrochage d'hiver: Photographies contemporaines.* February 8–March 14.

Bergen Kunstmuseum, Bergen, Norway. *New York Expression.* February 15–April 28. Catalogue.

Le Bellevue, Biarritz. *Les Jeux dans l'art du XXème siècle.* June 22–October 3. Traveled to Palacio de Montemuzo, La Lonja, Saragossa, Spain, October 29– January 6, 2003.

Gertrude Silverstone Muss Gallery, Bass Museum of Art, Miami. *In the Spirit of Martin: The Living Legacy of Dr. Martin Luther King, Jr.* September 6– November 10. A Smithsonian Institution traveling exhibition. Catalogue.

Galerie Jérôme de Noirmont, Paris. *Zoo.* FIAC (Foire Internationale d'Art Contemporain), October 24–28.

2003

Museum Morsbroich, Leverkusen, Germany. *Talking Pieces: Text und Bild in der zeitgenössischen Kunst.* January 26–April 20.

Contemporary Arts Museum Houston. *Splat Boom Pow! The Influence of Comics in Contemporary Art.* April 12–June 29. Traveled to Institute of Contemporary Art, Boston, September 17–January 4, 2004; Wexner Center for the Arts, Columbus, Ohio, January 31–April 30, 2004. Catalogue.

Museo Correr, Venice. *Pittura / Painting: Rauschenberg to Murakami, 1964–2003.* June 15–November 2.

Galerie Jérôme de Noirmont, Paris. *Fantasme fantasque.* October 8–13.

Jan Krugier Gallery, New York. *The Fire under the Ashes: From Picasso to Basquiat.* November 6–January 6, 2004. Traveled to Ditesheim & Cie, Geneva, April 29–July 31, 2004.

Stella Art Gallery, Moscow. *Andy Warhol – Tom Wesselmann – Jean-Michel*

Basquiat. November 28–January 31, 2004. Curated by Edward Mitterrand.

2004

Galeria Guereta, Madrid. *Los Años 80.* January 8–February 10.

Gagosian Gallery, London. *Drawings.* January 29–April 17.

Castellani Art Museum, Niagara University, Niagara Falls, N.Y. *African American Artists of the 20th Century: Selections from the Permanent Collection.* March 1–May 31.

The Museum of Modern Art and El Museo del Barrio, New York. *MoMA at El Museo: Latin American and Caribbean Art from the Collection of the Museum of Modern Art.* March 5–July 25. Catalogue.

Musée du Luxembourg, Paris. *Moi! Autoportraits du XXe siècle.* March 31– July 25. Catalogue.

Tony Shafrazi Gallery, New York. *Picasso, Bacon, Basquiat.* May 8–July 30.

Feldman Gallery, New York. *Takes & Outtakes: From the Andy Warhol Museum.* June 10–July 30.

BIBLIOGRAPHY
MONOGRAPHS AND ONE- AND
TWO-PERSON EXHIBITION
CATALOGUES

1982

Diacono, Mario. *Jean-Michel Basquiat: Il campo vicino l'altra strada.* Exh. brochure. Rome: Galleria Mario Diacono, 1982. Reprinted in Mario Diacono, *Verso una nuova iconografia.* Reggio Emilia, Italy: Collezione Tauma, 1984.

Sonnenberg, Hans. *Jean-Michel Basquiat.* Exh. cat. Rotterdam: Galerie Delta, 1982.

1983

Jean-Michel Basquiat: Painting. Text by Maki Kuwayama. Exh. cat. Tokyo: Akira Ikeda Gallery, 1983.

1984

Collaborations: Jean-Michel Basquiat, Francesco Clemente, Andy Warhol. Exh. cat. Zurich: Galerie Bruno Bischofberger, 1984.

Jean-Michel Basquiat: Paintings, 1981-1984. Text by Mark Francis. Exh. cat. Edinburgh: The Fruitmarket Gallery, 1984.

Jean-Michel Basquiat. Text by A. R. Penck. Exh. cat. New York: Mary Boone Gallery, 1984.

1985

Collaborations: Jean-Michel Basquiat, Francesco Clemente, Andy Warhol. Exh. cat. Tokyo: Akira Ikeda Gallery, 1985.

Jean-Michel Basquiat. Text by Constance Lewallen. Exh. cat. Berkeley: University of California Art Museum, University of California, 1985.

Jean-Michel Basquiat. Text by Robert Farris Thompson. Exh. cat. New York: Mary Boone–Michael Werner Gallery, 1985.

Jean-Michel Basquiat. Exh. cat. Zurich: Galerie Bruno Bischofberger, 1985.

Jean-Michel Basquiat: Drawings. Limited ed. New York: Mary Boone

Gallery; Zurich: Galerie Bruno Bischofberger, 1985.

Jean-Michel Basquiat: Paintings. Exh. cat. Tokyo: Akira Ikeda Gallery, 1985.

1986

Collaborations: Jean-Michel Basquiat and Andy Warhol. Exh. cat. Tokyo: Akira Ikeda Gallery, 1986.

Thompson, Robert Farris. *Jean-Michel Basquiat.* Edited by Carl Haenlein. Exh. cat. Hannover: Kestner-Gesellschaft, 1986.

Zaunschirm, Thomas. *Jean-Michel Basquiat: Bilder, 1984–1986.* Exh. cat. Salzburg: Galerie Thaddaeus Ropac, 1986.

1987

Jean-Michel Basquiat. Exh. cat. Tokyo: PS Gallery, 1987.

Jean-Michel Basquiat: New Works. Exh. cat. Tokyo: Akira Ikeda Gallery, 1987.

1988

Collaborations: Andy Warhol, Jean-Michel Basquiat. Text by Keith Haring. Exh. cat. [London: Mayor Rowan Gallery, Mayor Gallery, and David Grob Limited], 1988.

1989

Basquiat, Jean-Michel. *Amateur Bout, New York.* Notebook facsimile. New York: Vrej Baghoomian Gallery, 1989.

Borràs, María Lluïsa. *Jean-Michel Basquiat.* Exh. cat. Barcelona: Dau al Set, Galeria d'Arte, 1989.

Borum, Jenifer Penrose. "Art and Addiction: A Self-Psychological Approach to Life and Work of Jean-Michel Basquiat." M.A. thesis, State University of New York at Stony Brook, 1989.

Enrici, Michael. *J. M. Basquiat.* Classiques du XXIe siècle, no. 3. Paris: Éditions de la Différence/Galerie Enrico Navarra, 1989.

Haenlein, Carl, ed. *Jean-Michel Basquiat: Das zeichnerische Werk.* Texts by Carsten Ahrens, Démosthènes Davvetas, Carl Haenlein, and Keith Haring. Exh. cat. Hannover: Kestner-Gesellschaft, 1989.

Jean-Michel Basquiat. Texts by Francesco Pellizzi and Glenn O'Brien. Exh. cat. New York: Vrej Baghoomian Gallery, 1989.

Jean-Michel Basquiat: Peintures, sculptures, oeuvres sur papier et dessins/Paintings, Sculptures, Works on Paper, and Drawings. Texts by Enrico Navarra, Démosthènes Davvetas, Annina Nosei, Alain Bonfand, and Pierre Cornette de Saint Cyr. Exh. cat. Paris: Galerie Enrico Navarra, 1989.

Müller, Grégoire, and Keith Haring. *Warhol-Basquiat: Collaborations.* Exh. cat. Paris: Didier Imbert Fine Art, 1989.

Palmqvist, Anna, ed. *Jean-Michel Basquiat/Julian Schnabel.* Essay by Jeffrey Deitch. Exh. cat. Malmö, Sweden: Rooseum, 1989.

1990

Basquiat. Texts by Nicolas Bourriaud, Henry Geldzahler, Remo Guidieri, Sylvie Philippon, Philippe Piguet, Jane Rankin Reid, and Greg Tate. Exh. cat. Paris: Galerie Fabien Boulakia, 1990.

216

Cheim, John, ed. *Jean-Michel Basquiat: Drawings.* Introduction by Robert Storr. Exh. cat. Boston: Little, Brown and Company, 1990.

1991

Levin, Kim, and David Ross. *Andy Warhol and Jean-Michel Basquiat.* Kyongju, Korea: Sonje Museum of Contemporary Art, 1991.

1992

Jean-Michel Basquiat. Text by Kyoichi Tsuzuki. Kyoto: Kyoto Shoin, 1992.

Jean-Michel Basquiat: An Introduction for Students. New York: Whitney Museum of American Art, 1992.

Marshall, Richard D. *Jean-Michel Basquiat.* Essays by Dick Hebdige, Klaus Kertess, Richard D. Marshall, Rene Ricard, Greg Tate, and Robert Farris Thompson. Exh. cat. New York: Whitney Museum of American Art, 1992.

Millet, Bernard, ed. *Jean-Michel Basquiat: Une Rétrospective.* Texts by Remo Guidieri, Bernard Millet, Philippe Piguet, and Frédéric Valabrègue. Exh. cat. Marseilles: Musée Cantini, Musées de Marseille, Réunion des Musées Nationaux, 1992.

Sterckx, Pierre. *Jean-Michel Basquiat.* Exh. cat. Brussels: Galerie Eric van de Weghe, 1992.

1993

Adès, Marie-Claire, and Dominique Le Guen. *Jean-Michel Basquiat: Peinture, dessin, écriture.* Exh. cat. Paris: Musée-Galerie de la Seita, 1993.

Angelou, Maya. *Life Doesn't Frighten Me.* Poems by Maya Angelou; paintings by Jean-Michel Basquiat. New York: Stewart, Tabori, Chang, 1993.

Jean-Michel Basquiat. Texts by Chantal Michetti-Prod'Hom and Angelika Affentranger-Kirchrath. Exh. cat. Pully-Lausanne, Switzerland: FAE, Musée d'Art Contemporain, 1993.

Jean-Michel Basquiat. Exh. cat. Tokyo: Alpha Cubic Gallery, 1993.

Jean-Michel Basquiat: Paintings and Drawings. Exh. cat. Tokyo: Galerie Sho Contemporary Art, 1993.

Warsh, Larry, ed. *Jean-Michel Basquiat: The Notebooks.* Introduction by Henry Geldzahler. Essays by Démosthènes Davvetas, Jeffrey Deitch, Klaus Kertess, Joe Lewis, and Greg Tate. New York: Art + Knowledge, 1993.

1994

Jean-Michel Basquiat. Exh. brochure. Overland Park, Kans.: Gallery of Art, Johnson County Community College, 1994.

Jean-Michel Basquiat: The Blue Ribbon Paintings. Essays by Bruce Guenther, Herbert Schorr, and Lenore Schorr. Exh. cat. South Hadley, Mass.: Mount Holyoke College Art Museum, 1994.

1995

Two Cents: Works on Paper by Jean-Michel Basquiat and Poetry by Kevin Young. Texts by Amy Cappellazzo, Elizabeth Alexander, and John Yau.

Exh. cat. Miami: The Centre Gallery, Miami-Dade Community College, Wolfson Campus, 1995.

1996

Jean-Michel Basquiat. Text by Richard D. Marshall. Exh. cat. Coral Gables, Fla.: Quintana Gallery, 1996.

Jean-Michel Basquiat. Text by Richard D. Marshall. Exh. cat. London: Serpentine Gallery, 1996.

Jean-Michel Basquiat. Texts by Richard D. Marshall and Ingrid Sischy. Exh. cat. Seville: Junta de Andalucia, Consejería de Cultura, Centro Andaluz de Arte Contemporáneo 1996.

Jean-Michel Basquiat. Oeuvres sur papier/Works on Paper. Paris: Galeries Lucien Durand–Enrico Navarra, 1996.

Jean-Michel Basquiat. Portraits. Text by Francesco Clemente. Zurich: Bruno Bischofberger Editions, 1996.

Marshall, Richard D., and Jean-Louis Prat. *Jean-Michel Basquiat.* 2 vols. Paris: Galerie Enrico Navarra, 1996.

Osterwold, Tilman, ed. *Collaborations: Warhol, Basquiat, Clemente.* Exh. cat. Ostfildern-Ruit: Cantz, 1996.

1997

Glusberg, Jorge, and Elena Ochoa. *Jean-Michel Basquiat. Obras sobre papel.* Exh. cat. Buenos Aires: Museo Nacional de Bellas Artes, 1997.

Jean-Michel Basquiat. Exh. cat. Tokyo: Kadokawa Bunko, 1997.

Jean-Michel Basquiat. Preface by Annie Wong Leung Kit Wah; essays by Richard D. Marshall and Enrico Navarra. 2 vols. Exh. cat. Vancouver: Art Beatus Gallery Ltd., 1997.

Kawachi, Taka, ed. *King for a Decade: Jean-Michel Basquiat.* Exh. cat. Kyoto: Korinsha Press, 1997.

Marshall, Richard D., and Katsuhiko Hibino. *Jean-Michel Basquiat.* Tokyo: Mitsukoshi Museum, 1997.

Marshall, Richard D., and Jean-Louis Prat. *Jean-Michel Basquiat.* Exh. cat. Kaohsiung, Taiwan: Taichung Museum, 1997.

Marshall, Richard D, and Jean-Louis Prat. *Jean-Michel Basquiat.* Exh. cat. Seoul: Galerie Hyundai, 1997.

Vierny, Dina, and Nathalie Prat. *Jean-Michel Basquiat: Oeuvres sur papier/Works on Paper.* Foreword by Enrico Navarra; essay by Bernard Blistène. Exh. cat. Paris: Fondation Dina Vierny-Musée Maillol, 1997.

1998

De Lontra Costa, Marcus, and Olívio Tavares de Araújo. *Jean-Michel Basquiat: Obras sobre papeis.* Exh. cat. Recife, Brazil: Museu de Arte Moderna, 1998.

Hoban, Phoebe. *Basquiat: A Quick Killing in Art.* New York: Viking Press, 1998.

Jean-Michel Basquiat. Exh. cat. Fort Napoléon, La Seyne-sur-Mer, France: La Tête d'Obisidienne, 1998.

Jean-Michel Basquiat: Paintings and Drawings 1980–1988. Exh. cat. Los Angeles: Gagosian Gallery, 1998.

Jean-Michel Basquiat. Obras sobre papeis/Pinturas. Texts by Antônio

Angarita, Emancel Araújo, Olívio Tavares de Araújo, Enrico Navarra, and Elena Ochoa-Foster. Exh. cat. São Paulo: Pinacoteca do Estado, 1998.

Jean-Michel Basquiat: Témoignage, 1977–1988. Texts by Jean-Michel Basquiat, Bruno Bischofberger, Claudio Caratsch, Francesco Clemente, Jeffrey Deitch, Henry Geldzahler, Anthony Haden-Guest, Ted Joans, Klaus Kertess, Madonna, Maripol, A. R. Penck, Rene Ricard, Lenore Schorr, and Andy Warhol. Exh. cat. Paris: Galerie Jérôme de Noirmont, 1998.

Leclercq, Stéfan. *Détermination et hasard de Jean-Michel Basquiat.* Collection Oui, mai–, no. 6. Mons, Belgium: Édition Sils Maria, 1998.

1999

Barbancey, Pierre. *Jean-Michel Basquiat.* Exh. cat. Le Mans, France: Centre Culturel L'Espal, 1999.

Basquiat. Texts by Virginia Baradel and Luca Massimo Barbero. Exh. cat. Forte dei Marmi, Italy: Galleria Dante Vecchiato; Cortina d'Ampezzo, Italy: Galleria Dante Vecchiato, 1999.

Basquiat a Napoli. Texts by Achille Bonito Oliva and Jean-Louis Prat. Exh. cat. Naples: Museo Civico Castel Nuovo, 1999.

Basquiat a Venezia. 48 Biennale di Venezia. Texts by Achille Bonito Oliva, Paul Lombard, Jean-Louis Prat, and Richard D. Marshall. Venice: Fondazione Bevilacqua La Masa, 1999.

Jean-Michel Basquiat. Texts by Bruno Bischofberger, Francesco Clemente, Démosthènes Davvetas, Henry Geldzahler, Isabelle Graw, Keith Haring, Luca Marenzi, Tobias Mueller, and Lisa Licitra Ponti. Exh. cat. Milan: Edizioni Charta, 1999. Also issued with a different cover as *Basquiat.*

Jean-Michel Basquiat. Texts by Peter M. Brant, Jeffrey Deitch, Henry Geldzahler, Keith Haring, Ted Joans, Richard D. Marshall, Glenn O'Brien, Francesco Pellizzi, Herbert and Lenore Schorr, Tony Shafrazi, and Franklin Sirmans. New York: Tony Shafrazi Gallery, 1999.

Jean-Michel Basquiat. Texts by Jacob Baal-Teshuva, Henry Geldzahler, Jeffrey Deitch, A. R. Penck. Exh. cat. Vienna: Kunsthaus, 1999.

Jean-Michel Basquiat: Oeuvres sur papier. Texts by Bernard Blistène, Elena Ochoa, Richard D. Marshall, and Robert Farris Thompson. Paris: Galerie Enrico Navarra, 1999. Also published in English.

Jean-Michel Basquiat. Werke auf papier/Works on Paper. Texts by Elena Ochoa and Richard D. Marshall. Exh. cat. Klagenfurt, Austria: Stadtgalerie, 1999.

2000

Basquiat en la Habana. Contributions by Nöel Adrian, Johnny Depp, Roberto Fernandez Retamar, Nelson Herrera Ysla, Elena Ochoa, and Yolanda Wood. Exh. cat. Havana: Casa de las Américas, Fundación Havana Club, 2000.

Clement, Jennifer. *Widow Basquiat: A Love Story.* Edinburgh: Payback Press, 2000.

Jean-Michel Basquiat. Preface by Enrico Navarra; texts by Bruno Bischofberger,

John Cheim, Pierre Cornette de Saint Cyr, Diego Cortez, Démosthènes Davvetas, Johnny Depp, Richard D. Marshall, Annina Nosei, Glenn O'Brien, Achille Bonito Oliva, Ouattara, Jean-Louis Prat, Herbert and Lenore Schorr, Tony Shafrazi, Michael Ward Stout, Robert Farris Thompson, and Larry Warsh. 2 vols. Paris: Galerie Enrico Navarra, 2000.

2001

Baal-Teshuva, Jacob, ed. *Jean Michel Basquiat: Gemälde und Arbeiten auf Papier/Paintings and Works on Paper: The Mugrabi Collection.* Texts by Jacob Baal-Teshuva, Francesco Clemente, Jeffrey Deitch, Henry Geldzahler, Jeffrey Hoffeld, A.R. Penck, and Richard Rodríguez. Exh. cat. Künzelsau, Germany: Museum Würth, 2001.

Basquiat Editions. Texts by Richard D. Marshall and Franklin Sirmans. Los Angeles: DeSanctis Carr Fine Art, 2001.

Jean-Michel Basquiat a Cuneo. Texts by Roberto Baravalle, Phillip King, and Victor de Circasia. Exh. cat. Cuneo, Italy: Il Prisma Galleria d'Arte, 2001.

O'Brien, Glenn. *New York Beat: Jean-Michel Basquiat in "Downtown 81."* Photography by Edo Bertoglio and Maripol. Tokyo: Petit Grand Publishing, Inc., 2001.

Young, Kevin. *To Repel Ghosts: Five Sides in B Minor.* Cambridge, Mass.: Zoland Books, 2001.

2002

Als, Hilton. *Andy Warhol – Jean-Michel Basquiat: Collaboration Paintings.* Exh. cat. New York: Gagosian Gallery, 2002.

Lumpkin, Libby. *Jean-Michel Basquiat: War Paint.* Exh. cat. New York: Spike Gallery, 2002.

Mercurio, Gianni, and Mirella Panepinto, eds. *Jean-Michel Basquiat: Dipinti.* Texts by Henri-François Debailleux, Gianni Mercurio, Enrico Pedrini, and Angela Vettese. Exh. cat. Milan: Electa; Rome: Chiostro del Bramante, 2002.

Warhol, Basquiat, Clemente: Obras en colaboración. Exh. cat. Madrid: Aldeasa, 2002.

2003

Chalumeau, Jean-Luc. *Basquiat: 1960–1988.* Découvrons l'art, XXe siècle. Paris: Cercle d'art, 2003.

Emmerling, Leonhard. *Basquiat.* Cologne and London: Taschen, 2003.

Jean-Michel Basquiat. Histoire d'une oeuvre/The Work of a Lifetime. Essays by Johnny Depp, Alain Jouffroy, and Dina Vierny; translations by Vivian Rehberg-Decavèle. Exh. cat. Paris: Foundation Dina Vierny-Musée Maillol, 2003.

2004

Jean-Michel Basquiat: An Intimate Portrait. Texts by Annina Nosei and Michael J. Beam. Exh. brochure. Niagara Falls: Castellani Art Museum, Niagara University, 2004.

GROUP EXHIBITION CATALOGUES AND GENERAL STUDIES

1982

Baynard, Ed., curator. *Fast*. Exh. cat. New York: Alexander F. Milliken Gallery, 1982.

Bonito Oliva, Achille. *Avanguardia/Transavanguardia*. Milan: Electa, 1982.

———. *Transavanguardia: Italia/America*. Exh. cat. Modena: Galleria Civica del Comune di Modena, 1982.

Brooks, Johnson, and Thomas W. Styron. *Still Modern After All These Years*. Exh. cat. Norfolk, Va.: Chrysler Museum of Art, 1982.

Cortez, Diego. *The Pressure to Paint*. Exh. cat. New York: Marlborough Gallery, 1982.

Fuchs, Rudi H., ed. *Documenta 7: Kassel*. Exh. cat. Kassel: P. Dierichs, 1982.

Haenlein, Carl. *New York Now*. Exh. cat. Hannover: Kestner-Gesellschaft, 1982.

Komac, Dennis L. *Body Language: A Notebook on Contemporary Figuration*. Exh. cat. San Diego: University Art Gallery, San Diego State University, 1982.

Stewart, Albert. *New New York*. Exh. cat. Tallahassee: Florida State University Fine Arts Gallery, 1982.

1983

Expressive: Malerei nach Picasso. Exh. cat. Basel: Galerie Beyeler, 1983.

Hannart, John G. *1983 Biennial Exhibition*. Texts by Barbara Haskell, Richard D. Marshall, and Patterson Sims. New York: Whitney Museum of American Art, 1983.

Honnef, Klaus. *Back to the USA: Amerikanische Kunst der Siebziger und Achtziger*. Bonn: Rheinisches Landesmuseum, 1983.

Mary Boone and Her Artists. Exh. cat. Tokyo: Seibu Museum of Art, 1983.

Shafrazi, Tony. *Champions*. Exh. cat. New York: Tony Shafrazi Gallery, 1983.

Terminal New York. Curated by Ted Castle, Rhonda Zwillinger, Carol Waag. New York, 1983.

1984

Alinovi, Francesca. *Arte di frontiera – New York Graffiti*. Milan: Mazzotta, 1984.

Becker, Astrid, Wolfgang Becker, and Ardi Poels. *Aspekte amerikanischer Kunst der Gegenwart*. Exh. cat. Aachen: Sammlung Ludwig, 1984.

Diacono, Mario. *Verso una nuova iconografia*. Reggio Emilia, Italy: Collezione Tauma, 1984.

Fox, Howard N., Miranda McClintic, and Phyllis D. Rosenzweig. *Content: A Contemporary Focus, 1974–1984*. Exh. cat. Washington, D.C.: Hirshhorn Museum and Sculpture Garden, Smithsonian Institution, 1984.

Jacobs, Joseph. *Since the Harlem Renaissance: 50 Years of Afro-American Art*. Exh. cat. Lewisburg, Pa.: Center Gallery of Bucknell University, 1984.

Kardon, Janet. *The East Village Scene*. Exh. cat. Philadelphia: Institute of Contemporary Art, University of Pennsylvania, 1984.

Kuroiwa, Kyosuke, ed. *Painting Now: The Restoration of Painterly Figuration*. Exh. cat. Kitakyushu, Japan: Kitakyushu Municipal Museum of Art, 1984.

Little Arena: Drawings and Sculptures from the Collection Adri, Martin and Geertjan Visser. Exh. cat. Otterlo: Rijksmuseum Kröller-Müller, 1984.

McShine, Kynaston, ed. *An International Survey of Recent Painting and Sculpture*. Exh. cat. New York: The Museum of Modern Art, 1984.

Metzger, Robert P. *American Neo-Expressionists*. Introduction by Larry Aldrich. Exh. cat. Ridgefield, Conn.: The Aldrich Museum of Contemporary Art, 1984.

Painting and Sculpture Today. Exh. cat. Indianapolis: Museum of Art, 1984.

Painting Now: Jean-Michel Basquiat, Sandro Chia, Francesco Clemente, Enzo Cucchi, David Salle, Salomé, Julian Schnabel. Exh. cat. Nagoya: Akira Ikeda Gallery, 1984.

Via New York. Exh. cat. Montreal: Musée d'Art Contemporain, 1984.

1985

Campbell, Eduard, et al. *Das Oberengadin in der Malerei, 18. Jahrhundert bis zur Gegenwart*. Exh. cat. Pontresina: Der Verkehrsverein, 1985.

The Door. Exh. cat. New York: Annina Nosei Gallery, 1985.

Felshin, Nina, ed. *Focus on the Image: Selection from the Rivendell Collection*. Texts by Thomas McEvilley and Nina Felshin. Exh. cat. San Francisco: The Art Museum Association of America, 1985.

Guenther, Bruce. *States of War: New European and American Paintings*. Exh. cat. Seattle: Seattle Art Museum, 1985.

7000 Eichen. Exh. cat. Tübingen, Germany: Kunsthalle Tübingen, 1985.

Nouvelle Biennale de Paris. Exh. cat. Paris: Electeur Moniteur, 1985.

Vom Zeichnen: Aspekte der Zeichnung, 1960–1985. Exh. cat. Frankfurt am Main: Frankfurter Kunstverein, 1985.

1986

Cortez, Diego. *Collection Peter Brams: Jean-Michel Basquiat, Gilbert & George, Milan Kunc, David McDermott & Peter McGough, Philip Taaffe, Rosemary Trockel*. Exh. cat. Clinton, N.Y.: Fred L. Emerson Gallery, 1986.

Detterer, Martina, and Peter Weiermair, eds. *Prospect 86: Eine internationale Ausstellung aktueller Kunst*. Exh. cat. Frankfurt am Main: Frankfurter Kunstverein, 1986.

Hunter, Sam, and Malcolm R. Daniel. *An American Renaissance: Painting and Sculpture since 1940*. Exh. cat. Fort Lauderdale: Fort Lauderale Museum of Art; published by Abbeville Press, New York, 1986.

Jung, Hugo, and Ingrid Jung. *Zeichen, Symbole, Graffiti in der aktuellen Kunst: Sammlung Jung III*. Aachen: Suermondt-Ludwig Museum und Museumverein, 1986.

Laursen, Steingrim, ed. *Portraet af en samler/Portrait of a Collector: Stephane Janssen*. Exh. cat. Humlebaek,

Denmark: Louisiana Museum of Modern Art, 1986.

Modern Art Market. Tokyo: Matsuya Ginza, 1986.

Naivety in Art. Text by Seiji Oshima, Dina Vierny, Sheldon Williams, Herbert Waide Hemphill, and Gail Mishkin. Exh. cat. Tokyo: Setegaya Art Museum, 1986.

Sims, Patterson. *Figure as Subject: The Last Decade*. Exh. cat. New York: Whitney Museum of American Art, 1986.

Sims, Patterson and Suzanne Stroh. *1976–1986: Ten Years of Collecting Contemporary American Art; Selections from the Edward R. Downe, Jr., Collection*. Exh. cat. Wellesley, Mass.: Wellesley College Museum, 1986.

Speyer, A. James, and Neal David Benezra. *75th American Exhibition*. Exh. cat. Chicago: The Art Institute of Chicago, 1986.

1987

Fox, Howard N. *Avant-Garde in the Eighties*. Exh. cat. Los Angeles: Los Angeles County Museum of Art, 1987.

Gassen, Richard W., Roland Scotti, and Gabriele Gassen *New York Graffiti*. Exh. cat. Ludwigshafen, Germany: Wilhelm-Hack-Museum, 1987.

America Europa dalla collezione Ludwig. Exh. cat. Florence: Forte Belvedere, 1987.

Schwartzman, Allan. *After Street Art*. Boca Raton, Fla.: Boca Raton Museum of Art, 1987.

1988

Collectiva 1. Exh. cat. Barcelona: Galerie Berini, 1988.

Sims, Patterson. *Figure as Subject: The Revival of Figuration since 1975. Selections from the Permanent Collection of the Whitney Museum of American Art*. Exh. cat. New York: Whitney Museum of American Art, 1988.

1989

Pellizzi, Francesco, Joseph Masheck, Pamela Gettinger, and David Shapiro. *1979–1989: American, Italian, Mexican Art from the Collection of Francesco Pellizzi*. Exh. cat. Hempstead, N.Y.: Hofstra Museum, Hofstra University, 1989.

Powell, Richard J. *The Blues Aesthetic: Black Culture and Modernism*. Exh. cat. Washington, D.C.: Washington Project for the Arts, 1989.

1990

Collins, Tricia, and Richard Milazzo. *The Last Decade: American Artists of the 1980s*. Essay by Robert Pincus Witten. Exh. cat. New York: Tony Shafrazi Gallery, 1990.

The Decade Show: Frameworks of Identity in the 1980s. Text by C. Carr, David Deitcher, Jimmie Durham, Guillermo Gómez-Peña, Julia P. Herzberg, Susan Torruella Leval, Eunice Lipton, Margo Machida, Micki McGee, Sharon F. Patton, Lowery Stokes-Sims, Laura Trippi, Gary Sangstar, and Judith Wilson. Chronology by Thelma Golden. Ed. Kinshasha Holman-Conwill, Nilda Peraza, and Marcia Tucker. Exh. cat.

New York: Museum of Contemporary Hispanic Art, The New Museum of Contemporary Art and The Studio Museum in Harlem, 1990.

21 Jahre Internationale Kunstmesse Basel/Art 21 '90. Exh. cat. Düsseldorf: Galerie Hans Mayer, 1990.

Pharmakon '90. Text by Jan Avgikos, Achille Bonito Oliva, and Motoaki Shinohara. Exh. cat. Tokyo: Akira Ikeda Corporation, 1990.

1991

Belli, Gabriella, and Jerry Saltz. *American Art of the 80s*. Exh. cat. Trento, Italy: Museo d'Arte Moderna e Contemporanea di Trento e Rovereto, 1991.

Cervantes, Miguel, and Charles Merewether. *Mito y Magia en América: Los Ochenta*. Text by Francesco Pellizzi, Alberto Ruy Sanchez, Peter Schjeldahl, and Edward J. Sullivan. Exh. cat. Monterrey, Mexico: Museo de Arte Contemporáneo de Monterrey, 1991.

Danoff, I. Michael, and Colleen Vojvodich. *Compassion and Protest: Recent Social and Political Art from the Eli Broad Family Foundation Collection*. Texts by David Cateforis, Michelle Myers, John Hutton, Rebecca Solnit, and Carol Squires. Exh. cat. San Jose: San Jose Museum of Art, 1991.

Kertess, Klaus. *Drawing Acquisitions 1980–1991: Selections from the Permanent Collection of the Whitney Museum of American Art*. Exh. cat. New York: Whitney Museum of American Art, 1991.

Rosenberg, Barry A., with Teresa Schainat. *Words & #s*. Essays by Barry A. Rosenberg and Carol A. Nathanson. Exh. cat. Dayton, Ohio: Museum of Contemporary Art, Wright State University, 1991.

Storr, Robert, and Judith Tannenbaum. *Devil on the Stairs: Looking Back on the Eighties*. Exh. cat. Philadelphia: Institute of Contemporary Art, University of Pennsylvania, 1991.

1992

Dickhoff, Wilfried, ed. *Ars pro Domo: Zeitgenössische Kunst aus Kölner Privatbesitz*. Exh. cat. Cologne: Gesellschaft für Moderne Kunst am Museum Ludwig, 1992.

Espirit de New York: Paintings and Drawings. Exh. cat. Amsterdam: Galerie Barbara Farber, 1992.

Hollevoet, Christel, Karen Jones, and Timothy Nye. *The Power of the City/The City of Power*. Exh. cat. New York: Whitney Museum of American Art, 1992.

Jean-Michel Basquiat, Jonathan Borofsky, Richard Bosman, Kang So Lee, Terry Winters. Exh. cat. New York: Haenah-Kent Gallery, 1992.

Paris Connections: African American Artists in Paris. Texts by Ted Joans, Theresa Leininger, and Marie-Françoise Sanconie. Exh. cat. San Francisco: Bomani Gallery and Jernigan Wicker Fine Arts, 1992.

Rose, Bernice. *Allegories of Modernism: Contemporary Drawing*. Exh. cat. New York: The Museum of Modern Art, 1992.

Yvon Lambert collectionne. Exh. cat. Villeneuve d'Ascq, France: Musée d'Art Moderne de la Communauté Urbaine de Lille, 1992.

Zeichen, Symbole, Graffiti in der aktuelle Kunst. Exh. cat. Aachen: Suermondt-Ludwig-Museum und Museumverein, 1992.

1993

Et tous ils chagent le monde. IIe Biennale d'Art Contemporain de Lyon. Exh. cat. Paris: Réunion des Musées Nationaux, 1993.

Lord, Catherine, ed. *The Theater of Refusal: Black Art and Mainstream Criticism.* Exh. cat. Irvine, California: Fine Arts Gallery, University of California, 1993.

1994

From Beyond the Pale: Art and Artists at the Edge of Consensus. Texts by Declan McGonagle, Thomas McEvilley, Eamonn P. Kelly, Nuala Ní Dhomhnaill, and David Frankel. Dublin: Irish Museum of Modern Art, 1994.

The Harmon and Harriet Kelley Collection of African American Art. Text by Gylbert Garvin Coker and Corrine L. Jennings. Exh. cat. San Antonio: San Antonio Museum of Art, 1994.

Maîtres modernes et contemporains. Exh. cat. Paris: Galerie Jérôme de Noirmont, 1994.

The Shaman as Artist/The Artist as Shaman. Exh. cat. Aspen: Aspen Art Museum, 1994.

1995

New York Time: Drawings of the Eighties. Exh. cat. Greenwich, Conn.: The Bruce Museum, 1995.

Passions privées. Exh. cat. Paris: Musée d'Art Moderne de la Ville de Paris, 1995.

1996

Comme un oiseau. Text by Hervé Chandès, Claude Lévi-Strauss et al. Exh. cat. Paris: Fondation Cartier pour l'Art Contemporain, 1996.

Nahon, Pierre. *Quelques impressions d'Afrique.* Exh. cat. Paris: Editions de la Différence with Galerie Beaubourg, 1996.

Rubin, David S. *Bill Traylor (c. 1854–1947), Philip Guston (1913–1980), Jean-Michel Basquiat (1960–1988), Gary Komarin (1951–).* Exh. cat. New York: John McEnroe Gallery, 1996.

1997

Folley-Cooper, Marquette, Deborah Macanic, Janice McNeil, comps. *Seeing Jazz: Artists and Writers on Jazz.* Edited by Elizabeth Goldson. Foreword by Clark Terry; afterword by Milt Hinton. Exh. cat. Washington, D.C.: Smithsonian Institution Traveling Exhibition Service, 1997.

Marshall, Richard D., and Leo Malca. *In Your Face: Keith Haring, Jean-Michel Basquiat, Kenny Scharf.* Exh. cat. New York: Malca Fine Art, 1997.

Mercurio, Gianni, and Mirella Panepinto. *American Graffiti.* Exh. cat. Naples: Electa Napoli, 1997.

1998

Oeuvres sur papier et photographies: La Collection Yvon Lambert, dialogue avec des artistes contemporains. Exh. cat. Yokohama, Japan: APT International, 1998.

Storsve, Jonas, and Guy Tosatto. *Au fil du trait: De Matisse à Basquiat. Collection Centre Georges Pompidou, Musée National d'Art Moderne, Cabinet d'Art Graphique.* Exh. cat. Paris: Centre Georges Pompidou; Nîmes: Carré d'Art, 1998.

30th Anniversary of Mr. Chow: Portrait Collection. Exh. cat. Beverly Hills, California: PaceWildenstein; London: Mayor Gallery, 1998.

1999

Abstraction, Gesture, Ecriture: Paintings from the Daros Collection. Contributions by Rosalind Krauss, Richard D. Marshall, Yve-Alain Bois, Brenda Richardson, and Enrique Juncosa. Zurich and New York: Scalo, 1999.

Ault, Julie, Brian Wallis, Marianne Weems, and Philip Yenawine. Art Matters: *How the Culture Wars Changed America.* New York: New York University Press, 1999.

Brehm, Margrit Franziska. *Bad-Bad: That Is a Good Excuse.* Exh. cat. Baden-Baden: Staatliche Kunsthalle Baden-Baden, 1999.

Friis-Hansen, Dana, Robert Atkins, and Greg Tate. *Other Narratives.* Exh. cat. Houston: Contemporary Arts Museum, 1999.

Hobbs, Robert, Suzanne Feldman, and Suzanne Farver. *20 Years/20 Artists.* Exh. cat. Aspen: Aspen Art Museum; Seattle: University of Washington Press, 1999.

Pfeffer-Lévy, Géraldine, and Nathalie Prat-Couadau. *Portrait Collection of Mr. Chow.* Exh. cat. Paris: Galerie Enrico Navarra, 1999.

Phillips, Lisa. *The American Century: Art and Culture, 1900–2000,* vol. 2: *1950–2000.* Exh. cat. New York: Whitney Museum of American Art, 1999.

Pittura dura: Dal Graffitismo alla Street Art. Exh. cat. Milan: Electa, 1999.

2000

Bernard, Catherine. *Jazz and Visual Improvisations.* Essay by Stanley Crouch. Exh. cat. Katonah, N.Y.: Katonah Museum of Art, 2000.

Haiti: Anges et démons. Exh. cat. Paris: Hoëbeke; Halle Saint-Pierre, 2000.

Prat, Jean-Louis. *La Nu au XXe siècle.* Exh. cat. Saint-Paul, France: Fondation Maeght, 2000.

2001

Barron, Stephanie, and Lynn Zelevansky. *Jasper Johns to Jeff Koons: Four Decades of Art from the Broad Collections.* Essays by Thomas Crow et al. Exh. cat. Los Angeles: Los Angeles County Museum of Art in association with Harry N. Abrams, 2001. Spanish ed.: *De Jasper Johns a Jeff Koons: Cuatro décadas de arte de las Colecciones Broad.* Bilbao: Fundación del Museo Guggenheim Bilbao, 2003.

Bonito Oliva, Achille. *Le Tribù dell'arte.* Exh. cat. Rome: Galleria Comunale d'Arte Moderna e Contemporanea, 2001.

Clearwater, Bonnie. *Mythic Proportions: Painting in the 1980s.* Exh. cat. North Miami: Museum of Contemporary Art, 2001.

Dimitriadis, Greg, and Cameron McCarthy. *Reading and Teaching the Postcolonial : From Baldwin to Basquiat and Beyond.* New York: Teachers College Press, Columbia University, 2001.

Di Pietrantonio, Giacinto. *In fumo: Arte, fumetto, comunicazione/Art, Comics, Communication.* Exh. cat. Bergamo: Galleria d'Arte Moderna e Contemporanea; Lubrina, 2001.

One Planet under a Groove: Hip Hop and Contemporary Art. Essays by Lydia Yee, Franklin Sirmans, and Greg Tate. Exh. cat. New York: Bronx Museum of the Arts, 2001.

Pincus-Witten, Robert. *Naked since 1950.* Exh. cat. New York: C & M Arts, 2001.

2002

Årbu, Grete. ed. *New York Expression.* Contributions by Démosthènes Davvetas, Glenn O'Brien, and Tama Janowitz. Exh. cat. Bergen, Norway: Bergen Kunstmuseum, 2002.

Chassman, Gary Miles. *In the Spirit of Martin: The Living Legacy of Dr. Martin Luther King, Jr.* Exh. cat. Atlanta: Tinwood Books, 2002.

2003

Cassel, Valerie, Roger Sabin, and Bernard Welt. *Splat Boom Pow! The Influence of Comics in Contemporary Art.* Exh. cat. Houston: Contemporary Arts Museum Houston, 2003.

Harris, Michael D. *Colored Pictures: Race and Visual Representation.* Chapel Hill: University of North Carolina Press, 2003.

Stapp, William F., Pete Hamill, Milton Esterow, and Tracey L. Avant. *Portrait of the Art World: A Century of ARTnews Photographs.* Exh. cat. Washington, D.C.: National Portrait Gallery, Smithsonian Institution, in association with Yale University Press, 2003.

2004

Basilio, Miriam, Fatima Bercht, Deborah Cullen, Gary Garrels, and Luis Enrique Pérez-Oramas, eds. *Latin American & Caribbean Art: MoMA at El Museo.* Exh. cat. New York: Museo del Barrio, Museum of Modern Art, 2004.

Bonafoux, Pascal. *Moi! Autoportraits du XXe siècle.* Exh. cat. Milan: Skira, 2004.

ARTICLES

1978

Faflick, Philip. "SAMO© Graffiti: Boosh-Wah or CIA?" *The Village Voice,* December 11, 1978, p. 41.

1980

Deitch, Jeffrey. "Report from Times Square." *Art in America* 68 (September 1980), pp. 58–63.

1981

Ricard, Rene. "The Radiant Child." *Artforum* 20 (December 1981), pp. 35–43.

1982

DeAk, Edit, and Diego Cortez. "Baby Talk." *Flash Art* 16 (May 1982), pp. 34–38.

Deitch, Jeffrey. Review of Annina Nosei Gallery exhibition. *Flash Art* 16 (May 1982), pp. 49–50.

Drohohowska, Hunter. "Schnabel and Basquiat: Explosions and Chaos." *Los Angeles Weekly,* April 23–29, 1982.

"Face." *Artforum* 21 (September 1982), ill. p. 3.

Frackman, Noel, and Ruth Kaufmann. "Documenta 7: The Dialogue and a Few Asides." *Arts Magazine* 57 (October 1982), pp. 91–97.

Gablik, Suzi. "Report from New York: The Graffiti Question." *Art in America* 70 (October 1982), pp. 33–39.

"Installation Avanguardia/ Transavanguardia." *Arts Magazine* 57 (December 1982), ills. p. 79.

Liebmann, Lisa. "Jean-Michel Basquiat at Annina Nosei." *Art in America* 70 (October 1982), p. 130.

Pincus-Witten, Robert. "Jean-Michel Basquiat." *Los Angeles Times,* July 16, 1982.

Review of Annina Nosei Gallery exhibition. *Artforum* 20 (summer 1982), pp. 81–82.

Ricard, Rene. "The Pledge of Allegiance." *Artforum* 21 (November 1982), pp. 42–49.

"VII Epics versus the Fifty Nine Cent Halo." *Artforum* 21 (November 1982), ill. p. 11.

Smith, Roberta. "Mass Productions," review of the Annina Nosei exhibition. *The Village Voice,* March 23, 1982, p. 84.

"Untitled [Emilio Mazzoli Collection, Modena]." *Flash Art* 16 (May 1982), ill. p. 38.

Wilson, William. "N.Y. Subway Graffiti: All Aboard for L.A." *Los Angeles Times,* April 16, 1982.

1983

Basquiat, Jean-Michel. "Tuxedo." *Paris Review* 25, no. 87 (spring 1983), ills. pp. 205–15.

Castle, Ted. "Jean-Michel Basquiat." *Artistes* (Paris), no. 14 (January–February 1983).

Cohen, Ronny. "New Editions: Jean-Michel Basquiat." *Art News* 82 (April 1983), p. 84.

Cortez, Diego. "New York: Basquiat." *Domus,* no. 642 (September 1983), p. 99.

D'Avossa, A. "The Question of Graffiti." *Op. cit.,* no. 57 (May 1983), pp. 26–42.

Geldzahler, Henry. "Art. From Subways to SoHo: Jean-Michel Basquiat." *Interview* 13 (January 1983), pp. 44–46.

Hapgood, Susan. "New York: Jean-Michel Basquiat." *Flash Art,* no. 111 (March 1983), pp. 58–59.

Isaacs, Florence. "Jean-Michel Basquiat: Young Rising Star in Contemporary Art." *Visions* 2, no. 1 (1983), pp. 36–39.

Moufarrege, Nicolas A. "X Equals Zero, as in Tic-Tac-Toe." *Arts Magazine* 57, no. 6 (February 1983), pp. 116–21.

———. "East Village." *Flash Art*, no. 111 (March 1983), pp. 36–41.

Nilson, Lisbet. "Making It Neo." *Art News* 82 (September 1983), pp. 62–70.

Restany, Pierre. "El destino de la nueva imagen no es el neoexpresionismo de la transvanguardia." *Cimal*, no. 22 (December 1983), pp. 11–13.

Robbins, D. A., interviewer. "The 'Meaning' of 'New': The 70s/80s Axis, an Interview with Diego Cortez." *Arts Magazine* 57, no. 5 (January 1983), pp. 116–21.

Schutz, S. "'Back to the USA': Amerikanische Kunst Heute." *Die Kunst und das schöne Heim* 95, no. 12 (December 1983), pp. 827–34, 884–85.

Winter, Peter. "New York Now," review of Kestner-Gesellschaft exhibition. *Das Kunstwerk* 36 (February 1983), pp. 53–54.

Wintour, Anna. "Fall Fashion: Painting the Town." *New York*, August 29, 1983.

Woodville, Louisa. "Summer Group Show," review of Annina Nosei exhibition. *Arts Magazine* 58, no. 1 (September 1983), p. 18.

1984

Antonio, Emile de, and Jean-Michel Basquiat. "Art: Radical Views on 'Painters Painting.'" *Interview*, July 1984, pp. 48–51. Reprinted in *Emile de Antonio: A Reader*, ed. Douglas Kellner, Dan Streible, pp. 129–35. Visible Evidence series, no. 8. Minneapolis: University of Minnesota Press, 2000.

Castle, Frederick Ted. "Occurrences/ New York." *Art Monthly*, no. 73 (February 1984), pp. 15–17.

Cohen, Ronny. "Jumbo Prints: Artists Who Paint Big Want to Print Big." *ARTnews* 83, no. 8 (October 1984), pp. 80–87.

Glueck, Grace. "A Neo-Expressionist Survey That's Worth a Journey." *The New York Times*, July 22, 1984, pp. H25, H28.

"Graffiti Artists in the Netherlands." *Flash Art*, no. 116 (March 1984), p. 31.

Kleyn, R. "Protective Mimicry." *Vanguard* 13, no. 2 (March 1984), pp. 24–30.

Linker, Kate. "Jean-Michel Basquiat." *Artforum* 23 (October 1984), p. 91.

Lubell, Ellen. "New Kid on the (Auction) Block." *The Village Voice*, May 29, 1984, p. 45.

McEvilley, Thomas. "On the Manner of Addressing Clouds." *Artforum* 22 (June 1984), pp. 61–70.

Moufarrege, Nicolas A. Review of the Boone/Werner Gallery exhibition. *Flash Art*, no. 119 (November 1984), p. 41.

Moynehan, Barbara. "New York: The Mood and Market." *Flash Art*, no. 115 (January 1984), pp. 28–29.

"New York Graffiti," review of the Galerie Daniel Templon exhibition. *Connaissance des arts*, no. 386 (April 1984), p. 23.

Ponti, L. Lichitra. "House of Jean-Michel." *Domus*, no. 646 (January 1984), pp. 66–68.

Raynor, Vivien. "Art: Paintings by Jean-Michel Basquiat at Boone." *The New York Times*, May 11, 1984, p. C25.

Renard, Delphine. "Jean-Michel Basquiat: The Crude Sign?" *Art Press*, no. 81 (May 1984), pp. 11–12.

Review of the Mary Boone Gallery exhibition. *Art News* 83 (September 1984), pp. 167–68.

Tomkins, Calvin. "The Art World: Up from the I.R.T." *The New Yorker*, March 26, 1984, pp. 98–102.

1985

Acker, Kathy. "Jean-Michel Basquiat at the ICA." *Artscribe* 51 (March–April 1985), pp. 52–53.

Albertazzi, Liliana. "Graffiti, Post-Graffiti." *Arte en Colombia*, no. 27 (February 1985), pp. 60–63.

Baumgartner, Attilio. "Basquiats Bildersturm." *Welt am Sonntag*, March 10, 1985.

Galligan, Gregory. "Jean-Michel Basquiat: The New Paintings." *Arts Magazine* 59 (May 1985), pp. 140–41.

Heartney, Eleanor. "Basquiat/Warhol," review of the Tony Shafrazi Gallery exhibition. *Flash Art*, no. 125 (December–January 1985–86), p. 43.

Komac, Dennis. "An Aggressive Energy," review of the La Jolla Museum of Contemporary Art exhibition. *Artweek* 16 (June 1, 1985), p. 5.

Madoff, Steven Henry. "What Is Postmodern about Painting: The Scandinavia Lectures, II." *Arts Magazine* 60 (October 1985), pp. 59–64.

Mahoney, Robert. Review of Andy Warhol/Jean-Michel Basquiat at Tony Shafrazi Gallery. *Arts Magazine* 60 (November 1985), p. 135.

Marschall, E. "Post Graffiti." *Sztuka* 10, no. 4 (1985), pp. 46–48, 71–72.

McGuigan, Cathleen. "New Art, New Money: The Marketing of an American Artist." *The New York Times Magazine*, February 10, 1985, pp. 20–28, 32–35, 74.

Newhall, Edith. "Galleries." *New York*, September 16, 1985, pp. 56–58.

Newman, Michael. "'Primitivism' and Modern Art." *Art Monthly*, no. 86 (May 1985), pp. 6–9.

Pincus-Witten, Robert. "Entries: Becoming American." *Arts Magazine* 60 (October 1985), pp. 101–03.

Pincus-Witten, Robert, Timothy Greenfield-Sanders, and Mark Kostabi. "The New Irascibles: Portfolio of Six Portraits by Timothy Greenfield-Sanders, entries by Robert Pincus-Witten, Drawings by Mark Kostabi." *Arts Magazine* 60 (September 1985), pp. 102–10.

Raynor, Vivien. "Art: Basquiat, Warhol." *The New York Times*, September 20, 1985, p. C22.

Rosenblatt, Roger. "The Faith of the Young Artist." *Esquire*, December 1985, pp. 159–60.

Taylor, Paul. "A New Avenue for Art ... Madison." *Vogue*, February 1985, p. 80.

Tomkins, Calvin. "The Art World: Disco." *The New Yorker*, July 22, 1985, pp. 64–66.

Wechsler, Max. "Collaborations," review of Bruno Bischofberger exhibition. *Artforum* 23 (February 1985), p. 99.

1986

Bosetti, Petra. "Typographie aus dem Underground." *Art*, no. 12 (1986), pp. 126–27.

Hiromoto Nobuyuki. "Jean-Michel Basquiat." *Bijutsu techō*, July 1986, pp. 76–81.

Jones, R. "Andy Warhol/Jean Michel-Basquiat." *Arts Magazine* 60, no. 6 (February 1986), p. 110.

Perry, Pam. "Robots and Skeletons, Doodles and Nuances." *Creative Loafing*, March 1, 1986, p. 1B.

Schwabsky, Barry. Review of the Annina Nosei Gallery exhibition. *Arts Magazine* 60 (February 1986), pp. 129–30.

1987

Criton, Sonia. Review of the Daniel Templon Gallery exhibition. *Flash Art*, no. 133 (April 1987), p. 115.

Davvetas, Démosthènes. "Lines, Chapters, and Verses: The Art of Jean-Michel Basquiat." *Artforum* 25, no. 8 (April 1987), pp. 116–20.

Graw, Isabelle. "Waiting for Basquiat." *Wolkenkratzer Art Journal*, no. 1 (January–February 1987), pp. 44–51, 106–07.

Winter, Peter. Review of Kestner-Gesellschaft exhibition *Das Kunstwerk* 40 (February 1987), pp. 53–54.

1988

Als, Hilton. "Jean-Michel Basquiat, 1960–88." *The Village Voice*, August 30, 1988, p. 82.

Bienek, Horst. "Wenn er träumt, verändert er die Welt." *ART: Das Kunstmagazin*, no. 10 (October 1988), pp. 30–46.

Davvetas, Démosthènes. "Jean-Michel Basquiat: La ligne." *Artstudio*, no. 11 (winter 1988), pp. 42–51.

———. "Jean-Michel Basquiat." *New Art International*, October–November 1988, pp. 10–15.

Galligan, Gregory. "New York: More Post-Modern than Primitive." *Art International*, no. 5 (winter 1988), pp. 59–63.

Guidieri, Remo. "Autels du loa: À propos de Jean-Michel Basquiat." *Art Press*, no. 124 (April 1988), pp. 7–10.

Haden-Guest, Anthony. "Burning Out." *Vanity Fair*, November 1988, pp. 180–98.

Haring, Keith. "Remembering Basquiat." *Vogue*, November 1988, pp. 234–36.

Hays, Constance L. "Jean Basquiat, 27: An Artist of Words and Angular Images." *The New York Times*, August 15, 1988, p. D11.

———. "Friends Recall Young Artist with Music and Verse." *The New York Times*, November 6, 1988, p. 52.

Hoban, Phoebe. "SAMO© ... Is Dead: The Fall of Jean-Michel Basquiat." *New York*, September 26, 1988, pp. 36–44.

Hughes, Robert. "Jean-Michel Basquiat: Requiem for a Featherweight." *The New Republic*, November 21, 1988, pp. 34–36. Reprinted in Robert Hughes, *Nothing If Not Critical: Selected Essays on Art and Artists*, pp. 308–12. New York: Alfred A. Knopf, 1990.

Kramer, Hilton. "Will the Death of Basquiat Awaken the Art World to Its Slimier Side?" *The New York Observer*, August 31, 1988, pp. 1, 10.

Lipson, Karen. "Very Famous, Very Young." *New York Newsday*, September 1, 1988, part 2, pp. 4–5, 11.

"Malerei: Neun Beispiele (die achtziger Jahre)." *Du*, no. 8 (1988), pp. 54–65.

Mueller, Cookie. "Art and About." *Details*, November 1988, pp. 101–02.

Patron, Eugene J. "Jean-Michel Basquiat," obituary. *New Art Examiner* 16 (October 1988), p. 11.

Robinson, Walter, and Cathy Lebowitz. "Obituaries: Jean-Michel Basquiat." *Art in America* 76 (October 1988), p. 226.

Schjeldahl, Peter. "Martyr without a Cause." *7 Days*, September 21, 1988, pp. 53–54.

Schwartzman, Allan. "The Business of Art: Banking on Basquiat." *Arts Magazine* 63 (November 1988), pp. 25–26.

Shapiro, David. "Jean-Michel Basquiat." *Beaux Arts Magazine*, no. 53 (January 1988), pp. 70–73.

Wilson, William. "The Meaning of Jean-Michel Basquiat's Life." *Los Angeles Times*, September 4, 1988, pp. 5, 18.

Wines, Michael. "Jean-Michel Basquiat: Hazards of Sudden Success and Fame." *The New York Times*, August 27, 1988, pp. 9, 14.

1989

Arnault, Martine. "Basquiat, from Brooklyn." *Cimaise* 36 (November–December 1989), pp. 41–44.

Bianchi, Paolo. "Outsidertum am Beispiel Jean-Michel Basquiat." *Kunstforum International*, no. 101 (June 1989), pp. 96–103.

Castle, Frederick Ted. "Court Battle Looming over Rights to Basquiat Estate." *Artnewsletter* 14, no. 22 (June 27, 1989).

———. "Saint Jean-Michel." *Arts Magazine* 63 (February 1989), pp. 60–61.

Cohen, Ronny. "Art Is Priceless." *Art & Auction* 11 (June 1989), pp. 166–71.

Decker, Andrew. "The Price of Fame." *Art News* 88, no. 1 (January 1989), pp. 96–101.

Greenspan, Stuart. "Art2." *Art & Auction* 11 (March 1989), pp. 138–41.

Joppolo, Giovanni. "Basquiat, le négropolitain." *Opus International*, no. 116 (November–December 1989), pp. 54–55.

Kuspit, Donald B. Review of the Annina Nosei Gallery exhibition. *Artforum* 27 (March 1989), pp. 130–31.

Leigh, C. Review of the Tony Shafrazi Gallery exhibition. *Flash Art*, no. 146 (May–June 1989), pp. 132–33.

Lewis, Joe. "Basquiat: Shrewd as Well as Unruly, the Late Jean-Michel Basquiat Learned His Art from Both the Masters and the Streets." *Contemporanea* 2 (July–August 1989), pp. 78–83.

Lipson, Karin. "Artist's Legacy: High-Stakes Legal Battle." *New York Newsday*, July 13, pp. 3, 12.

Liu, C. "The Umbilicus of Limbo." *Flash Art*, no. 146 (May–June 1989), pp. 102–05.

McKenzie, Michael. "Post-Warhol no artists tachi" [Post-Warhol artists]. *Mizue*, no. 950 (spring 1989), pp. 78–105.

Merkin, Richard. "Farewell, My Unlovelies." *Go*, April 1989, pp. 112, 116–17.

Pincus-Witten, Robert. "African Rococo: The Persistence of James Brown." *Arts Magazine* 64, no. 3 (November 1989), pp. 68–73.

Review of the Galerie Enrico Navarra exhibition. *L'Oeil*, no. 412 (November 1989), p. 83.

Review of *Warhol-Basquiat: Collaborations*: Galerie Didier Imbert exhibition. *L'Oeil*, no. 412 (November 1989), p. 82.

Smith, Roberta. "Outsiders Who Specialized in Talking Pictures." *The New York Times*, November 19, 1989, pp. H35, H41.

Spector, Nancy. "Funeral for a Friend." *Art & Auction* 11 (January 1989), p. 28.

Tate, Greg. "Nobody Loves a Genius Child: Jean-Michel Basquiat, Lonesome Flyboy in the 80s Art Boom Buttermilk." *The Village Voice*, November 14, 1989, pp. 31–35. Reprinted in Greg Tate, *Flyboy in the Buttermilk: Essays on Contemporary America*, pp. 231–44. New York: Simon & Schuster, A Fireside Book, 1992.

Taylor, Paul. "The Resurrection of Jean-Michel Basquiat." *Fame*, January 1989, pp. 18–21.

Winter, Peter. "Das zeichnerische Werk," review of the Kestner-Gesellschaft exhibition. *Das Kunstwerk* 42 (December 1989), pp. 70–72.

1990

Adams, Brooks. "Warhol et les années 90." *Art Press*, no. 148 (June 1990), pp. 29–32.

Berko, Susan. Review of the Galerie Enrico Navarra exhibition. *Flash Art*, no. 151 (March–April 1990), pp. 153–54.

Haring, Keith. "Warhol & Basquiat." *Kunstforum International*, no. 107 (April–May 1990), pp. 179–83.

Hauser, Enrique. "The Leonardo Addiction of Jean-Michel Basquiat." *Achademia Leonardi Vinci: Journal of Leonardo Studies and Bibliography of Vinciana* 3 (1990), pp. 93–100.

Hess, Elizabeth. "Burning Down the House." *The Village Voice*, November 20, 1990, p. 107.

Kimmelman, Michael. "Jean-Michel Basquiat: Drawings." *The New York Times*, November 9, 1990, p. C26.

Mantegna, Gianfranco, interviewer. "Ouattara." *Journal of Contemporary Art* 3, no. 2 (fall–winter 1990), pp. 26–33.

Reid, Calvin. "Kind of Blue." *Arts* 64, no. 7 (1990), pp. 54–55.

Review of the Galerie Fabien Boulakia exhibition. *L'Oeil*, no. 423 (October 1990), p. 96.

Rubell, Jason, interviewer. "Keith Haring: The Last Interview." *Arts Magazine* 65, no. 1 (September 1990), pp. 52–59.

Thompson, Robert Farris. "Requiem for the Degas of the B-boys: Keith Haring." *Artforum* 28 (May 1990), pp. 135–41.

Winter, Peter. "The Drawings of Jean-Michel Basquiat," review of the Kestner-Gesellschaft exhibition. *Art International*, no. 10 (spring 1990), pp. 94–95.

1991

Caley, Shaun. "Life Is Fresh, Crack Is Wack." *Kunstforum International*, no. 112 (March–April 1991), pp. 308–11.

Cameron, Dan. "Shifting Tastes." *Art & Auction* 14 (September 1991), pp. 78–79.

Cyphers, Peggy. Review of the Robert Miller Gallery exhibition. *Arts Magazine* 65 (February 1991), pp. 97–98.

Glueck, Grace. "The Basquiat Touch Survives the Artist in Shows and Courts." *The New York Times*, July 22, 1991, pp. C13–C14.

————. "Judge Dismisses Claim against Basquiat Estate." *The New York Times*, September 2, 1991, p. 15.

Hauser, Enrique. "Basquiat's 'Madonna Litta.'" *Achademia Leonardi Vinci: Journal of Leonardo Studies and Bibliography of Vinciana* 4 (1991), pp. 262–63.

Lufy, C. "Eclecticism in the Arty Ward." *Art News* 90 (March 1991), pp. 106–07.

Piguet, Philippe. "À propos de collage." *L'Oeil*, no. 429 (April 1991), pp. 52–57.

Rankin-Reid, Jane. "One Warrior's Words: The Texts of Jean-Michel Basquiat." In *Binocular: Focusing-Writing-Vision*, pp. 67–98. Sydney: Moët & Chandon, 1991.

Walker, Richard W. "The Basquiat Battle." *Art News* 90 (May 1991), p. 38.

1992

Baal-Teshuva, Jacob. Review of the Whitney's traveling exhibition. *Cimaise* 39 (November–December 1992), pp. 90–91.

"Basquiat News Update: The Many Lawsuits that Circulate around His Unsold Works and Confused Estate." *Flash Art*, no. 163 (March–April 1992), pp. 129ff.

Gopnik, Adam. "The Art World: Madison Avenue Primitive." *The New Yorker* 68, no. 38 (November 9, 1992), pp. 137–39.

Hughes, Robert. "The Purple Haze of Hype," review of the Whitney's traveling exhibition. *Time*, November 16, 1992, pp. 88, 90.

Jacques, Geoffrey. "Haitian-American Artist's Work Reflects Anger, Pain." *New York Amsterdam News*, March 28, 1992, p. 30.

Januszczak, Waldemar. "Voodoo Meets Graffiti in the Twilight World of SAMO." *The Guardian*, August 25, 1988.

McEvilley, Thomas. "Royal Slumming: Jean-Michel Basquiat Here Below." *Artforum* 31, no. 3 (November 1992), pp. 92–97.

"Quelle place pour Basquiat?," review of the Whitney's traveling exhibition. *Connaissance des arts*, no. 489 (November 1992), p. 28.

Radaelli, Severo. "Ragazzo negro dai graffiti ai miliardi." *Arte* 22, no. 226 (February 1992), pp. 64–69.

Sanconie, Maïca. "Noire Amérique." *Beaux Arts Magazine*, no. 105 (October 1992), pp. 54–64.

Sayre, Henry M. "Pursuing Authenticity: The Vernacular Moment in Contemporary American Art." *South Atlantic Quarterly* 91, no. 1 (1992), pp. 139–60.

Sichel, Berta. "Jean-Michel Basquiat." *Art Nexus*, no. 6 (October 1992), pp. 68–71, 186–88.

Smith, Roberta. "Basquiat: Man for His Decade," review of the Whitney's traveling exhibition. *The New York Times*, October 23, 1992, pp. C1, C20.

1993

András, Edit. "Mi zajlik a művészetben odaát, és mi kerül ide át?" (What's going on in art over there, and what gets here?). *Új Művészet* (Budapest) 4, no. 7 (July 1993), pp. 19–23.

Chin, Daryl. "Those Little White Lies." *M/E/A/N/I/N/G*, no. 13 (May 1993), pp. 24–30.

Francblin, Catherine. "And They All Do Change the World." *Art Press*, no. 183 (September 1993), pp. 36–40, E16–20.

Gulden, Dona N. "Lyon: Keine Scheu vor Grossen Namen." *Ambiente*, no. 10 (October 1993), pp. 58–64.

Hall, Charles. Review of the Crane Gallery exhibition. *Arts Review* 45 (January 1993), p. 54.

Heartney, Eleanor. Review of the Whitney's traveling exhibition. *Art News* 92 (January 1993), p. 129.

hooks, bell. "Altars of Sacrifice: Re-membering Basquiat," review of the Whitney's traveling exhibition. *Art in America* 81, no. 6 (June 1993), pp. 68–75, 117. Reprinted in bell hooks, *Art on My Mind: Visual Politics*, pp. 35–48. New York: New Press, 1995.

Kino, Carol. "Basquiat in Armani." *Modern Painters* 6, no. 1 (spring 1993), pp. 72–76.

Larson, Kay. "Jean-Michel Basquiat." *Galeries Magazine*, February–March 1993, pp. 75–77.

Markovich, Annie. "Bra bilder av en dålig resa" (Good pictures of a bad journey). *Paletten*, no. 4 (1993), p. 17.

McCormick, Carlo. Review of the Whitney's traveling exhibition. *Art & Antiques* 15 (January 1993), p. 85.

O'Grady, Lorraine. "A Day at the Races: Basquiat and the Black Art World." *Artforum* 31 (April 1993), pp. 10–12.

Review of the Musée d'Art Contemporain, Pully/Lausanne exhibition. *L'Oeil*, no. 454 (September 1993), p. 83.

Tully, Judd. "A Boost for Basquiat: Renewed Critical Interest in the Artist's Career." *Art News* 92 (March 1993), p. 27.

1994

D'Arcy, David. "Hollywood Turns to SoHo for Inspiration." *Art & Antiques* 17 (summer 1994), p. 19.

Debailleux, Henri-François. "Another Set of Images." *Art Press*, no. 189 (March 1994), pp. 38–45.

Foney, E. L. "A Visual Arts Encounter: African Americans and Europe," review

of the Palais du Luxembourg exhibition. *International Review of African American Art* 11, no. 4 (1994), p. 63.

Gordon, A. "The Theater of Refusal: Black Art and Mainstream Criticism." *Artweek* 25 (January 6, 1994), p. 19.

Schaffner, I. "Cursive: Writing in Contemporary Art." *Parkett*, no. 42 (1994), pp. 114–22.

Stein, Deidre. "The Wild Child," review of the book, *Life Doesn't Frighten Me*. *Art News* 93 (March 1994), p. 21.

Vogel, Carol. "Inside Art ... Authenticating Basquiat." *The New York Times*, May 6, 1994, p. C23.

————. "Inside Art ... a Basquiat Verdict." *The New York Times*, December 2, 1994, p. C28.

1995

"Acquisitions 1992–94 at the Musée National d'Art Moderne, Centre Georges Pompidou, Paris." *Burlington Magazine* 137, no. 1105 (April 1995), pp. 283–88.

Arthur, John. Review of the Mount Holyoke College Art Museum exhibition, *Jean-Michel Basquiat: The Blue Ribbon Paintings*. *Art New England* 16 (February–March 1995), pp. 46–48.

Ebony, David. "Art Stars Go Hollywood." *Art in America* 83 (May 1995), p. 31.

Geer, Suvan, and Sandra Rowe. "Thoughts on Graffiti as Public Art." *Public Art Review* 6, no. 2 (spring–summer 1995), pp. 24–26.

Jennings, K. F. "Bruce Museum/ Greenwich: A New York Time, Selected Drawings of the Eighties." *Art New England* 16 (April–May 1995), p. 59.

McKenzie, Michael. "Visionaries: Beauty for Now and for the Future." *SunStorm Fine Art* 20, no. 4 (autumn 1995), pp. 49–55.

Thon, Ute. "Art Stars Go Hollywood." *Kunstforum International*, no. 132 (November 1995–January 1996), p. 456.

Zimmer, William. "An Odd Pairing, with Interesting Contrast: Two Retrospectives at the Wadsworth." *The New York Times*, March 5, 1995, p. CN20.

1996

Adams, B. "Basquiat," review of Schnabel's film. *Art in America* 84 (September 1996), pp. 39–40.

"Basquiat a Londra Subway e sregolatezza." *L'espresso* 42, no. 11 (1996), pp. 124–27.

"Basquiat, bref et grand," review of the Galerie Enrico Navarra exhibition. *Connaissance des arts*, no. 528 (May 1996), p. 18.

Bevan, Roger. "Just How Good Was Jean-Michel Basquiat?," review of the Serpentine Gallery exhibition. *Art Newspaper* 7 (March 1996), p. 9.

Bonami, Francesco. "Schnabel on Basquiat." *Flash Art*, no. 190 (October 1996), pp. 110–11.

Bowie, David. "Basquiat's Wave." *Modern Painters* 9, no. 1 (spring 1996), pp. 46–47.

Boyd, William. "Basquiat: Brief Candle," review of Schnabel's film. *Modern Painters* 9, no. 4 (winter 1996), pp. 74–75.

Chang, C. "Mind over Matter: The Artiste as Filmmaker." *Film Comment* 32 (September–October 1996), pp. 54–56.

Coleman, Beth. "*Basquiat*: An American Success Story, Miramax Films." *NKA: Journal of Contemporary African Art*, no. 5 (fall 1996), p. 71.

Cotter, Holland. "Jean-Michel Basquiat: 'A Tribute,'" review of the Tony Shafrazi Gallery exhibition. *The New York Times*, November 1, 1996, p. C32.

Couturier, Elisabeth. "Basquiat, Super Star." *Beaux Arts Magazine*, no. 145 (May 1996), pp. 88–93, 134.

Cronau, Sabine. "Drei Stars tauschen ihre Leinwände." *ART: Das Kunstmagazin*, no. 2 (February 1996), pp. 92–93.

Denby, David. "With Jeffrey Wright's Performance at Its Core, Basquiat Is Wittily Tender," review of Schnabel's film. *New York* 29, no. 32 (August 19, 1996), p. 46.

"Eventi/Warhol–Basquiat: Andy & Friends." *L'espresso* 42, no. 43 (1996), pp. 130–39.

Fairbrother, Trevor. "Double Feature," collaborative paintings of Andy Warhol and Jean-Michel Basquiat. *Art in America* 84, no. 9 (September 1996), pp. 76–83.

Gardner, Paul. "Julian Schnabel: 'I can do what I want without compromising.'" *Art News* 95 (October 1996), pp. 54–56.

Gaskins, Bill. "What's Wrong with This Picture: Reviewing Basquiat." *New Art Examiner* 23 (November 1996), p. 18.

Gillick, Liam. "Basquiat," review of Schnabel's film. *Art Monthly*, no. 200 (October 1996), pp. 46–47.

Houborg, Jørn. "Malerkunstens Jimi Hendrix." *Hrymfaxe* 26, no. 1 (March 1996), pp. 13–17.

Hubbard, Sue. "Arts in Society: Death in the Urban Jungle—Jean-Michel Basquiat Wanted Greatness for His Art, Not Just Cult Status, Argues Sue Hubbard." *New Statesman Society*, March 22, 1996, p. 31.

Jodidio, Philip, interviewer. "Les Oiseaux," interview with Hervé Chandès, organizer of the exhibition at Fondation Cartier. *Connaissance des arts*, no. 529 (June 1996), pp. 40–47.

Kaplan, James. "Lives of the Artists," review of Schnabel's *Basquiat*. *New York* 29, no. 31 (August 12, 1996), p. 30.

Lane, Anthony. "The Current Cinema: 'Kansas City,' 'Basquiat.'" *New Yorker*, August 19, 1996, pp. 78–79.

Lehuard, Raoul. "Art africain & art contemporain: Quelques impressions d'Afrique." *Arts d'Afrique noire*, no. 100 (winter 1996), pp. 45–48.

Lucie-Smith, Edward. "The Writing on the Wall." *Art Review* 48 (March 1996), pp. 20–22.

MacDonnell, Virginia. "Outsider Art Is In." *Artfocus* 4, no. 3 (spring 1996), pp. 18–20.

Maslin, Janet. "A Postcard Picture of a Graffiti Artist." *The New York Times*, August 9, 1996, p. C5.

McGuigan, Cathleen. "Andy and Jean-Michel." *The New York Times Magazine*, April 14, 1996, p. 144.

Melvin, Joanna. "Jean-Michel Basquiat: Cultural Sniper." *Contemporary Art* 3, no. 3 (late spring 1996), pp. 21–24.

Muñoz, José Esteban. "Famous and Dandy like B. 'n' Andy: Race, Pop, and Basquiat." In *Pop Out: Queer Warhol*, ed. Jennifer Doyle, Jonathan Flatley, and José Esteban Muñoz, pp. 144–79. Durham, N.C.: Duke University Press, 1996.

Murat, Laure. "Visite très privée chez les plus grands collectionneurs." *Beaux Arts Magazine*, no. 141 (January 1996), pp. 50–63, 123–24.

Picard, Denis. "Basquiat vu par Schnabel." *Connaissance des arts*, no. 531 (September 1996), pp. 116–19.

Piguet, Philippe. "Jean-Michel Basquiat: Une Oeuvre manifeste," review of the Galerie Enrico Navarra exhibition. *L'Oeil*, no. 480 (May–June 1996), p. 1U.

"Portrait of Basquiat." *Newsweek* 128, no. 7 (1996), p. 64.

Rimanelli, David. "Basquiat," review of Schnabel's film. *Artforum* 35 (September 1996), pp. 19–20.

Smith, Roberta. "Portraits of the Artists on the Big Screen." *The New York Times*, August 4, 1996, pp. H11, H20.

Stamets, Bill. "A Cautionary Tale: Memorializing Basquiat." *New Art Examiner* 23 (November 1996), pp. 19ff.

Steiner, Wendy. "Jean-Michel Basquiat." *London Review of Books* 18, no. 13 (1996), p. 14.

1997

Bruzzi, Stella. "Basquiat," review of Schnabel's film. *Sight & Sound*, n.s., 7 (April 1997), pp. 35–36.

Delory, Patrice. "Basquiat: Le trait de la fulgurance," review of the Fondation Dina Vierny/Musée Maillol exhibition. *Beaux Arts Magazine*, no. 160 (September 1997), p. 31.

Fulford, Robert. "Portrait of the Artist as Explosive Device." *Canadian Art* 14, no. 1 (spring 1997), pp. 54–59.

Hayt, Elizabeth. "Jean-Michel Basquiat," review of the Tony Shafrazi exhibition. *Art News* 96 (January 1997), p. 114.

Jodidio, Philip. "Basquiat." *Connaissance des arts*, no. 538 (April 1997), pp. 40–41.

Jover, Manuel. "Basquiat graphique," review of the Fondation Dina Vierny/Musée Maillol exhibition. *L'Oeil*, no. 486 (June 1997), p. 26.

Kuspit, Donald. "Schnabel's 'Basquiat.'" *Art New England* 18 (December 1996–January 1997), p. 9.

Lanzl, C. "Artists Making Movies." *Art New England* 18 (April–May 1997), pp. 28–29.

Morice, Jacques. "Basquiat," review of Schnabel's film. *Beaux Arts Magazine*, no. 155 (April 1997), p. 20.

Nemeczek, Alfred. "Künstler als Monster im Kino." *ART: Das Kunstmagazin*, no. 3 (March 1997), p. 66.

Saada, N., interviewer. "Entretien avec Julian Schnabel." *Cahiers du cinema*, no. 512 (April 1997), pp. 65–68.

Sasson, Selim. "Basquiat, le film." *Art et culture* 11, no. 9 (May 1997), pp. 34–35.

Szabadi, Judit. "Az exhibicionizmus mint muveszet es letforma: latogatas a Stuck-villaban" (Exhibitionism as a way of life: Visit to the Museum Villa Stuck). *Új Művészet* (Budapest) 8, nos. 3-4 (March–April 1997), pp. 16–21, 25–31.

Toubiana, Serge. "Basquiat," review of Schnabel's film. *Cahiers du Cinema*, no. 512 (April 1997), pp. 62–64.

Wilson, Andrew, interviewer. "Basquiat: 'Like Boom for Real,'" interview with Michael Holman. *Art Monthly*, no. 210 (October 1997), pp. 8–11.

Young, Kevin. "Cassius Clay by Basquiat." *Callaloo* 20, no. 2 (1997), p. 294.

1998

Adams, Brooks. "Keith Haring: Radiant Picaresque" *Art in America* 86, no. 4 (April 1998), pp. 94–99, 130.

Attias, Laurie. "Jean Hamon: Strokes of Luck." *Art News* 97, no. 7 (summer 1998), pp. 136–37.

Bosworth, Patricia. "Hyped to Death: The Short Life of Jean-Michel Basquiat, Graffiti Artist Turned Gallery Commodity," review of *Basquiat: A Quick Killing in Art*, by Phoebe Hoban. *The New York Times*, August 9, 1998, book review sec., p. 4.

Cunningham, M. "Colorful Character." *Metropolitan Home* 30, no. 6 (November–December 1998), pp. 160–65.

Selwood, Sara, Adam Thomas, Leonard Latiff, Michelle McNally, and Jo O'Driscoll. "Art and Antiques Trade." *Cultural Trends*, no. 29 (1998), pp. 37–65.

Tansini, Laura. "Basquiat as the New Warhol: A Pricing Phenomenon." *Art Newspaper* 10, no. 87 (December 1998), p. 51.

———. "German Paintings All Bought for the US, US Paintings for Europe." *Art Newspaper* 8 (January 1998), p. 30.

Vogel, Carol. "Graffiti Artist Makes Good: A Basquiat Sells for a Record $3.3 Million." *The New York Times*, November 13, 1998, p. B4.

Wichelhaus, Barbara. "Kunst im Kollektiv: Gemeinsam hergestellte Werke." *Kunst+Unterricht*, no. 226 (October 1998), pp. 22–34, 38.

1999

"Basquiat fra Trento e Venezia: Tutti pazzi per Samo." *L'espresso* 45, no. 22 (1999), pp. 147–48.

Benhamou-Huet, Judith. "Artistes contemporains: Les Cotations marquantes." *Connaissance des arts*, no. 559 (March 1999), pp. 54–61.

———. "Basquiat Hits the Art Market Firmament." *Art Press*, no. 242 (January 1999), pp. 16–17.

———. "Incontournables: FIAC 99." *Beaux Arts Magazine*, no. 184 (September 1999), pp. 102–05.

Bevan, Roger. "Contemporary Art." *Art & Auction* 21, no. 21 (September 1-14, 1999), p. 46.

Blistène, Bernard. "Une Histoire de l'art du XXe siecle 20: L'Art aujourd'hui—'situations et enjeux.'" *Beaux Arts Magazine*, no. 187 (December 1999), pp. 98–110.

Caprile, Luciano. "Gioventu bruciata." *Arte* 12, no. 61 (June–July 1999), pp. 24–29.

Dornberg, J. "Old Masters, Contemporary and Modern Art." *Art & Auction* 21, no. 21 (September 1–14, 1999), p. 50.

Edwards, Michael. "Maleriet och forandringens konst" (Painting and the art of transformation). *Paletten* 60, no. 3 (1999), pp. 38–46.

Ermann, Lynn. "Prop Art." *ARTnews* 98, no. 7 (summer 1999), pp. 146–48.

Franceschetti, Roberta, with Jeffrey Deitch, Keith Haring, Francesco Clemente, and Andy Warhol. "Basquiat: Il rapper del colore." *Arte*, no. 311 (July 1999), pp. 78–85.

Frohne, Andrea. "Representing Jean-Michel Basquiat." In *African Diaspora: African Origins and New World Identities*, edited by Isidore Okpewho, pp. 439–50. Bloomington: Indiana University Press, 1999.

Gigli, Nicoletta Cobolli, Angela Vettese, Stefano Zecchi, and Gabriele Mazzotta. "Capire: l'arte oggi." *Arte*, no. 316 (December 1999), pp. 91–101.

Handler, Ruth. "Schlechte Entschuldigung," review of the Staatliche Kunsthalle Baden-Baden exhibition. *ART: Das Kunstmagazin*, no. 6 (June 1999), p. 97.

"Konige, Helden und die Strasse." *ART: Das Kunstmagazin*, no. 2 (February 1999), p. 80.

Lerouge, Stephanie. "Le Prix de l'art." *Beaux Arts Magazine*, no. 184 (September 1999), pp. 123–29.

Page, A. "À New York: Les Ventes de peintures." *Connaissance des arts*, no. 557 (January 1999), pp. 112–13.

Panicelli, Ida. "Jean-Michel Basquiat," review of the Fondazione Bevilacqua La Masa and Museo Revoltella. *Artforum* 38, no. 3 (November 1999), p. 150.

Rickels, L. A. "American Psychos: The End of Art Cinema in the '90s." *Art/Text*, no. 67 (November 1999–January 2000), pp. 58–63.

Sosa, Ernest, and Issa Maria Benitez Duenas. "ExpoArte Guadalajara '98: 7th International Forum on Contemporary Art Theory." *Art Nexus*, no. 31 (February–April 1999), pp. 84–86.

"Tops & Flops: 1998." *Beaux Arts Magazine*, no. 177 (February 1999), pp. 112–17.

Tully, Judd. "Contemporary Art, Part II." *Art & Auction* 21, no. 20 (July–August 1999), p. 46.

Van Arsdol, Robin. "Basquiat a Venezia: Graffiti sul Canal Grande." *D'Ars* 39, no. 158 (July 1999), pp. 42–45.

Whisson, Ken. "Some Thoughts Arising from the 48th Venice Biennale of Visual Art." *Art Monthly Australia*, no. 122 (August 1999), pp. 4–5.

Wilson, Andrew. "All over the Place." *Art Monthly*, no. 228 (July-August 1999), pp. 7–10.

Wolinski, N. "Jean-Michel Basquiat," book review. *Beaux Arts Magazine*, no. 183 (August 1999), p. 86.

2000

Attias, Laurie. "Jean-Michel Basquiat," review of Enrico Navarra exhibition. ARTnews 99, no. 8 (September 2000), p. 182.

Badia, Montse. "El presente global del arte." Lapiz 19, no. 162 (April 2000), pp. 18–23.

Calvo Serraller, Francisco. "La fotogenia cinematografica de los artistas." Arte y parte, no. 28 (August–September 2000), pp. 82–94.

Carfi, Chiara. "La guerra del linguaggio illeggibile: Dal buio della subway alla luce artificiale delle gallerie." D'Ars 40, no. 161 (January 2000), pp. 48–51.

Marshall, Cora. "Jean-Michel Basquiat, Outsider Superstar." International Review of African American Art 16, no. 4 (2000), pp. 32–36.

McGonigal, M. "Same ol' Samo." Artforum 38, no. 10 (summer 2000), p. 53.

McLean, I. "Probability, Rap and Coincidence: Gordon Bennett's Notes to Basquiat." Third Text, no. 50 (spring 2000), pp. 107–09.

Meyer, Laure. "Africains d'Afrique ou d'Amerique," review of Transatlantic Dialogue exhibition. L'Oeil, no. 518 (July–August 2000), p. 95.

Miller, Harland. "A Wave from Jean-Michel." Modern Painters 13, no. 3 (autumn 2000), pp. 42–43.

Schaernack, Christian. "Der Kunstler als Superstar," review of Around 1984 at P.S. 1. ART: Das Kunstmagazin, no. 8 (August 2000), pp. 93–94.

Wavrin, Isabelle de, Jean-Max Colard, and Isabel Garcia-Gill. "Les folles journées de Bâle; Dans la jungle de la foire; La 'Young Art Fair' alternative et tremplin; 10 Oeuvres qui creent l'evenement," includes a review of the Basel Art Fair. Beaux Arts Magazine, no. 193 (June 2000), pp. 112–15.

2001

Armand, Louis. "Jean-Michel Basquiat©: Identity and the Art of (Dis)Empowerment." Litteraria Pragensia 11, no. 21 (2001), pp. 94–106.

Beatrice, Luca. "Contaminazioni: Arte & fumetto," review of the Galleria d'Arte Moderna e Contemporanea in Bergamo exhibition. Arte, no. 340 (December 2001), pp. 157–58.

Finkel, J. "Modern, Postwar and Contemporary Art." Art & Auction 23, no. 2 (February 2001), p. 78.

Forgacs, Eva. "Toys Are Us: Toys and the Childlike in Recent Art." Art Criticism 16, no. 2 (2001), pp. 6–21.

Israel, Nico. "VII Bienal de La Habana: Various Venues, Havana, Cuba." Artforum 39, no. 6 (February 2001), pp. 147–48.

Rabinowitz, Cay Sophie. "Artiste verité: Rediscovering the Original 'Basquiat,'" review of Downtown 81. Art Papers 25, no. 4 (July–August 2001), pp. 20–21.

2002

Allen, H. "NY Contemporary Auctions: Strong Sales, Low Energy." Flash Art 34 (July–September 2002), pp. 49, 55.

Benhamou-Huet, Judith. "The Big Three in Big Trouble." Art Press, no. 281 (July–August 2002), p. 16.

Clement, Jennifer. "The Black Man Who Dreamed in Spanish: Jean-Michel Basquiat." Latino Leaders, October–November 2002.

Goodyear, Frank H., Kristin Smith, Tess Mann, and William F. Stapp. "Portrait of the Art World." ARTnews 101, no. 9 (October 2002), pp. 136–43.

Gravagnuolo, Emma. "Basquiat: Fiabe di ordinaria violenza." Arte, no. 342 (February 2002), pp. 36–37.

Hafner, Hans-Jurgen. "Basquiat," review of the Museum Würth exhibition. Kunstforum International, no. 158 (January–March 2002), pp. 342–43.

Holman, Michael. "Downtown 81." Art Monthly, no. 252 (December 2001–January 2002), pp. 51–53.

Holmes, Pernilla. "Report Card: Jean-Michel Basquiat." Art Review 53 (June 2002), p. 77.

Honigman, Ana. "American Graffiti." Contemporary, no. 1 (January 2002), pp. 16–21.

Jimenez, Carlos. "Warhol-Basquiat-Clemente." Lapiz 21, no. 182 (April 2002), p. 84.

Kehr, Dave. "Basquiat and Friends: In Creative Serendipity." The New York Times, July 13, 2002, p. E23.

Leris, Sophie. "The Natural," collection of Enrico Navarra. Art Review 53 (September 2002), pp. 100–05.

Marsano, Beba, ed. "Basquiat superstar: Il passaggio folgorante di una meteora." Arte, no. 343 (March 2002), p. 14.

——. "La violenza del gesto e la sua eco da Dubuffet fino a Basquiat." Arte, no. 346 (June 2002), p. 16.

Moreno, Gean. "Post-Graffiti." Art Papers 26, no. 6 (November–December 2002), pp. 20–21.

Murray, Derek. "One Planet under a Groove: Hip Hop and Contemporary Art." NKA: Journal of Contemporary African Art, no. 16–17 (fall–winter 2002), pp. 60–65.

Ongiri, Amy Abugo. "Downtown 81: A Tribute to Jean Michel Basquiat." NKA: Journal of Contemporary African Art, no. 16–17 (fall–winter 2002), p. 108.

Probst, U. M. "Elizabeth Peyton: 16 Artists: Salzburger Kunstverein." Kunstforum International, no. 162 (November–December 2002), pp. 365–66.

Reid, Calvin. "'One Planet under a Groove' at the Bronx Museum." Art in America 90, no. 9 (September 2002), pp. 132–33.

Spagnesi, Licia. "Rinascimento a New York." Arte, no. 346 (June 2002), pp. 86–93.

Tully, Judd. "Postwar and Contemporary Art." Art & Auction 24, no. 8 (summer 2002), pp. 88–89.

Vincent, Steven. "The Man Who Would Be Basquiat." Art & Auction 24, no. 9 (October 2002), pp. 28–30.

2003

Adair, Gilbert. "Moving Images." Art Quarterly (autumn 2003), pp. 50–55.

Adams, Brooks, interviewer. "'80s Then: Francesco Clemente Talks to Brooks Adams." Artforum 41, no. 7 (March 2003), pp. 58–59, 260.

Civati, Stefano, and Emma Gravagnuolo. "The Annina Nosei Story." Arte, no. 356 (April 2003), pp. 180–83.

Diez, Renato. "Mercato: Collezionare l'arte di oggi." Arte, no. 356 (April 2003), pp. 146–54.

Druhl, Sven. "Der Paranoia-Diskurs: Conspiracies, UFOs und Verschworungsdenken," review of the Museo Correr exhibition. Kunstforum International, no. 163 (January–February 2003), pp. 102–35.

Ermen, Reinhard. "Pittura/Painting," review of the Museo Correr exhibition. Kunstforum International, no. 166 (August–October 2003), pp. 306–09.

Etherington-Smith, Meredith. "The Office," works for sale at Hamiltons Gallery, London. Art Review 54 (March 2003), pp. 109–13.

Farine, Manou. "Expressionnismes: La Grande Famille." L'Oeil, no. 546 (April 2003), p. 111.

Fronz, Hans-Dieter. "Expressiv!," review of the Fondation Beyeler exhibition. Kunstforum International, no. 165 (June–July 2003), pp. 354–55.

Haden-Guest, Anthony. "Wannabe Big Shot Is Busted." Art Review 54 (March 2003), pp. 34–35.

Johnson, Ken. "Art in Review: 'Fire under the Ashes: From Picasso to Basquiat.'" The New York Times, December 19, 2003, p. E39.

Krienke, Mary. "Expressive!," review of the Fondation Beyeler exhibition. ARTnews 102, no. 9 (October 2003), pp. 140, 152.

Kroner, Magdalena. "Talking Pieces." Kunstforum International, no. 164 (March–May 2003), pp. 321–23.

Landi, Ann. "The Fire under the Ashes: From Picasso to Basquiat." ARTnews 102, no. 11 (December 2003), p. 116.

Lavigne, J. "En compagnie de Basquiat," book review. Beaux Arts Magazine, no. 225 (February 2003), p. 106.

Morel, Guillaume. "Basquiat: La Rage de peindre," review of Fondation Dina Vierny-Musée Maillol exhibition. L'Oeil, no. 550 (September 2003), p. 24.

2004

Barker, G. "London Sales Preview." Art & Auction 26, no. 11, part 12 (June 2004), pp. 112–15.

Craven, R. R. "Crossing Currents: The Synergy of Jean-Michel Basquiat and Ouattara Watts." Art New England 25, no. 5 (August–September 2004), p. 31.

Ebony, David. "Records Smashed at Fall Auctions." Art in America 92 (January 2004), pp. 21, 23.

Gleadell, Colin. "Smash Hits." Art Review 54 (March 2004), pp. 38, 40.

Hafner, Hans-Jurgen. "One Planet under a Groove." Kunstforum International, no. 168 (January–February 2004), pp. 352–53.

FILMS/VIDEOTAPES

1983

Young Expressionists. New York: Inner-Tube Video, 1983. Videocassette; 28 min. Directed by Paul Tschinkel and Marc H. Miller; produced by Paul Tschinkel; text and interviews by Marc H. Miller. Works by Jean-Michel Basquiat at Fun Gallery, Francesco Clemente at Mary Boone and Sperone-Westwater Galleries, and Julian Schnabel at Leo Castelli Gallery. Interviews with Basquiat and Schnabel.

1984

Graffiti/Post-Graffiti. New York: Inner-Tube Video, 1984. Videocassette; 28 min. Produced by Marc H. Miller and Paul Tschinkel. Interviews with Charlie Ahearn, Patti Astor, Jean-Michel Basquiat, Fred Brathwaite, "Crash," Stefan Eins, Futura 2000, Keith Haring, Sidney Janis, "Lady Pink," Dolores and Hubert Neumann, Rammellzee, and Tony Shafrazi.

1989

Jean-Michel Basquiat: An Interview. New York: Inner-Tube Video, 1989. Videocassette; 34 min. 1981 interview by Marc H. Miller.

Jean-Michel Basquiat (1960–1988). New York: Inner-Tube Video, 1989. Videocassette; 57 min. Produced by Paul Tschinkel. Covers career of Basquiat. Includes interviews with Peter Schjeldahl, Jeffrey Deitch, Fab 5 Freddie, and Annina Nosei; interview of Basquiat by Marc Miller.

1990

Shooting Star. London: Illuminations Production, 1990. 52 min. Directed by Geoff Dunlop; produced by Linda Zuck. Contributions by Glenn O'Brien, Fab 5 Freddie, and Annina Nosei.

1993

"Jean-Michel Basquiat: Artist's Achievements Debated." Sunday Morning program, January 24, 1993, CBS Television, 8 min.

2000

Downtown 81 (New York Beat). New York, NY: Zeitgeist Films, 2000. 72 min. Directed by Edo Bertoglio; written by Glenn O'Brien; produced by Maripol; cinematography by John McNulty. Filmed 1980–81 under the working title "New York Beat." Reconstruction released 2000.

INDEX OF ILLUSTRATIONS

Acque Pericolose 28–29
All Colored Cast (Part II) 96
Arroz con Pollo 33
Ascent 184

Baby Boom 79
"Beat Bop" covers 90, 103
Bird on Money 178
Bishop 206
Boxer Rebellion 211
Boy and Dog in a Johnnypump 75
Brother's Sausage 112–13

Cabeza 168
Charles the First 80
CPRKR 81

Después de un Puño 162, 176
*The Dingoes That Park Their Brains with
 Their Gum* 150
Discography (One) 84
Discography (Two) 85
Dog Leg Study 193
Dos Cabezas 169
Dwellers in the Marshes 207

Eroica 154
Eroica I 158
Eroica II 159
Exu 160–61
Eye of Troof 187
Eyes and Eggs 64

False 185
50¢ Piece 201
Flexible 140
Formless 188

Glenn 50
Gold Griot 146
Gravestone 155
Gri Gri 171
Grillo 142–43
Gringo Pilot (Anola Gay) 93
The Guilt of Gold Teeth 177

Head of a Fryer 70
Hollywood Africans 69
*Hollywood Africans in Front of the
 Chinese Theater with Footprints
 of Movie Stars* 102
Horn Players 88

In Italian 40, 115
In This Case 51
Irony of the Negro Policeman 32

J's Milagro 172
Jawbone of an Ass 37
Jesse 58
Jim Crow 147
Jimmy Best ... 15

King Alphonso 197
King Brand 200
King Pleasure 164

La Colomba 114
Large Body of Water 191
Leeches 180
Leonardo da Vinci's Greatest Hits 59
Liberty 202
Light Blue Movers 105

Mace 203
Max Roach 83
Melting Point of Ice 116, 117
Mitchell Crew 43
Monticello 192

Napoleon Stereotype as Portrayed 183
*Native Carrying Some Guns, Bibles,
 Amorites on Safari* 68
The Nile 106
Notary 108–09
Now's the Time 86–87

Obnoxious Liberals 65
Olympic 198

Pegasus 157
Peptic Ulcer 194
Per Capita 30–31
Peso Neto 2, 34
Philistines 26, 27
Piscine versus the Best Hotels 36
Pork 23
*Portrait of the Artist as a Young
 Derelict* 67
PPCD 182
Price of Gasoline in the Third World 55
Profit I 98

Replicas 204
Ribs, Ribs 20
Riddle Me This, Batman 151
Riding with Death 152, 153
Roast 205

SAMO graffiti 99
Santo versus Second Avenue 71
Savonarola 189
Self-Portrait with Suzanne 38
Sienna 127
Six Crimee 72, 73
Skin Head Wig 209
Snakeman 186
St. Joe Louis Surrounded by Snakes 76
Steel 208

Techu-Anpu 190
Television and Cruelty to Animals 175
*Three Quarters of Olympia Minus the
 Servant* 62
Titian 196
To Be Titled 174
To Repel Ghosts 141
Tree Version 210
Trumpet 82
Tuxedo 118

Unbleached Titanium 181
Undiscovered Genius 199
*Undiscovered Genius of the Mississippi
 Delta* 110–11
Untitled (1980) 16
 (1980–81) 17
 (1981) 12, 13, 18, 19, 22, 94
 (1982) 38, 39, 60, 61
 (1983) 107
 (1984) 144
 (1985) 89
 (1987) 156, 173
Untitled (collaboration with Andy
 Warhol) 126
Untitled (from the Blue Ribbon series)
 124, 125
Untitled (Baptism) 54
Untitled (Black Tar and Feathers) 66
Untitled (Boxer) 78
Untitled (Caucasian/Negro) 145
Untitled (Cheese Popcorn) 121
Untitled (Crown) 10–11, 119
*Untitled (The Daros Suite of Thirty-two
 Drawings)* 180–211
Untitled (God/Law) 131
Untitled (Head) 35, 128
Untitled (Helmet) 21, 165
Untitled (Jackson) 122
Untitled (Maid from Olympia) 63
Untitled (Mostly Old Ladies) 121
Untitled (Olive Oil) 123
Untitled (Plaid) 120

Untitled (Quality) 120
Untitled (Self-Portrait) 74
Untitled (Series of Poems) 166
Untitled (Sugar Ray Robinson) 77
*Untitled (Suite of Fourteen
 Drawings)* 24–25
Untitled (Two Heads on Gold) 95
Untitled (We have decided ...) 14

Victor 25448 148–49

Wolf Sausage 195

WORKS BY OTHER ARTISTS

Beuys, Joseph, *Untitled (Sun State)* 56
Gauguin, Paul, *Spirit of the Dead
 Watching* 53; *Yellow Christ* 52
Kirchner, Ernest Ludwig, *Self-Portrait
 as a Soldier* 47
Lam, Wifredo, *Zambezia, Zambezia* 167
Leonardo da Vinci, *Studies of Legs of
 Man and the Leg of a Horse* 48
Matisse, Henri, *La Négresse* 45
Picasso, Pablo, *Les Demoiselles
 d'Avignon* 57; *Girl Before a
 Mirror* 137
Twombly, Cy, *The Italians* 49

PHOTOGRAPHS

Basquiat with Martin Burgoyne and
Madonna 100; with Fab 5 Freddy 92;
with the band Gray 100; with Keith
Haring 97; with Glenn O'Brien 99; with
Andy Warhol 57; writing graffiti in the
film *Downtown 81* 101; painting *Gold
Griot* 170; photographed for the cover
of *The New York Times Magazine* 104
Illustration from Burchard Brentjes,
African Rock Art 134